FAREWELL YELLOW BRICK ROAD

MEMORIES OF MY LIFE ON TOUR

ELTON JOHN

FOREWORD BY DAVID FURNISH

HYPERION AVENUE
LOS ANGELES NEW YORK

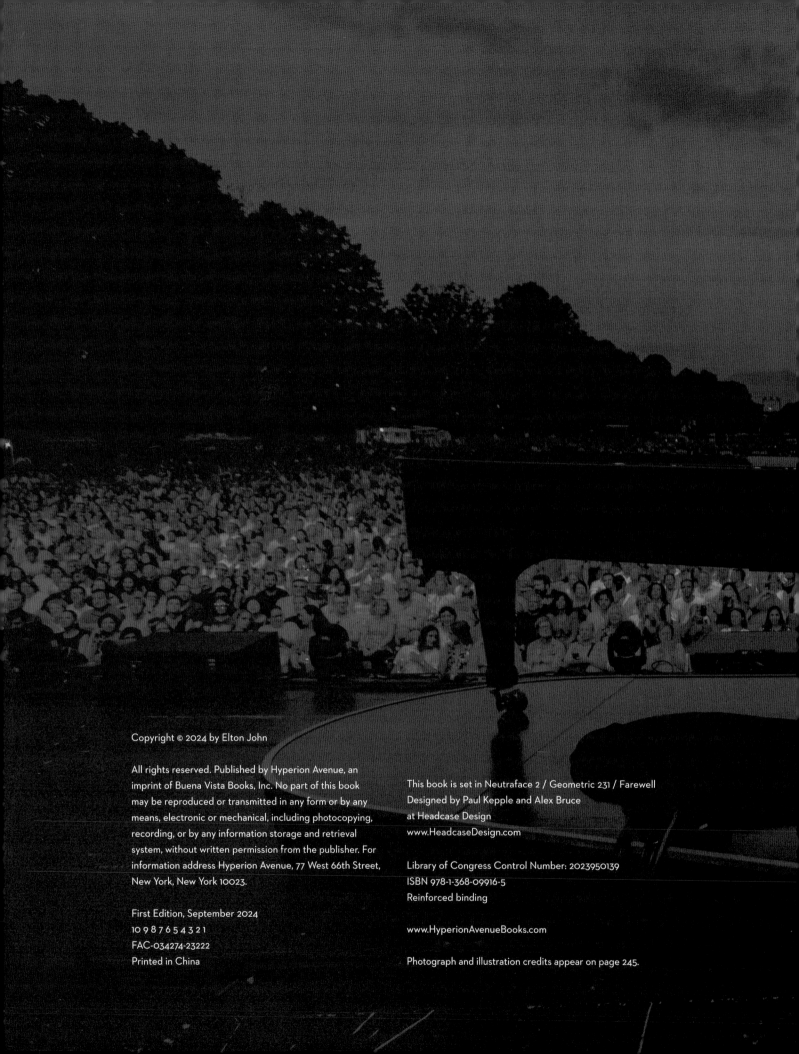

All rights reserved. Published by Hyperion Avenue, an
imprint of Buena Vista Books, Inc. No part of this book
may be reproduced or transmitted in any form or by any
means, electronic or mechanical, including photocopying,
recording, or by any information storage and retrieval
system, without written permission from the publisher. For
information address Hyperion Avenue, 77 West 66th Street,
New York, New York 10023.

First Edition, September 2024
10 9 8 7 6 5 4 3 2 1
FAC-034274-23222
Printed in China

This book is set in Neutraface 2 / Geometric 231 / Farewell
Designed by Paul Kepple and Alex Bruce
at Headcase Design
www.HeadcaseDesign.com

Library of Congress Control Number: 2023950139
ISBN 978-1-368-09916-5
Reinforced binding

www.HyperionAvenueBooks.com

Photograph and illustration credits appear on page 245.

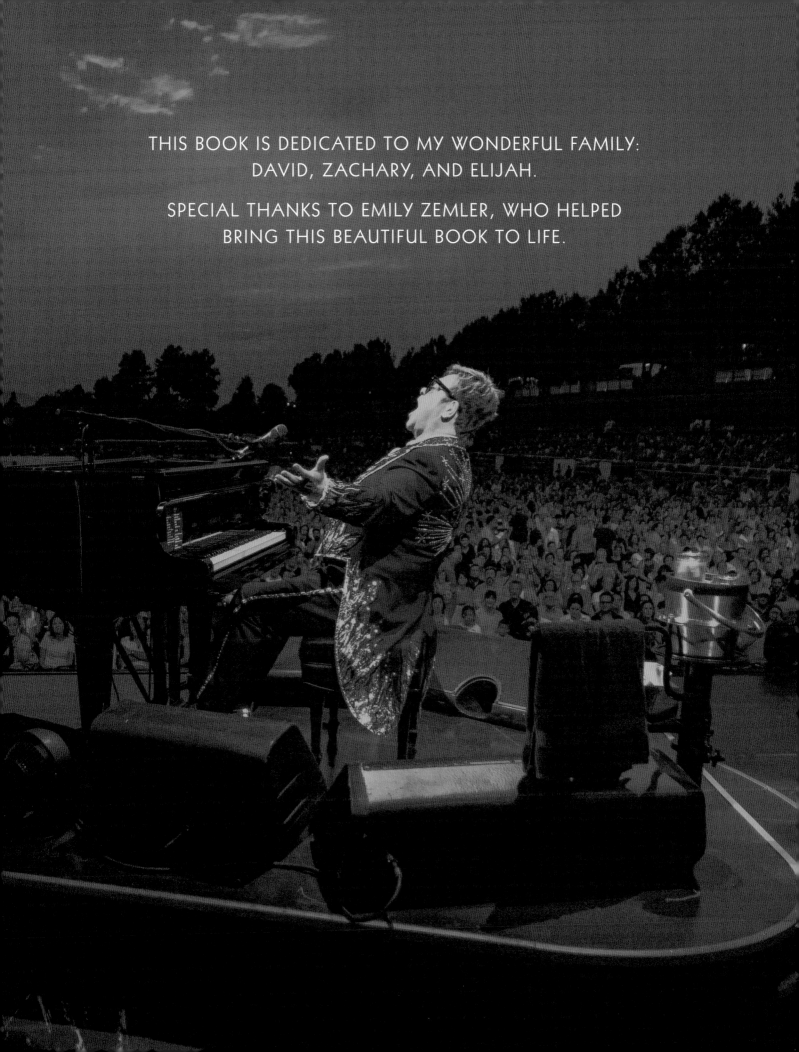

THIS BOOK IS DEDICATED TO MY WONDERFUL FAMILY:
DAVID, ZACHARY, AND ELIJAH.

SPECIAL THANKS TO EMILY ZEMLER, WHO HELPED
BRING THIS BEAUTIFUL BOOK TO LIFE.

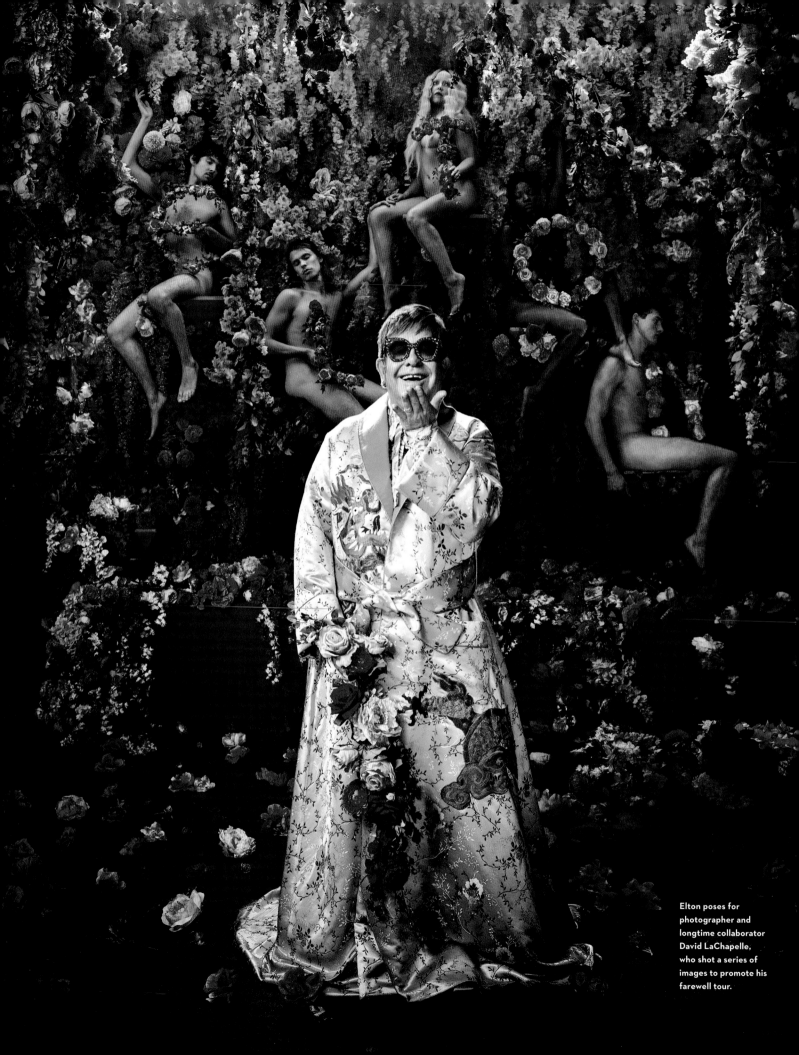

Elton poses for photographer and longtime collaborator David LaChapelle, who shot a series of images to promote his farewell tour.

CONTENTS

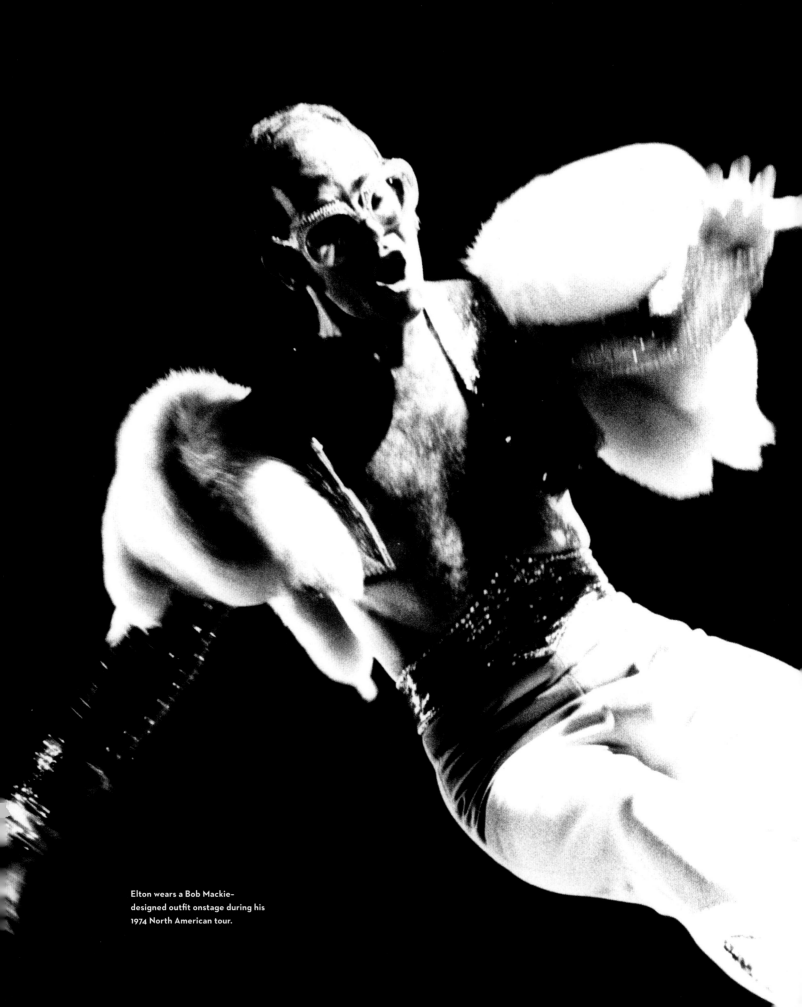

Elton wears a Bob Mackie–
designed outfit onstage during his
1974 North American tour.

FOREWORD

BY DAVID FURNISH

Throughout his career, Elton John has created magical moments for fans around the world. His memorable songs have risen above the everyday and become part of the fabric of our lives—and there's nowhere that is clearer than when he is standing on a stage performing for an audience. When it came time for Elton to retire from touring, I wanted to ensure that his farewell tour would properly celebrate him as one of the greatest living entertainers. It was a joyous opportunity for me, as both his husband and his manager, to lead the creative team behind his momentous Farewell Yellow Brick Road Tour. Elton said he wanted to go out on a high, so we had our work cut out for us.

Impossible as it seemed when we began planning the tour in 2015, we wanted to create a stage show that paid tribute to Elton's storied musical career while allowing his unparalleled artistry to truly shine. He deserved to go out in a blaze of glory with concerts that allowed him to thank his fans for their decades of dedication. Planning the tour, the largest and most extensive tour Elton has ever undertaken, was a responsibility I took very seriously. The creative team and I left no detail to chance. Everything the fans saw onstage was carefully considered with both Elton's legacy and the fans' experience in mind. I am so proud of what we created. To me, the Farewell Yellow Brick Road Tour allowed Elton to sit on a golden throne that only he could sit on.

For more than fifty years, Elton has been a transformative force in many people's lives, including mine. He presents himself with pride and confidence, and he gifts that potential for genuine self-expression to others. I grew up a closeted gay man, thinking I'd never be able to fully be myself, but Elton makes it okay for all of us to be ourselves and to celebrate ourselves. It's a talent that transcends his music. For a long time, Elton himself struggled. The first time he performed at Dodger Stadium in 1975, he was deeply unhappy and struggling with addiction. When he appeared onstage at Dodger Stadium again for two nights in 2022, he was the happiest he's ever been. He's a living example of how to move forward without trying to erase or ignore the past. Each time he steps onto a stage he brings joy and hope to so many, and he will continue to exude that hope even now that he's no longer on the road.

Elton has received many awards and accolades in his career as a recording artist and performer, but nothing compares to the connection he's developed with his fans. From his early club shows in the 1970s to the more recent arena tours, Elton has always captivated with his stage show. He's proved that a grand piano and a flamboyant costume can be truly rock 'n' roll. He's performed all over the world, from America to Australia to Europe to Japan to the former USSR. Each night, he gave everything he had to the audience. He never faltered, no matter the circumstances. It will be a great change in our lives to have Elton come off the road. Our sons and I are looking forward to spending more time with him. And I'm excited to see what he does next, as I know the fans are, too.

Elton is someone who doesn't spend too much time looking back or looking forward. He stays in the moment, which is something we've both learned from being in recovery. I don't know what the future holds for Elton John, but I know it will be bright and probably covered in sequins. I'm grateful for the chance to have been part of the Farewell Yellow Brick Road Tour and to see the fans embrace him onstage one final time. It felt historic in many ways. I join the fans in thanking Elton for his decades of undeniable, unforgettable concerts.

This book is a celebration of those performances, from small clubs to massive stadiums. I hope it can help memorialize what made the shows so great. Although Elton doesn't always look to the past, a lot of memories surfaced for him during his farewell tour. He became unusually nostalgic, as you'll see as he reflects on more than fifty years of touring. Life is punctuated by endings, but each ending is also an opportunity for a beginning. As Elton John steps onto the yellow brick road and walks into the sunset like he did each night on the Farewell Yellow Brick Road Tour, I know there is something equally memorable waiting on the horizon.

David J. Furnish

ABOVE AND RIGHT:
David proudly watches early rehearsals for Elton's Farewell Yellow Brick Road Tour, for which he acted as creative director.

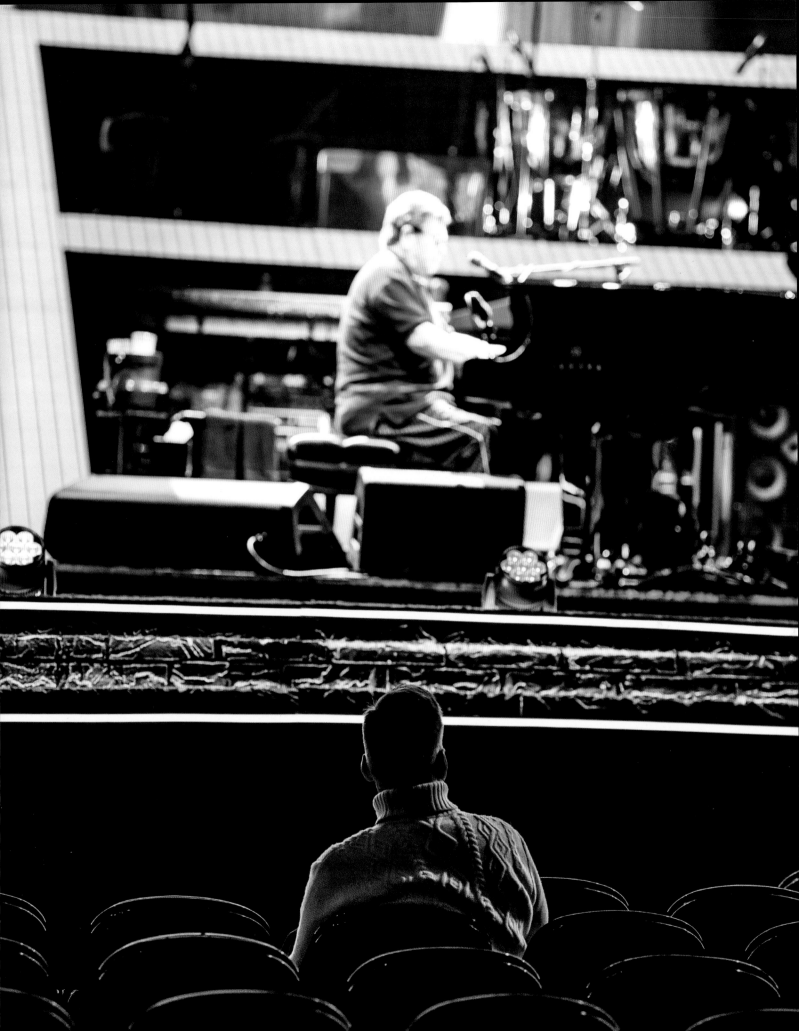

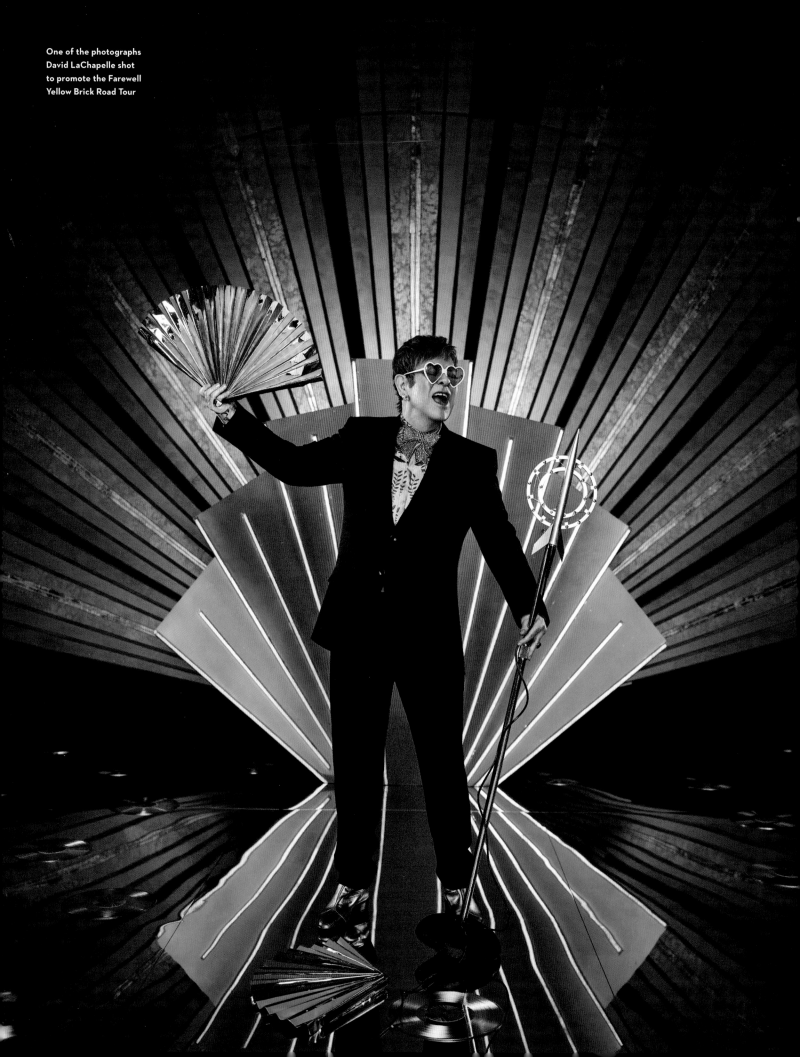

INTRODUCTION

I've been performing, in one way or another, for almost my entire life—since even before I was Elton John. Being in front of an audience on a stage is what I live for. It's electric, frustrating, and, ultimately, fulfilling. It's exciting because you never know what's going to happen. Every town is different, every venue is different, and every audience is different, and it's that magic of not knowing that makes performing live so special. Although I played gigs as a kid, I officially began touring when I was eighteen years old. That was spring of 1965, when I was playing in clubs around England with Bluesology. Back then, I was Reginald Dwight. I was as much a fan as I was a performer. I had long dreamed of the stage. There was something magical about a musician being there in the moment, playing their songs for a live audience, the entire room creating a surge of energy out of nowhere.

Growing up in Pinner, England, in the 1950s, I admired artists like Elvis Presley, who captivated his fans with a sense of drama and showmanship. I wanted to do the same. There was a freedom to rock 'n' roll that I immediately understood. I became obsessed with going to see live music. My love

for concerts started at a venue called the Harrow Granada, where I saw Little Richard, Jerry Lee Lewis, Eddie Cochran, and Gene Vincent. I idolized Little Richard and Jerry Lee Lewis. I looked on in awe as they leapt around the stage and exuded a sense of excitement that made each song feel even more alive than it did on my record player. I'd been playing the piano from an early age, but this was something else entirely. I wanted to play and sing with that kind of raw ferocity. Watching other musicians encouraged me to get onstage myself. Somewhere inside, I knew that I could do this, too.

The first time I faced a real audience was 1964, when I was a schoolboy of sixteen. I sang and played piano in the public bar of the Northwood Hills Hotel every Friday, Saturday, and Sunday for over a year. The upright piano was completely out of tune. I sang Jim Reeves, Al Jolson, and Cliff Richard songs through a little amplifier and did the best I could with the sound quality. I was paid £1 per night—which was not very much, even at the time—but I passed around a box at the end of the evening to collect more. When I started, no one came in. But eventually I drew a crowd, and the pub was packed out every weekend. It got pretty

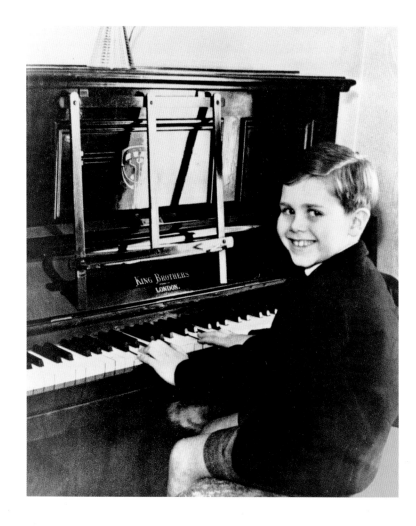

rowdy. There were a few times when I had to dive out the window because a fight broke out, but it was a good place to learn my craft. Sometimes, if I didn't play things like "Roll Out the Barrel," someone in the crowd would hurl a pint of beer at me. Still, I earned enough money to buy a Hohner electric piano and an amplifier of my own.

A real taste of the road came when I played with my band Bluesology for several years. It started as a hobby when I met Stuart Brown, a friend of my cousin, but the band we hoped to form didn't work out. A few years later, we put Bluesology together. We weren't the most successful group in

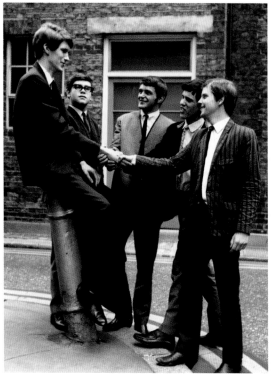

England, but we performed with musicians like the Ink Spots, Major Lance, Billy Stewart, and Patti LaBelle and the Bluebelles. I was the organ player, not the singer. They didn't even let me sing backup vocals. We played a lot of gigs, always loading and unloading our own gear. Sometimes we played more than one show a night. In 1966, we joined up with well-known British soul singer Long John Baldry and became his backing band. We started playing bigger shows in bigger rooms. But I wasn't happy. I wanted to sing and make my own music. I told the band I was leaving and headed back to London with an idea of becoming a new man.

After leaving Bluesology in December 1967, I was soon reborn as Elton John. I didn't think "Reg Dwight" sounded like a rock 'n' roll star, so I changed it. I nicked the name from two of my former bandmates in Bluesology: Elton from saxophonist Elton Dean and John from Long John Baldry. Although I didn't legally change my name to Elton Hercules John until a few years later, it stuck.

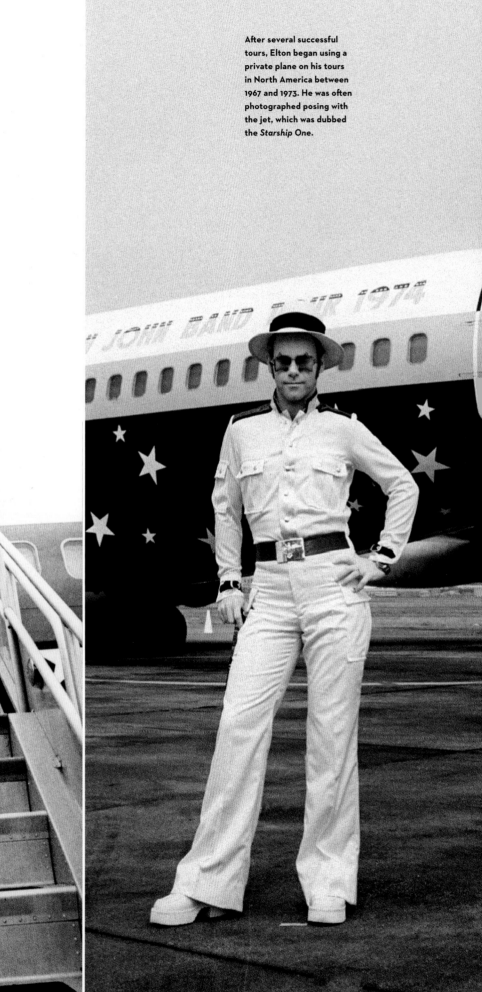

After several successful tours, Elton began using a private plane on his tours in North America between 1967 and 1973. He was often photographed posing with the jet, which was dubbed the *Starship* One.

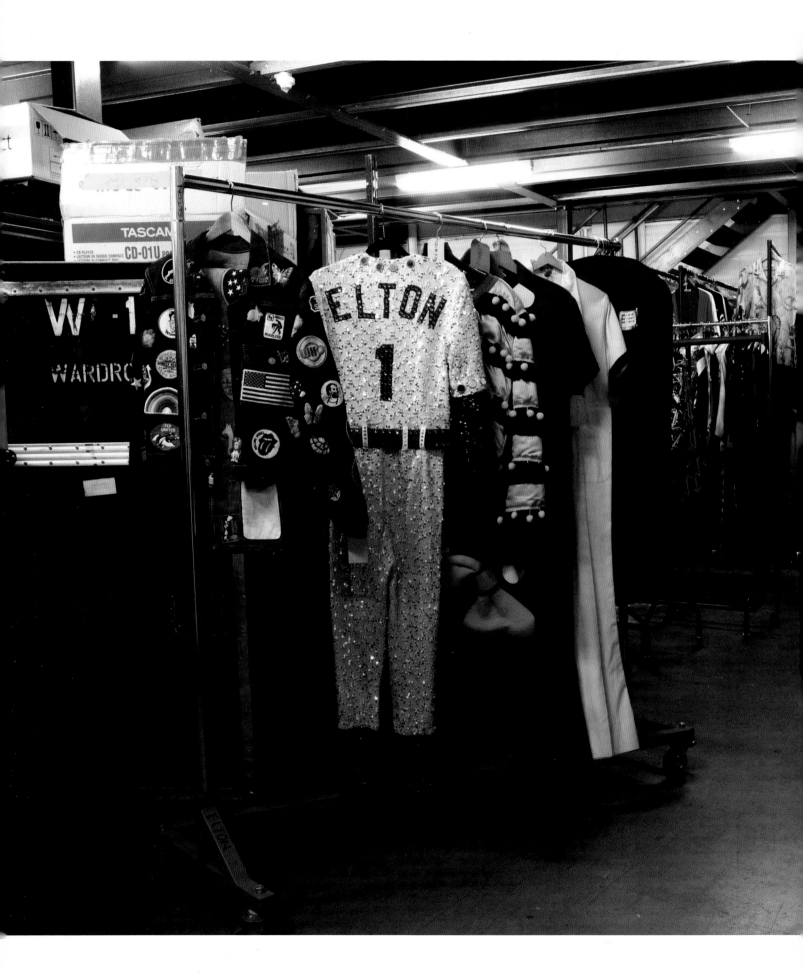

Around the same time I quit Bluesology, I met Bernie Taupin, my steadfast collaborator and primary lyricist for all these years. Bernie and I both responded to a Liberty Records ad in the *New Musical Express* looking for songwriters. It was happenstance that we connected, but it was meant to be. We were musical soulmates from the very beginning. Together, we began writing Elton John songs with him as my lyricist. Bernie was—and still is—the brother I never had.

I released my first album, *Empty Sky*, in 1969, and around the same time, I began performing as a solo artist. My big breakout came in 1970, during my first tour in America. That same year, I declared, "I didn't want to be a performer. I would sooner have stayed at home writing songs. But I'm having the time of my life." How glad I am that I didn't stay at home. In the decades following, I performed thousands of concerts, in every country imaginable.

I've traversed the globe many times over, taking my songs to the far corners of the world. It's been a life of travel and adventure, and I've enjoyed every minute of it. As a touring musician, you're a bit like a nomad, traveling and discovering. There's nothing quite like going to another country and meeting new people and learning about their culture. I've always said: You have to go and see it for yourself. You can't judge a place based on television or newspapers. The audience differs from country to country, and it was exciting to play in all these different places, especially when I was young and hadn't been anywhere except Pinner. Ultimately, it's been a dream come true to play my songs for people of all races, genders, creeds, and nationalities. Music transcends everything, especially when you share the experience live. Nothing brings people together like music.

Over the past fifty years, I've played to the biggest crowds in the biggest venues that anyone could play. And I've played to the absolute best of my ability. I don't think I can achieve anything bigger or better as a live performer. When you've been touring for as long as I have and you've given everything you have to audiences for so many years, there comes a point where you have to decide what to do

next. Several years ago, I began to consider what sort of life I wanted to live going forward. I've never really had a home life. And now I have a family to consider. I have an amazing husband and two beautiful young sons, and I want to dedicate more of my time to being with them. I feel tremendous excitement about being able to do something different. I will always be a musician, a performer, and an artist. I will always carry my memories of touring the world with me. All those nights onstage, sharing my songs with an audience, have become part of who I am. I am forever changed because of what the fans have given back to me when I perform.

Embarking on a farewell tour was important to me. I didn't want to simply stop. It felt essential to honor the fans who have shown up for me year after year, and who have given me love, acceptance, and loyal support. The audiences have made my career possible—every performing artist knows this. The fans create an energy every night, and that energy is what fuels me to be the best I can be. The decision to retire from touring was an easy one. I don't regret it for a minute. The Farewell Yellow Brick Road Tour allowed me to go out on top in the right way.

We announced my intention to retire from touring in early 2018, along with the news of the tour. The first sixty shows sold out in minutes when tickets went on sale. It was a huge honor to feel that kind of love from the fans. They wanted to see me perform just as much as I wanted to spend my final tour with them. After a lot of complicated planning by David and the hugely talented creative team, the tour launched in Allentown, Pennsylvania, on September 8, 2018. As the tour continued to build momentum, we announced more dates. We revisited many of the cities and venues I'd loved playing over the years, and also performed in new places for the first and last time. We didn't know our well-conceived plans would be derailed by a global pandemic, which pushed the pause button on both the tour and our lives. An injury to my hip added further postponements, which meant that my farewell tour officially came to an end in 2023 in Stockholm, Sweden, rather than at Dodger Stadium in Los Angeles, where we had originally planned.

Despite these ups and downs, it was an honor and a delight to bring the Farewell Yellow Brick Road Tour to my fans, young and old. I tend not to look back, but it's been strangely cathartic to reflect on how far I've come since I began playing live as Elton John in 1968. I remembered being Reg Dwight and dreaming of being a performer. I remembered playing the Troubadour in Los Angeles in 1970, a concert that helped to launch my career. I remembered my first American tour, when we drove between shows in a rented station wagon, and my second, when we rode on a hired Greyhound bus. By the time I toured America again in 1973, I was on my own plane, a Boeing 720 nicknamed the *Starship One*—which shows you how quickly my career took off. As we visited places from my past, my wild, sometimes ridiculous tour wardrobes flashed through my head. I recalled all the people who supported me and came back to see me perform again and again. But, in the end, the main thing I thought about was how much things changed after I met my husband, David, and again after we had our sons, Zachary and Elijah.

I've treasured every moment I've spent on the road. There have been big highs and big lows, but I wouldn't trade in any of it. My career has taken me to amazing places and to some unlikely ones, as well. In thinking about how to reflect on the Farewell Yellow Brick Road Tour in this book, I recalled specific moments from particular places we stopped. But these are by no means the only important stops. I have memories of everywhere I've ever performed, and they're all equally meaningful. Imagine this book as a montage of moments from my distant and recent past, like a convergence of flashing memories. It will give you a glimpse of what it was like to say goodbye to the road and hello to whatever is next.

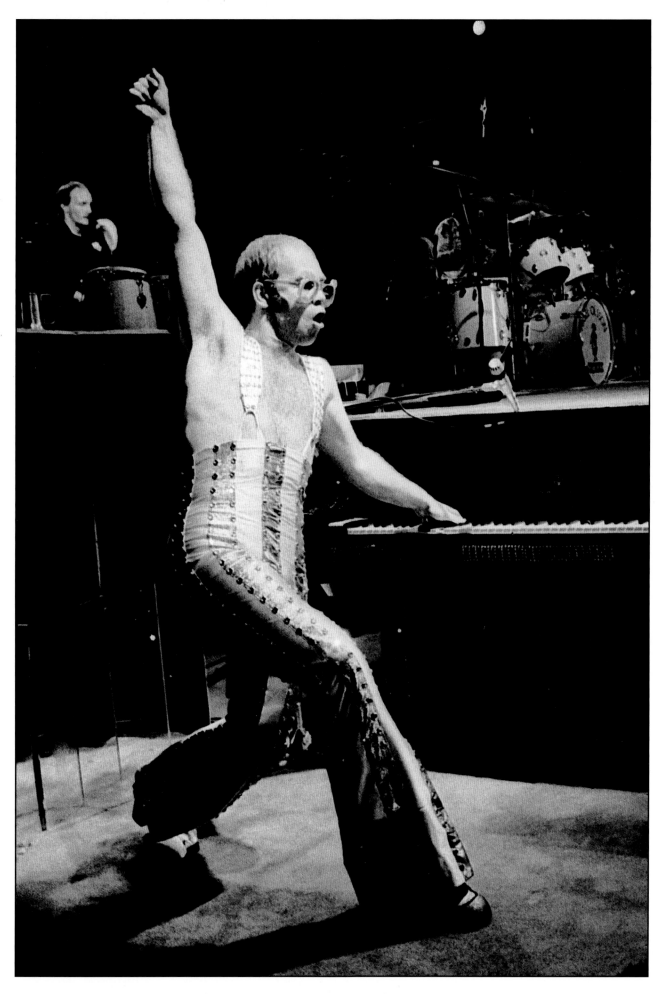

Elton gives a dynamic performance at Madison Square Garden on his North American tour in 1974. He was later joined onstage by John Lennon. The bedazzled ensemble was designed for the singer by Bob Mackie.

'ELTON JOHN IS BOWING OUT STILL AT THE HEIGHT OF HIS POWERS, PERHAPS THE GREATEST SHOWMAN OF OUR TIMES'

★ ★ ★ ★ ★ ★ ★ ★ ★ ★ ★ ★ ★ ★ ★ ★ ★ ★

—*THE DAILY TELEGRAPH*, 2019

Elton always finds a meaningful connection with his audience. Here, he takes a moment onstage to acknowledge their cheers.

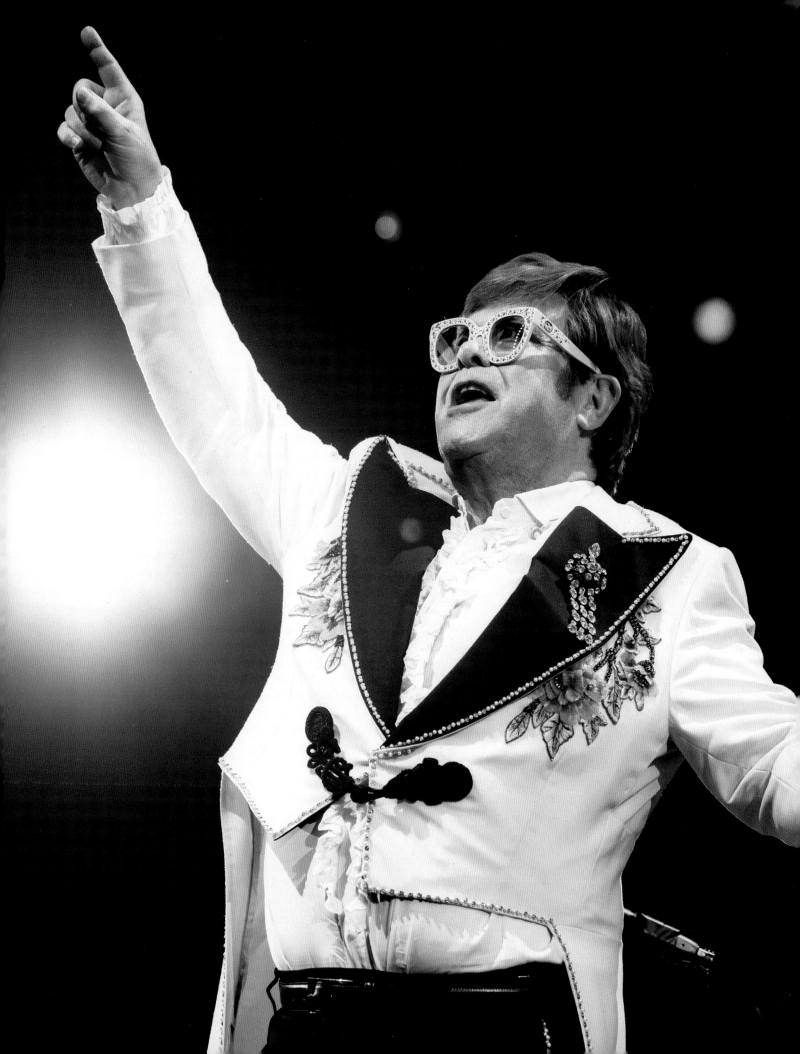

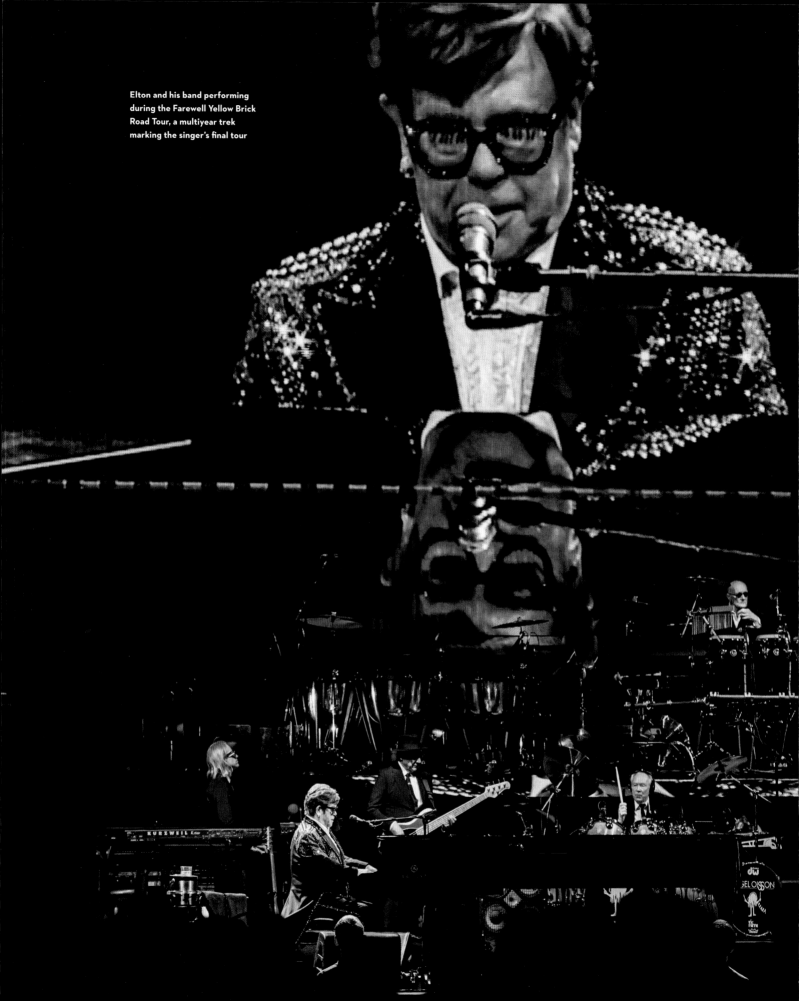

Elton and his band performing during the Farewell Yellow Brick Road Tour, a multiyear trek marking the singer's final tour

PLANNING THE FINAL TOUR

When I began touring, I never thought about there being an end point to my life on the road. I've semi-retired a few times, more than once famously declaring that I'd never play another show again. But I don't think I ever truly considered leaving this part of my life behind for good until recently. As they say, though, all good things must come to an end eventually. I've been clear with my fans that while the Farewell Yellow Brick Road Tour is the culmination of my touring career I still plan to perform live. What this will entail I don't yet know. I do know that the five years I spent on this final tour included some of the most memorable shows I've ever played. If you're going to call it quits, make it the best good bye party it can be.

Over a decade ago, my husband, David Furnish, and I decided to start a family. We weren't entirely sure what that would look like, but we knew we had love to share. I first realized I might want to be a father on a visit to Ukraine in 2009 when I met a young orphan boy and carried him around for hours. Someone said, "You seem very fond of this little boy. Would you think of adopting him?" I didn't hesitate. "I'd actually love to," I replied. Unfortunately, David

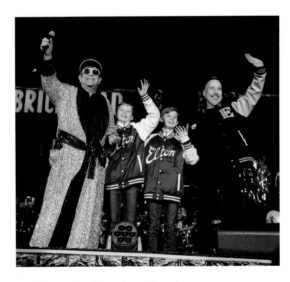

Elton onstage at Dodger Stadium with David and their two children, Zachary and Elijah

and I weren't allowed to adopt because we are gay. The discrimination hurt, but the experience encouraged me to realize that I wanted to be a father. The story had a happy ending when we had our sons, Zachary and Elijah, by surrogate in 2010 and 2013. After so many years as Elton John, I suddenly had another name: Daddy.

Nothing prepares you for parenthood until the reality of it arrives. For the first few years, David and

LEFT:
ALL ACCESS passes from the Farewell Yellow Brick Road Tour

OPPOSITE:
Original lyric sheets written by Bernie Taupin and annotated by Elton during the writing process

I brought the kids along with us on the road. It was joyful. We had bath time in dressing rooms using blow-up duck tubs. We dressed the boys in tiny pajamas, read them bedtime stories, and sent them off to the hotel each evening. Then Daddy would go onstage and perform. It was great fun. But as Zachary and Elijah got older, David and I agreed we didn't want to homeschool them. It's important to us that the boys experience the world and create their own identities. I don't want them to be defined by my career. It's my passion, but it's also my job. And now that David is my manager, it's his job, too. Our sons deserve to become individual people in their own community outside of the entertainment industry. We want to disrupt that as little as possible.

When we looked at the school schedule and my tour schedule side by side, it just wasn't compatible. For the past twenty-five years, I'd been performing one hundred concerts per year—and sometimes more. It didn't seem possible to be in both places at once. David said, "I know where I want to be. Where do you want to be?" I replied, "Well, I don't want to be away from my family."

In that moment, we knew: I would have to come off the road. But it seemed a shame to stop abruptly. I didn't want to simply quit. Instead, I wanted to bookend my touring career with something really magnificent.

"Okay," I said to David. "Let's do a proper farewell tour. I want to say goodbye to my fans. And I want to thank them. I feel like I'm playing and singing better than I ever have, and I want people to remem-

ber me with that kind of vibrancy and vitality. I have so much passion for my music. How can we do this in a way that celebrates that?"

You can't just go on a farewell tour. It takes a lot of planning. I trusted David to figure out the details, so he wrote up a business plan. It was the first time a proper business plan had ever been written in the history of my career. Until that moment, everybody just kept the plates spinning. Now we needed to get the plates down in one piece and put them on display. The first thing David asked for was a setlist. "What do you want to say on your farewell tour musically?" he asked. It didn't take me long to figure out. I wanted my goodbye concerts to celebrate the songs I've made with Bernie Taupin. He's the brother I never had. There would be no Elton without Bernie. Our songs were the first thing that defined me as an artist. It was important to me that the setlist reflect and celebrate that key relationship in my life.

Getting the setlist exactly right was really important. If I don't know how to put a setlist together by now, I never will. It's like having sex: You start, and then you slow down, and then you start again, and at the end, there's a big climax. You have ups and downs. I think the setlist on the farewell tour worked really well. We made a few changes along the way—we added "Have Mercy on the Criminal" and "Sorry Seems to Be the Hardest Word" during some shows—but overall everything worked. And I didn't get bored along the way. In fact, the first half of the show just zipped by. For me, it was the most perfect first half I've ever done.

In determining which songs to include, I focused on the idea of taking the audience on a journey. It was a combination of giving the fans what they wanted and also including songs the band and I would really enjoy playing. Which songs could we really show

Goodbye yellow brick road

When are you gonna come down ?
when are you going to land, ?
I should have stayed on the farm
I should have listened to my old man.

You know you cant hold me forever
I didnt sign up with you,
I'm not a present for your friends to open
this boys to young to be singing the blues.

So goodbye yellow brick road
where the dogs of society howl,
you cant plant me in your penthouse
im going back to my plough

Back to the howling old owl in the woods
hunting the horny back toad,
OH I've finally decided,my future lies
beyond the yellow brick road.

What do you think you'll do then
I bet that'll shoot down your plane,
it'll take you a couple of vodka and tonics
to put you back on your two feet again.

Maybe you'll get a replacement
theres plenty like me to be found,
mongrels,who aint got a penny
sniffing for tit-bits like you to the ground.

 B.J.T.

SLOW - FUNKY (9)

Bennie and the Jets

Hey kids,shake it loose together
the spotlights hitting something
thats been known to change the weather,
we'll kill the fatted calf tonight
so stick around,
your going to hear electric music
solid walls of sound.

Say Candy and Ronnie have you seen them yet
but their so spaced out Bennie and the Jets,
and their so weird and wonderful
oh Bennie she's really keen
she's got electric boots a mohair suit
I read it,I read it in a magazine.

Hey kids,plug into the faithless
maybe their blinded
but Bennie makes them ageless,
and music mutations,we shall survive
lets take ourselves along
where we fight our parents out in the streets
to prove who's right and who's wrong.

 B.J.T.

FAST - HOT A

Love lies bleeding

The roses in the window box
have tilted to one side,
everything about this house
was born to grow and die.

It does'nt seam a year ago
to this very day
you said Im sorry honey
if I dont change the pace
I cant face another day

And love lies bleeding in my hand
it kills me to think of you
with another man

I was playing rock-n-roll and you were just a fan
but my guitar couldnt hold you
so I split the band

I wonder if those changes
have left a scar on you
like all the burning hoops of fire
that you and I passed through.

Your a bluebird on a telegraph line
and I hope your happy now
Well if the wind of change comes down your way
you'll make it back somehow.

 B.J.T.

FAST - HEFT G

Saturday Nights Alright(for Fighting)

It's gettin late have yer seen me mates
Ma tell me when the boys get here,
it's seven-o-clock and I want to rock
to get a belly full of beer.

mans drunker than a barrel full of monkeys
an me old lady she dont care,
my sister looks cute in her braces and boots
and a handfull of grease in her hair.

dont give us none of yer aggravation
we've had it with yer discipline,
saturday nights alright for fightin
get a little action in.

Get about as oiled as a diesel train
gonna set this dance alight
cause saturday nights the night I like
saturday nights alright alright alright OH

Well there packed pretty tight in here tonight
Im looking for a dolly who'll see me right
I may use a little muscle to get what I need
I may sing a little drink and shout out she's with me

And a couple of the sounds that I really like
are the sound of a switchblade and a moterbike,
Im a juvenile product of the working class
who's best friend floats in the bottom of a glass.

OH dont give us none ect ect ect.

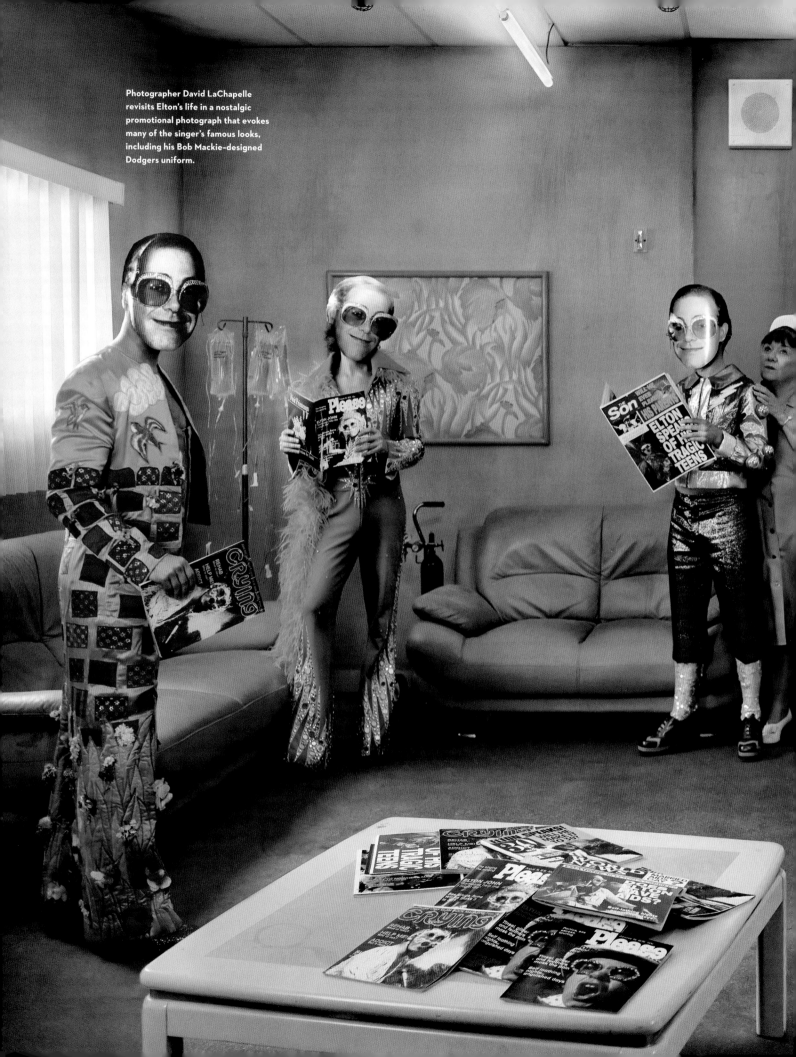

Photographer David LaChapelle revisits Elton's life in a nostalgic promotional photograph that evokes many of the singer's famous looks, including his Bob Mackie-designed Dodgers uniform.

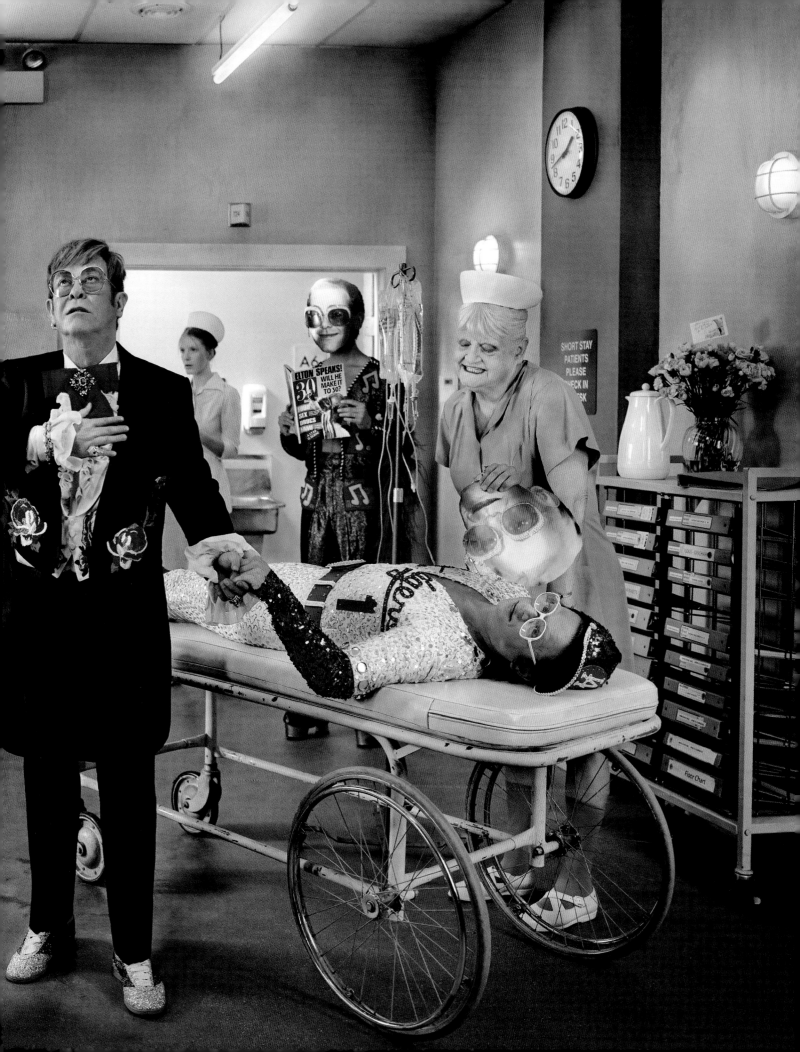

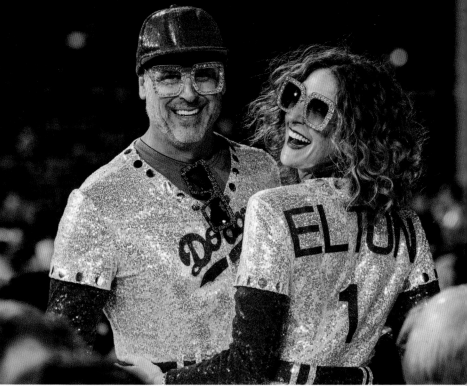

Elton was blown away by the creativity of the fans who turned up night after night in festive outfits that were both meaningful and moving. Here, fans are dressed to the nines at Dodger Stadium.

off live? I love my band, and I wanted to give them an opportunity to let fly. I've always consulted them about the setlist because they have their opinions, too. Sometimes, we've gotten it wrong and had to change it for the subsequent show. But I felt good about this particular setlist going in.

The farewell tour setlist opened with "Bennie and the Jets" and ended with "Goodbye Yellow Brick Road." I didn't want to shy away from the big hits. If you've got a song like "Tiny Dancer," which has had an incredible life, you should play it. That song was not a big hit when it first came out, but it got revitalized by *Almost Famous* and Cameron Crowe in 2000, and was in the musical adaptation on Broadway.

It's probably one of the best songs that I've ever done, so I enjoyed playing it every night on tour. It was the same with "Someone Saved My Life Tonight." Along with the hits, I included numbers like "Border Song," "Take Me to the Pilot," "Levon," "Burn Down the Mission," and "Funeral for a Friend." I wanted to have deeper musical genres going as well. It was important for me to play the music I felt really comfortable playing onstage, but I also loved

performing songs like "Levon" and "Burn Down the Mission" because they challenged me musically. A good setlist has to have everything.

Once I felt confident in the setlist, I handed it over to David. He and an amazing group of creatives took care of the rest of the planning. They brought so many elements together to create a memorable show. The title of the tour, the Farewell Yellow Brick Road Tour, was an idea David and I had together. A little nod to my 1973 album *Goodbye Yellow Brick Road* and the title track. Planning the farewell tour was like preparing for an army maneuver. It took over a year for the team to design and build the pieces of the show, from the stage set to the animated videos to the costumes. It was important for the artistic vision to reflect all of my years of making music and performing live—and I've been doing this for a while. There was an astonishing stage set, with a beautiful proscenium arch that paid tribute to moments from my life and my career. David commissioned a series of visuals and films to pair with the songs, which gave new life to old tunes.

One of the things I'm most known for is how I present myself visually onstage. I'm part of a great British tradition. If you look at all the great British acts from over the years, they've all been pretty flamboyant with what they've worn. They put on a spectacle. I sit at a piano, which isn't enough to entertain a crowd. From early on, I knew I wasn't Rod Stewart or Marc Bolan or Freddie Mercury or David Bowie. It was clear I would have to present myself as something

special. I had to make it not boring for me, as well as not boring for the audience. When I put my clothes on each evening before a show, I feel ready. For the Farewell Yellow Brick Road Tour, I didn't want my stage wardrobe to overshadow the performance, but I still wanted it to feel bold and memorable.

David and I had met Alessandro Michele, the fashion designer formerly behind Gucci, through Jared Leto at *Vanity Fair*'s Oscar party, and we'd become great friends. It was the perfect time to ask Alessandro to design the tour wardrobe. Gucci and I were like a hand in a glove. He and his team did an amazing job making me feel important. Everything he designed felt timeless and classic while also being contemporary and current. The tour ended up taking more than four years to complete, but nothing felt dated by the end. Having the right wardrobe gives you confidence, which makes the shows even better. The clothes Alessandro created had the exact vibe I wanted to convey throughout the tour. The goal was to evoke my usual sense of spectacle while keeping an intimacy with the fans. I'm not as young as I once was, so there would be no handstands on the piano or kicking stools around. It all had to come together around creating genuine moments of connection with everyone in the audience.

My previous tour, the Wonderful Crazy Night Tour, ran from 2016 through 2018, extending from Europe to North America to South America to Australia. It was in support of my thirty-third studio album, *Wonderful Crazy Night*, which I'd recorded with my band in 2015. While I was on the road for the Wonderful Crazy Night Tour, jetting from city to city, David and his team were already in the process of conceptualizing and building the farewell tour. By the time I'd reached the Wonderful Crazy Night finale, in Shekvetili, Georgia, on July 1, 2018, almost everything was in place for the farewell tour. All the tickets for the Farewell Yellow Brick Road Tour had sold out. I could tell it was going to be a wild ride.

When you've been performing for as long as I have, it's staggering to realize that your fan base has grown and evolved with you. There aren't many musical artists who can say they draw a crowd of grandparents, parents, and kids all at once. Those who discovered me in the '70s have shared my songs with the younger generations, passing Elton John records down like a family recipe or a treasured heirloom. What a trip to think about the impact my music has had. I've also picked up some new fans along the way, too, especially in recent years. Thanks to *Rocketman*, the 2019 feature film inspired by my life, and my recent collaborations with younger artists like Ed Sheeran, Dua Lipa, Charlie Puth, and Britney Spears, my musical family has grown substantially. I can look out into the crowd and see people from every generation, each one singing the words to songs Bernie and I wrote decades earlier.

A modern-day reimagining of the artwork for Elton's *Goodbye Yellow Brick Road* LP, designed by Ian Beck

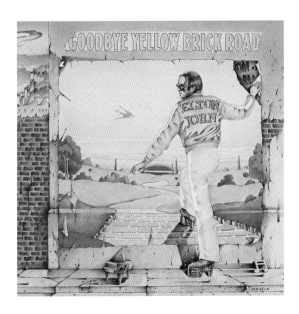

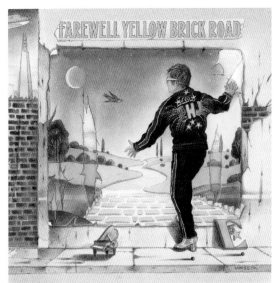

It was fun, too, to look into the crowd and see all the fans so dressed up. Their outfits were all so brilliant: The Dodger Stadium costume. The Captain Fantastic outfits. The feather suit. I especially loved seeing really butch men with glittery outfits. At each show, there were hundreds of pairs of light-up eyeglasses. Everyone made an effort. It was like they were all saying, "Do you see us?" It made me smile every night, and it helped to break the ice. They wanted to have a good time, and I did, too.

The Farewell Yellow Brick Road Tour wrapped during the summer of 2023, with the final performance in Stockholm on July 8. In total, I played 330 concerts in North America, Europe, and Oceania throughout the tour. That's a lot of shows. The Farewell Yellow Brick Road Tour was an uplifting celebration, but I did feel the sadness of its finality. When it began, I was surprised by the sense of affection I read in the reviews. Such positive words and sincere accolades, accompanied by a real sorrow that I'd decided to stop touring. That sort of emotion is contagious. As we went along, it dawned on me that I was playing cities or countries possibly for the final time. My last night in Sydney. My last night in Vienna. My last night at Madison Square Garden, a venue that's meant so much to me over the years. The tour also gave me the opportunity to tie up some loose ends and connect with people from my past I hadn't seen in so long.

I'm ready to discover what's next, but before I leave the road for good, I want to share some of the memories I encountered as I embarked on the last tour of my career. From Allentown to Dodger Stadium, I'll never forget the magic of my final jaunt as a touring performer. My fans will have their own memories, both from the Farewell Yellow Brick Road Tour and from all the shows before. As we collectively reflect on all these shows, let's not be sad that it's over. Let's be grateful we got to share so many nights together, singing and feeling the joy of human connection.

The original working art for the
***Goodbye Yellow Brick Road* album cover**
by Ian Beck. It was created in 1973 and
rediscovered by Beck in 2017.

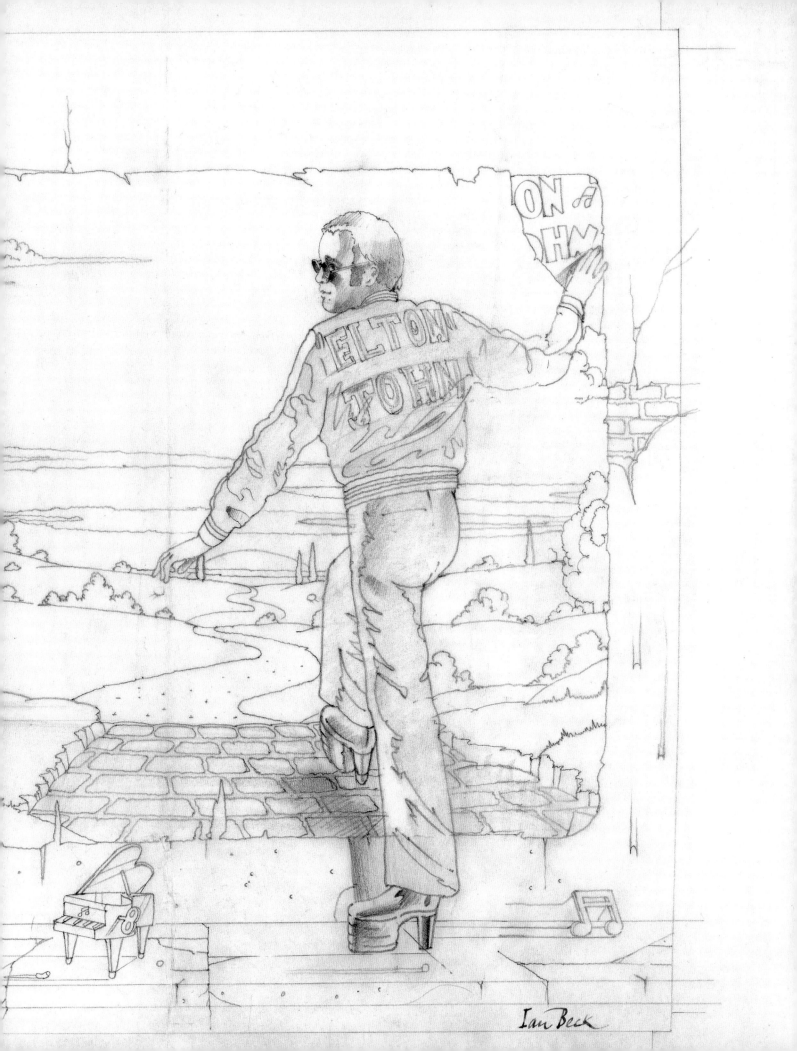

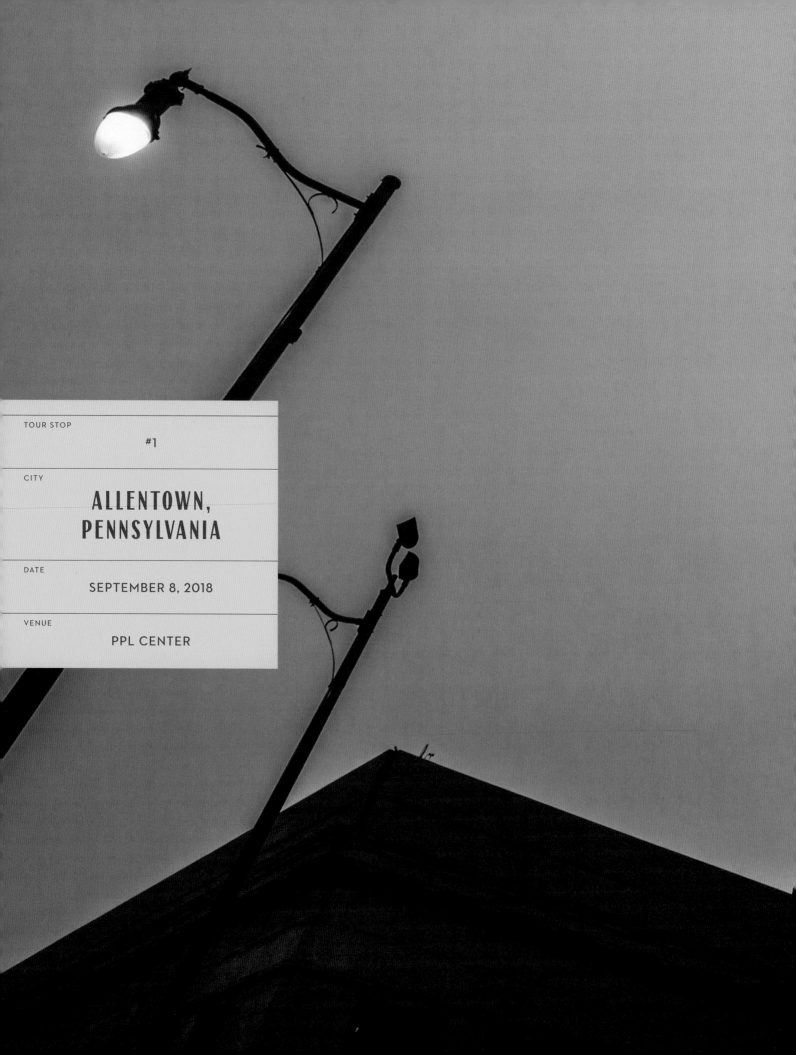

TOUR STOP

#1

CITY

ALLENTOWN, PENNSYLVANIA

DATE

SEPTEMBER 8, 2018

VENUE

PPL CENTER

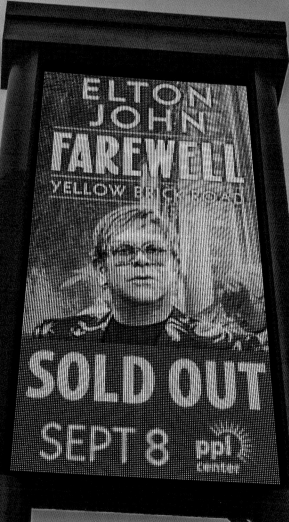

ELTON
JOHN
FAREWELL
YELLOW BRICK ROAD

SOLD OUT

SEPT 8 ppl

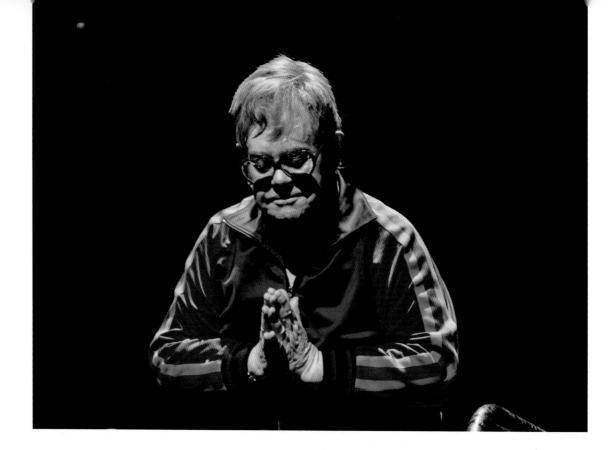

There was great excitement as the Farewell Yellow Brick Road Tour approached. I tend not to look too far forward or too far back. Being in recovery from addiction has taught me to take things day by day. But there was a lot of anticipation leading up to the first night of the tour. I hoped and prayed that the tour would be good. And I hoped and prayed that I'd be able to play well.

I flew to Allentown a few days before the tour started. I had my great band assembled: guitarist Davey Johnstone, drummer Nigel Olsson, bassist Matt Bissonette, percussionist Ray Cooper, keyboardist Kim Bullard, and percussionist John Mahon. I'd been playing with them for years—some of them for decades, including Davey, who is also my musical director—and we just clicked. Together, we've grown and grown and grown. It's gotten so much better with time, and we all really know each other. I've been lucky to work with such brilliant musicians, but especially on such an important tour.

By the time I got to Allentown, the band had spent a few weeks rehearsing the show in Los Angeles. Meanwhile, the creative team had tested the stage construction in a nearby warehouse. I had three days to come in and shake off the cobwebs. I'm not big on rehearsal or soundchecks, so it suited me to get the feel for the show without overplanning anything. It was my first time seeing the stage, which had been built nearby in Pennsylvania. It was the biggest and most complex stage I'd ever had. The rehearsals in Allentown were my first time experiencing the full production with all the lighting cues and the videos. Everything looked incredible. The show encapsulated decades of my career without being overly nostalgic. After the first rehearsal, I was immediately confident in the artistic vision. I nodded and said, "Okay, we really have something here."

I could tell David was nervous. He had put so much of himself into the creative direction. This was his baby as much as it was mine. David always says he worries about me the least when I'm onstage. He has so much confidence in my ability as

Elton bows in gratitude during the first night of the Farewell Yellow Brick Road Tour.

a live performer. Maybe even more than I do. But I was ready. The band was ready. We wanted to give the fans the best final hurrah they could experience. I wanted the show to feel uplifting and to have a sense of true togetherness. If we achieved that on the first night, we could do it on every other night going forward.

The first evening arrived. The tour kicked off on September 8 at the PPL Center in Allentown, an arena I'd previously played in 2016. I showed up at the venue around 3:30 in the afternoon. During any tour, it's important to me not to have a bare-bones, boring dressing room. Keith, my wardrobe guy, did the most amazing job every night by putting out all kinds of things I've collected during my tours over the years. He put up photos of David and the boys so I could have them with me wherever I went. It became like a mini home. It was really comforting to have on such a long tour, and in fact, I often compared it to a hug.

Usually, before a concert I try to take a nap. Sometimes I don't sleep, but I always lie down in the dressing room. I can't remember if I slept before the show in Allentown; it was more about the ritual of it. I've always been very particular about my schedule when I'm on tour: my meal at 6:15 p.m., and then a sports game on television, maybe football (or, as Americans call it, soccer) or basketball. On this particular night, I started getting ready at 7:30 p.m., which involved selecting my outfit and putting on my makeup. I did a quick vocal warm-up in the toilet—that's where the best sound is when you're backstage. People might be surprised by how almost nonexistent my warm-up is. I sing a few bars, and that's it. Sometimes I feel nervous while I'm still in the dressing room, but never once I get on the stage.

Although I didn't have much history in Allentown, the fans welcomed me with a celebratory mood. I wasn't sure how I'd feel walking out onto the stage, but beyond the sense of excitement, I wasn't particularly anxious. There wasn't much about this tour that was different for me compared with previous tours—I still had to concentrate on performing. The big change was in the production, where my piano would slowly move from stage right to stage left—and back again—as I played and sang "Candle in the Wind" and "Funeral for a Friend" (with a quick costume change in between). But it was someone else's job to make the piano move. I trusted that everything was in its place and that the videos and the lighting would serve the performance. While I didn't feel the flutter of nerves you might expect, there was a sense of importance in the air.

"This is quite a night for us, and for me especially, because it's been two and a half years in the making and thinking about," I told the crowd before we launched into the twenty-four-song setlist. "I hope you enjoy what we're going to play for you and show you." By then, I felt the fans understood why I was retiring from the road. But I still wanted to share a few thoughts on the inspiration behind this farewell tour.

"I want to thank you from the bottom of my heart for everything you've given to me these past fifty years," I explained. "But I have the most beautiful family, and I really need to spend more time with them. I know you understand since a lot of you have children of your own. I just want to be there for them, and that's why I'm doing this tour. It's to say thank you and say goodbye to touring."

During the performance, I took a few opportunities to remember people we'd lost. I paid my respects to Aretha Franklin, who had died only weeks before, which I did at many of the shows after. To me, she was the greatest singer of all time. I reminded the audience of that before my rendition of "Border Song," which she covered in 1970 as Bernie and I were still starting out. I dedicated the song to

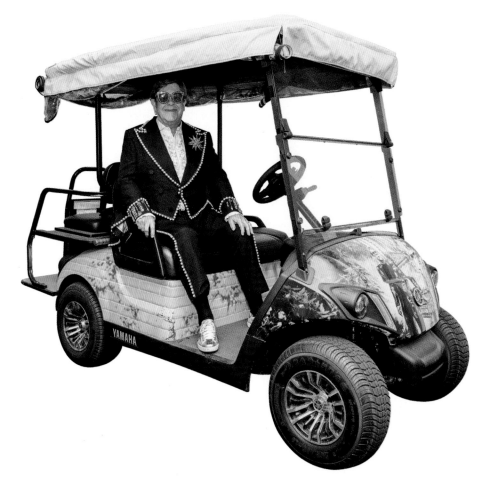

her, but also to so many other people who'd broken down borders in their lives and careers. The faces of Martin Luther King Jr., Princess Diana, John Lennon, Elizabeth Taylor, Rosa Parks, Elvis Presley, and so many more people flashed on the video screens behind me. I'd originally rehearsed "Border Song" with a full band, but I felt it would be more powerful as a solo piece. It felt very emotional to perform it for the audience in Allentown with just me and my piano.

Later on, I dedicated "Don't Let the Sun Go Down on Me" to Mac Miller, who had died the day before the show at the age of twenty-six. The rapper was from nearby Pittsburgh, and it felt touching to be able to pay tribute to him in his home state. "It's inconceivable that someone so young and who had so much talent could do that," I said. "I would just like to pass all of our love and our best wishes to his loved ones, his family, his friends. And, Mac, wherever you are, I hope you're happy now."

When I left the stage at the end of the set, I heard the cheers echoing behind me. I never could have dreamed it would be as good as this. The band and I agreed, wholeheartedly, that this was the best we'd ever played. That's a tribute to them as much as it is to me. I'm a musician and performer who always wants to get better. I've always been like that, since I was a kid. I knew from the first evening that on this tour I was going to become better at what I do. The reaction backstage was immense. Everyone was buzzing. Being at the center of the show meant that I wasn't able to see the videos or the stage production, but everyone said, "That was fantastic."

Although I knew it went well, it felt good to get the first show out of the way. Psychologically, once the opening night of a tour is done, you're fine. You can do anything. I trusted the process because it was so familiar to me. I knew after the opening night in Allentown that the Farewell Yellow Brick Road Tour was going to be a success. One down, 329 more to go.

Elton backstage on his custom farewell tour golf cart, which features David LaChapelle imagery

★ 24

"JOHN STILL PUTS AN ORIGINAL SPIN ON HIS BEST-KNOWN HITS, SYNCOPATING HIS PHRASING AND EXPERIMENTING WITH HIS WELL-KNOWN MELODIES. AUDIENCE MEMBERS COULD STILL SING ALONG—AND, OH BOY, DID THEY EVER—BUT ALSO RECEIVED AN ORIGINAL PRESENTATION OF EVERY BALLAD, EVERY POP TUNE."

★ ★

—*LANCASTER ONLINE, 2016*

FAREWELL YELLOW BRICK ROAD TOUR SETLIST

ALLENTOWN, PENNSYLVANIA
PPL CENTER
SEPTEMBER 8, 2018

1 . Bennie and the Jets
2 . All the Girls Love Alice
3 I Guess That's Why They Call It the Blues
4 . Border Song
5 . Tiny Dancer
6 . Philadelphia Freedom
7 . Indian Sunset
8 Rocket Man (I Think It's Going to Be a Long, Long Time)
9 . Take Me to the Pilot
10 . Someone Saved My Life Tonight
11 . Levon
12 . Candle in the Wind
13 Funeral for a Friend / Love Lies Bleeding
14 . Burn Down the Mission
15 . Believe
16 . Daniel
17 . Sad Songs (Say So Much)
18 . Don't Let the Sun Go Down on Me
19 . The Bitch Is Back
20 . I'm Still Standing
21 . Crocodile Rock
22 . Saturday Night's Alright (For Fighting)

ENCORE:

23 . Your Song
24 . Goodbye Yellow Brick Road

"IF HE'S ABLE
TO KEEP UP THE
ENERGY AND
JOY OF THE
FIRST SHOW,
IT'S GOING TO
BE ONE HELL
OF A WAY TO
SAY GOODBYE."

★ ★ ★ ★ ★ ★ ★ ★ ★ ★ ★ ★ ★ ★ ★ ★ ★

—ROLLING STONE, 2018

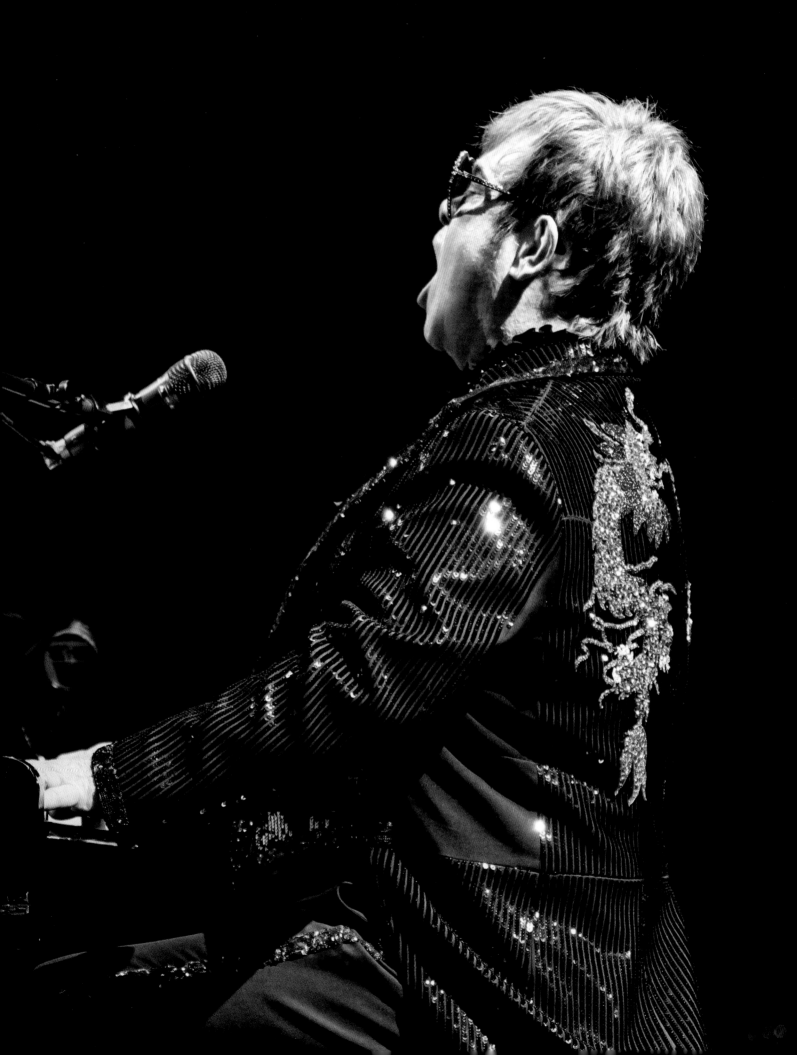

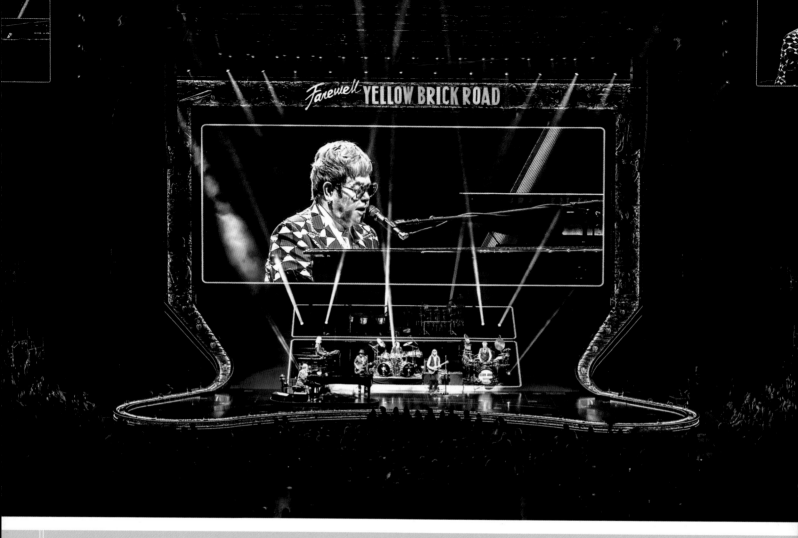

THE FAREWELL TOUR SETS

A farewell spectacle needs an equally spectacular stage production. David Furnish, Tony King, Sam Pattinson, and Patrick Woodroffe led the creative vision behind Elton John's Farewell Yellow Brick Road Tour. King and Pattinson took the lead on the tour's video and stage visuals, while Woodroffe handled the lighting design. The stage, featuring an impressive proscenium arch, was designed by Stufish Entertainment Architects, and engineered, built, and automated by creative-engineering group TAIT. Additionally, the set's three-dimensional scenic sculpture was crafted by Jacqueline Pyle. Because Elton's career has embraced a broad spectrum of visual styles and iconic moments, the overall concept was to capture

and embody that array with one set. It needed to be celebratory and personal at the same time, reflecting everything that is meaningful to Elton both on and off the stage.

There was a strong emphasis on vibrant, brilliant colors in the set design, and the team wanted it to feel contemporary rather than vintage despite the nostalgic sensibility of a farewell tour. The tour set design centered on a gold frame that featured some of Elton's favorite memorabilia and moments throughout his career. Those included images from *The Lion King* and *Gnomeo & Juliet*, the Gucci logo, a photograph of Elton with John Lennon, the Watford FC logo, and the album cover for *Madman Across the Water*. The stage itself was designed in

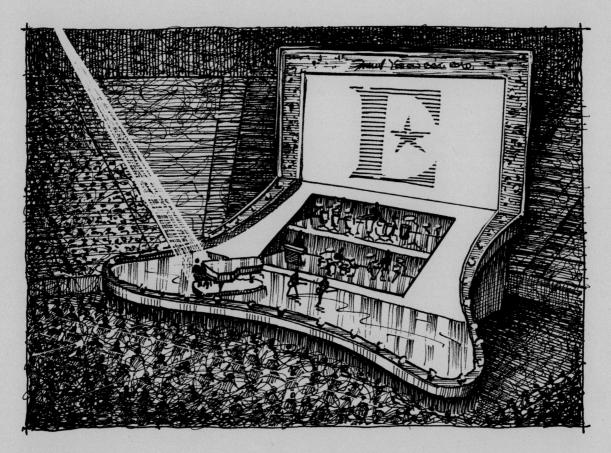

fluid Baroque style, and dripped down at the edges. The area where Elton performed was dubbed the Yellow Brick Road by the team, and featured real yellow bricks.

The massive LED video screen, which covered the backdrop of the stage, featured custom videos and animation created specifically for each song. Woodroffe's lighting design was intended to augment the on-screen imagery and give a jubilant, colorful texture to the performance. Everything was intended to come together to evoke emotion, nostalgia, and hope in the fans. While the production was a serious undertaking and required several years to put together, once it was inside venues with Elton on the stage, everything felt seamless and natural.

"People have seen a lot of different Elton John shows over the years and some big production shows in Vegas, but this one had to feel like a farewell celebration," Furnish explains. "That meant it should be emotional. It should be life-affirming. It should lift you up, it should make you contemplative and sad at key moments and also reflective. But, ultimately, we wanted to send people away feeling like they were celebrating everything that is Elton as a touring artist. And we wanted to give Elton an opportunity to make people feel how grateful and appreciative he was for the life they've given him."

It's also the biggest show Elton has ever taken on the road. "With that level of production, you want to ensure it doesn't blur or complicate the musical and emotional farewell narrative, and we were just so thrilled that it landed in exactly the way that we'd all hoped it would," Furnish says. "It's a testament to everyone involved that it came together so beautifully."

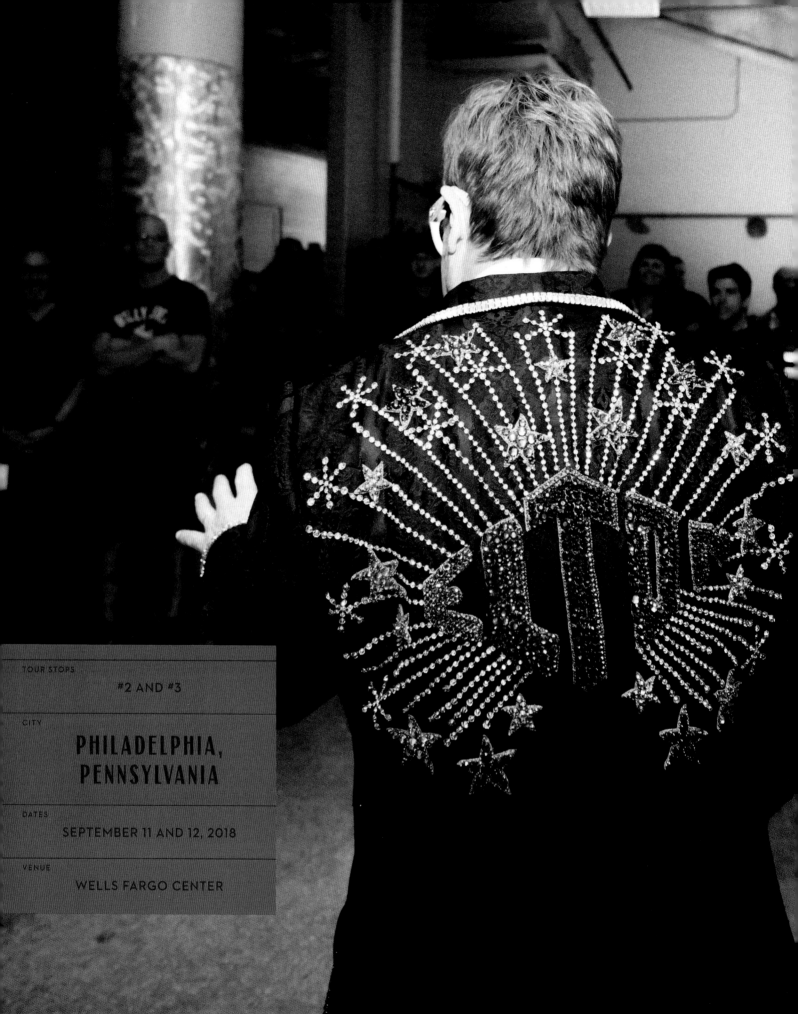

TOUR STOPS
#2 AND #3

CITY
PHILADELPHIA,
PENNSYLVANIA

DATES
SEPTEMBER 11 AND 12, 2018

VENUE
WELLS FARGO CENTER

Elton addresses the tour crew backstage in Philadelphia while wearing his Gucci-designed tour jacket.

The tour continued onward to Philadelphia, a city I've always loved because it is one of the first places I ever played in America. It was hard not to be a little bit nostalgic for September 11 and 12, 1970, when I took the stage at the Electric Factory for two nights. The initial evening marked my first time performing in Philadelphia, and I wasn't sure what to expect. I'd recently come off a string of shows at the Troubadour in Los Angeles—a famous run that cemented me as a burgeoning star in the music industry—and there were a lot of expectations. After Los Angeles, we'd gone to San Francisco and New York City, but those concerts hadn't quite lived up to the explosion of energy from the Troubadour. When I arrived in Philadelphia all those years ago, I could really feel the anticipation.

At the time, I was on tour supporting my second studio LP, *Elton John*. Russ Regan, who had signed me to my American record label, Uni Records, believed in me from the word go, and he was behind a lot of the promotion of my album. Russ had been calling the label sales reps on the East Coast to tell them I was coming. They replied, "Who is this guy? We've never heard of him." The record label was unhappy that Russ was spending so much money on my tour and I wasn't selling any records. At one point before the first Electric Factory concert, MCA Records president Mike Maitland rang up Russ and said, "You know what they're calling your superstar at the Tower? Regan's Folly!" That was me: Regan's bloody Folly.

Russ came over to my dressing room and told me what had happened. I took it on board, paused, and then replied, "Tonight I'm gonna burn the city of Philadelphia down!" I meant it. The night felt bigger still because the Band had come to see me play and I was completely in awe. When my bassist Dee Murray, my drummer Nigel Olsson, and I got on that stage, we went wild. There was no holding back. We closed the show with "Burn Down the Mission," extending the song for nearly fifteen minutes. I was jumping up on the piano and rolling underneath it. At one point, I hurled myself into the audience. Everyone went berserk. I could feel the energy resonating through the room, but I couldn't tell if it started with me or with the crowd. It was like we were creating this moment together, this burst of momentum ricocheting back and forth between the band and the fans. By the end, I knew we'd done it. Regan's Folly had proved them all wrong.

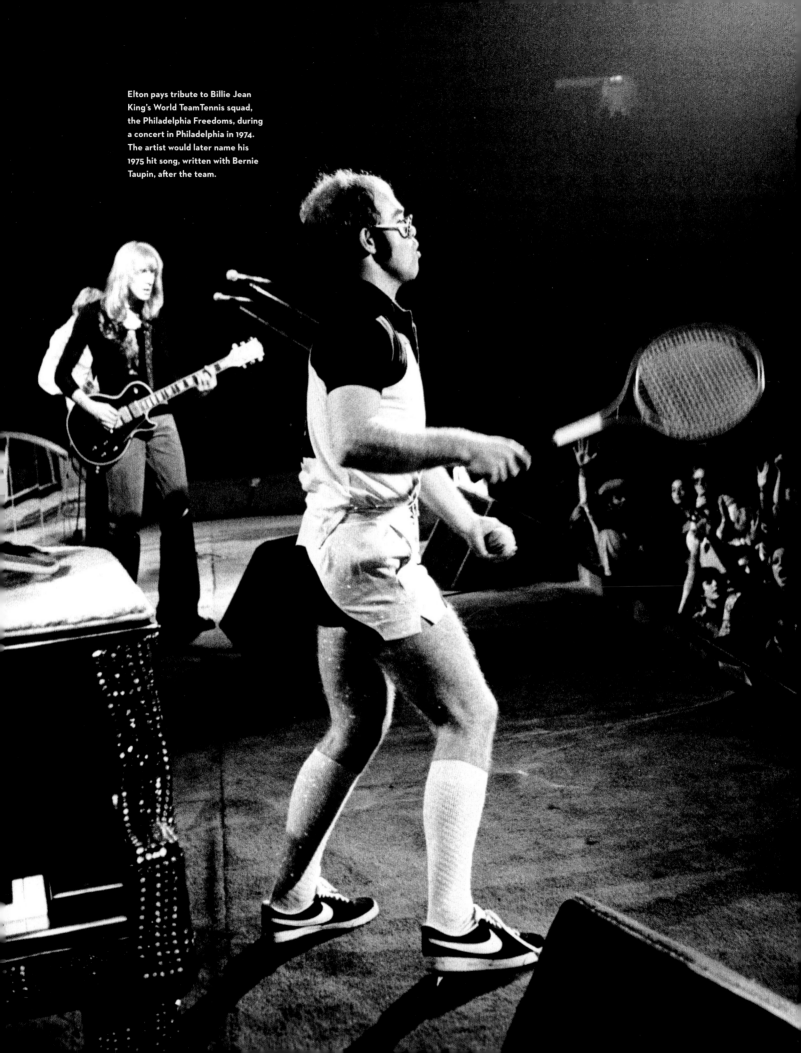

Elton pays tribute to Billie Jean King's World TeamTennis squad, the Philadelphia Freedoms, during a concert in Philadelphia in 1974. The artist would later name his 1975 hit song, written with Bernie Taupin, after the team.

"JOHN SINGS HIS SONGS (ACCOMPANIED BY HIS OWN PIANO WORK, NIGEL OLSSON ON DRUMS, AND DEE MURRAY ON BASS) WITH AN UNINHIBITED FREE-FLIGHT STYLE THAT MAKES IT CLEAR TO HIS AUDIENCE THAT SOMETHING FRESH AND APPEALING HAS ARRIVED."

★ ★ ★ ★ ★ ★ ★ ★ ★ ★ ★ ★ ★ ★ ★ ★

—*THE PHILADELPHIA INQUIRER, 1970*

At the time, I was only twenty-three years old. I idolized performers like Mick Jagger and John Lennon. They were exciting. I had a suspicion that an ordinary life wasn't for me, and artists like that showed you that living an ordinary life was boring. I knew I had to be outrageous onstage. Ordinarily, I was a quiet person. Shy, almost. But on the stage, performing for an audience, I could be someone who astonished people.

Late that night, after the show, Russ got a call from one of the East Coast sales reps. Orders for my album were coming in by the thou-

Elton and bassist Matt Bissonette bring energy to the Wells Fargo Center in 2018.

sands. Demand was rising. Stores were selling out. In my history of touring, those shows at the Electric Factory sometimes stand in the shadow of the ones at the Troubadour. And the Troubadour concerts *were* a singular moment in time. They changed my career. But Philadelphia proved that I could consistently deliver. I was becoming a star everywhere, not just in Los Angeles. It was a great feeling to connect with an audience in that way. I was so grateful to Russ for believing in me. He died in 2018, only a few months before the Farewell Yellow Brick Road Tour kicked off. I remember him as the person who launched my career. I'm no one without the people who support me. Returning to Philadelphia so many decades later reminded me of Russ's unfailing dedication.

The truth is, I never thought my career as a touring artist would be what it is today. How could you? How could you possibly think you'd be going out after five decades of touring as a bigger artist than you'd ever been? It's sometimes difficult to acknowledge the way my music has touched people. I can't think about that too much. If I did, I might go nuts. But I understand how far I've come since I played the Electric Factory in 1970 on my first visit to America, and it's mind-boggling.

Not long after I performed at the Electric Factory in September 1970, my band and I came back to America for a full US tour. I hadn't quite broken out in England yet, but in America the fans were clamoring for more. When the idea of touring America was originally discussed, I'd had my doubts about whether I was ready for that, but it turned out the fans were ready even if I wasn't. I remember telling *Rolling Stone*, "I feel more American than British. Really." And it was true. The country gave me my start. America became the focus of the promotion of *Elton John*, and after that initial four-city run, I came back to the States three more times in twelve months.

I returned to the Electric Factory on November 6 and 7, 1970, playing a total of three shows, and the room was still vibrating with the energy of those initial gigs just two months prior. By April of 1971, I'd sold out the Spectrum, a venue that was a big leap from the Electric Factory, which only holds a few thousand fans. I needed a spectacle to match—bolder stage clothes, a wilder performance. By then, my band felt really tight. I was growing more comfortable onstage. I could really let loose, throwing my head back in ecstasy and kicking my legs in the air as I pounded on the piano keys. It felt liberating to be in the moment in that way. Oddly, as comfortable

"HAVING ATTENDED DOZENS OF JOHN SHOWS IN THE PAST, THIS SEEMED TO BE THE MOST PERSONAL, PERSONABLE, AND EMOTIVE OF HIS GIGS."

★ ★

—*VARIETY*, 2018

as I was during concerts, I felt less comfortable offstage. I was still this insecure, nervous person inside. Being successful didn't cure that.

On my 1971 tour, I split each show in two. It began with me performing solo with my piano, and my band joined for the latter half. It was a great way to showcase my songs. By then I'd released another studio album, *Tumbleweed Connection*, which hit No. 5 on the *Billboard* Top 200 chart in the US. It had been recorded before we went to the States in 1970, but Bernie had been inspired by American artists while writing it, so it fit in perfectly. When my third American tour wrapped, we were already deep into the next studio album, *Madman Across the Water*, which came out in November 1971. It was clear I was the biggest British pop star to break in America in the early '70s, and there was no more telling of a crowd than the one in Philadelphia.

By the time the Farewell Yellow Brick Road Tour concluded in 2023, I'd performed in Philadelphia fifty-two times in total. And I'd performed in Pennsylvania ninety times, making it one of my top-five markets in the country. I returned to the City of Brotherly Love twice more on my farewell tour, in 2019 and again in 2022. Each time, I felt a rush of welcoming love from the fans, especially when we played "Philadelphia Freedom." That initial evening at the Wells Fargo Center on September 11, 2018, the second night of my farewell tour, was especially poignant. It was reflected in the reviews, with *Variety* calling the show "visually and sonically arresting in every way."

It was a meaningful night because David and Bernie were both there. It began to really dawn on me that my touring career was coming to a close. I didn't have any regrets, but I did have some bittersweet feelings about the fact that a huge chapter of my life was nearing its end. I realized I was saying goodbye to performing my songs live on tour. And it was amazing to realize the scope of the crowds. I could see people of all ages singing along when I glanced out into the audience: teenagers holding cell phones in the air, parents dancing along on a night out, and older generations playing air piano alongside me. I could tell everyone was having a good time.

A series of original lithographs was created for the farewell tour, including this one from Philadelphia created by Sam Green.

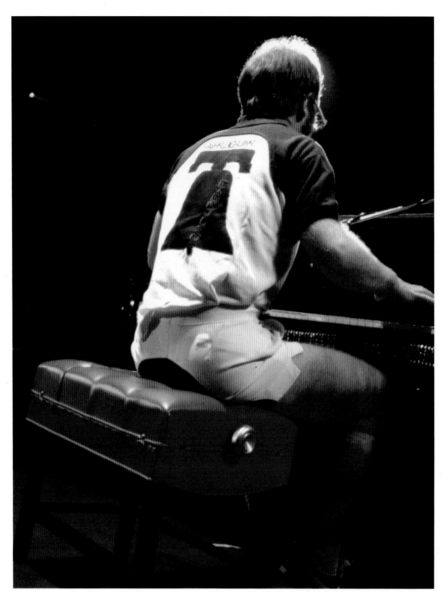

LEFT:
Elton dons a Philadelphia
Freedoms T-shirt during
a concert in Philadelphia
in 1974.

RIGHT:
While on tour in the 1970s,
Elton wrote a series of
postcards to the staff at
Dick James Music. These
were sent from Honolulu,
Los Angeles, and Osaka,
Japan.

As we played, I wanted to share the love with the fans. "There has been a common denominator throughout my journey: It is you," I told the crowd. "You guys bought the singles, the albums, the tapes, the cassettes, the CDs, the DVDs, the merchandise. But the most important thing is that you bought the tickets for the shows. You don't know how much I love playing here. If ten years ago you had told me that I would be doing a farewell tour, I would have asked you to put acid in my drink instead."

That was how it felt. Like a surreal haze or a flickering of moments, rather than something completely real. When I look back, some of my memories seem like dreams. The truth about life is that you can't plan it. You can try, but even the most carefully conceived plans never turn out as one initially imagines. So many things had to happen for me to end up here, playing the second night of my farewell tour. So many choices made, so many happy accidents along the way. I was a kid from Pinner who wanted to play the piano and write songs. I didn't anticipate I'd ever end up on a massive farewell tour encircling the globe. But here I was. I never could have expected this. How far I'd come from being called Regan's Folly.

Postcard 1

HAWAIIAN POSTCARD

C-38

MIRRO-KROME CARD BY H. S. CROCKER CO., INC., SAN BRUNO, CALIF. 94066

EISENHOWER USA 8c **EISENHOWER USA** 8c

Dear Helen - Chris,
The tour is wonderful,
You're wonderful,
I'm ~~wonderful~~.
~~fantastic~~
a genius ✓

love Ethn
(insoluble)

HELEN WALTERS
D. J. M
71.75 NEW OXFORD ST
LONDON WC1
ENGLAND

RED ANTHURIUM, GIANT TREE FERNS and wild banana thrive beneath the tall exotic trees of Hawaii's rain forests.
Color Photograph By R. Wenkam

A CONTINENTAL CARD · AKU ... SERVICE, INC. P. O. BOX 2835, HONOLULU, HAWAII 96803

Postcard 2

FOOTPRINTS OF THE STARS
Forecourt of Grauman's Chinese Theatre, Hollywood, where in cement have been immortalized the footprints, handprints, and signatures of the movie stars of yesterday and today.

AIR MAIL P76755

LOS ANGELES CALIF OCT 19'70

POST CARD

Dear Helen and Chris

Had a terrible flight
took us 15 hours!
but now we're basking
in boiling hot sunshine
sipping martinis and
being massaged and
YAWN! YAWN! love Reg

Mrs Helen Walters
D J M Records
71.75 New Oxford
London WC1
England.

Plastichrome by COLOURPICTURE
BOSTON, MASS. 02130

DISTRIBUTED BY: MITOCK & SONS, 4110 GREENBUSH AVE. NORTH HOLLYWOOD, CALIF.

Postcard 3

MIDO-SUJI STREET (OSAKA)
The biggest bustling street in OSAKA. Platan and Ginkgo are planted along the main street, and they harmonized so well with artificial beauty in OSAKA. Underground railroad symbolizes this modern city.

POST CARD **AIR MAIL**

Dear Helen, Chris
'Ah So' and 'Rello!'
Everything here is fantastic
We're really popular
and I'm knocked out. People
are so friendly — Got
some clippings from you
today. TA
love Reg - John
XX

MRS. H. WALTERS AND CHRIS
DICK JAMES MUSIC
71·75 NEW OXFORD ST
LONDON WC1
ENGLAND.

御堂筋（大阪）
大阪最大の繁華街。南北に貫くメインストリートには、
ラタナス、イチョウの並木が植えられ、文化都市大阪の
人工美と見事に調和している。地下にはメトロが走り、
近代都市の姿を象徴している。

P.C. 234

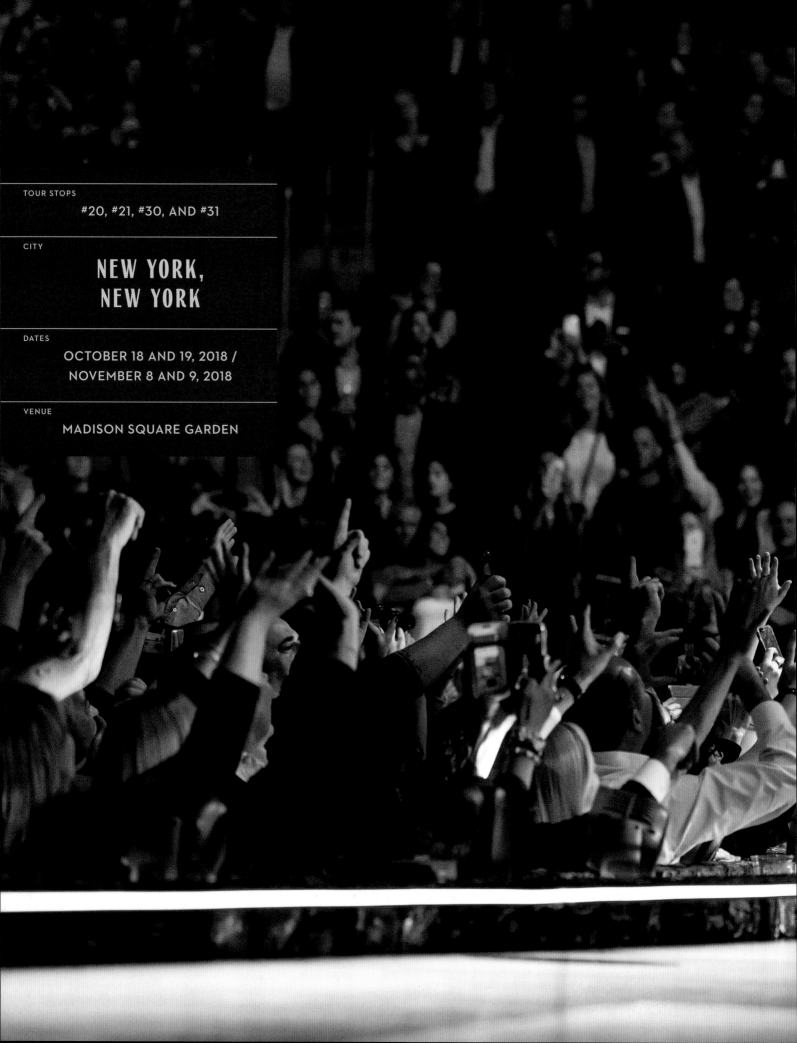

TOUR STOPS

#20, #21, #30, AND #31

CITY

NEW YORK, NEW YORK

DATES

**OCTOBER 18 AND 19, 2018 /
NOVEMBER 8 AND 9, 2018**

VENUE

MADISON SQUARE GARDEN

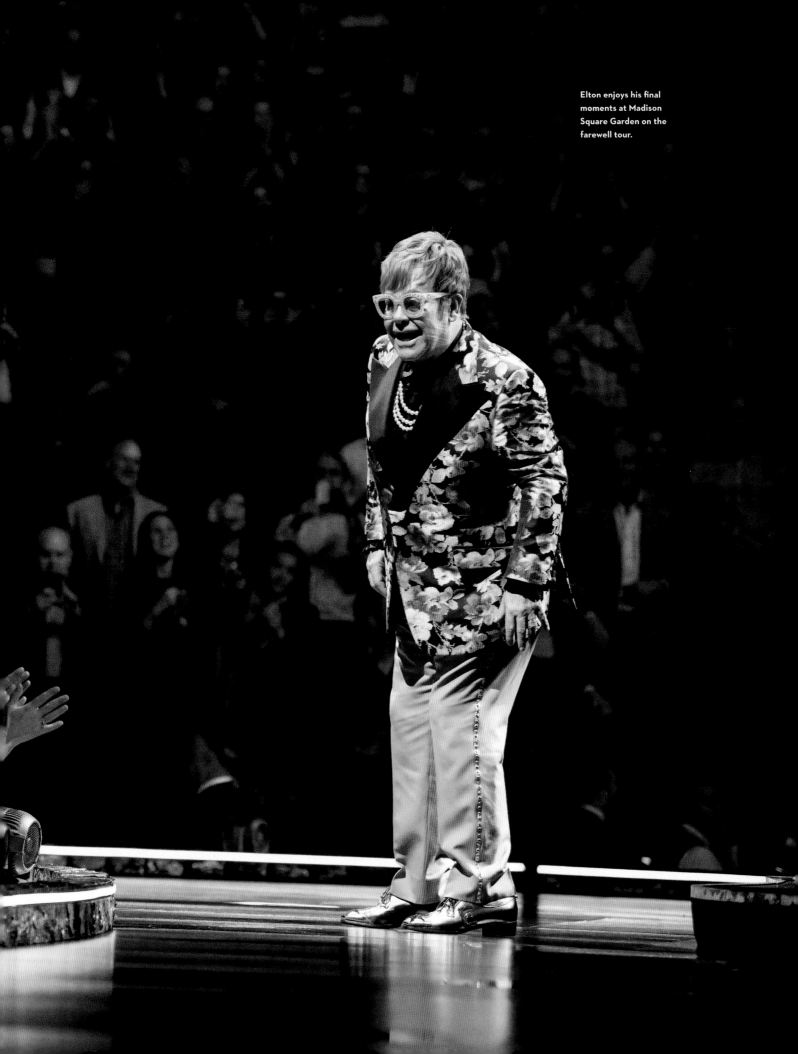

Elton enjoys his final moments at Madison Square Garden on the farewell tour.

Madison Square Garden is one of the most magical rooms in the world, if not the most magical room in the world. The way it's designed and the sound are unparalleled. Everything about it makes it an incredible place to play. You can feel the audience, and you can see the audience. Even with twenty thousand people in the venue, they seem really close. When they bounce up and down, the floor bounces up and down. It's got an ambience and atmosphere that you can't manufacture. Throughout its history, the room has seen so many great concerts and so many amazing sporting events, and now it's like there's something spiritual in the building. At one point, they were going to move it, and I'm so glad they didn't rebuild it somewhere else because it's in the perfect place. Throughout my career, I've had the privilege of performing seventy-two concerts in Madison Square Garden—a number so impressive I can hardly believe it.

Of course, I wasn't always famous enough to play Madison Square Garden. The first time I performed in New York City was September 10, 1970, right after I played the Troubadour in Los Angeles and the Troubadour North in San Francisco. Ironically, the gig was at the Playboy Club. It wasn't one of my best, although everything after the Troubadour was going to feel like something of a letdown. Most people prefer to pretend that Playboy show never happened. I came back to New York only a few months later on my first full American tour. This time I played four shows at the Fillmore East in two nights, on November 20 and 21. Those gigs were much more of a success.

I'd met Leon Russell during my run at the Troubadour—he was in the audience on the first night—and he'd suggested booking me to promoter Bill Graham. I was in awe of the sound system and the lighting at the Fillmore East. During my set, Leon joined me for a nine-minute jam following "Burn Down the Mission." It was incredible. It felt like my idol accepting me. I thought, "Well, if he thinks I'm all right, then I must be all right, because he's my hero." Later, I heard that Leon was so blown away by my set that he told a reporter that he thought his career was over because I was so much better than him. A humbling thought, but it was me who was impressed. I remember those concerts as a magical time. Having someone I admired show me that kind of generosity meant the world to me.

Each time I returned to New York City, I was in a bigger room with a bigger crowd. I hit the stage of the Fillmore East again in April of 1971, but by that June, I'd booked Carnegie Hall. I booked it again in 1972. By 1973, I was onstage at Madison Square Garden for the first time. It was a major touring milestone, and it showed just how much my career had taken off in the previous three years. My most

RIGHT:
Photographer Sam Emerson captured Elton and John Lennon backstage at Madison Square Garden in 1974, shortly before John joined Elton and his band to perform three songs.

BELOW:
A ticket stub from Elton's 1974 concert at Madison Square Garden

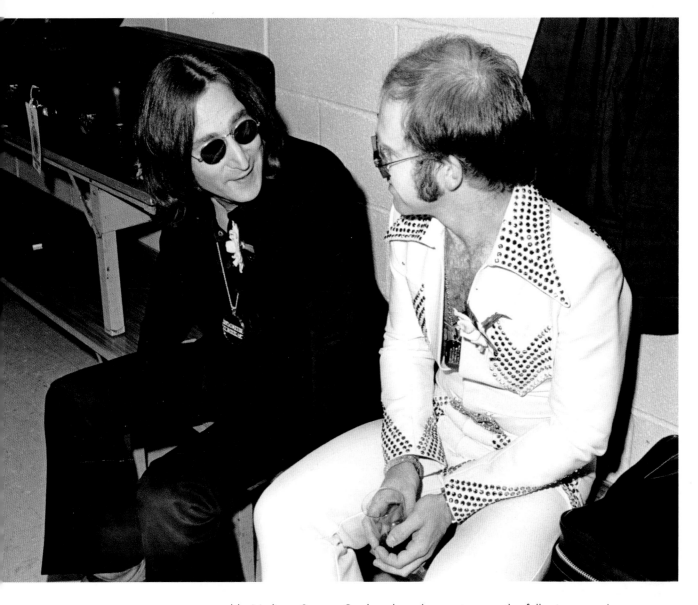

memorable Madison Square Garden show, however, came the following year. I played two shows there, on November 28 and 29, 1974. It's the first night that is now the stuff of legend.

I met John Lennon through Tony King on the set of a commercial video shoot in 1973. They were filming a television spot for John's album *Mind Games*, and Tony had dressed up as the Queen of England. I was very intimidated and very excited at the same time. As a member of the Beatles, John was one of my idols. But I also took to him personally right away. As soon as we started talking, it felt like we'd known each other our entire lives. John and I became fast friends, often spending time together when I was back in America. We had a lot of good times—sometimes too good. It was like a whirlwind romance. In the summer of 1974, he invited me to play and sing backup vocals on two of his new songs, "Whatever Gets You Thru the Night" and "Surprise, Surprise (Sweet Bird of Paradox)." We recorded them at the Record Plant East studio in New York City. I was certain "Whatever Gets You Thru the Night" was going to be a big hit. John was less convinced. So I offered him a bet: If the track got to No. 1 on the *Billboard* charts, he had to come onstage and play with me.

Of course, the song shot right up the charts to No. 1, just as I'd known it would. It was John's first No. 1 solo single. Part of me expected John to try to shirk the bet. But to his credit, he didn't weasel out of it. I was booked to play the Boston Garden

41 ★

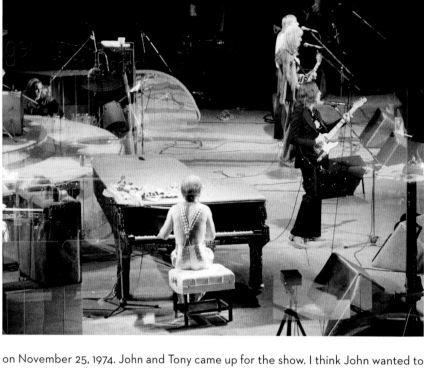

RIGHT:
Elton performs
at Central Park in
1980 wearing his
Donald Duck suit,
a historic moment
that was captured
by Roxanne Lowit.

LEFT:
John Lennon
playing with
Elton and his
band at Madison
Square Garden, a
truly memorable
moment in both of
their careers

on November 25, 1974. John and Tony came up for the show. I think John wanted to see what he was getting himself into. I wore one of my typically flamboyant outfits for the encore, and apparently, John was somewhat shocked. "Fucking hell," he said to Tony afterward, "is this what rock 'n' roll's about nowadays, then?"

But three days later, John joined the band and me onstage at Madison Square Garden, undeterred, for my Thanksgiving night show. His only condition was that Yoko Ono wouldn't be in attendance—they were currently estranged—but she showed up anyway. John hadn't been performing much in those years, which was partially why I was so desperate to watch him play. I recalled seeing the Beatles in concert at the Hammersmith Odeon in London in 1964. It was like seeing God. Backstage at Madison Square Garden, however, John was terrified. Before the show began, he threw up into a bucket. I hoped he would be okay to play. When the band and I went onstage, I wasn't certain John would actually come out.

Midway through the performance, I announced we would be joined by someone special. "I'm sure he will be no stranger to anybody in the audience, when I say it's our great privilege, and your great privilege, to see and hear Mr. John Lennon," I told the audience. They were stunned. To this day, I've never heard a crowd make the amount of noise the fans did that night when I shouted John's name. They cheered and clapped and screamed their heads off. John ran onto the stage carrying his guitar. It was overwhelming. I shared the fans' excitement. I couldn't believe I was going to perform with one of my longtime musical idols. It was an unparalleled moment in my touring career and, as some have said, in rock history.

We played three songs with John, starting with the one that brought us there in the first place, "Whatever Gets You Thru the Night." Then we covered two Beatles songs, "Lucy in the Sky with Diamonds" and "I Saw Her Standing There." The second one was unexpected because John hadn't written it; Paul McCartney had. John told the crowd, "We're trying to think of a number to finish off with so I can run out of here and be sick." Initially, I'd suggested we do "Imagine," but John claimed it would be too boring. He wanted to do something more rock 'n' roll.

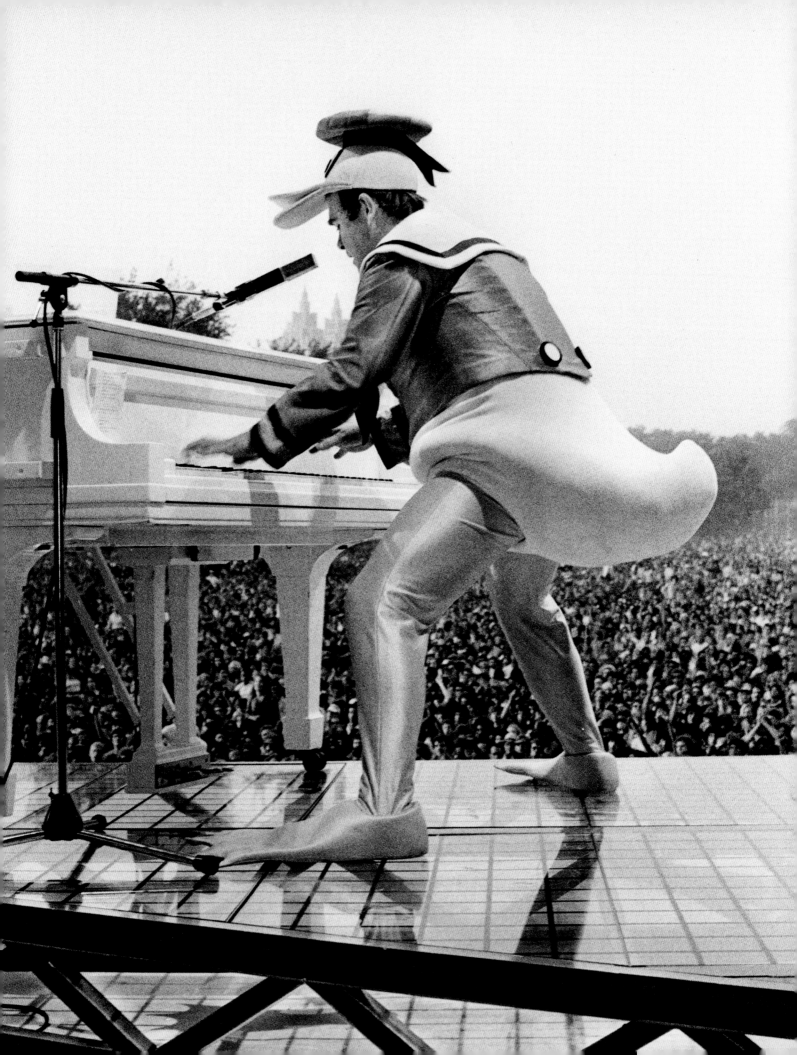

"THE SHOW WAS WELL PACED, PROFESSIONAL,
AND BRILLIANTLY STAGED; A FRESH HOUR OR SO
OF MUSIC THAT CHASED AWAY ALL WORLDLY
FEARS. THE CAPTAIN WAS COOKING AND THE
BAND PLAYED THEIR BOTTOMS OFF."

★ ★

—SOUNDS, 1974

To me, it felt like a whirlwind. It was one of those moments that just happens and it's only afterward that you can really come to grips with what's taken place. It was a dream come true and very surreal. Later, during the encore, John returned, this time with Bernie, to play tambourine on a rendition of "The Bitch Is Back." I'll never forget it. It was an unbelievable moment for me, but it was also John's last major concert appearance. I'm so honored we shared that experience. In fact, I wrote my 1982 song "Empty Garden (Hey Hey Johnny)" about Madison Square Garden feeling so empty after John was murdered.

Performing at Madison Square Garden with John was a true highlight of my touring history. A few years later, I played another New York City show that sticks out in my memory, and it had its own connection with John. Madison Square Garden holds around twenty thousand people during a concert, and that's a big crowd. But it was nothing compared to the sea of fans who turned up on September 13, 1980, when I headlined in Central Park. It was a free show, sponsored by Calvin Klein, and no one wanted to miss it. The crowd included more than four hundred thousand people—a staggering number and the largest I've ever performed to. I wanted it to be memorable. It was part of my 1980 World Tour, in support of my latest album, _21 at 33_. Andre Miripolsky and Bruce Halperin made me a costume that resembled a military uniform, except more colorful with yellow and red stripes. The lapels looked like a piano keyboard, and there was a cap to match.

As if that ensemble wasn't flashy enough, for the encore I wore a Donald Duck suit created by Bob Mackie, complete with a beaked hat. Bob had designed the suit to be worn with yellow webbed feet and padded white gloves. It was impossible to put on, and for some reason, we'd never done a dress rehearsal. Backstage, I struggled to pull the bloody thing over my legs. I was laughing hysterically, trapped in this oversized duck costume. Everyone told me to just forget about it and hurry back out for the encore. But, eventually, I managed to get all the pieces on. The rubber-soled flippers meant I couldn't walk properly. And how was I supposed to play the piano in padded gloves? I left those behind. By the time I got back to the piano, I realized the padded bum wasn't designed for actual sitting. Instead, I perched on the stool, trying to keep my balance. I couldn't stop giggling as we started performing "Your Song." The whole thing was so ridiculous. I decided to go with it, so I quacked a few times mid-song.

We still had another song to go for the encore. I waddled to the front of the stage, hurled my towel into the screaming crowd, and couldn't stop laughing. We kicked up the energy with "Bite Your Lip (Get Up and Dance!)" and finally I gave

up on trying to sit at the piano. I stood up, still in my duck costume, and kicked my webbed foot onto the piano before dancing around the stage. What a spectacle. And so much fun. By the end of the song, I'd shoved the piano stool out of the way. The band and I really gave that performance our all. Some people thought the Donald Duck outfit was a mistake, but I thought it was funny. And it's lived on. Years later, Courtney Love wore it to perform a cover of "Don't Let the Sun Go Down on Me" during a charity concert in London.

The Central Park performance was memorable for another reason, too. I wanted to honor John, who lived nearby in the Dakota apartment building. Throughout my world tour at the time, I'd been covering his famous song "Imagine." I told the audience, "We're going to do a song written by a friend of mine who I haven't seen

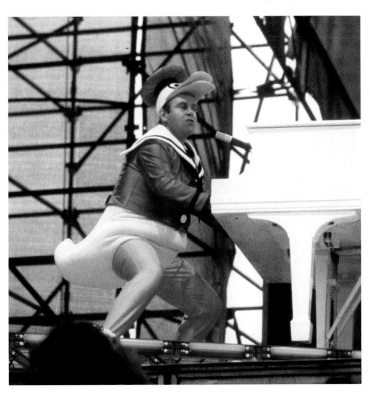

Elton's famous Donald Duck costume, designed by Bob Mackie

for a long time. But this is a very beautiful song. You all know it." I added, thinking fondly of him, "He hasn't made a record for ages, but he's doing well at the moment." Looking back, it's a poignant memory. That night, after the gig, John and Yoko showed up at the after-party, which was held on a ship in the East River. It was completely out of the blue. He said he was making an album. He was full of excitement about the possibility of writing and recording new music. I didn't stay very long at the party—I was exhausted—but John and I agreed to meet up the next time I was in New York City. I think that was the last time I ever saw him.

An amazing thing about touring is that it reconnects you with so many people, fans and friends, around the world. I've always loved returning to different places and seeing people I haven't seen in a long time. When I think of New York City, I think of John, of course, but I also think of so many other people who've come out to be part of my shows, including fabulous friends like Divine. Madison Square Garden has been a big part of that. Some evenings there stand out more than others. In 2007, I performed there on my sixtieth birthday. It was very important to me that the show be held in Madison Square Garden. That was where I wanted to play. The Brooklyn Youth Chorus joined the band and me for a few songs, and we filmed the entire thirty-three-song set for a concert DVD, *Elton 60—Live at Madison Square Garden*. President Bill Clinton, Robin Williams, and Whoopi Goldberg came up onstage to celebrate me, and Bernie, overcoming his usual stage fright, led the crowd in a rendition of "Happy Birthday."

Onstage, President Clinton joked that I was joining his favorite club: the sixty-year-olds. "I love that every time he sings he reminds me that we've still got a little juice left even though we've lived six decades," he quipped. He was very flattering in describing my music as a gift, but the real honor was the president supporting the Elton John AIDS Foundation, which I'd started in 1992. He encouraged the crowd to cheer for something besides my music, which I appreciated. Turning sixty was a milestone— one I was happy to share with a room full of fans—and I felt that my activism and

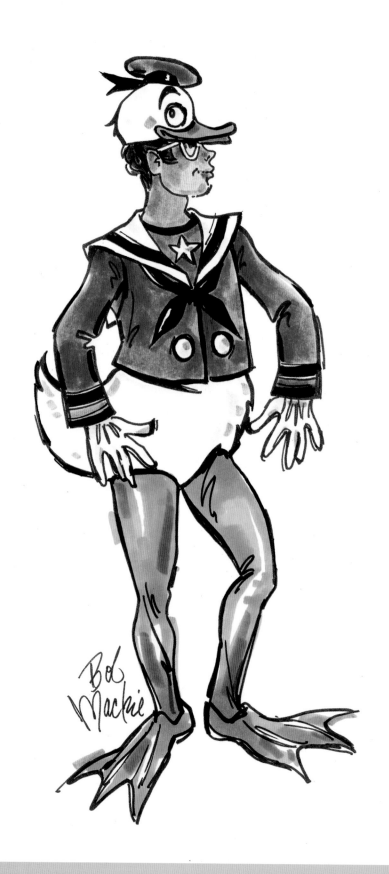

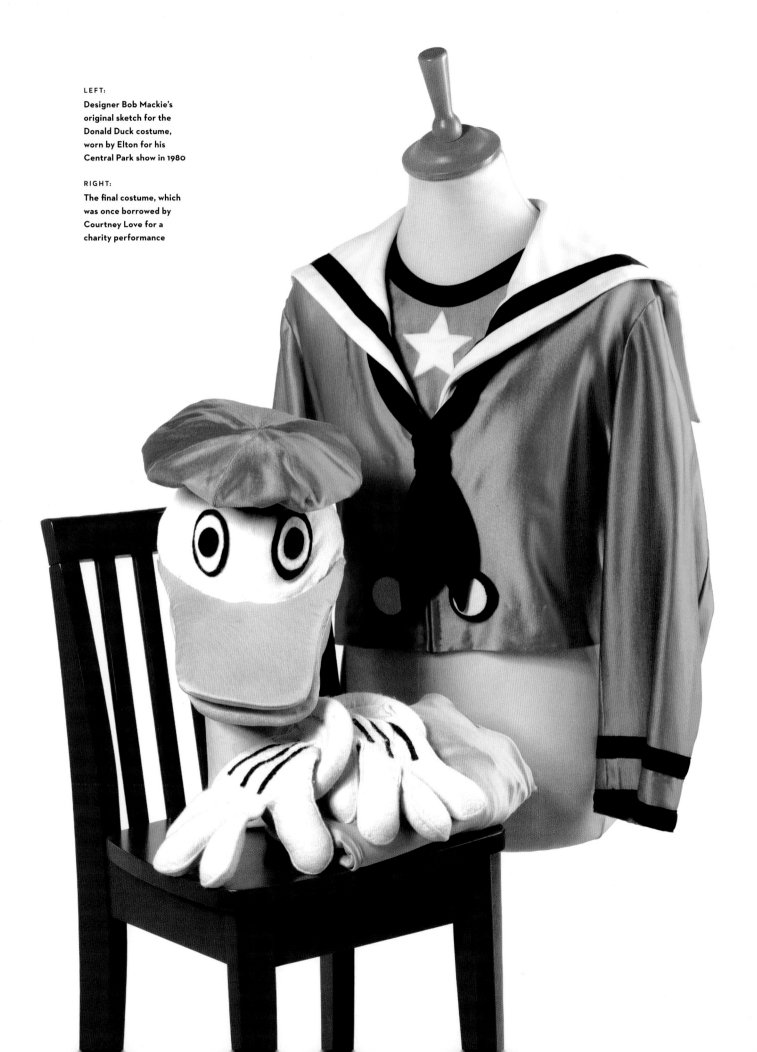

LEFT:
Designer Bob Mackie's original sketch for the Donald Duck costume, worn by Elton for his Central Park show in 1980

RIGHT:
The final costume, which was once borrowed by Courtney Love for a charity performance

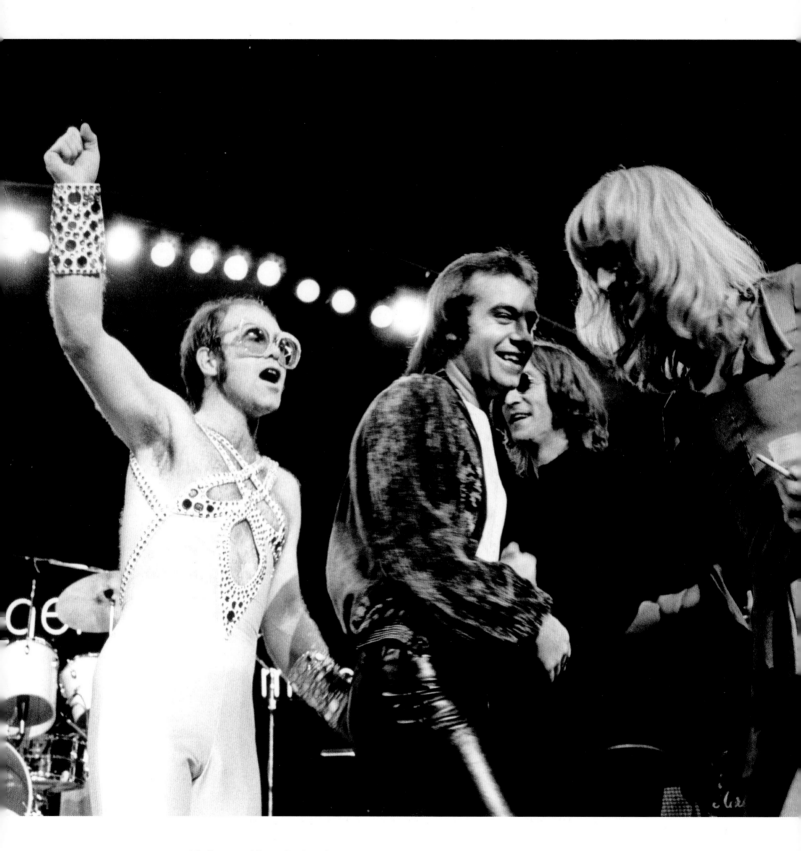

John Lennon and Bernie Taupin soak in
the moment with Elton and Davey Johnstone
after their historic performance at Madison
Square Garden.

fundraising around AIDS and HIV was my greatest achievement, even more so than the songs and the concerts. Big birthdays force you to confront your successes, as well as your failures, and hearing the president praise my foundation was the best thing I could hope for during a celebration like this one. It was quite a night.

I've taken the stage at Madison Square Garden throughout both the highs and the lows of my career. In 1977, I became the first non-athlete inducted into the Madison Square Garden Hall of Fame. As of this writing, only Billy Joel has performed there more times than me. I've returned so many times that it feels like home. In 1986, I booked a four-night run of gigs there. I was struggling with vocal-cord issues, but pushed through and performed two-hour sets each night. In 2000, I brought my One Night Only greatest-hits show to the venue's stage. A great many fellow artists joined me for the performances, including Bryan Adams on "Sad Songs (Say So Much)," Mary J. Blige on "I Guess That's Why They Call It the Blues," Ronan Keating on "Your Song," Anastacia on "Saturday Night's Alright (For Fighting)," and Kiki Dee on "Don't Go Breaking My Heart." The concert was later released as a live album and DVD, although, despite the name, it was actually recorded over the two nights. On the first, there were some issues with the sound. Despite the hiccup, the experience reminded me of how much I loved performing for an audience. It was a great thrill to play these songs for my fans after so many years.

"JOHN IS MAKING A TYPICALLY FLAMBOYANT VISUAL FAREWELL."

★ ★

—*THE NEW YORK TIMES*, 2018

I felt the same way coming back on the Farewell Yellow Brick Road Tour. We brought the tour to Madison Square Garden several times, which felt fitting. Early on in the tour, in 2018, we played there twice in October and twice in November. Two more shows were held in March 2019, and two more in February 2022, which had originally been scheduled for 2020. During the final evening, on February 23, I realized I was saying goodbye to one of my favorite venues of all time. Sure, we still had a few New York City–area shows left—the tour was heading to Newark, New Jersey, later that week and to Brooklyn in early March—but this felt truly final. Several special friends had turned up to see me, including Selena Gomez, who I called out from the stage.

I tried not to be overly emotional, especially since I had a show to deliver. But I understood the conclusiveness of the moment. "This is definitely the most magical venue to play in the world," I reflected. "I have had so many wonderful nights here." I could feel the response and the energy of the crowd. When I affirmed, "This is my last show here," everyone began to boo. They didn't want me to go. "By the time I finish my last show, I'll be seventy-six, and I want to spend time with my family and my children," I explained. "There are other people who will take my place, and you'll enjoy them." At the end of the night, after we'd played the finale of "Goodbye Yellow Brick Road" and I climbed onto my moving platform, I took one last closing bow, perhaps my last ever in Madison Square Garden. It's a place I'll always keep in my heart.

THE FAREWELL TOUR BAND

Although Elton John is a solo artist, his incredible band has always been an essential part of his recordings and his performances. Here his farewell-tour band shares their memories of the final hurrah.

DAVEY JOHNSTONE,
MUSICAL DIRECTOR/GUITARS/
MANDOLIN/BANJO/VOCALS

"Elton called me regularly to enthuse about the level of brilliance we were able to achieve on this farewell tour, each night being more astounding than the previous night. That's my greatest achievement—that my dear friend was still loving what we were doing together because we were always reaching higher, never just going through the motions."

NIGEL OLSSON,
DRUMS/VOCALS

"To say goodbye is hard for me as someone who has lived and breathed the magic of Elton and Bernie's music since 1967, and to have been involved along with Dee Murray, Davey Johnstone, Ray Cooper, Gus

Dudgeon, and Paul Buckmaster in being a part of the creation of the 'Elton John sound.' Performing live with all the top, most incredible musicians and vocalists along the decades has been very special and memorable. This tour was another learning experience for me because of the devotion of so many people involved keeping us rolling. Our crew in all positions were the key to pulling off the most incredible mission ever in music touring history. They are my heroes, and I will miss them dearly. With all that the world has endured over the past few years, seeing the massive amount of people, especially families old and young together, come to see the shows with huge smiles of happiness moved me sometimes to tears. If I can make someone smile and be happy just for a moment in time, my job is done and the joy is mine."

RAY COOPER,
PERCUSSION

"I was, and will remain, so honored to have been asked by Sir Elton John to journey with him and his incredible band on this final tour, Farewell Yellow Brick Road. We have known each other from the very early days of our careers and made music together

over many decades. It is the knowledge garnered over time and tide that Sir Elton trusts my musical contribution and my performance interpretations of both his music and the illuminating poetry of Bernie Taupin's masterly words. It is because of that treasured understanding that this final tour, this musical odyssey, was such an extraordinary and fulfilling experience for me. I am eternally grateful to Sir Elton John for the opportunity to bear witness to the immense love and joy that all the audiences on this Farewell Yellow Brick Road Tour have shown, like the unforgettable concert at Liverpool football ground, where, in a musical interlude, the whole magnificent audience started to sing en masse their football anthem as a spontaneous, collective outpouring of their love for Sir Elton.

"I wish to acknowledge my gratitude to the wonderful men and women of the backstage crew: all the various skilled departments and every crew member constantly demonstrating their unconditional support and devotion to Sir Elton, his exemplary band, and myself. Each member of the crew exuding genuine camaraderie and warmth. Without them and their expertise, we would not have had this incredible, magical show. I will miss profoundly the joy of making music with Sir Elton, those moments where we all fly beyond the clouds and scorching sun to be, for a treasured moment, just below the angels."

JOHN MAHON,
PERCUSSION/VOCALS

"Landing my two thousandth show in Cleveland, Ohio—not far from my hometown of Canton, Ohio—was a memorable event. I have been with Elton for over twenty-five years, but when I thought about two thousand shows—wow, even I could not believe that I'm going to miss my friends in the band and crew. We are a family, and these people are very special to me. I'm going to miss the master, a knight of the Round Table, playing his heart and soul out, keeping us on our toes, never just going through the motions, every night. I'm going to miss the fans that scream, cheer, sing along, and quite often cry their eyes out, making even me choke up, when they hear their cherished song. I'm going to miss seeing the world. I've been a very lucky nomad on a free ride to endless adventure."

KIM BULLARD,
KEYBOARDS

"People at our shows were watching a movie of their life as they listened to the music. It was a layered experience. I don't know exactly what that movie was, but to see their faces as they relived special moments of their lives, through the music, was to bear witness to something holy. It was profound, and never got old. Because the music and the maestro mean so much to people, because the shows went beyond being simply entertainment, I felt in a real way that I was being of service, which was a good place for me to be. I will miss being in Elton's orbit, seeing the world through his unique lens, but more than that, I will simply miss the work. Elton works harder than any other artist out there, so to be able to do what I do at the top level, with a genius, night after night, is a special gift. I will miss playing truly live music—no click tracks, no backing tracks—with this incredible band, I will miss our crew, every one of them, and, of course, I will miss the fans."

MATT BISSONETTE,
BASS GUITAR/VOCALS

"Going back to play in Detroit, my hometown, was a highlight. Playing at Comerica Park and other famous Detroit sports arenas, being such a Detroit sports fan, always seemed surreal. And of course my first gig with Elton, when I had a holy-smokes moment of realizing where I was, that I'll never forget. I'll miss being with this special group of guys and gals. The band and crew have become great friends of mine, and I will cherish them forever. It's amazing when you start something new, for me over ten years now, and you never realize how much further your life will be blessed by meeting people you never knew existed."

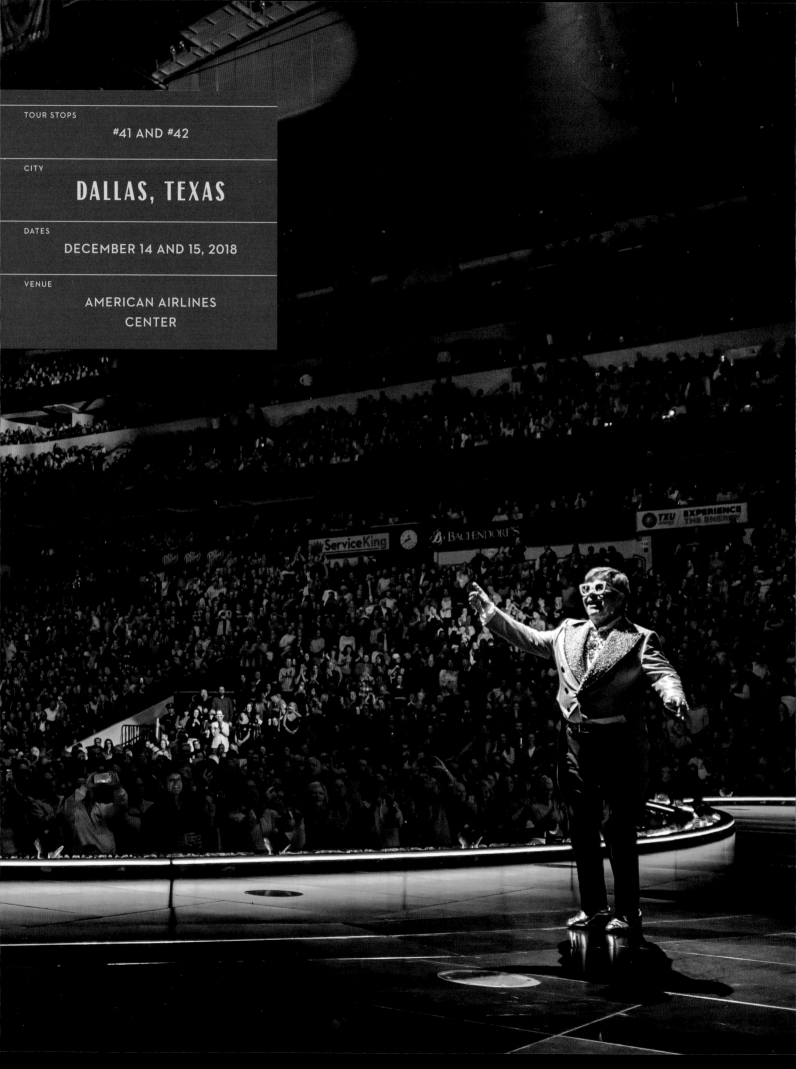

"OLD-FASHIONED SHOWMANSHIP IS ONE OF THE BACKBONES OF ELTON JOHN'S PROGRAM. HIS EASY RAPPORT WITH THE AUDIENCE HARKS BACK TO THE ROCK ERA WHEN PERFORMERS CAME ONSTAGE TO ENTERTAIN, IN A DIRECT SENSE, RATHER THAN ASTONISH OR OVERWHELM."

★ ★

—THE DALLAS MORNING NEWS, 1973

I got to know America well during my first three US tours in the early 1970s. It's a country I've enjoyed touring because it's so vast and each tour stop is so different. And it always seemed like I was hitting the right note in America. Although I'm British, my home country didn't embrace me with quite the same fervor when I got my start. By my second American tour, in the spring of 1971, there was a frenetic response from the fans. During the shows, some of them would climb up onstage and try to hug me. "Look," I'd tell them politely, "you better get off the stage." It was overwhelming sometimes, but I didn't have a lot of time to ruminate on how much my life had changed. We toured for the entire year, in America and as far away as Japan and New Zealand. That was the first year I came to Texas.

Being from England, I had a lot of ideas about what America would be like. Texas, for instance, conjured up images of cowboys and the Old West. But when I visited, I realized it was a whole different kettle of fish. The 1971 tour was packed with shows. It was me, Nigel Olsson on drums, and Dee Murray on bass. We started in the UK with a long run of shows before flying to America in early April. We went all over the country and even jetted to Honolulu for a show before taking a few much-needed days off. The advice had been to book slightly smaller venues than we thought we could fill, which worked splendidly—each night the venue floor was heaving with fans. By the time we arrived in Texas, it felt like we'd seen nearly every state in the country. We had four Texas shows on the itinerary: Houston, San Antonio, Dallas, and Fort Worth.

In Dallas, we performed in Music Hall at Fair Park, a performing arts theater not far from the Cotton Bowl Stadium. It held around three thousand people. The vibe in Texas seemed to square with my over-the-top look and performance style. Americans appreciated a spectacle, and that was what I gave them. By the time we came back to Dallas, over a year later, I was playing to nearly four times that audience at the Dallas Memorial Auditorium, now with guitarist Davey Johnstone added to the band. The 1972 tour was bigger and even more overwhelming.

The crowd welcomes Elton during a performance in Dallas in 2018 as the singer wears a tailcoat reimagined with rock 'n' roll styling.

The shows blurred together, but I'll always remember visiting Texas that year because the band and I were invited to the NASA Johnson Space Center in Houston, where we took a tour with astronaut Al Worden. It was a fitting experience, as "Rocket Man" had recently been released.

My first really big show in Dallas came the following year at the third annual Cotton Bowl Spectacular. There were more than twenty thousand people in the audience. It was a hot August day, and Steely Dan played right before us. At the time, I was performing several songs from my next LP, *Goodbye Yellow Brick Road*, which was set for release in October. The band and I were playing something fierce. The 1973 summer tour had seen us performing in a lot of American sports centers and arenas, which I found quite fun. I grew up going to Watford FC matches at Vicarage Road with my dad, and that year I'd become vice president of their football club. Although I was a die-hard fan of English football, I enjoyed seeing where the American teams played. There are two things that really unite people: live music and sporting matches. I love both for similar reasons. There's something truly undeniable about fans gathered together in a space with a shared passion, whether it's for a particular musical artist or a sports team.

Sometimes people ask me how I can perform in places with opposing views to my own. How can I take the stage somewhere that doesn't protect LGBTQ+ rights? Many people were shocked when I toured the former Soviet Union and are still shocked when I visit modern-day Russia. But I have to. I want to draw awareness to problematic situations and be a voice for change, but I also want to be there for my fans. After Matthew Shepard, a twenty-one-year-old gay man, was murdered in Laramie, Wyoming, in 1998, I went there and played a concert at the University of Wyoming the next year. I was so appalled by what had happened. My friend Ingrid Sischy, who was the editor of *Interview* magazine, helped me to write a speech to give during the concert, which raised more than $250,000 for the Matthew Shepard Foundation and other anti-hate organizations.

"When I fly over America on my broomstick, as I do a lot when I'm touring, I get to physically see and experience what a big country this is—it's big enough for everyone," I said. "That's what this concert is about—ending hate. Despite all the progress that has been made in civil liberties, gay rights, religious tolerance, we're still living in a world where people are hated, even killed, for the simple fact that they are a different religion, a different color, a different race, a different sex, or living a different lifestyle. Such hate and violence against that which is different may seem ridiculous or unbelievable, but it is painfully real. Many of you in Laramie know how ridiculous firsthand."

I felt very passionately about what I was saying. It underscored my belief that you can't shy away from bad things. I wanted to raise awareness for what had happened, but I also wanted to help heal the community. "I felt it was my duty as a gay man to publicly do what Dylan Thomas meant when he said, 'Do not go gentle into that good night,'" I continued. "I couldn't just hear about Matthew Shepard's

ABOVE:

Original ticket stubs from Elton's early concerts in Dallas

RIGHT:

Elton's stage costume in Dallas features pearl beading detail on the lapels—a signature look only Elton could carry off.

murder and think about it as something that just happened and move on. I wanted to do a concert in his memory right here in Laramie, where he should still be living and going to school." I added, "I want this to be a celebration of music, not a wake." Later, Bernie and I wrote a song, "American Triangle," in dedication to Matthew.

A decade later, I had another opportunity to practice what I always preach. In 2010, many artists canceled concerts in Israel—a country I've always loved visiting—due to political pressure. But why shouldn't I give the people there something to smile about? If I canceled my upcoming shows, I'd be part of the problem. Instead I performed in Tel Aviv, telling the crowd that I believe music spreads peace and brings people together, instead of separating us. "That is what we do," I affirmed, noting, "We do not cherry-pick our consciences, okay?" I genuinely believe I can't avoid cities or states or countries that oppress people or fail to protect their citizens. Texas hasn't always been the most progressive state, but I love my fans there and they always welcome me as an openly gay man with open arms.

Ultimately, music is a healer. It's a common thing that brings people together in a shared space, whether they're politically opposed or religiously opposed. For that two and a half hours—or for however long I perform—they forget about that, which is a very powerful thing. It's a very powerful thing to bring fans of completely disparate viewpoints together as one. I want to use my spotlight for good. As a gay

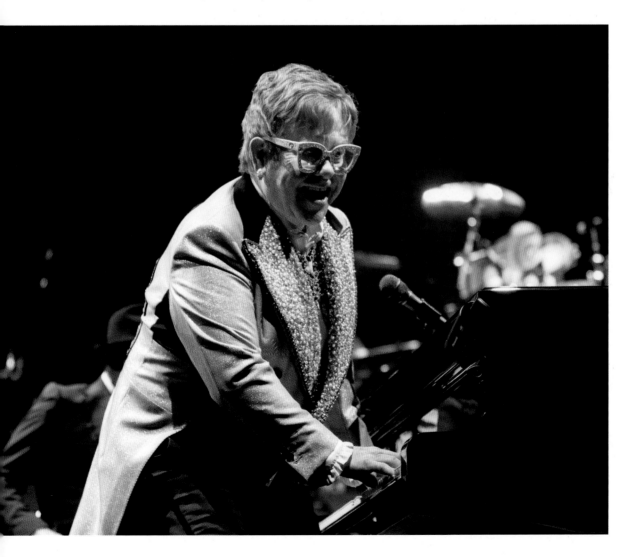

man, I can encourage fans who come from less tolerant backgrounds to become more accepting. The fans love and accept me for who I am, and I hope for that same level of love and acceptance outside the walls of the venue, no matter where in the world I am.

By nature, humans are political. Engaging in society on any level makes us political, whether we identify as such or not. Over the years, it's been important to me to speak out about causes or issues that are meaningful. Critics sometimes say that celebrities should stick to their art. Fuck that. My art is inherently about acceptance. It's about being who you are without fear. If I feel strongly about something, I have to make a statement. It's why I started my nonprofit, the Elton John AIDS Foundation. If I can use my platform as a musician to bring people together and encourage positive change in the world, then it's all the more impactful. To me, it doesn't matter whether a state skews red or blue; I'm going to play my best there regardless. I don't judge my fans for their beliefs. Instead, I want to give everyone a few hours of togetherness without any sense of division. It's a joyful, hopeful thing to do.

When we arrived in Dallas on the Farewell Yellow Brick Road Tour, I hadn't been to the city in four years. It felt good to be back. We were dozens of shows into the tour, and by now the band and I were really hitting our stride. I was having the most fun I'd had in years. Already, I felt the tour was the best of my career. Each city had a slightly different vibe, but when a tour is really long, I can often make out where I am from the reaction of the fans. Dallas is a place where I can really feel the adoration. On our first night at the American Airlines Center in 2018, everyone sang along with such enthusiasm. I could make out shouts of glee and praise between each song on the setlist.

During many of the performances, I hoped to genuinely convey how important this connection between my fans and me has been in my career. It means the world to me. In Dallas that night, I marveled, "Ask any musician, and they'll tell you: The greatest thing you can do is play for another human being and get a reaction. You have given me the most incredible experiences of my life." I know I said similar things on other nights of the tour. I always meant it. It's truly staggering to see the extent of my impact on people.

We were scheduled to return to Dallas in the summer of 2020, but those two shows were postponed because of the pandemic. They were rescheduled for January 2022 when the farewell tour kicked off again, but after we played Houston, I tested positive for Covid. I felt terrible that we had to postpone the concerts a second time, but it was out of my hands. It's always a massive disappointment not to be able to play. Thankfully, I was vaccinated and boosted, and my symptoms were mild. In March, we returned to Dallas and closed out my time in Texas with two shows at the American Airlines Center and another in September 2022 at the Globe Life Field in Arlington.

Like most cities in America, Dallas has been part of my touring life since the early days. Performing there in 2018 was a fond farewell. It also marked our final two shows on that first US leg of the tour. After dozens of concerts, the band and I took a much-needed break. I flew home to see David and the boys, and everyone had a month off for the winter holidays. We would reconvene in Boise, Idaho, on January 11, 2019. A new year, a new set of tour dates, and endless possibilities. I was looking forward to bringing the Farewell Yellow Brick Road Tour to more cities in America, including Los Angeles, where my career as a performer really began.

Elton enjoys the moment while performing a memorable concert in Dallas.

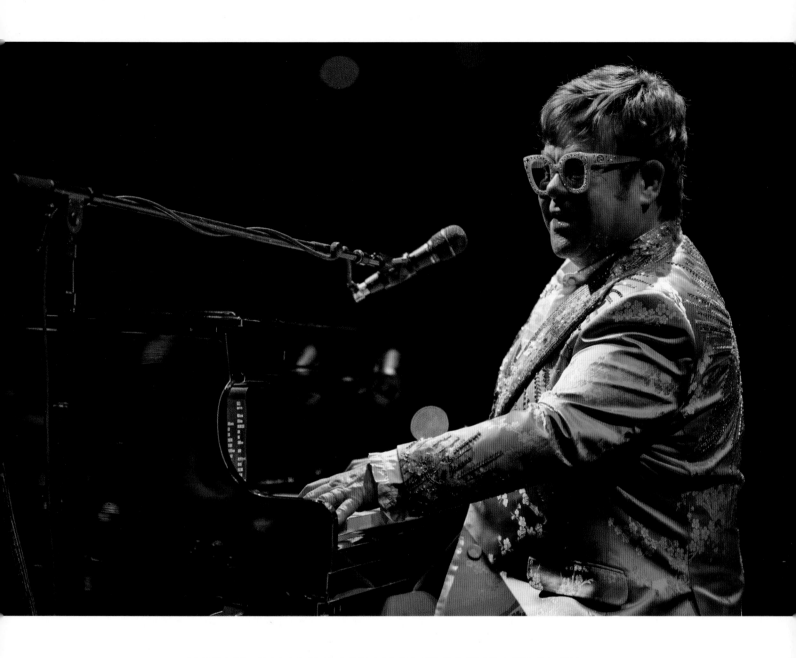

"ICONS, PARTICULARLY THOSE IN THE MIDST OF
GRADUAL GOODBYES, CAN OFTEN TAKE THEIR
FEET OFF THE GAS PEDAL. JOHN, BACKED BY AN
AIRTIGHT SEXTET FEATURING SEVERAL LONGTIME
COLLABORATORS LIKE DRUMMER NIGEL OLSSON,
PERCUSSIONIST RAY COOPER AND GUITARIST
DAVEY JOHNSTONE, SHOWED NO INTEREST IN
TAKING IT EASY."

★ ★

—*THE DALLAS OBSERVER*, 2018

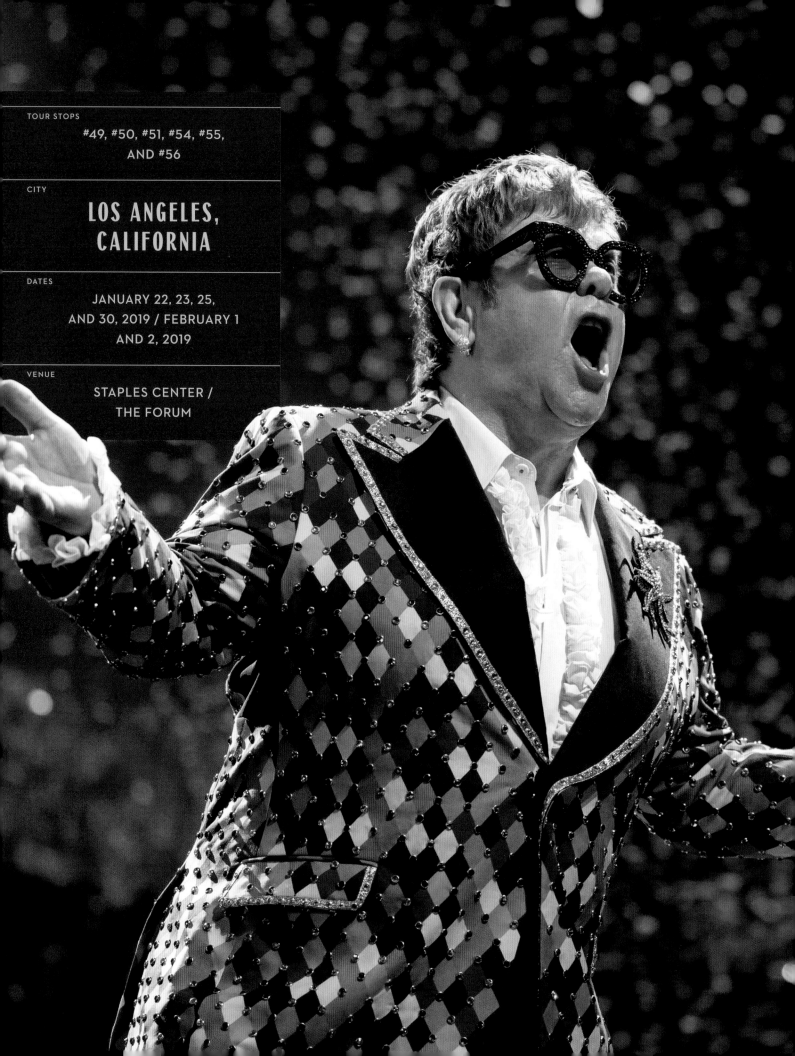

TOUR STOPS

#49, #50, #51, #54, #55, AND #56

CITY

LOS ANGELES, CALIFORNIA

DATES

JANUARY 22, 23, 25, AND 30, 2019 / FEBRUARY 1 AND 2, 2019

VENUE

STAPLES CENTER / THE FORUM

os Angeles is the first place in America I ever played, and it was among the most memorable. My concert at the Troubadour, a club opened by Doug Weston in the 1950s, on August 25, 1970, is credited with launching my entire career. Since then, the city has been very supportive of me as a performer. I have a house in Beverly Hills and live there part-time with my family. Each year in Los Angeles, I host the Elton John AIDS Foundation Academy Awards Viewing Party to raise money for my foundation. As we were planning the Farewell Yellow Brick Road Tour, it was important to give fans in Los Angeles as many opportunities to see me as possible. I started with four nights at the Staples Center downtown in early 2019. There was so much excitement from fans in all the venues, but I was most looking forward to revisiting the Forum, an arena I'd been playing for four decades.

Performing concerts in Los Angeles always brings up memories for me. My relationship with the city has evolved over the years, but I will always hold those initial shows at the Troubadour in my heart. Although I'd been Elton John for over a year, I still hadn't fully caught on with the public. My new US record label, Universal City Records, decided they wanted me to perform some club shows—in America. I didn't see the point. I'd released my debut LP, *Empty Sky*, the year before in England, although it hadn't yet come out in America. My follow-up, a self-titled album recorded with producer Gus Dudgeon and arranger Paul Buckmaster, had arrived in April. We were just starting to get traction in the UK, and I was worried we'd lose the momentum we were building if we went over to America, where no one knew me. Everyone was adamant I should go. An offer came from Jeff Beck for me, Dee Murray, and Nigel Olsson to sign on as his backing band for an American tour. I would get a solo spot to play my own songs as well. It seemed like a decent enough idea. I was ready to agree, but Dick James, who had signed Bernie and me to a music publishing deal, told them to stuff it. At first, I was horrified. But it turned out Dick was right. I didn't need Jeff Beck.

Still, I wasn't convinced I was ready for America. Bernie said, "Let's think of it like a holiday." I figured at the very least we could use it as an excuse to go to Disneyland or go buy records, which sounded like great fun. I was twenty-three and I'd never been to America, so I shrugged. If it ended up just being a holiday, great. I flew to Los Angeles with Dee, Nigel, Bernie, my managers Steve Brown and Ray Williams, graphic designer David Larkham, and our roadie Bob Stacey. When we arrived, the record label met us with a British double-decker bus. On the side, it said ELTON JOHN HAS ARRIVED. I was so embarrassed. I had been expecting a limousine

LEFT:
Elton performing at the Staples Center in 2019

RIGHT:
A newspaper advertisement for Elton's career-changing show at the Troubadour in 1970

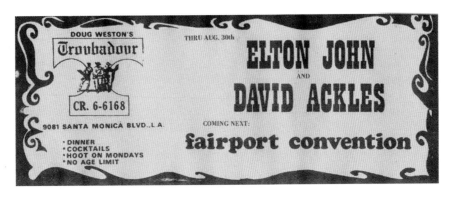

STAPLES CENTER / THE FORUM

JANUARY 22, 23, 25, AND 30, 2019 /
FEBRUARY 1 AND 2, 2019

LOS ANGELES, CALIFORNIA

#49, #50, #51, #54,
#55, AND #56

"BY THE END OF THE EVENING, THERE WAS NO QUESTION ABOUT JOHN'S TALENT AND POTENTIAL. TUESDAY NIGHT AT THE TROUBADOUR WAS JUST THE BEGINNING. HE'S GOING TO BE ONE OF ROCK'S BIGGEST AND MOST IMPORTANT STARS."

★ ★

—*THE LOS ANGELES TIMES*, 1970

or a Cadillac, so this seemed ridiculously over the top. As we drove from LAX airport to the hotel, Bernie lowered himself in his seat so no one could spot him through the bus windows. But the city looked exactly like it did on television in *The Beverly Hillbillies*. There were palm trees everywhere. I remember thinking how everything there looked and sounded amazing.

Everyone from my US record label was extremely enthusiastic about the upcoming shows. Somehow, they'd created a real sense of hype. I was this unknown kid from England, but everyone was coming. I was set to headline over David Ackles, which seemed ludicrous. I'd been skeptical about performing in America, but now I was fucking terrified. Who was I to be headlining the Troubadour for a whole week? At one point, I told everyone I was going home to London. I threatened to get on a plane. But then I came to my senses. If all of these people were coming out to see me, I was going to give them the performance of their lives.

The evening of August 25 arrived. Before I left England, I'd bought a bunch of clothes from a store called Mr. Freedom, run by designer Tommy Roberts. On the night of the show, I put them all on—yellow dungarees, a T-shirt covered in stars, and bright yellow boots with red wings. It was not at all the way I looked on the cover of *Elton John*, which depicted a serious singer-songwriter. The crowd, who had never seen me before, certainly wasn't expecting the version of Elton John who appeared onstage with Dee and Nigel. Neil Diamond, who I'd met for the first time earlier that week, introduced us. As I sat down at the piano, I could hear a surprised murmur in the crowd. I remember it distinctly. I didn't look like America in 1970. They'd expected some moody guy to come out and play Randy Newman–esque songs on the piano. But we were a rock band.

I opened the set with "Your Song." I was nervous, my eyes down on the piano keys as I sang. I quickly realized, however, that I couldn't let the crowd's surprise throw me. Something shifted. I decided to push up the energy with the second song, "Bad Side of the Moon." "Right!" I told the crowd. "If you won't listen, perhaps you'll bloody well listen to this!" I kicked my piano stool out of the way, just as I'd seen Jerry Lee Lewis do all those years earlier, and started pounding the notes out like Little Richard. Something inside me took over. I went wild. I leapt on the piano. I flung my legs up into the air. I howled into the microphone. The crowd,

A series of photos taken by David Larkham during Elton's performance at the Troubadour in 1970, now some of the only images that exist from the show. Larkham shot the photographs from the back of the stage with the intention of creating a sequence.

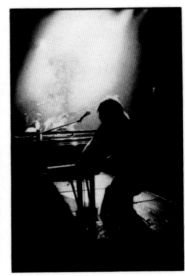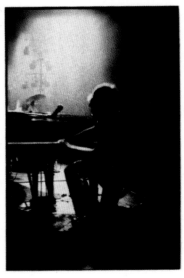

initially so stoic, responded and began to move along and applaud. I knew this was my big moment, and I had to go for it. At one point during the set, while playing "Burn Down the Mission," I realized with a shock that Leon Russell was in the second row. He was my idol. I couldn't believe he was there watching me play. Once the set was over, it was clear something special had happened in that room.

Afterward, I was in the dressing room and someone introduced me to Quincy Jones as "a genius." Leon came backstage and was incredibly kind to me and invited me to go on tour with him. I knew the show had been a success, but I wasn't ready to buy into all the hype. I wanted to write good songs and have people enjoy them. I wasn't thinking about becoming a star. That week, I played seven more shows at the Troubadour. It was a blur, like a fuzzed-out dream. More celebrities came. I kept dressing myself up in spectacular Mr. Freedom outfits and hurling my body around the stage. I could sense the opportunity in the air, and I wasn't going to let it go.

That week of performances opened a lot of doors for me. The *Los Angeles Times* critic Robert Hilburn wrote in his review, "Rejoice. Rock music, which has been going through a rather uneventful period lately, has a new star." It was like everything I'd been waiting for had finally happened. I was the kind of performer I'd always admired. All of these important people wanted to know me. I went from being a complete nobody to being Elton John in a matter of days. But with all that admiration came a lot of pressure. Now I had to re-create that magic in other cities. Looking back, I can't believe we got the reaction we did. It was a complete surprise. I still can't explain how it happened. We just caught everybody on the hop. And it was the right place at the right time. True serendipity.

Three months after the Troubadour residency, I returned and played a show at the Santa Monica Civic Auditorium to three thousand people—a noticeable increase from the three hundred at the Troubadour. It was a brilliant show despite some issues with my microphone. We played for nearly two hours. The audiences in America seemed more receptive than the ones we'd played for in England. By the end of the show, the crowd was wild. I was feeling more and more confident in my showmanship onstage, too. I could have come out there in a pair of Levi's and a shirt, but I would have been bored to death. Instead, I donned a leather top hat and a blue velvet cape and went nuts. I wasn't trying to prove anything—I just wanted to have fun while performing. I still feel that way.

Things kept getting bigger. Nineteen days later, I played to nine thousand people at the Anaheim Convention Center, and by 1973, I was booked at the Hollywood Bowl. The shows on that 1973 tour were intended to launch my new album, *Goodbye Yellow Brick Road*, in America, and I was playing five songs off the LP, including my single "Saturday Night's Alright (For Fighting)." By then, I was a star. I was obsessed with making grand entrances, and that first concert was pure extravagant spectacle. Onstage, my close friend Tony King introduced actress Linda Lovelace, who in turn introduced a series of celebrity lookalikes, including the Queen of England, Marilyn Monroe, and the Beatles, before I appeared. I wore an outrageous ensemble covered in white marabou feathers. As I came onto the stage, the lids of five grand pianos sprang open and spelled out ELTON. We planned for four hundred white doves to fly out of the pianos, but they didn't cooperate. Only a few took to the sky. The glamourous after-party was held at the newly opened Roxy Club. It was a must-have ticket.

Although I've returned to the Hollywood Bowl several times, by 1974 I'd moved up to the Forum, an arena then frequented by the likes of David Bowie, the Rolling

Stones, and Elvis Presley himself. Coming back to the Forum on the Farewell Yellow Brick Road Tour all these years later, it was amazing how it still had the same vibe. I tried to ensure that each performance on my farewell tour felt as special as the next. Although certain performances stand out because something notable happened or I brought a surprise guest onstage to sing with me, no night was better than any other. That was something I learned as early as the Troubadour. You can't rest on your laurels just because people like your songs. As a performer, I want to be pushing myself to always be the best—a sentiment I share with my band.

Returning to the Forum in 2019 felt oddly emotional for me. On the first night, there was such a wave of acknowledgment, love, and appreciation from the audience. It was a mutual rush of feeling that was completely spontaneous. It took me—and the band—completely by surprise. Here I was back in the city that gave me my first shot. A city that always delivered for me. I think you had to be there to completely understand how it felt, but love poured onto the stage from the fans. I was speechless. Finally, as I found my voice, I acknowledged, "I won't forget tonight, ever." After we played "Your Song," I offered the love back. "This is *your* song, Los Angeles," I said. It was a full-circle moment for me, and for the city as well.

The first Troubadour show in 1970 will go down in history as the night that made me Elton John. Everything that happened after is a result of so many things coming together in the right way in the right moment. I have such a history with Los Angeles because of it. But while the Troubadour shows are what set me on my path, my performance at Dodger Stadium five years later was the pinnacle of my career. It solidified the legend of Elton John. But we'll get to that. . . .

BELOW:

Elton performs at the Hollywood Bowl in 1973, one of the most historic of the singer's concerts.

INSET:

A ticket stub from Elton's 1973 concert at the Hollywood Bowl

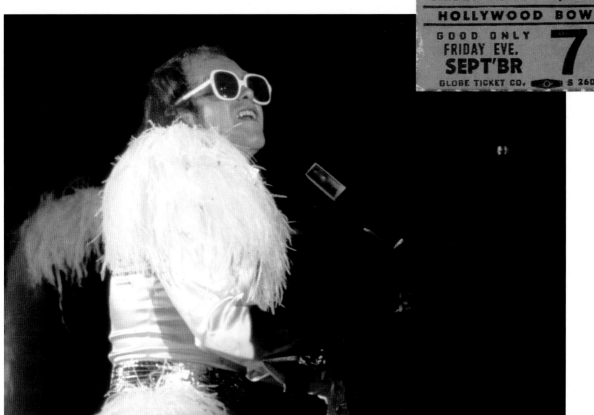

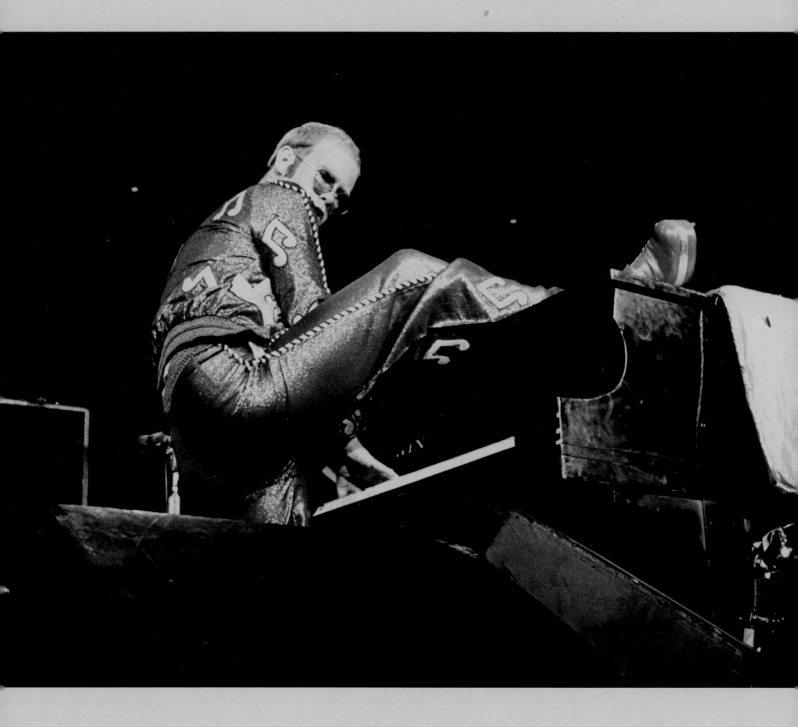

Elton has always brought
dynamic energy to his live
performances, from his early
concerts in the 1970s to his
farewell tour. On the left, he
performs at the Hollywood
Bowl in 1973, and on the right,
he performs at the Staples
Center in 2019.

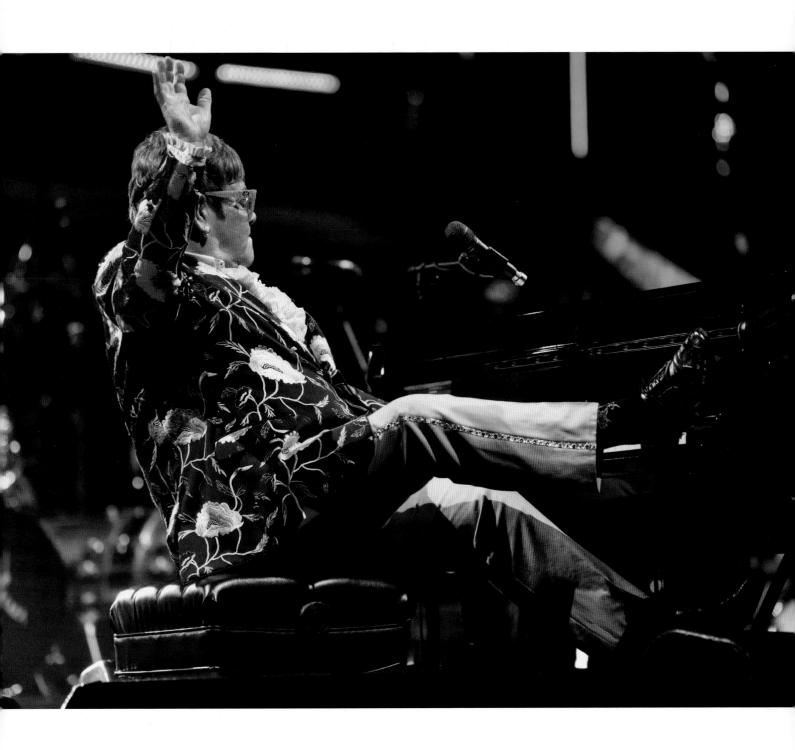

"FOR THOSE WHO FORGOT HOW JOHN BECAME A
POP MUSIC LEGEND, OPENING NIGHT OF HIS
SIX-NIGHT STAND IN L.A., THREE AT STAPLES CENTER
THIS WEEK, ONE MORE NEXT WEEK AND TWO AT THE
FORUM NEXT WEEK, WAS A DAZZLING REMINDER."

★ ★

—FORBES, 2019

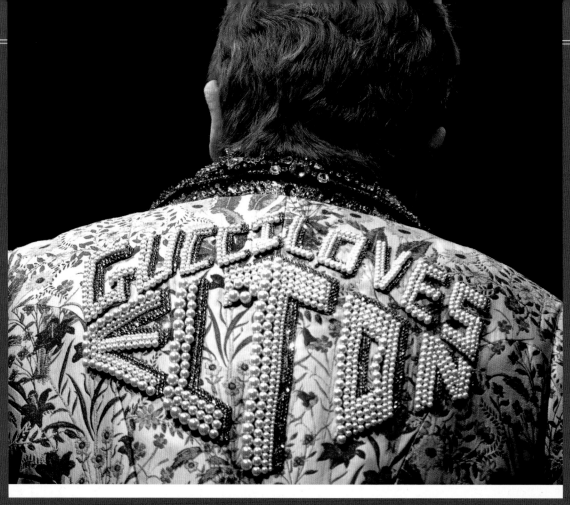

THE FAREWELL TOUR WARDROBE

From the beginning, Elton has brought a sense of stylish swagger to his stage looks. While he is well-known for his iconic songs and impressive live performances, the musician has also embraced sartorial self-expression in an unparalleled way. Since he performed his first US show in 1970 at the Troubadour in Los Angeles, Elton has made a lasting impact with his vibrant ensembles.

"If you're playing the piano and you're not a lead singer and you're not walking around, you've got to try and do something," the musician explains. "So I started trying to dress in a different way, in almost a cartoonish way. I wasn't Rod Stewart, I wasn't Mick Jagger, I wasn't a sex symbol. Tommy Roberts had a shop in London called Mr. Freedom, and I became his mannequin in a way—his clothes were really fun, colorful, boots with wings on, silver hot pants, jumpsuits. When I came onstage at the Troubadour, no one else looked like that."

Over the years, Elton has made it clear that he loves a costume. He's worn everything from a feather suit to a sequined Dodgers uniform while performing, and his love of fashion is infectious. The costumes augment the overall spectacle of the concerts and live performances and have created truly memorable moments that have become iconic in the pop culture lexicon. For his farewell tour, it was only fitting that Elton collaborate with Gucci's then-current creative director Alessandro Michele. The pair were first introduced by Jared Leto in 2016 at the *Vanity Fair* Oscar party and quickly found a connection in their love of ostentatious, revolutionary fashion. Michele began incorporating nostalgic Elton John looks into his Gucci collections, with encouragement and inspiration from Elton and David Furnish. In his Spring/Summer 2017 collection, Michele included a handbag emblazoned with ELTON in red sequins and a vintage-inspired bedazzled denim jacket.

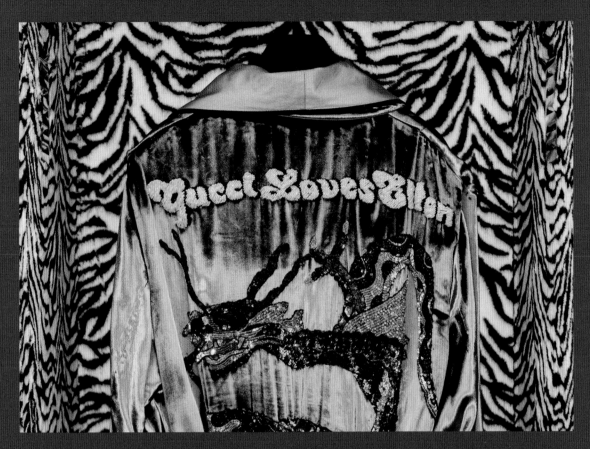

"I was blown away," Elton recalls of seeing his fashion history walk down the runway. "It wasn't a literal retread of my past, but a cleverly refashioned vision that fits so well in the Gucci world of today. It really put a big smile on my face. Opening up my costume archive and seeing how Alessandro reinterpreted key looks unearthed an exhilarating rush of emotions. I can't believe how sartorially crazy I was. With fashion back then, I was like a big kid in a sweetshop. I get the same rush of enthusiasm when I walk into a Gucci boutique today."

When it came time to select the best stage looks for his send-off tour, Elton looked to Michele, a longtime fan of the musician's fashion and songs. Michele designed a custom collection of three distinct ensembles for the tour, which included suits, shirts, jewelry, eyewear, ties, and shoes made especially for Elton. The only thing Elton added of his own was his jewels.

"They are all so beautiful and exquisitely crafted," Elton reflects of the Gucci pieces. "I find it difficult to go onstage without putting on a costume that allows me to become a performer. The theatricality of the costume pieces Alessandro and Gucci have created for me is totally transformational."

From a creative perspective, Michele's designs were the perfect fit for the overall concept behind the Farewell Yellow Brick Road Tour. "There was all of this weirdness, this amazing synergy, and this serendipitous connection with things that were happening at Gucci at the time," Furnish says. "It was colorful, it was celebrating self, it was celebrating self-expression, it was celebrating people in all shapes and sizes and colors. Fashion can be quite unforgiving sometimes in that it puts forward unrealistic ideals of really skinny people, and that's just not who Elton has ever been. Gucci really

caters to everybody. They also cater to young people, and Alessandro has a real connection with a younger consumer in the same way that Elton is so passionate about new music and young artists. They both have a real connection with all generations, really, but a particular affinity and passion for the young and the future. That magically went into the cauldron of this tour."

For Elton, the three looks from the Farewell Yellow Brick Road Tour reflect memorable aspects of his career. They pay homage to his '70s flair, while also embracing the sense of diversity that is so important to Elton in general. The stage wardrobe feels both current and timeless.

"I feel so blessed to have been a songwriter and performer in the 1970s," Elton says. "It was a decade with an unprecedented explosion of creativity in music, fashion, and filmmaking. There was inspiration everywhere. There was so much individuality, revolution, positivity, and hope. I find it massively uplifting that today's generation is drawn to the same spirit in Alessandro's Gucci collections. I loved how Alessandro celebrated the cult of the individual at Gucci. Alessandro's vision for Gucci was a celebration of diversity. There's so much negativity and divisiveness in the world. He presents a proposition for the world that is uplifting, positive, and unifying. It celebrates people's desires to express themselves as unique individuals and to be accepted for that. It's a fun and happy world that anyone can step into. It's inclusive yet individual. That's why a Gucci wardrobe was perfect for my farewell tour."

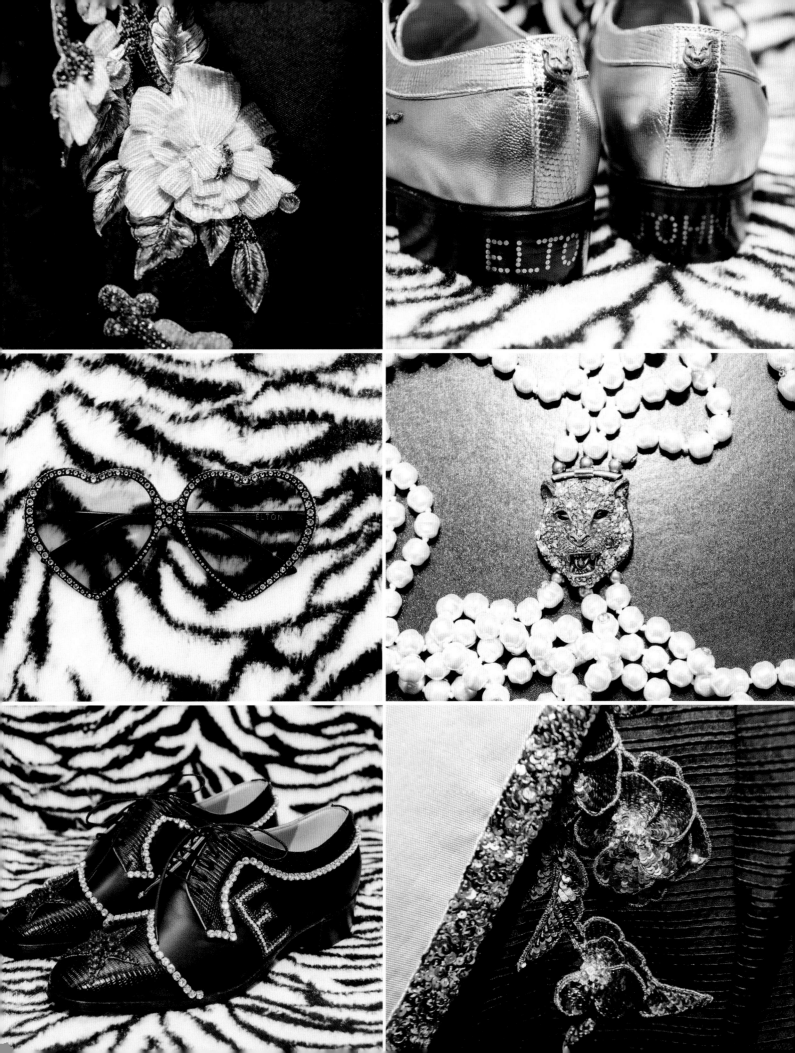

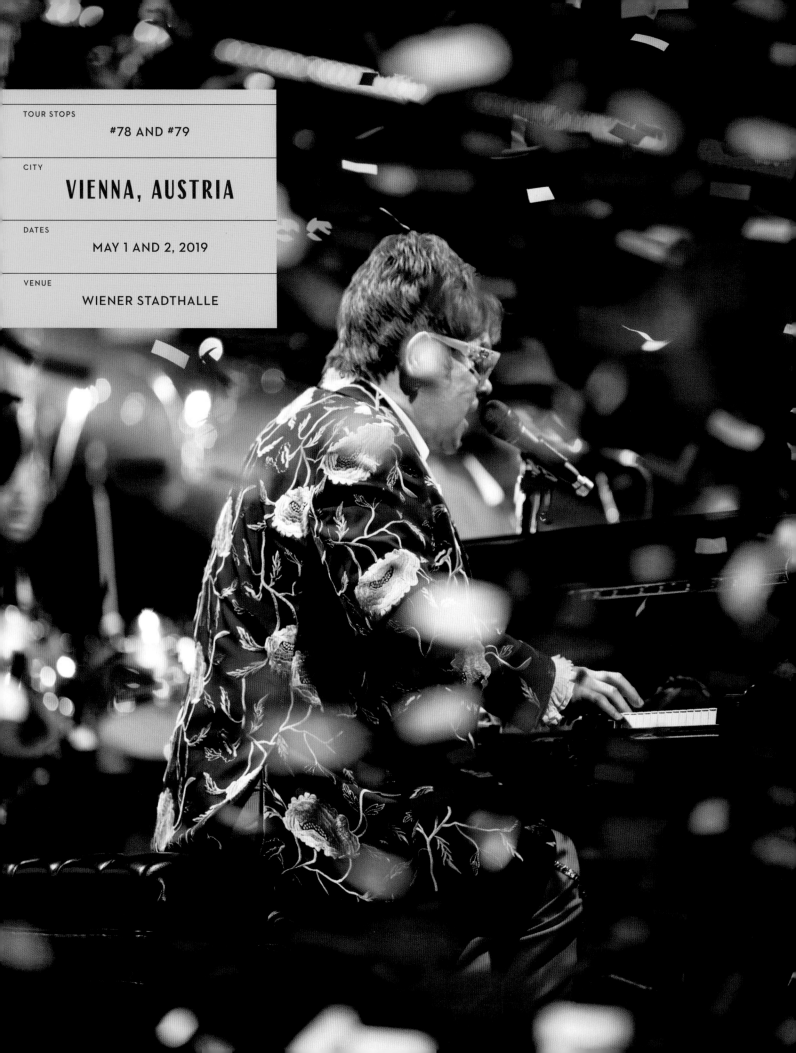

TOUR STOPS

#78 AND #79

CITY

VIENNA, AUSTRIA

DATES

MAY 1 AND 2, 2019

VENUE

WIENER STADTHALLE

"NO INTERNATIONAL ROCK STAR HAS FILLED THE STADTHALLE THREE TIMES."

★ ★

—*RENNBAHN EXPRESS*, 1986

The initial North American stretch of the Farewell Yellow Brick Road Tour visited dozens of cities. We played nearly eighty shows, from Allentown to Orlando, before the band and I took a little over a month off. Two legs down. It was a relief to pause after such relentless touring, and I was grateful to spend time at home with my family. But I was also eager to keep the momentum of our farewell adventure going. The next leg of the tour was booked for Europe and the UK, with more than thirty concerts scheduled in cities like Prague, Munich, Copenhagen, Paris, and Dublin. We knew it would be great fun to bring the show to new audiences in some of my favorite countries.

As we were gearing up for the European leg of the tour, we were also gearing up for the release of *Rocketman*, a film based on my life. The idea for a biopic had been in the works for over a decade. It was finally coming to fruition with the director Dexter Fletcher at the helm and Taron Egerton playing me. David produced the film through our Rocket Pictures along with Matthew Vaughn and his wonderful team at Marv Studios. David was very involved in the movie's development and creation. Although I was an executive producer, I wasn't really part of the day-to-day, so I was as excited as anyone to see how it turned out. *Rocketman* was scheduled to premiere at the Cannes Film Festival in France on May 16, 2019, so the European tour leg had been routed with a few days off between Germany and Denmark to attend Cannes.

After my time off, I flew from London to Vienna, where we were booked for two concerts at Wiener Stadthalle. The venue is an indoor arena on the outskirts of the Austrian city, which I'd sold out several times prior. When you come from England, Europe is an easy place to access. The first place I ever played in Europe was the Top Ten Club in Hamburg, Germany, with Bluesology in March 1966. It was exciting to perform outside of my home country, although the tour was not exactly glamorous since we were young and broke. Once I became Elton John, I slowly began to play gigs in places outside the UK. In March of 1970, I performed in Paris for the first time, opening for Sergio Mendes & Brasil '66 at the Théâtre des Champs-Elysées. It was not a good fit. The crowd didn't take to us and threw fruit at the stage. But I wasn't put off—there would be other audiences who appreciated my songs.

Giant confetti cannons explode around the stage as Elton plays "Saturday Night's Alright (For Fighting)."

On July 11, 1970, I was booked on the bill of the Knokke Festival in Knokke, Belgium, a fun experience even if I was still small-fry. But once I visited America and made my big splash at the Troubadour, the focus shifted to the US. During 1971 and 1972, I trekked around North America, as well as the UK, and didn't have much opportunity to bring my songs to Europe. Despite the endless touring, I only played six shows each in Germany in early 1972 and in Italy in the spring of 1973. In fact, it wasn't until 1979 that I really began to make my mark touring in Europe.

That year, I was on my A Single Man tour, which lasted from February through May. The tour was in support of my most recent LP, *A Single Man*, which had come out the previous fall, and it included a massive amount of dates. I had semi-retired from touring, but agreed to get back on the road if we played smaller venues. I wanted it to feel more intimate—just me, my piano, and Ray Cooper on percussion. I'd known Ray since the late '60s and he had been in my band on and off since 1973, so it was great to collaborate in this new way. I was also interested in the challenge of performing in unusual or unpredictable places where I wasn't yet popular, like Switzerland or Israel. And to date, I hadn't played in Spain and Ireland, which was somewhat confounding. It felt like the right time to reorient my touring career.

Usually, musicians only play gigs in places where they can make money. I'd had enough of that. I wanted to see different people around the world. We kicked off the 1979 tour in Stockholm—in the dead of winter—and visited several countries, including Germany, France, and Denmark. I performed a run of six concerts at the Théâtre des Champs-Elysées in Paris. Getting to see Paris was loads of fun, and I did a photo shoot in front of the Eiffel Tower. Thankfully, the Parisians had a much better reaction to my music this time around. No fruit was thrown. My newfound relationship with Europe continued through the 1980s, when I went on several world tours. Two of the most notable: the European Express Tour in 1984 and the World Tour in 1989.

Launching the first European leg of the Farewell Yellow Brick Road Tour in Vienna didn't have some big significance, although I'm a fan of performing in Austria. It was just the best routing of the tour. But it was the first time fans and music critics saw the show on this side of the Atlantic. All the British press turned up. It felt like a big moment, even though we'd played this set dozens of times in America. Europe is a whole different kettle of fish. How would it go over here? But, of course, there was no reason to be nervous. The crowd was lively and welcoming, and it felt great to be back onstage again after six weeks off.

"THE GOOD NEWS IS THAT JOHN IS GOING NEITHER QUIETLY NOR GRACEFULLY. HE IS DRAGGING HIMSELF INTO RETIREMENT RAUCOUSLY AND DEFIANTLY. WHEN ELTON JOHN PLAYS A GREATEST HITS SET, THEY REALLY ARE HITS, THEY REALLY ARE GREAT, AND THEY STAY PLAYED."

★ ★

—*METRO*, 2019

Elton poses in front of the Eiffel Tower in Paris in 1979. He was on a European tour with percussionist Ray Cooper.

"These are our last shows ever in Vienna," I confirmed. "We've been coming here for nearly fifty years, and you have always been good to us, so we are going to give you as much fun as we possibly can." By the end of the set, I could sense the emotion in the air. Being onstage is the closest I can get to most of the fans. In the past, I encountered some of them backstage or in hotel lobbies, and in more recent decades, I've met a few at meet and greets. But it's not the same thing as connecting with a fan while you're performing. Nothing gets you as close as seeing someone experiencing a live show and reacting. On the farewell tour, the audiences were quite big. It was difficult for me to fully see the scope of the crowd from the stage. But I could sense it. I could feel their energy each night. There was such a palpable bittersweetness in the air as we played "Your Song" that I nearly teared up.

Looking back, there was an optimistic innocence in the spring of 2019. No one could have imagined the global pandemic that would affect us all less than a year later. The band and I were riding high on the success of the tour so far. David and I were excited—and emotional—about *Rocketman* finally arriving in cinemas. I'd been working on my tell-all memoir, *Me*, which was set for release later in the year. It felt great to be back on the road in Europe and revisiting cities I'd long loved playing. Everything was a possibility.

Through being in recovery, I've learned to take things one day at a time. I tried to take each show as it came without overly anticipating or worrying about it. We were flying through the farewell tour, and everything seemed on track. And it was, for now. The reviews were strong, we were feeling good, and the fans were happy. What more could a touring artist ask for? Although I kept my focus on whatever show was coming up that day, I couldn't help but reflect. There were some countries we couldn't visit on the Farewell Yellow Brick Road Tour. That doesn't make them any less meaningful to me. As we wound our way around Europe, I remembered how revelatory that 1979 tour had felt. We played in so many places for the first time, including somewhere very few Westerners had played before: the Soviet Union.

As we were planning the A Single Man tour in 1979, I wanted to consider places I'd never been. We booked shows in European cities and countries where I didn't already have a big following. As I was thinking about where I might want to go, I suggested offhandedly, "What about Russia?" At the time, the country was part of the Soviet Union. They were due to host the Summer Olympic Games in Moscow in 1980, and I was curious what it would be like to play there. At that point, only two Western artists, Cliff Richard and Boney M., had performed in the communist nation. It seemed impossible that Elton John might follow. My manager, John Reid, invited a cultural officer from the Soviet embassy in England to attend my show in Oxford. He was so impressed, they invited me to play a series of concerts in Leningrad and Moscow.

Later, I discovered the Soviet Union did want rock musicians to tour there. Although I was one of the first to make the journey behind the Iron Curtain, it wasn't because the country was uninterested in Western music. They wanted artists like Paul McCartney, Eric Clapton, Neil Diamond, and Pink Floyd to come to Russia. The only reason more people hadn't played there was simply because they hadn't asked for permission. It's a fucking good lesson: If you want something, ask for it. I was eager to visit somewhere new and meet the people of another country—it was that simple. But I did blaze the trail for more musicians to perform in the Soviet Union. In the 1980s, everyone from Queen to David Bowie to the Rolling Stones went there.

During my tour, I performed four concerts in Leningrad and four in Moscow between May 21 and 28, 1979. None of my records were available in Russia at the time. In fact, fans could only hear my music on black-market cassette tapes—something I found shocking. The Russian media refused to announce the news of the concerts, so by the time the public learned about them, most of the tickets had been snapped up by high-ranking Communist Party officials. I didn't know what to expect, but it turned out to be fantastic.

We arrived in Moscow on a blisteringly hot day, and I was surprised to find a small group of fans waiting for me. From Moscow, we went on to Leningrad by train. I don't tend to get nervous when I perform, but before the first show, I was a bit terrified. Nobody really knew me here, and there was so much that could go terribly wrong. I kept thinking someone would put a stop to the shows with a resounding "Nyet!" but they never did. I was given a few rules: Do not put your feet on the piano keys, do not kick the piano stool, and do not play the Beatles' "Back in the USSR."

On the first evening, Ray and I took the stage at the Great October Hall in Leningrad, a 3,800-seat venue, and tentatively began to perform. I had discarded my usual costumes and spectacle for this tour—this was about the music—and it took some effort to get past the crowd's stoic vibe. At one point early on during the twenty-seven-song set, two young women came to the front of the audience and handed me roses. Suddenly, I felt more at home. It had been years since I'd

Elton's groundbreaking trip across the Iron Curtain in 1979 was well documented. Here the famously gay singer defies tradition as he poses in Red Square wearing a string of pearls.

"THE PERFORMER IS NOT THE FLAMBOYANT ELTON JOHN THAT WE'RE ACCUSTOMED TO IN THE UNITED STATES.... BUT JOHN HASN'T TONED IT DOWN FOR RUSSIA."

★ ★

—*THE LOS ANGELES TIMES*, 1979

performed for people who didn't really know my music, and I realized it was a challenge I very much enjoyed. I had to win them over. I followed the first two rules, but not the third. Our finale medley of "Crocodile Rock," "Get Back," and "Back in the USSR" was a rousing success.

As the shows went on, I continued to be surprised by people's friendliness. The crowds were brilliant. They'd never seen anything like me. I really fell in love with the Russian people. They were so kind, and I was similarly surprised by the country itself, which was so beautiful. When we returned to Moscow for the final four shows, we saw a performance of *Swan Lake* by the Bolshoi Ballet and went to a reception at the British embassy. I did an interview and performance for a Moscow television station, which was entertaining, to say the least. Despite the welcome from fans and the captivating beauty of Moscow, we could sense the Communist Party rule in the background. We were being monitored by the KGB. The audiences in the capital were more reserved than those in Leningrad. Our second Moscow concert, at Rossiya Hall, aired on BBC Radio, creating a link between my own country and this foreign land.

My first tour in Russia was one of the most interesting and happy tours I've ever been on. The final show on May 28, 1979, which was filmed for a documentary, *To Russia . . . With Elton*, was probably one of the best concerts I've ever given. Or at least it felt that way. I've always believed it's important to bring my music to places around the world regardless of their politics. Even if a government holds opinions I disagree with, it's my duty to appear there anyway. I wanted to show Russia and the world that I cared about them. I want to unite, not isolate. Music is a powerful thing, and it brings people together, despite any differences. It does not discriminate. I've held that belief closely in the years that followed.

Since 1979, I've been back to Russia many times. I've returned for the people who have been my fans, and for the LGBTQ+ community who needs me to go there and support them. In 2013, Russian president Vladimir Putin signed new legislation that made it illegal to promote homosexuality, or even just to talk about being gay, to people under eighteen. It was awful. It discriminated against and targeted a community of people who deserve equality and compassion. Even worse, the law has since then been expanded to encompass people of any age, which has pushed communities even further underground. Many Westerners called for artists to boycott Russia because of it. I could understand the two schools of thought from critics: Either artists could stop performing in Russia in protest, or they could go anyway in solidarity with their fans. For me, it wasn't a choice. How could I abandon the people who were gay and suffering under the anti-gay laws in an isolated situation? As a gay man, I simply couldn't. I had to go over there and support them.

In December 2013, I was booked to perform two sold-out concerts in Russia. As the new legislation picked up more and more press coverage, rumors began to fly that I was planning to cancel. But those rumors were complete nonsense. I always intended to be there for my Russian fans. In Moscow, I dedicated my concert to a young

Elton performed eight concerts in Russia in May of 1979, accompanied by Ray Cooper.

man named Vladislav Tornovoi, who was tortured and murdered after supposedly telling his friends he was gay.

"You've always welcomed me with warmth and open arms every time I visited," I told the audience. "You have always embraced me, and you have never judged me. So I am deeply saddened and shocked over the current legislation that is now in place against the LGBT community here in Russia." I added, "The spirit we share tonight is what builds a future of equality, love, and compassion for my children and for your children. Please don't leave it behind when you leave tonight."

The following year, Putin tried to use me as an example that there was no discrimination against gay people in Russia. During an interview on *The Andrew Marr Show* on the BBC in England, Putin claimed, "It seems to me that the law we adopted doesn't harm anybody. What's more, homosexual people can't feel inferior here, because there is no professional, career, or social discrimination against them. When they achieve great success, for example Elton John—he's an extraordinary person, a distinguished musician, and millions of our people sincerely love him, regardless of his sexual orientation." Putin was wrong. Violence against LGBTQ+ people increased after the anti-propaganda laws came into place. I was livid. The law abused Russian citizens' basic human rights. I had met fans there who were being victimized by the legislation, and it was clearly because of their sexual orientation. I felt compelled to respond.

In a statement, I offered to introduce Putin to gay people who were being verbally and physically threatened as a direct result of his vicious legislation. I felt a deep connection with my fans in Russia, and I wanted to protect them. They deserved equal rights no matter their sexuality. They were being treated horribly. I wanted to disabuse Putin of his ridiculous notions about gay people. The post first resulted in two Russian TV hosts prank calling me and then Putin himself calling me, although things haven't gotten better for the LGBTQ+ community in Russia. But I will always stand up for those who are being degraded and discriminated against.

I don't only go to Russia to perform on public stages. I take the opportunity to meet with LGBTQ+ groups and speak to them about how I can help. I want to understand the specific situation there. There is so much misinformation in the press and online—I want to hear about people's lived experiences directly. They've told me, "Don't boycott us. It doesn't help us. It makes us scapegoats. It pushes us deeper into the shadows." Making someone an "other" creates a culture of difference and fear. It encourages an "us vs. them" dynamic and sets the stage for discrimination and violence. Instead, I want to represent the LGBTQ+ community in Russia—and around the world. People generally accept me as a gay man, so hopefully I can be a bridge to greater tolerance and acceptance.

Performing in the former Soviet Union and in Russia has been deeply important to me. I wasn't able to return as part of my farewell tour, but the country stayed on my mind. During a concert in Newark, New Jersey, in February 2022, I dedicated "Don't Let the Sun Go Down on Me" to the people of Ukraine and criticized Putin for his invasion of that country. I was heartbroken by the conflict and its impact on the people there. There is only so much one person can do to encourage change, but I always try to do my part. The best thing I can do is go to the places where things are challenging and speak out. A boycott would just harm the communities impacted by discrimination. The Russian people warmly welcomed me in 1979. They made me feel at home. They still do, but they need to look in the mirror and ask themselves why they can't accept all LGBTQ+ people the way they accept me.

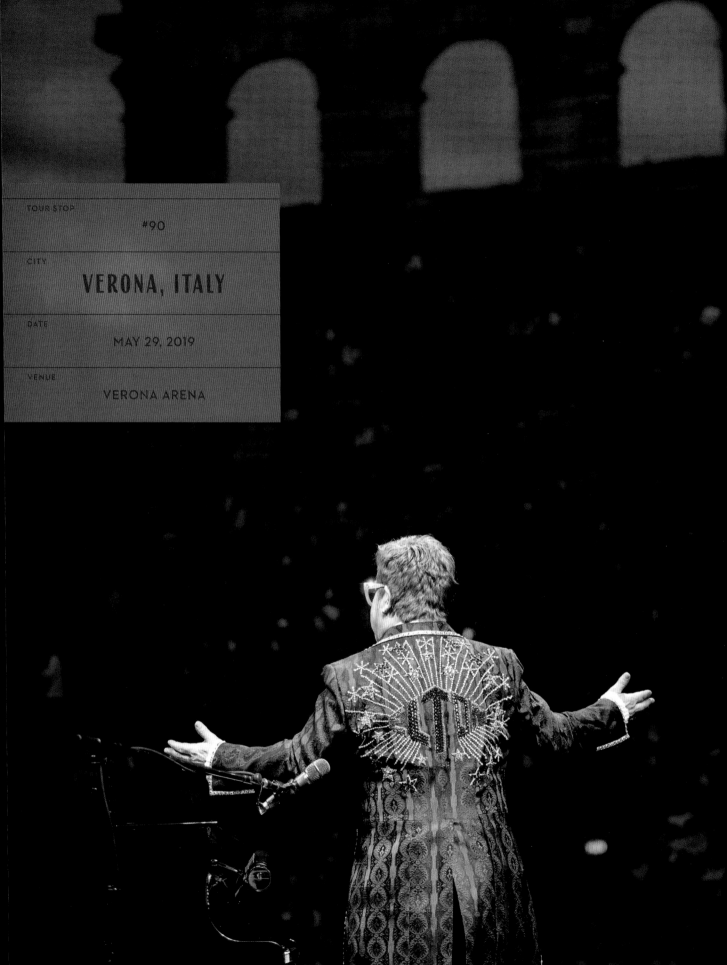

TOUR STOP

#90

CITY

VERONA, ITALY

DATE

MAY 29, 2019

VENUE

VERONA ARENA

By the time we arrived in Verona in the spring of 2019, I was riding high on the early acclaim for *Rocketman*. The film had premiered at Cannes without a hitch. It was the first time I'd seen the finished film, and I was completely blown away. It was like I was looking at myself on the screen, not its star, Taron Egerton. The scene that touched me the most was when Bernie, played by Jamie Bell, visited me in rehab. It brought back so many memories that I broke down watching it. It just showed the incredible love between us. Our relationship has survived everything, the good and the bad. Later, at the after-party, Taron and I took the stage for a surprise performance of "Rocket Man" and "Tiny Dancer," and I also played "I'm Still Standing" solo. As usual, I couldn't keep it together. "This has been a very emotional night for me," I told the crowd. "Even if the movie doesn't make one penny at the box office, it is the movie I wanted to make."

After the premiere at Cannes, the film was released in the UK on May 17 to incredible reviews. Its US release, scheduled for May 31, was only days away. The buzz of being back in Europe and the energizing success of the film made the shows feel even more exciting. Over the years, I've performed numerous shows in Italy. In fact, by the end of the tour I had played sixty-six concerts in the country. But I didn't perform in Verona, a city famous for its tragic romance, until the late '80s.

My first time playing in the Italian city was on April 26, 1989, at the Verona Arena, the same venue I played on the farewell tour. I was on a world tour in support of *Reg Strikes Back*, my twenty-first studio album. The concert was going to be broadcast live on Sky TV in Europe and the UK, which felt exciting. When the band and I got onstage, we found our groove almost immediately. We performed twenty-one songs, our usual setlist from that tour, culminating with a rousing finale of "I'm Still Standing." I had three backing singers with me, and a highlight of the set was "Sad Songs (Say So Much)." We injected some gospel soul into that tune, bringing the spirit of the American South to Verona. I've always loved gospel and soul because their emotional powers reach down deep inside my heart. It can be nerve-racking when you know your performance is being broadcast, but it was very successful. The audience was really supportive and I think we played well. Since then, the footage has been repurposed on DVD and online. I still have fond memories of that evening.

Twenty years later, I returned to the Verona Arena on my Rocket Man tour with American singer Anastacia as my support act. I think she has a brilliant voice. We had great fun on that tour. I've always enjoyed visiting Verona, but it rains there every time I go. The Verona Arena is a beautiful Roman amphitheater. It dates back to AD 30 and it's an absolute marvel of architecture. It's stunning to play there. But it has the worst backstage facilities you've ever seen. It's terrible being back there. Luckily, the amphitheater itself is so beautiful and so magical that you can't help being inspired. It gets into your veins. I loved playing for Italian fans—they have so much enthusiasm—and that night Julia Roberts joined them in the crowd. Onstage, looking up and seeing this ancient building, I felt momentarily awestruck. I was one of so many artists and performers and speakers to grace its stage. Maybe that's why I felt so encouraged to speak up that night about an issue that was bothering me: Brexit.

Elton warmly welcomes the crowd in Verona Arena in front of a spectacular background of Roman arches.

I may be a musician, but I don't live in a bubble. Real-world issues affect me and those I love, so when I have something to say, I say it. As I've said, I don't buy into the idea that celebrities shouldn't discuss politics. While we were revisiting countries like Italy, France, and Germany, I'd been thinking a lot about Brexit. The divisive 2016 vote in the UK had been completely ridiculous. People in Britain weren't told the truth. Being back on tour in Europe and experiencing the impact of Britain leaving the European Union firsthand caused the frustration and anger to hit me all over again. Not all musicians had my privilege and my stature. A lot of younger artists couldn't afford the extra fees and paperwork now needed to tour in Europe. I'd always been able to easily go back and forth between England and the Continent. Now that freedom had been taken away from so many people.

One of Britain's greatest and most successful exports has been its music. Look at the Beatles. David Bowie. The Rolling Stones. Adele. Ed Sheeran. Me. We have created an extraordinary global musical footprint. While musicians are not official ambassadors of a country, we do generate a sort of soft diplomacy for our homeland. We connect with people around the world and bring them together. When I go to a new place, I leave a footprint behind, and that matters. The UK has a massive pool of young talent whose futures are now at risk because of Brexit. The government has slapped leg irons on them when it comes to touring in Europe. They are jeopardizing each artist's future, and also the country's status as a cultural force. It horrified me, and continues to.

"I'm ashamed of my country for what it has done," I told the crowd in Verona. "It's torn people apart." I felt very fired up. The audience cheered. I know most fans didn't turn up to my farewell tour to see me spout off about Brexit. But I had to say it. The news media picks up everything I say, so why not take the opportunity? Whatever it takes to get people thinking about the issues.

The reality is that I've been able to pop back and forth between England and Europe for my entire career. In the 1970s, I went to France to record three of my most successful albums, and to shop in Paris on my days off. I could play a few nights in Germany or Sweden without much hassle. Throughout my life, being a British national meant that you were European. We were part of Europe. I'm not going to lose that just because the bloody government tricked people into a bad vote. I've always said that I feel like I'm a citizen of many nations. I'm essentially half American. But I've felt part of so many places in the world. I've been welcomed into so many communities of people and so many cultures. The beauty of travel is that you take on elements of different cities and countries and you carry them with you. In my heart, I am European even though I was born in Pinner. I won't let anything take that away from me.

A lot of doors have opened for me during my life because I

RIGHT:
Elton fittingly plays "Don't Let the Sun Go Down on Me" in the open-air Verona Arena.

BELOW:
Itinerary pages from Elton's 1989 European tour

ELTON JOHN TOUR · 1989

APRIL			PAGE	
WED	12... ESSEN	GRUGHALLEN	29	✓
THU	13... COLOGNE	SPORTHALLE	30	✓
FRI	14... FRANKFURT	FESTHALLE	31	✓
SAT	15... FRANKFURT	FESTHALLE PARIS	32	✓
SUN	16... DAY OFF	PARIS	33	✓
MON	17... SAARBRUCKEN	SAARLANDHALLE*	34	✓
TUE	18... LAUSANNE	PATINOIRE DE MALLEY ***	35	✓
WED	19... LAUSANNE	PATINOIRE DE MALLEY ***	36	✓
THU	20... DAY OFF	LYON	37	
FRI	21... ZARAGOSSA	SPORTS PALACE	38	
SAT	22... SAN SEBASTIAN	VELODROME	39	
SUN	23... MADRID	SPORTS PALACE	40	
MON	24... BARCELONA	SPORTS PALACE	41	
TUE	25... DAY OFF	MILAN	42	
WED	26... VERONA	THE ARENA	43	
THU	27... MILAN	PALATRUSSARDI	44	
FRI	28... ROME	PALEUR	45	
SAT	29... DAY OFF ROME	PALEUR	46	
SUN	30... DAY OFF	VIENNA	47	
MAY				
MON	1... VIENNA	STADTHALLE	48	
TUE	2... VIENNA	STADTHALLE	49	
WED	3... MUNICH	OLYMPIAHALLE	50	
THU	4... DAY OFF	ZURICH	51	
FRI	5... ZURICH	HALLENSTADION *	52	
SAT	6... ZURICH	HALLENSTADION *	53	
SUN	7... ZURICH	HALLENSTADION ***	54	
MON	8... BREAK TO MAY 16	LOS ANGELES ·	55	

ALL SHOWTIMES ARE 7:30 PM EXCEPT WHERE ASTERISKS APPEAR
*..... DENOTES 8:00 PM SHOW
**.... DENOTES 8:30 PM SHOW
***... DENOTES 7:00 PM SHOW

ELTON JOHN TOUR · 1989

MARCH			PAGE	
WED	15... PARIS	ZENITH REHEARSAL	1	✓
THU	16... PARIS	ZENITH REHEARSAL	2	✓
FRI	17... PARIS	ZENITH REHEARSAL	3	✓
SAT	18... PARIS	ZENITH REHEARSAL	4	✓
SUN	19... DAY OFF	PARIS	5	✓
MON	20... LYON	PALAIS DE SPORTS **	6	✓
TUE	21... PARIS	PARIS	7	✓
WED	22... PARIS	BERCY **	8	✓
THU	23... PARIS	BERCY **	9	✓
FRI	24... PARIS	BERCY **	10	✓
SAT	25... DAY OFF	PARIS	11	
SUN	26... PARIS	BERCY **	12	✓
MON	27... PARIS	BERCY **	13	✓
TUE	28... DAY OFF	PARIS	14	✓
WED	29... BRUSSELS	FOREST NATIONAL *	15	✓
THU	30... BRUSSELS	FOREST NATIONAL **	16	✓
FRI	31... DAY OFF	PARIS	17	✓
APRIL				
SAT	1... DUSSELDORF	PHILIPSHALLE	18	✓
SUN	2... KIEL	OSTSEEHALLE	19	✓
MON	3... DAY OFF	DUSSELDORF	20	✓
TUE	4... BERLIN	DEUTSCHLANDHALLE	21	✓
WED	5... DAY OFF	HAMBURG	22	✓
THU	6... HAMBURG	SPORTHALLE	23	✓
FRI	7... COPENHAGEN	VALBYHALLEN	24	✓
SAT	8... DAY OFF	COPENHAGEN	25	✓
SUN	9... STOCKHOLM	GLOBE ARENA	26	✓
MON	10... OSLO	DRAMMENSHALLE	27	✓
TUE	11... DAY OFF	DUSSELDORF	28	✓

ALL SHOWTIMES ARE 7:30 PM EXCEPT WHERE ASTERISKS APPEAR
*..... DENOTES 8:00 PM SHOW
**.... DENOTES 8:30 PM SHOW
***... DENOTES 7:00 PM SHOW

"AND FOR A PARTY FULL OF FUN AND POP CHEER, THERE CAN'T BE A MORE SUITABLE MASTER OF CEREMONIES THAN ELTON JOHN."

★ ★

—*LA REPUBBLICA*, 1989

am a musician. When I became Elton John, my dream was to write and record songs. I didn't particularly want to tour. But touring found me, and it has been a real gift. It's been exhausting at times, and I've missed out on a home life, but I've also experienced the world. I've seen places I never imagined I'd see. I've met people who have opened my eyes to new things and new ideas. I feel utter dismay about any law that tries to separate us. Music connected me with the world, and that's something I've always tried to give back to my fans. Don't accept division. Raise your voice, stand up for what you believe in, and embrace everyone around you. That's what I hoped to convey in Verona that night—a reminder that we can't let anyone tear us apart, especially in these trying times.

"THE SINGER'S PROFILE IS CURRENTLY AS HIGH AS IT HAS BEEN IN YEARS."

★ ★ ★ ★ ★ ★ ★ ★ ★ ★ ★ ★ ★ ★ ★ ★ ★ ★ ★

—THE GUARDIAN, 2019

The Verona Arena offers a memorable setting for Elton's performance.

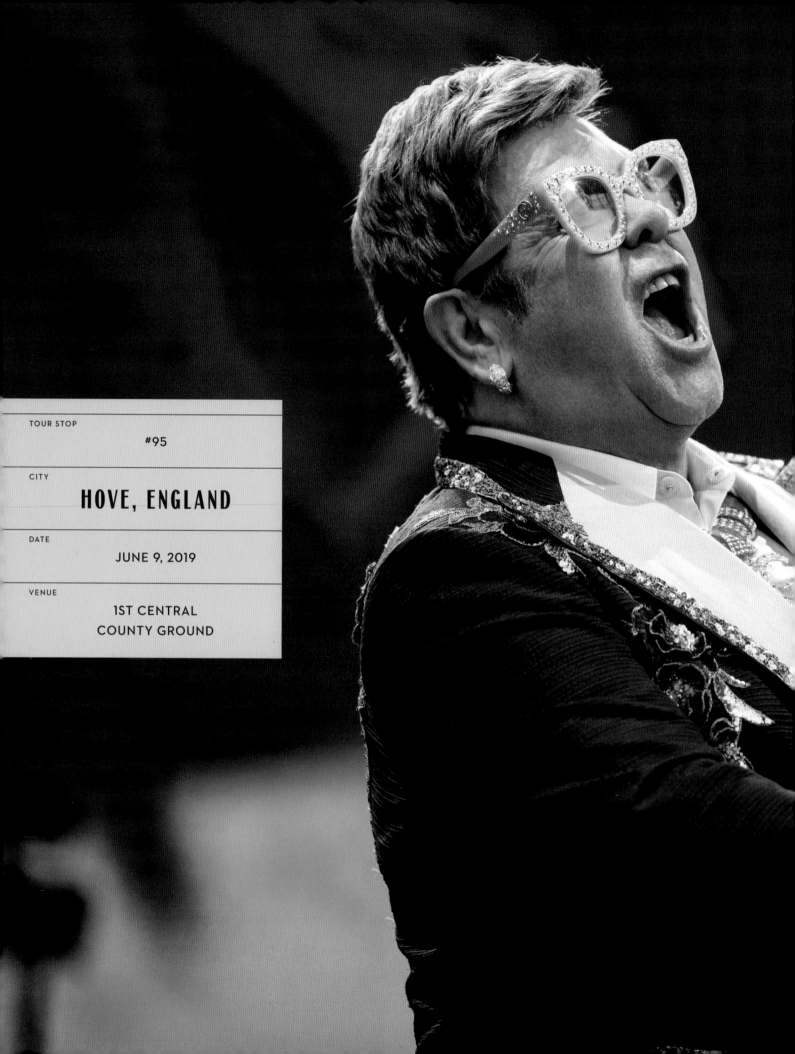

TOUR STOP	#95
CITY	**HOVE, ENGLAND**
DATE	JUNE 9, 2019
VENUE	1ST CENTRAL COUNTY GROUND

Elton performs "Bennie and the Jets" as a colorful montage celebrating his decades-long career plays on the video screens during a concert in Hove.

Original ticket stubs from Elton's concerts in Southampton in 1973 and Portsmouth in 1972

Over the past fifty years, it feels like I've performed in every nook and cranny of England. It's not a massive country, but when you're hauling your own gear in and out of venues as a young performer, it can feel enormous. With Bluesology, my first band, I played in dozens of cities and towns around England, appearing in clubs, hotels, and ballrooms. We gigged everywhere from Durham to Sheffield to Windsor. London is the pinnacle for touring artists in Britain, but I also enjoyed visiting places I'd never seen before. Some of the cities reminded me of Pinner, and some felt very far from home. The south coast of England is a particularly interesting part of the country, known for its white cliffs and Victorian architecture, and I felt at home there instantly. The faded majesty of the seaside towns was depressing and beautiful in one glimpse.

The first time I performed on the south coast was in Portsmouth with Bluesology in December of 1965. The venue was called the Birdcage Club. It had only opened earlier that year, but it brought in a good crowd. At the time, we were the backing band for an American R&B singer called Major Lance. Bluesology returned to the south coast a few times, including to play in Southampton after we joined up with Long John Baldry.

In 1968, the south coast became associated with the Isle of Wight Festival, which was held for three years near the town of Newport. After I met Bernie, we traveled down to the festival in 1969. That year it was held in Wootton and it packed in thousands of fans. Everyone had come to see Bob Dylan play the headlining set on the final day. There were rumors that the Beatles planned to join him onstage; although that never came to fruition, the Band did. It was great fun. I admired Bob Dylan as a musician and as a songwriter, and seeing him play had a big impact on me. He and I are very different performers, but we share a love of connecting with an audience. There are photos of Bernie and me at the festival, and you can see the delight on our faces.

Once I became Elton John, I returned to Portsmouth in 1972 to play the Guildhall. I wore a pair of maroon velvet cropped trousers from Mr. Freedom, which I later sold as part of a charity sale. Throughout the 1970s, I also took the stage at the Brighton Dome and Gaumont Theatre in Southampton. But although I've made my way around England and back again, I didn't book a gig in Hove until 2006, when I performed at the Sussex County Cricket Ground—as it was then called—for the first time. I returned in 2011, and here I was back again on the farewell tour. It's great fun to put on a show in Hove, which is located right next to Brighton. The fans are welcoming and open-minded—Brighton and Hove have one of the biggest gay pride parades in the country—and I enjoy the outdoor venues because you can see the sun set while you perform.

Throughout the Farewell Yellow Brick Road Tour, I didn't bring very many special guests onstage. That was by design. It was my swan song, and the fans had come to see me. The show was intended to spotlight my catalogue of songs the way that my band and I perform them. But in Hove I wanted to do something special. I invited Taron Egerton, who played me in *Rocketman*, to share the stage with me for a rendition of "Your Song." I knew he could sing after seeing his performance in the film. He had done such a wonderful job. It's overwhelming to see an actor embody you on-screen. It puts you under a microscope and reminds you of all the ups and downs you've had. But he was so fantastic. He was me to a T. I wanted to thank him for the most amazing job that he did, singing and acting. If he didn't sing so well, I wouldn't have brought him onstage. I thought he might like to come onstage and perform for an audience. I wanted him to experience belting out an Elton John song for an Elton John crowd.

We kept the cameo a surprise. After explaining to the audience that I hadn't had a guest on the tour yet, I announced, "Tonight, I'm going to bring out me." Taron, wearing a black T-shirt with a rainbow across it, strolled onto the stage, and we clasped hands, holding up our united grip for the cheering crowd. I sat at the piano to kick things off before Taron came in on the second verse. We brought our voices together on the chorus. It felt magical. The sun was setting behind the audience.

An obsessive music fan, Elton attends the Isle of Wight Festival in 1969. In this snapshot, he waits for Bob Dylan to take the stage.

I know it meant a lot to Taron. It was so much fun that he came back onstage with me later that year for *Rocketman: Live in Concert* at the Greek Theatre in Los Angeles.

Throughout the tour, I was able to reconnect with a lot of people from my life. Hove was memorable for the audience because I sang with Taron, but it was memorable for me because of who was in that audience. My stepmom, Edna, came to the show along with three of my half brothers—Simon, Stanley, and Robert—and their kids. She and I hadn't always had the best relationship, but I'd always liked her. Having everyone backstage, together again, felt so comfortable. Edna and I got along like a house on fire, and any tension melted away. She paid me some great compliments. Stanley brought along his son, Olly, my nephew, who I had never met before. Olly had ambitions to work in the music industry, which, of course, delighted me. He and I swapped emails, and started what has become a wonderful friendship. We hired him as a tour assistant on the farewell tour, and he worked bloody hard. He learned so much, and my friendship with him has continued to blossom.

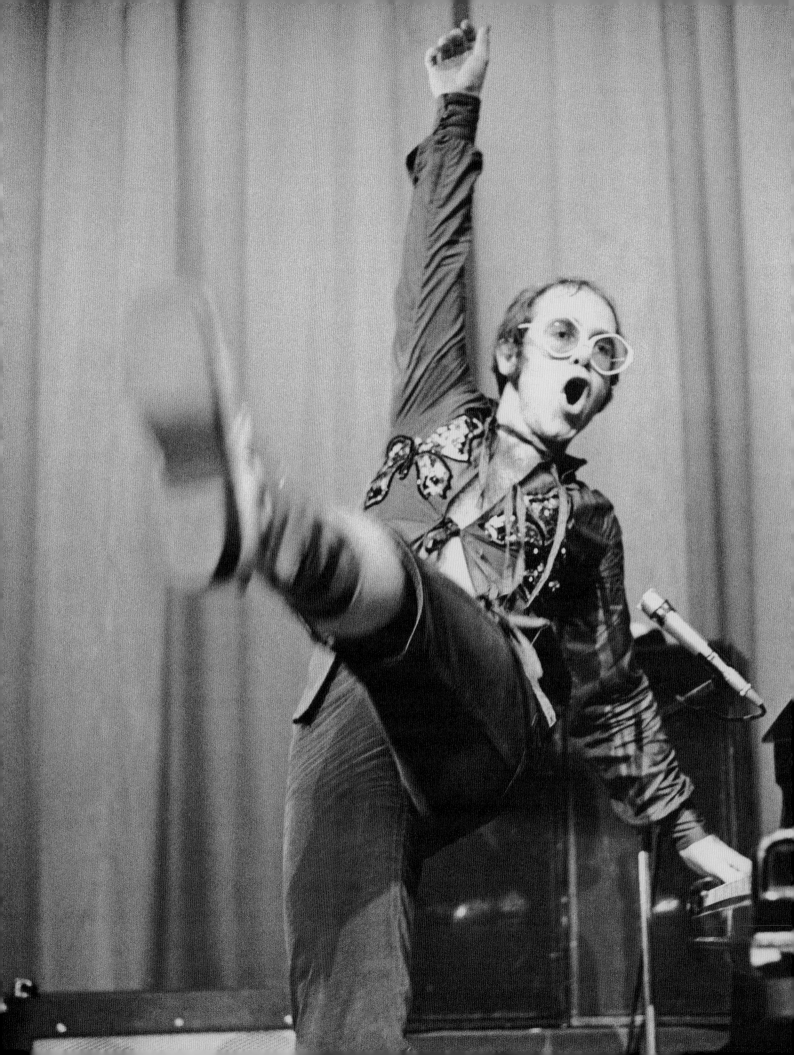

"THROUGHOUT, THOUGH, I WAS AMAZED AT THE WAY ELTON ALLOWED HIS PIANO TO FUSE IN WITH THE BAND WHILE SO OBVIOUSLY BEING THE LEADING MAN— BUT THEN THE FINEST ACTORS ALWAYS MERGE WITH THEIR CAST."

Elton performs in Portsmouth, England, in 1972. His velvet Mr. Freedom trousers, seen here, were later sold for charity.

★ ★ ★ ★ ★ ★ ★ ★ ★ ★ ★ ★ ★ ★ ★ ★ ★

—*THE NEWS*, PORTSMOUTH, 1972

"THE FILM'S STAR, TARON EGERTON, IS BROUGHT OUT TO DUET ON 'YOUR SONG,' AND THE EERIE SIGHT OF YOUNG AND OLD ELTONS SHOWS JUST HOW FAR HE HAS COME: A MAN WHO TOOK AMERICAN FORMS—ROCK 'N' ROLL, BLUES, GOSPEL—AND GAVE THEM AN ECCENTRIC ENGLISH THEATRE, RESULTING IN SOMETHING THAT IS STILL UNMATCHED. HE HAS EARNED HEART, BRAINS, AND COURAGE IN SPADES, BUT IT STILL FEELS TOO SOON FOR THE END OF THIS YELLOW BRICK ROAD."

★ ★

—*THE GUARDIAN*, 2019

I was so grateful to have my family be part of this farewell tour, even in a small way. One of the really wonderful things about it was that so many people came back into my life—or into my life for the first time. I felt like I could finally properly connect with them. Retiring from the road is about spending more time with my family. That's not just David and our sons, but also the rest of my family. People like my half brothers and my nephew. I look forward to building these relationships off the road with more time and consideration.

As I've said, I don't tend to look back too much. But a goodbye tour is nostalgic by nature, and I couldn't help but reflect on how far I'd come. My childhood was challenging in many ways, but as I sat backstage in Hove, I realized I'd let that go. Now I was happy. I was settled. I was closing a chapter of my life so I could open a new one. As the tour continued, it was important for me to have moments like that, where I could pause and remember what it all meant. It suddenly occurred to me that this was my last concert on the south coast of England. It was one I'll never forget.

Rocketman star Taron Egerton joins Elton onstage in Hove. Taron was one of the only guests who performed with Elton during the entire farewell tour.

grew up going to football matches with my dad. From the time I was five years old, we regularly cheered on the Watford FC team at Vicarage Road. Back then, there were only two rickety old stands and the team played in blue. My father and I had a distant relationship, but sports matches and music were the two things we had in common, so to me our tradition represented something even bigger. Those afternoons around the pitch solidified my love of sports and instilled in me the importance of people coming together around a common interest.

As I grew up and became a musician, I kept that connection with Watford FC. I was a fan for life. In the early '70s, the club was struggling financially and the only way of raising money was for me to perform a concert at Vicarage Road. We planned a show with Rod Stewart as my special guest and Scottish rock band Nazareth as the opening act. The ticket sales would benefit Watford FC, which felt like the least I could do for my team. The football ground was in horrible shape at the time, and it was important to me to show the fans how much I cared. I also wanted to build a future for Watford FC so it could eventually become a more successful club.

The concert, held on May 5, 1974, was the first-ever rock 'n' roll show to be staged in a British football stadium. It was loads of fun, especially as Rod joined me onstage halfway through the show. It was so generous of him to come out. The crowd was composed of more than thirty thousand people, and they were boisterous, to say the least. There was a lot of excitement in the air. I stomped onstage in a yellow-and-black bumble-bee ensemble that paid a colorful homage to the Watford team: the Hornets. It was a bit of a ridiculous getup, designed by Annie Reavey, but the audience went nuts for it. I kicked off the set with "Funeral for a Friend," and focused on my hits, including "Bennie and the Jets," "Daniel," and "Rocket Man." Partway through the show, it began to pour. The fans got absolutely soaked. But as usual, I was undeterred. I launched into a rendition of "Singin' in the Rain," calling for everyone to join me. The crowd was equally delighted when I led the band into a cover of the Beatles' "Lucy in the Sky with Diamonds."

Rod performed three songs with the band and me in the middle of my set. The crowd screamed when he appeared. He sounded brilliant. Rod and I have had an up-and-down relationship over the years, but he's good fun onstage. After Rod waved farewell to the audience, I concluded the show with a few more songs before an

PLAYING FOR WATFORD

CITY

WATFORD, ENGLAND
WATFORD FOOTBALL CLUB

DATE

MAY 5, 1974

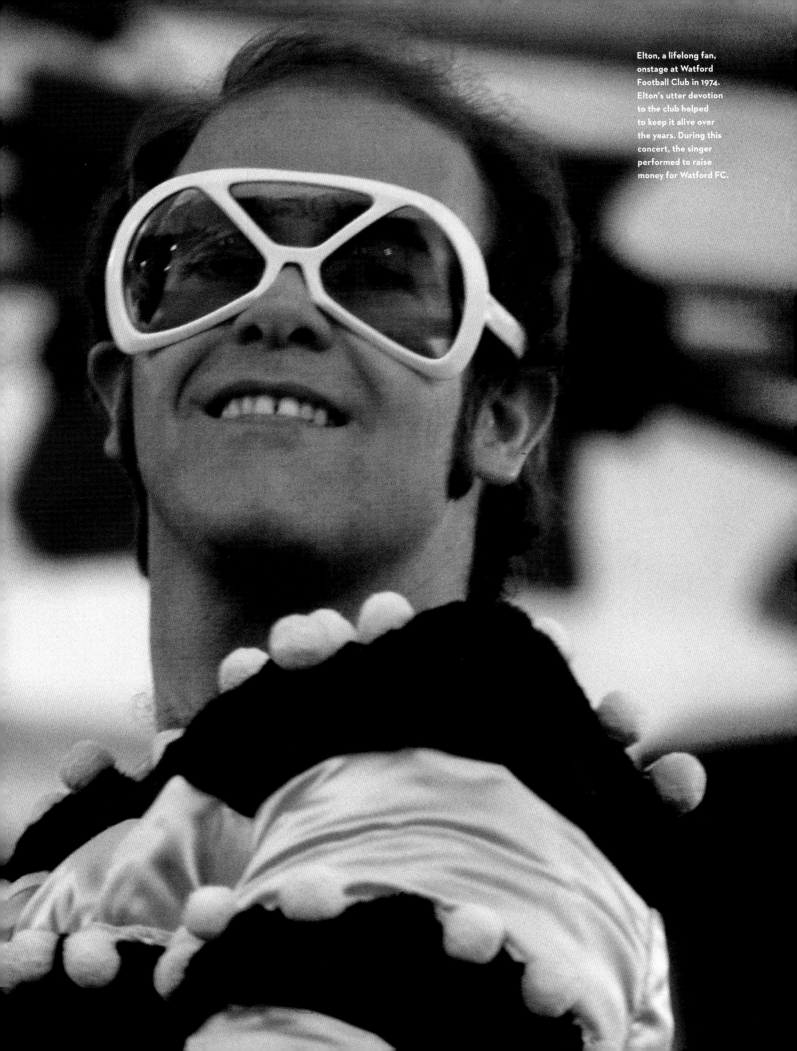

Elton, a lifelong fan, onstage at Watford Football Club in 1974. Elton's utter devotion to the club helped to keep it alive over the years. During this concert, the singer performed to raise money for Watford FC.

encore of "Your Song" and "Saturday Night's Alright (For Fighting)." The fans were really hyped up, especially now that the rain had stopped. As I took a bow, I could see a few of them tearing off their clothes. I enjoy a streaker as much as the next person, and that's exactly what they were doing. One of the newspapers called it a "spate of streaking," which I found hilarious. I didn't see all the naked fans running out of Vicarage Road, but every review mentioned it. It's part of why the show has gone down in infamy.

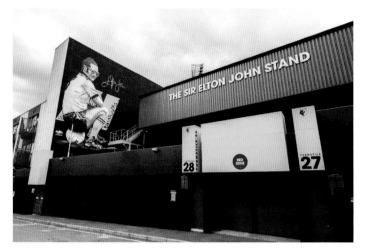

ABOVE:
A mural created by MurWalls for Elton's July 2022 Watford shows

OPPOSITE:
Elton's famous hornet costume from the 1974 concert in Watford, now kept in his archive

In 1973, I bought shares in the club and became its vice president, and the following year I was made its director. In 1976, I became the club chairman and president of Watford FC. In the position, which was a great honor, I worked with the club for years and loved every minute of it. Graham Taylor, the club's manager who I recruited in 1977, and I took the team to the FA Cup Final for the first time in 1984—a hugely proud moment. In 1990, I sold Watford FC, while still maintaining my role as president. More recently, I became the club's Honorary Life-President, and I continue to support the Hornets as much as I can. Over the years, I've performed several concerts to raise money for Watford. I've contributed to the team so much that in 2014 the stadium's rebuilt East Stand was named in my honor, with the chorus to "Your Song" scrawled on the back wall. The opening of the new stand was one of the greatest days of my life. I walked onto the pitch with David and our boys, and it dawned on me how amazing it felt to have our family accepted in the world of football, which doesn't have many openly gay players or managers. I was so proud to be part of the legacy at Watford FC.

During the farewell tour, I performed two nights at Vicarage Road, which was deeply meaningful to me as both a musician and as a sports fan. It's a place where David and I take our own kids to see football matches. I want to share the same tradition with them that I had with my father. Watford FC is in my heart and it's in my soul. It's something I just can't get rid of. My passion for the club has never died. As I played my final farewell show in the stadium in July of 2022, I looked out over the familiar stands. I could see the lines from "Your Song" forever imprinted there. It was a place with a lot of memories. As the crowd cheered, I confirmed, "This is one of the places that means most to me."

"ELTON HIMSELF IS A WHIZZ KID ON THE PIANO, HIS VOICE IS CLEAR AND DISTINCTIVE, AND HIS BEAUTIFUL SONGS APPEAL TO MOST PEOPLE. AND WITH A COMBINATION LIKE THAT YOU CAN'T POSSIBLY GO WRONG."

★ ★

—HERTS LOCAL, 1974

TOUR STOPS

#110 AND #111

CITY

LAS VEGAS, NEVADA

DATES

SEPTEMBER 6 AND 7, 2019

VENUE

T-MOBILE ARENA

Elton loves Vegas so much
that after an impressive 466
shows there, he returned for
the farewell tour.

"ELTON JOHN HAS ACHIEVED A RARE POP-MUSIC FEAT IN HIS VEGAS-ONLY SHOW: WITH DAVID LACHAPELLE, HE HAS CREATED A CAREER OVERVIEW PIECE THAT'S VISUALLY STIMULATING AND AS ARTISTICALLY SOUND AS IT IS COMMERCIAL. COLLECTIVELY IT'S AS ELABORATE AS HIS MID-'70S COSTUME-HEAVY SHOWS AND, THANKS TO THE CONSISTENTLY HIGH QUALITY AND EXECUTION OF THE MATERIAL, MORE SPECTACULAR THAN THE OUTINGS OF HIS HEYDAY. THIS IS A SHOW PEOPLE WILL TALK ABOUT."

★ ★ ★ ★ ★ ★ ★ ★ ★ ★ ★ ★ ★ ★ ★ ★ ★ ★

—*VARIETY*, 2004

once proclaimed, "I won't be playing a casino when I'm forty-five." At the time, I meant it. In my younger years, I was adamant that I didn't want to be a Vegas musician. Weren't the artists who found themselves performing on the Las Vegas Strip completely washed up? I imagined it as the end of the road. Old-man Elton, dragging himself to the piano to prove he still had some spectacle left. But that's not really what it's like playing in Vegas these days, as I eventually learned. Despite the flashing lights and glitter of the Strip, Las Vegas is an American city filled with music fans like anywhere else.

The first time I performed there was in 1971 on my second American tour. We appeared in the Convention Center Rotunda, and there was a billboard to announce the concert. I came back in 1975 on the West of the Rockies Tour, and played regularly in the Nevada city throughout the 1980s. By the '90s, I was selling out the MGM Grand Garden. Still, I never thought I'd actually have a residency in Vegas. I'd never even stayed the night there.

Someone floated the idea of a residency at the Colosseum at Caesars Palace, which had been built for Celine Dion. The idea was that I would perform when she wasn't there. But I wasn't sure if it was the right move for me. The Vegas Strip used to be where musicians would go to end their careers, not continue them. Despite my hesitation, I also understood the possibilities, which is what eventually convinced me. We agreed I could set up the residency for limited dates. I would fill Celine's slot, as I used to joke. That way I could perform there for as many people as wanted to see me, but I'd still have the opportunity to go home or to play elsewhere around

the world. It was once unthinkable that a '70s rock star would become a Las Vegas headliner, but here I was. And it turned out to be the best possible place for me.

The stage at the Colosseum is one of the largest in the world. I couldn't just show up there with my band and play. I needed a show that could fill a venue of that scale. The entire point of coming to Vegas was to do something entirely new. David LaChapelle is a photographer I really admire. He shot me for the cover of *Interview* and directed several of my music videos. He has an amazing ability to understand and capture an artist's iconography. He really understands my connection to the 1970s. He and I became great friends, and there was a really magical artistic connection between us. When it came to the Vegas show, he exemplified the aesthetic of controversial pop, which is what I wanted to do.

"Listen," I said to David, "should we do this show together?" He agreed immediately. I wanted it to be outrageous, camp, and fun—all things I associate with David's work. I gave him the directive and sent him to work. It was his first time directing a stage show, and he absolutely nailed it. I knew it would be a risk. But I wanted to see what it would be like to perform a truly spectacular show on the Las Vegas Strip.

The residency, which opened on February 13, 2004, was titled The Red Piano. We designed the concert around the idea of love. It was completely risqué, even for a Vegas stage concert. David made wild and colorful videos for the songs—two of which were reused for my farewell tour—and the show ended with an onslaught of phallic imagery that delighted the crowds. No one had seen a show like this in Vegas before. On the first night, something magical happened with the audience. During "Saturday Night's Alright (For Fighting)," the last song in the main part of the set, people came onstage and just started to dance. At first, I was petrified. I thought they were coming for me! It was completely off the wall, and I have no idea why it happened. But throughout the

Japanese fashion designer Yohji Yamamoto created a series of custom jackets for Elton's Las Vegas residency The Red Piano. The designs reference moments from Elton's career and music, including his songs "Rocket Man" and "Goodbye Yellow Brick Road." Yamamoto used a rare Japanese dyeing technique called yūzen to create the colorful images.

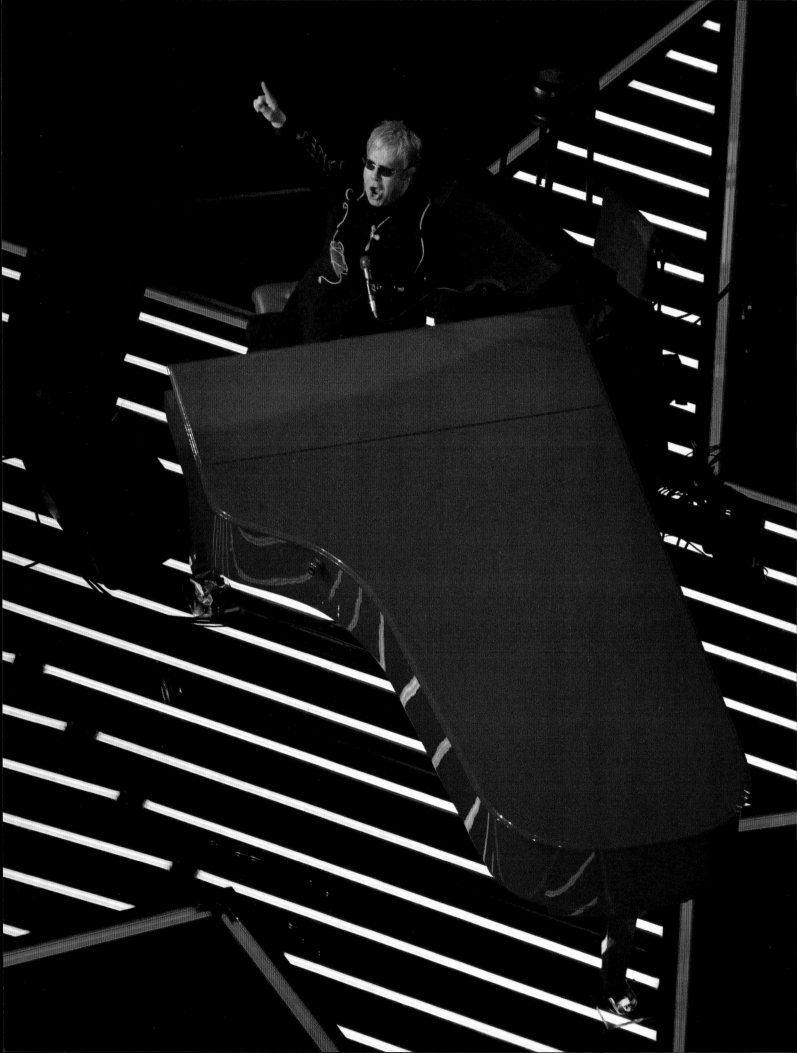

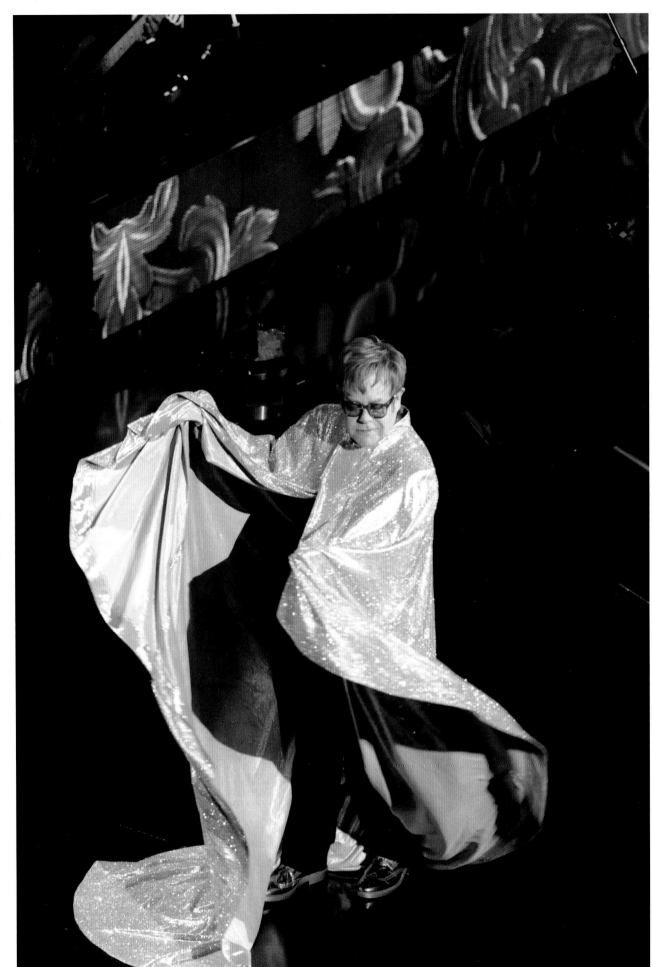

LEFT:
Elton rocks out onstage during the Red Piano residency in Las Vegas in 2004.

RIGHT:
Elton enters with a typically stylish flourish during his acclaimed Million Dollar Piano residency, which kicked off in 2011.

residency, it became a tradition. The people in the first few rows would come up, kick the balloons out of the way, and have a great time. It was a really uplifting show to play.

Initially, I was scheduled to perform seventy-five concerts at the Colosseum over three years, which seemed like a lot. But by the end of the run, I had played 241 concerts over six years, with the finale held on April 22, 2009. In between the Las Vegas dates, I also took The Red Piano to the UK and Europe. The production was so good, and David's videos were so compelling, it would have been a shame for the rest of the world to miss out. By the time the residency wrapped up, I assumed I was played out in Vegas. But the Colosseum came calling again only two years later.

In 2011, I returned to the venue with a new show: The Million Dollar Piano, which was creative-directed by my old pal Tony King. It was a classed-up concert compared with The Red Piano, and definitely less controversial. I performed on a one-of-a-kind Yamaha piano covered with LED video monitors, which they made for me specially. I wanted a less-produced show with more connection to the audience. During The Red Piano, I didn't really speak to the fans. But with this format, I could talk directly to them. The setlist included fewer hits, but more fan favorites, like "Mona Lisas and Mad Hatters," "Better Off Dead," and "Indian Sunset." It had several songs in a row that only die-hard Elton John fans knew, and I was proud of that.

The Million Dollar Piano was a very different show from The Red Piano, but ultimately it was just as good, and I thoroughly enjoyed it. The show ran from September 28, 2011, through May 17, 2018, although I only appeared for short stints each year. By the end, I felt like I'd done my time. And I felt as though I had changed the perception of Vegas along the way.

Over the past few decades, Las Vegas has become a place for the young as well as the old. You still get people like Donny and Marie Osmond, but you also get newer musicians like Britney Spears or Lady Gaga. In 2018, it seemed like I was leaving at the right time and opening the door for the next generation of performers. The Red Piano certainly pushed some boundaries. How do you top David LaChapelle's video for "Goodbye Yellow Brick Road," which featured Amanda Lepore in an electric chair with sparks flying out of her vagina? But I never had any real objections from the fans. It was fun, it was outrageous, and only a few people walked out. I don't get enough credit for changing the scene in Vegas, but I paved the way for other artists to do similarly audacious, boundary-breaking things.

For me, Las Vegas represented a glimmer of what could be possible in my career going forward. I had great creative freedom, and I didn't have to travel from show to show. I got to create a larger-than-life spectacle that reflected who I am. Despite my initial hesitations, as it turned out Las Vegas and Elton John were made for each other. So it was bittersweet arriving in Vegas on the Farewell Yellow Brick Road Tour. It felt strange to be in a new venue after so many shows at the Colosseum. But as I looked out over the sea of fans, I felt something so familiar.

"I want to tell you that I'm going to miss you guys," I told the crowd. "You're in my heart, you're in my soul, every fiber of my being. I will never forget you, but I have a life now. Years ago I never thought I'd have a family of my own, but I do now." I'd said goodbye to Vegas twice before, and now I was saying it again. I don't think there's another Las Vegas residency in my future—I've done what I wanted to do there—but I'm glad I didn't listen to my younger self and skip out on becoming a part of the city's musical history. Now I count myself lucky to have performed in a Vegas casino at any age. I've done some groundbreaking things in my career, and performing in Las Vegas was one of them.

David LaChapelle created spectacular, larger-than-life background videos, sets, and giant inflatables celebrating the iconography of LasVegas for the Red Piano residency. Here Elton performs the final show of his 241-concert run.

"AFTER FIFTY-TWO YEARS OF TOURING, MORE THAN
THIRTY ALBUMS AND THREE HUNDRED MILLION
RECORDS SOLD WORLDWIDE, ELTON JOHN GAVE
A MEMORABLE FAREWELL TO LAS VEGAS—A CITY
THAT CAN FOREVER CALL HIM ONE OF ITS OWN."

★ ★

—LAS VEGAS WEEKLY, 2019

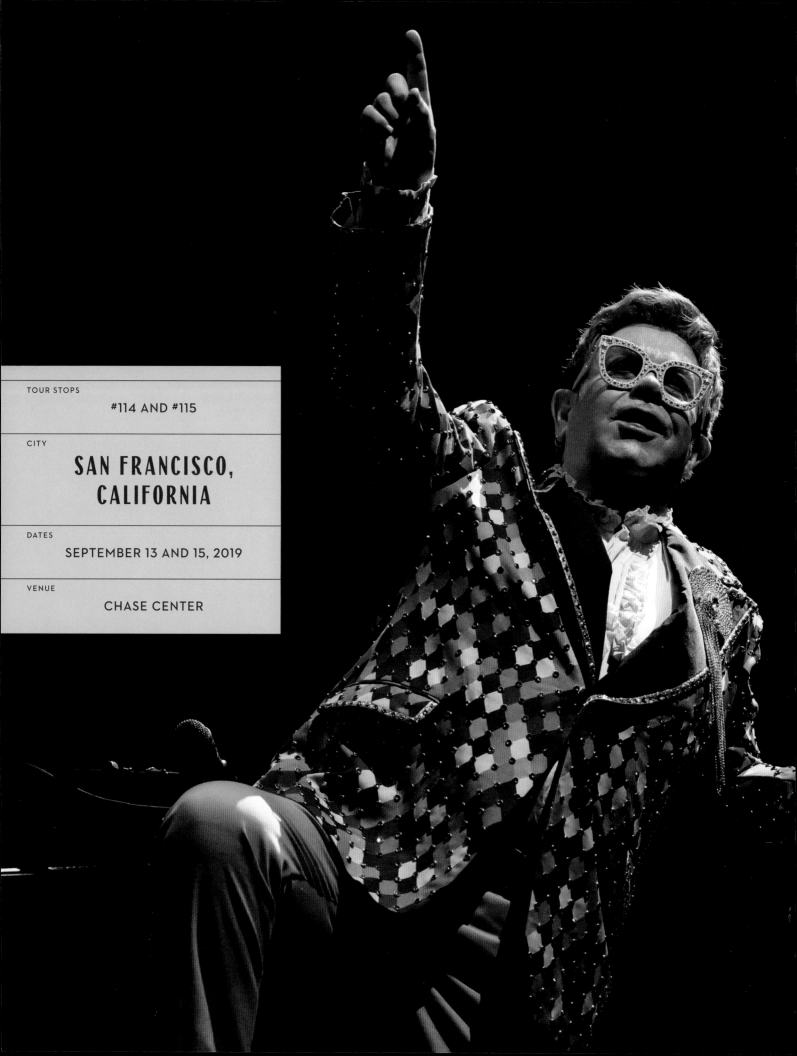

TOUR STOPS

#114 AND #115

CITY

SAN FRANCISCO, CALIFORNIA

DATES

SEPTEMBER 13 AND 15, 2019

VENUE

CHASE CENTER

Elton performs in San Francisco in 2019. Each night of the tour, Elton mixed and matched his stage outfits, including his custom ruffle shirts, trying not to wear the same look twice.

E veryone remembers the success of my first visit to America because of the concerts at the Troubadour in Los Angeles. But immediately after that explosive and life-changing week of shows, the band and I flew to San Francisco to perform six nights at the Troubadour North. I was riding high on the blur of acclaim from LA, and I felt the confidence that comes along with being suddenly shoved into the spotlight. Robert Hilburn, the *Los Angeles Times* critic who had proclaimed me the next big thing in rock, followed us up to the Bay Area to interview Bernie and me before the first show. There was a vibrant buzz of anticipation in the air, which felt infectious.

On the first night at the Troubadour North, I wore my red Mr. Freedom overalls and silver shoes that had served me so well in Los Angeles. Backstage, I was introduced to Bill Graham, the legendary promoter, who invited me to play the Fillmore East, his club in New York City. It was also the night I began a relationship with John Reid, who became my partner and manager during the '70s. I'd previously met John through Tony King, but had been too shy to pursue anything. That evening, however, my newfound self-assurance led me to call him after hearing he was also in San Francisco. "To hell with it," I thought. Looking back now, I realize I was basking in the glory of being a burgeoning celebrity.

The show itself was rowdy and full of the same energy we'd generated in LA. It felt great knowing that the Troubadour hadn't been a fluke. After that first evening, the *San Francisco Examiner* wrote, "The trouble with Elton John is that he's about as good as his publicity."

I could tell from minute one that I loved San Francisco. The early '70s were a time of freedom and self-expression in Northern California, and that vibe was also mine, although in a slightly different way. San Francisco was

a magical place because of all the music that was coming out of the city. It was the home of some really great artists and bands, like Jefferson Airplane, the Grateful Dead, Janis Joplin, Sly and the Family Stone, and Quicksilver Messenger Service. It was a great city for music, and I was absolutely enthralled. Bill Graham was an integral part of that scene—he started the Fillmore East and the Fillmore West—and at the time he was the most famous promoter in America. The fact that he took an interest in me was a huge compliment. He could make or break careers in America. A few months later, in November, the band and I returned to San Francisco to play a series of concerts at the Fillmore West.

The sound at the Fillmore West has always been incredible. Sound quality is very important to me as a live performer. That might seem obvious, but not every venue prioritizes the sound in the same way. The top-billed band on the lineup was the Kinks, which excited me, and fellow Brits Juicy Lucy opened the show. By that point, we were on a full American tour, and I was in the groove of performing for the audiences there. They weren't stoic, like the crowds back home, and their energy made me feel completely liberated onstage. I didn't want to just play the piano and sing; I wanted to create a real spectacle. To churn things up, I climbed under the piano, on top of it, and pounded on the keys while standing—something I still do. It was immensely satisfying to generate that surge of energy out of nothing and feel the audience respond.

San Francisco—and the surrounding Bay Area—became a regular addition to my tour itin-eraries. In 1971, I performed at the San Francisco Civic Auditorium, and in 1974, I played the Cow Palace with Kiki Dee. The Cow Palace wasn't San Francisco's most iconic venue, but it attracted a lot of big artists in the '70s. It was an arena originally built for livestock events, a fact I found delightful, and it had hosted a lot of my idols, including Elvis Presley and the Beatles. Playing there meant you'd moved into the big time. San Francisco didn't have a big arena in the center of town, so once you had a fan base that could fill one, you had to book the Cow Palace, which was technically in Daly City. More demand from fans, in fact, meant that clubs like the Fillmore West were out of the question by the mid-'70s. In 1979, Ray Cooper and I took our Back in the U.S.S.A. tour to the Berkeley Community Center, where I'd previously played in 1972, and the nearby Oakland Coliseum was a regular fixture on our tours in the '70s.

The Farewell Yellow Brick Road Tour was so extensive that we could visit the entire Bay Area more than once. We booked stops in Oakland and San Jose in early 2019, and returned in September for a two-night stand in San Francisco at the Chase Center. Although a lot of emphasis was put on Los Angeles as the city that launched my touring career, I feel a similar connection to San Francisco. It was great to be onstage there. The experience of those early shows at the Troubadour

A colorful hat from Elton's archive of stage costumes

North, which reopened as the Boarding House in 1973 and was eventually torn down in 1980, flooded through my mind. They felt like just yesterday.

By now, we were more than one hundred shows deep into the goodbye tour, and I couldn't help but have occasional moments of nostalgia. As I've said, I tend not to look back. But some of these memories, like being onstage at the Troubadour North in 1970 or the Cow Palace in 1974, popped up and then dissipated again. It was becoming clear to me that I couldn't avoid glancing in the rearview mirror as the tour continued. On some days, Nigel or Davey would recall a concert we'd played in that city decades before. "Remember when we . . . ?" one of us would say backstage as the others nodded. The band and I had been performing together on and off for a long time, and they were as nostalgic as I was. Sometimes more.

Revisiting the past can, at times, be uncomfortable. I choose not to dwell in the past not because I'm being avoidant, but because part of my recovery has been about learning to be in the moment. *Now* is the truest thing of all. I can't control what's happened or what might happen, but I can accept how I feel right now. I take things one day at a time. But, of course, I'm aware my past is there, lurking. It's a part of me. It's made me who I am as a person and as an artist. It would have been impossible to embark on a multiple-year farewell tour without any of these memories coming to the surface. A farewell tour is by definition nostalgic. I knew that going in. But I didn't know exactly how it would feel once we got on the road.

My constant recollections were amplified by the success of *Rocketman*. The film was building an early buzz leading into awards season, which felt exciting. I'd experienced a version of that when I wrote songs for Disney's animated film *The Lion King*, but this was a movie about my life. In addition, my autobiography, *Me*, was weeks away from release. It had been in the works for years and had involved a lot more looking back than I'd preferred. But it seemed like everything was converging around a reminiscence of my life and career. And I *had* truly done some amazing things and met some amazing people. It was incredible to see it all stacked up at once. Some of it was fate or serendipity or happenstance—there are a dozen possible words for the sensation of life putting you in the right place at the right time—and some of it was genuine hard work and talent. My story was, without a doubt, extraordinary.

All that is to say, by the time we arrived in San Francisco with more than one hundred shows behind us, I was more aware than ever of the chapter I was

> "JOHN IS A POWERFUL PIANIST WITH IMMENSE TALENT AND, AS JAZZ PEOPLE SAY, VERY GOOD EARS—HE COMBINES MARVELOUS TECHNIQUE AND MUSICAL BRAINS TO PULL OFF MAGNIFICENT COMBINATIONS OF STYLE AND JUXTAPOSITIONS OF DYNAMICS AND RHYTHM. HIS MANNER MAKES THINGS SEEM AS SIMPLE AND RELAXED AS FALLING OFF A PIANO STOOL."

★ ★ ★ ★ ★ ★ ★ ★ ★ ★ ★ ★ ★ ★ ★ ★ ★ ★ ★

—*SAN FRANCISCO HERALD*, 1970

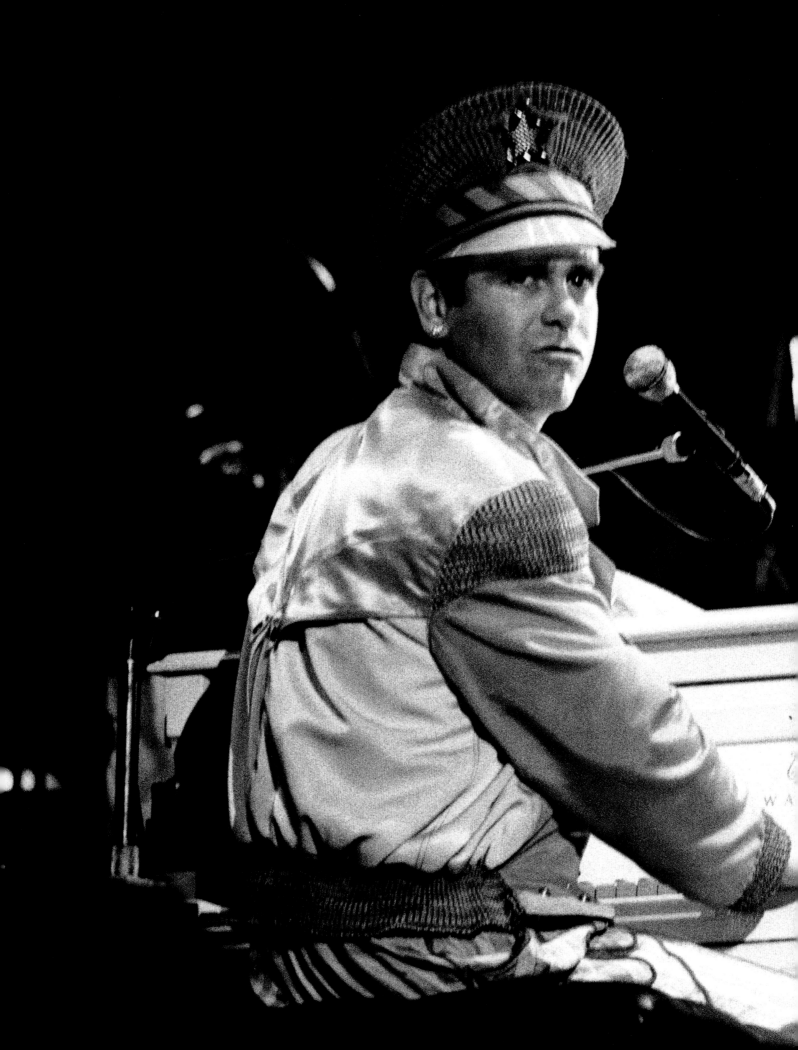

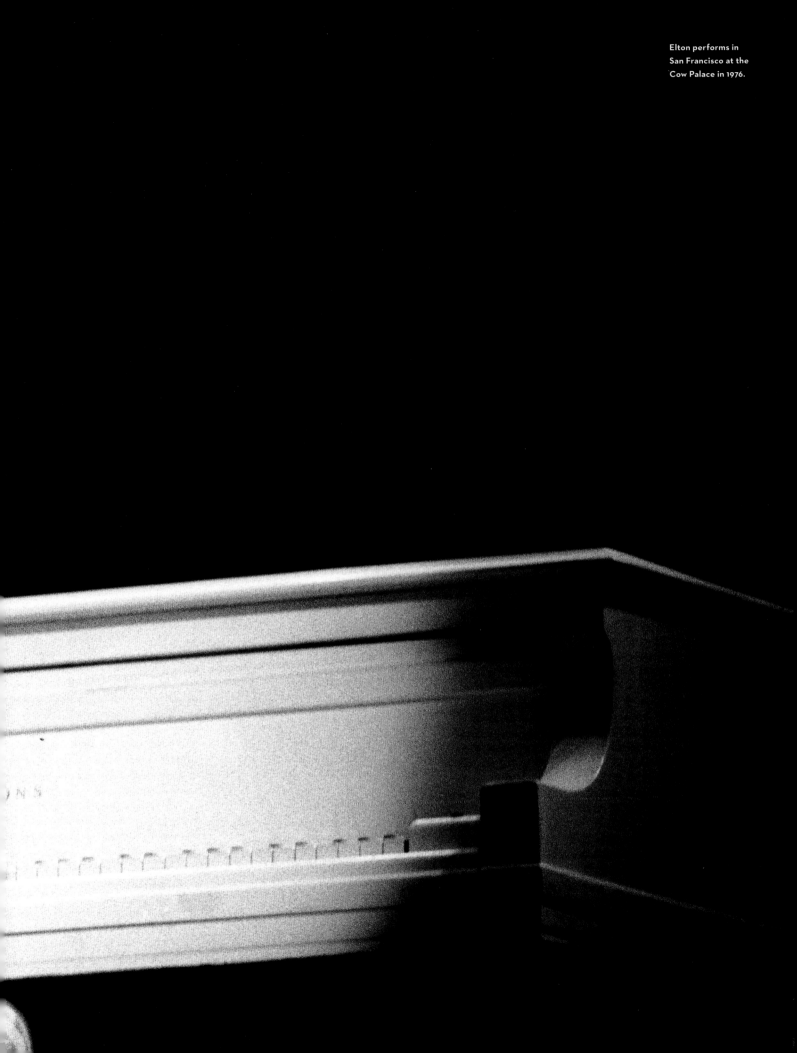

Elton performs in
San Francisco at the
Cow Palace in 1976.

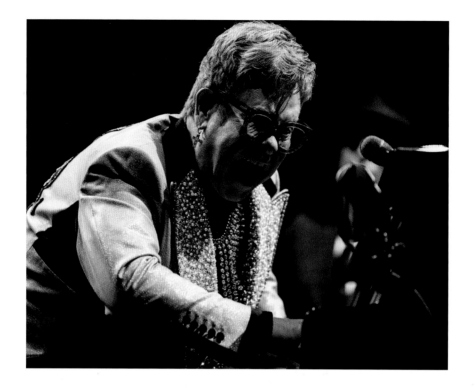

"IT COULDN'T HAVE BEEN A MORE FITTING, OR SATISFYING, FAREWELL."

★ ★

—*SAN FRANCISCO EXAMINER*, 2019

preparing to close. But even with these emotions and memories coming to the forefront on days like this, I didn't regret my choice to retire from touring. I made that decision without hesitation. I was ready. I wanted to be with my kids. I wanted to be at home with David. I wanted to discover what it would be like to have a day-to-day existence that didn't revolve around constant travel. After San Francisco, we had another two months of tour dates in North America before flying to Australia at the end of November. I was looking forward to returning to Australia and New Zealand, especially as David and I planned to bring the boys along for part of it. I would take it one day at a time and one show at a time until it was time to turn the page to my next chapter. Of course, I couldn't have predicted what was waiting for us in the months ahead. As it turned out, my current chapter was about to get a couple of years longer.

ABOVE:
Elton enjoys two nights at San Francisco's Chase Center.

RIGHT:
Massive confetti cannons shower the stage during the concert's finale.

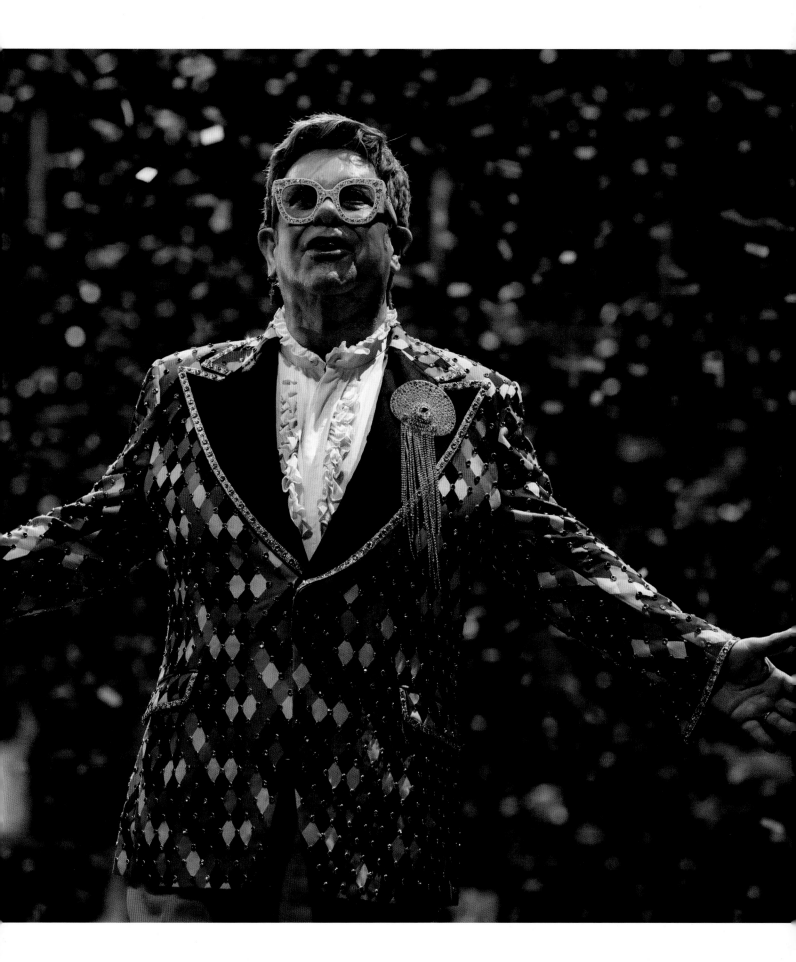

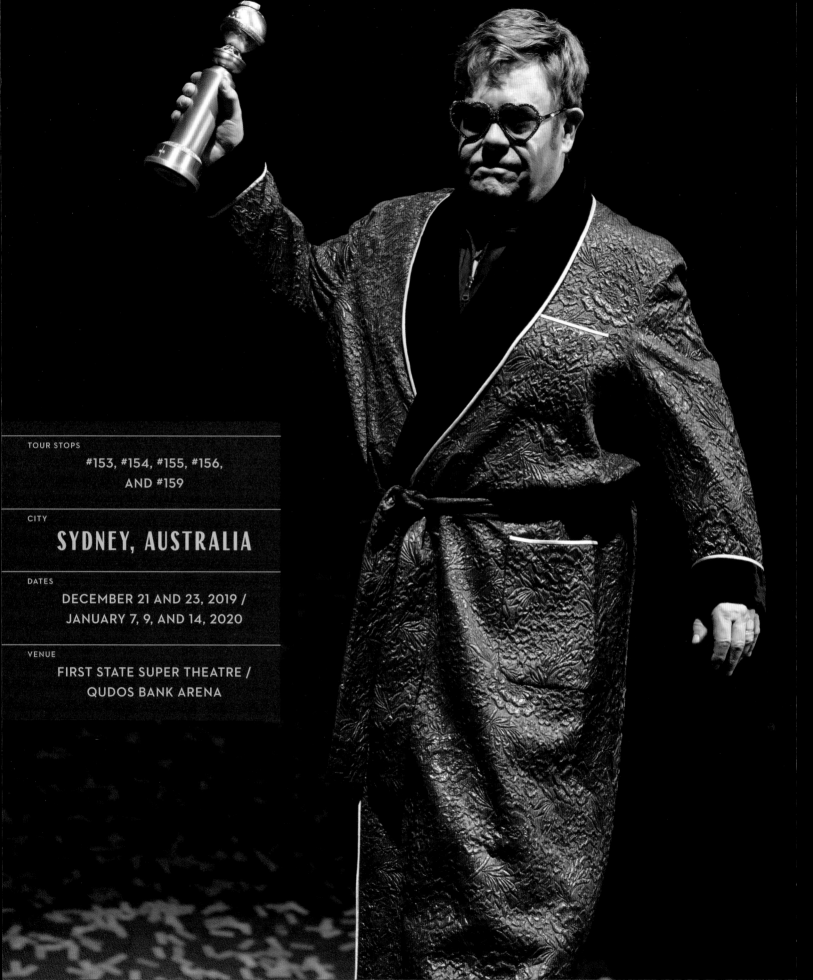

TOUR STOPS
#153, #154, #155, #156,
AND #159

CITY
SYDNEY, AUSTRALIA

DATES
DECEMBER 21 AND 23, 2019 /
JANUARY 7, 9, AND 14, 2020

VENUE
FIRST STATE SUPER THEATRE /
QUDOS BANK ARENA

've always had a special place in my heart for Australia. The first time I toured down under was 1971. Originally, I was scheduled to play a single show in Sydney between my two North American tours, but it was quickly expanded to six shows in fourteen days. Before visiting Australia, I played several concerts in Japan and then flew to Perth. By then, my career felt like a whirlwind of touring and recording. I didn't have too much time to think about how much my life had changed. But it did occur to me how far from home I'd traveled. I was twenty-four, and that trip was the farthest I'd ever been from Pinner. It was thrilling and terrifying in equal parts. I was fond of Australia immediately, but that initial Australian run had its ups and downs.

At first, the press focused its attention on everything except my music. My hair, then dyed orange with purple highlights, seemed to be an issue. At the press conference, a reporter asked if I took drugs. Although I'm not a fan of denim—in fact, I think it's horrid—one of my early custom wardrobe items was a denim jacket and jeans covered in patches and badges sewn on by Anett Murray, who was my bassist Dee's wife. Some of the patches were a bit off-color, but we all thought it looked cool. Once I tried to get into Disneyland while wearing the outfit and they told me I couldn't come in, so I knew there was something seemingly lurid about the look. When we got to Australia, I discovered that denim jacket and trousers apparently violated the country's code of decency. Anett gamely covered some of the patches with plasters so I wouldn't offend anyone and so we could enter the country. As soon as we were out of sight of the authorities, the plasters came right off.

Those early hiccups quickly became overshadowed by the experience of Australia itself. In Perth, we visited the Double Helix in Kings Park. We enjoyed four days off in Adelaide, where we went to the beach and met koalas. During the shows, I played whatever grand piano was available at each venue, often performing through ninety-minute sets, which were long at the time. The audiences loved us. By the end of the night, they'd be screaming for more.

The crowds grew as we went along, leading up to the final performance at Randwick Racecourse in Sydney. I played a white grand piano—as many fans know, I detest white pianos—and I remember the wind howling across the stage. Some of the local crew were forced to hold a tarp over us while we played, but the wind was so strong the cover nearly fell on the band and our instruments. But it didn't matter to the fans. They danced and sang and hung off the speaker towers. I was so caught up in the energy that I ripped off my shoes and hurled them into the crowd during the encore. I can't remember if I ever got them back.

At one point during the tour, a reporter asked me what I thought of Australia. "Well," I said, "I'm still smiling." And I was. In the years since, I've toured the country repeatedly. One of my most memorable shows coincided with me almost losing my singing voice forever. In 1986, I returned on my Tour de Force tour, which featured twenty-six total concerts and culminated in twelve nights at the Sydney Entertainment Centre. For the tour, I wore a sparkling outfit by Bob Mackie and a neon Tina Turner wig. I had told Bob to go as wild as he wanted, which is how I ended up on the stage in an absolutely audacious outfit that made me look like Mozart was fronting a glam rock band. I was performing with the

Elton proudly holds his Golden Globe onstage in Sydney in 2020. He flew straight from the awards show in Los Angeles to Australia and performed the same night.

LEFT:
Anett Murray customized a double-denim look for Elton in 1972. He wore the ensemble in Sydney during a tour of Australia, but was forced to cover up the more outrageous patches temporarily.

RIGHT:
Elton's love of America is reflected in the stars and stripes of his towering platform boots.

"THE RATHER CURIOUS PARADOX IS THAT ELTON JOHN QUIT HIS JOB IN AN ENGLISH ROCK 'N' ROLL BAND TO ESCAPE WORKING ON THE ROAD. HE WANTED A HOME AND A CHANCE TO LIVE IN IT, AND THE PEACE TO WRITE SONGS. BUT TO ENSURE THE SUCCESS OF HIS SONGS AND HIS IMAGE HE MUST KEEP ON PERFORMING."

★ ★

—*THE BULLETIN REVIEW,* SYDNEY, 1971

Melbourne Symphony Orchestra, so the Mozart reference was fitting. I wanted the tour to feel like a true spectacle, so memorable that it would be all the fans could think about.

I've performed with an orchestra several times in my career, and it's always slightly nerve-racking. But on this occasion, I was also struggling with my voice. I'd been dealing with vocal fatigue for several years, going so far as to remain completely silent when not onstage, but in Sydney, it came to a head. Whenever I opened my mouth to sing, I had absolutely no idea what was going to happen. Sometimes I was fine, and sometimes I would just wheeze and rasp. My voice was completely ravaged by the time the Sydney shows came around.

On the first night, between songs, I coughed and spat up wads of gunk. I knew I needed to do something. I couldn't carry on croaking my way through shows. I went to see a doctor in Sydney, who found cysts on my vocal cords. He wanted me to cancel the rest of the Sydney concerts—there was still a week to go—but I couldn't. Too many people were involved in the tour and too much money was at stake. And I still wanted to sing.

By the last night of the tour, scheduled for December 14, I was exhausted and in pain. I could barely get words out. The show was being broadcast live on television and was later released as *Live in Australia with the Melbourne Symphony Orchestra*, and I was so daunted I rushed out of the Sydney Entertainment Centre only minutes before we were scheduled to start. I didn't know if I could do it. But I turned around before I even made it to the car. If this was going to be my final show, I was going to go out with a bang. As we performed, I could feel myself falter on "Rocket Man." I worried the audience would be put off by my voice. But I didn't want to give up mid-show. I always believe in giving the fans my absolute best, and that's what I did that night.

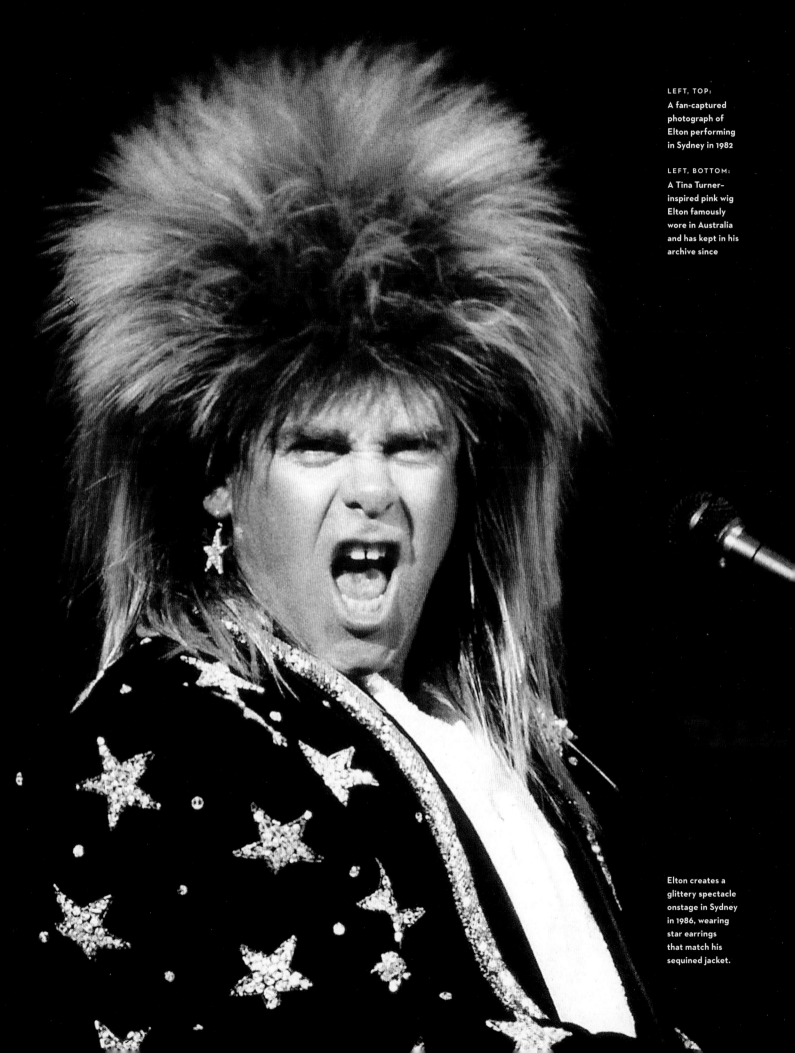

LEFT, TOP:
A fan-captured
photograph of
Elton performing
in Sydney in 1982

LEFT, BOTTOM:
A Tina Turner–
inspired pink wig
Elton famously
wore in Australia
and has kept in his
archive since

Elton creates a
glittery spectacle
onstage in Sydney
in 1986, wearing
star earrings
that match his
sequined jacket.

Later, someone said they thought I was worried the concert might be my last and assumed that's why I wanted to give it my all. My voice may have been raspy and rough, but I powered through the performance and it turned out to be the best show of all. Three weeks later, I had throat surgery at St. Vincent's Hospital in Sydney, and thankfully, it was a success. Although my voice changed after the operation, I liked how it sounded. And I was grateful I could carry on touring. It's hard to imagine how different my life would be if I'd been forced to quit performing in 1986. I certainly wouldn't be where I am today.

We were more than a year into the Farewell Yellow Brick Road Tour when we arrived in Australia. The Australia and New Zealand tour leg involved dozens of concerts all over the two countries, including a few places I hadn't been before. We began in Perth and flew to Adelaide, Geelong, Melbourne, and Brisbane before finding ourselves in Sydney. I was scheduled to perform in two different venues in Sydney, the ICC Sydney Theatre and the Qudos Bank Arena, and another show was booked for March at the former Bankwest Stadium to conclude the Australian dates. Every single concert was sold out. I was delighted to be back in front of my Australian fans, but even better was being there with David and the boys.

As someone who loves traveling and experiencing new places, it's been important for me to share that with my kids. We brought them along to Australia, and they loved it. Between shows, we took them to see the Great Barrier Reef, where they snorkeled and went fishing. They learned to surf at Bondi Beach within sight of where I'd filmed the video to "Blue Eyes" years earlier. We visited the outback and they met kangaroos. They saw and experienced everything that makes Australia so special. It reminded me of our early tours there, when the band and I got to be tourists for the first time. What a gift to see these places over so many decades of my life.

The final moments of one of Elton's shows in Sydney

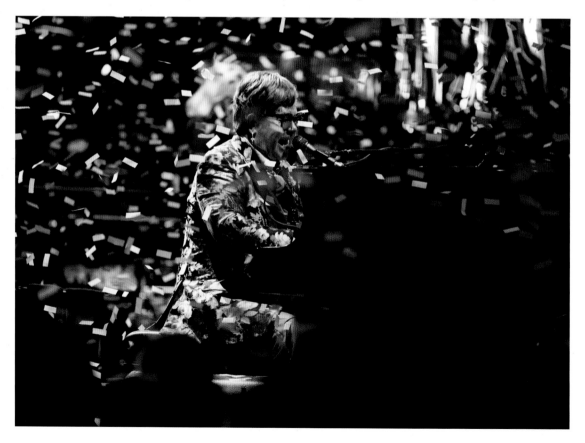

"POP-ROCK ICON ELTON JOHN IS ONLY APPROACHING THE HALFWAY POINT OF HIS THREE-YEAR FAREWELL YELLOW BRICK ROAD TOUR YET IS DETERMINED, ON THIS NIGHT'S EVIDENCE ANYWAY, TO GIVE EVERY SHOW EVERYTHING HE'S GOT."

★ ★

—*SYDNEY MORNING HERALD*, 2019

Despite the unique beauty of the country, not all was right there when we arrived. Australia was suffering through what became known as the Black Summer, where horrible wildfires were ravaging the bush. You could smell them in Sydney, and the air was thick with smoke and ash. There was massive devastation. Homes and lives were lost, and it was heartbreaking to witness. I didn't know what to do, but I wanted to help. We donated one million dollars from the tour to the relief effort. In the scope of things, it was a small gesture, but I hope it made a difference to the people there.

The tour broke for the holidays in late December, and we flew back to Los Angeles for the Golden Globes. Bernie and I had been nominated for Best Original Song for "(I'm Gonna) Love Me Again" from *Rocketman*, while Taron had been nominated for Best Actor in a Musical or Comedy. I felt pure joy when Taron won. David and I jumped out of our seats and clapped and cheered. I was even more moved when Bernie and I won, because it was so meaningful to be recognized for something that he and I wrote together. Onstage, I was emotional. "This is the first time I've ever won an award with him," I told the audience, gesturing to Bernie. "We've never won a Grammy together, just this." It was incredible.

I was so proud of the award that I took it with me back to Australia on my plane. I carried it in my hand as we disembarked in Sydney. I wanted to share it with the world. On the first evening back, at the Qudos Bank Arena, I brought the statue onstage and showed it to the crowd. It felt like a great way to start 2020. We continued through Australia and then flew to New Zealand. By mid-January, we got the best news of all: "(I'm Gonna) Love Me Again" had been nominated for an Academy Award for Best Original Song. I was beside myself. "I can't believe it," I said to David. I was bitterly disappointed, however, that Taron hadn't been nominated. He deserved the spotlight for his performance. It had required such courage for him to take on the role of someone like me, who was still alive, and to sing those songs. Taron put his heart and soul into that performance, and I was genuinely upset about the snub. But it was great to have the film celebrated for its music. We planned to be back in Los Angeles for the Oscars in early February. Perhaps when we returned to New Zealand to continue the tour I'd have another, even better, award to show the audience.

The first time I went to Japan, I felt like an alien venturing onto a new planet. It was so different from anywhere I'd ever been. The Japanese people were incredible and deeply respectful. I felt welcome there instantly. We flew to Japan in October of 1971 for a week, with four shows scheduled in Tokyo and two in Osaka to promote my most recent LP, *Madman Across the Water*. My band at the time was composed of Dee and Nigel, and we wanted to do something a little bit different for the performances. I planned an eighteen-song setlist for the tour, with a focus away from my hits. The concerts were my introduction to Japan, which gave me a sense of freedom. I didn't have to cater to the existing fans. Instead, we could play some rarities.

The tour was a great success. The Japanese audiences were very quiet, especially compared with those in America, but very receptive. They seemed to like my songs. The concert at Tokyo's Kosienenkin Kaikan on October 11 was recorded and broadcast on Japan's NHK radio station and the *Rock Carnival* television show, and it's since become a coveted bootleg for fans. Visiting Japan fueled my newly discovered love of travel. I'd seen some of Europe and most of the UK, as well as America, but Japan was something else entirely. It represented the possibility of seeing the entire world, not just the West. Was this what being a touring musician meant? It seemed incredible to me that my music could spread this far from home. I loved trying new foods and meeting new people and learning about a culture that wasn't mine. It felt exciting, but also important. The more you see, the more your mind opens.

I've always loved touring in Japan because it's such a wonderful experience. And it's unlike any other. For example, you go everywhere by train and the fans are there on the train with you. There's also a very robust music culture in Japan. Everyone there is always buying and collecting music, which is great fun. The record shops stock different versions of vinyl LPs, with great packaging. Every time I return to Japan, I spend a lot of time in the record stores looking at jazz albums or soul albums I haven't really seen before. The Japanese people are very serious and very knowledgeable about their music.

I also adore Japanese fashion. It's made a huge impact on my style over the years. There have been so many great designers there—Yohji Yamamoto, Issey Miyake, Kenzo Takada—and Japanese fashion has really influenced what people want to wear. Yohji designed my costumes for a long time and made beautiful quality pieces with hand-painted images. There is such amazing attention to detail. You can see that detail in the artwork from Japan, as well, which I have collected. I bought extraordinary Japanese pottery from a pottery studio. I love the way they presented it. When I started collecting photography, Japanese photographs were a big part of my

A ticket stub from the Shibuya Kōkaidō in Tokyo during Elton's first tour in Japan in 1971

The cover of Elton and Ray Cooper's tour itinerary for Japan in 1995

initiation into the medium. Japan is such an intriguing place, and it's somewhere I hope to spend more time once I'm off the road.

Although I haven't consistently toured in Japan, I've performed there more than forty times over the past fifty years. In 1974, we returned to perform shows in Tokyo, Osaka, Fukuoka, Hiroshima, Kyoto, and Nagoya—which was incredibly exciting—and in 1988, I went back with Eric Clapton. Ray Cooper and I played a stripped-down run of shows in 1995, while Billy Joel and I visited the country on our Face to Face tour in 1998. Those shows became some of my favorite I've played in Japan.

Japan is one of the greatest places in the world for shopping. They have all sorts of delightful things, many of them impossible to even imagine. You can buy anything there. David and I loved digging around in the stores every time I toured Japan. During the Face to Face tour, we found a funny-looking Godzilla mask at a shop in Tokyo, which I insisted we had to buy. "I'm going to wear this onstage tonight," I announced to David. He just laughed. But while Billy was performing "My Life," I squeezed my head into the ridiculous rubber mask and strolled out onto the stage. There was a hole in the gaping jaw for my face to come through. The audience clapped in appreciation. Billy gave a surprised shriek and shook his head, but didn't stop playing. I kept the mask on as I sat down at my piano and joined him in song. There's grainy video footage of the performance online, and it's absolutely hilarious. Me, in my suit and Godzilla mask, swaying back and forth at the piano. I love moments like that, where everything feels spontaneous and fun. I take my job as a performer very seriously, but I don't think performing itself has to be so serious.

Bringing my music to far-off places like Japan has been important to me. I want to share my music with the world, not just the countries with which I'm most familiar. It's good to get out of your comfort zone and see what an audience in an unfamiliar city will do. I've made even more of an effort over the past decade. From 2012 to 2013, in celebration of the fortieth anniversary of "Rocket Man," I embarked on a world tour that went everywhere from Guangzhou, China, to Buenos Aires, Argentina, to Kuala Lumpur, Malaysia. In 2015, I did a tour of Australia and Asia that included concerts in Hong Kong, Seoul, Bangkok, and Singapore. It's been incredible to visit so many countries and experience so many cultures.

Unfortunately, there were many places to which I didn't get to return during the Farewell Yellow Brick Road Tour. That was for a variety of reasons, most of them logistical. We originally hoped to bring the tour to Japan and the rest of Asia, but it became impossible, especially with the pandemic. I've performed in dozens of countries, from Brazil to Israel to Malta, and I've loved every minute of it. I want the fans around the world to know I was thinking of them during the farewell tour, even if I didn't make it to their country or their city. These shows were for everyone, including the fans who weren't in attendance. That's why we broadcast the third night at Dodger Stadium in 2022 live on Disney+, to allow everyone through the doors and into the audience from places near and far.

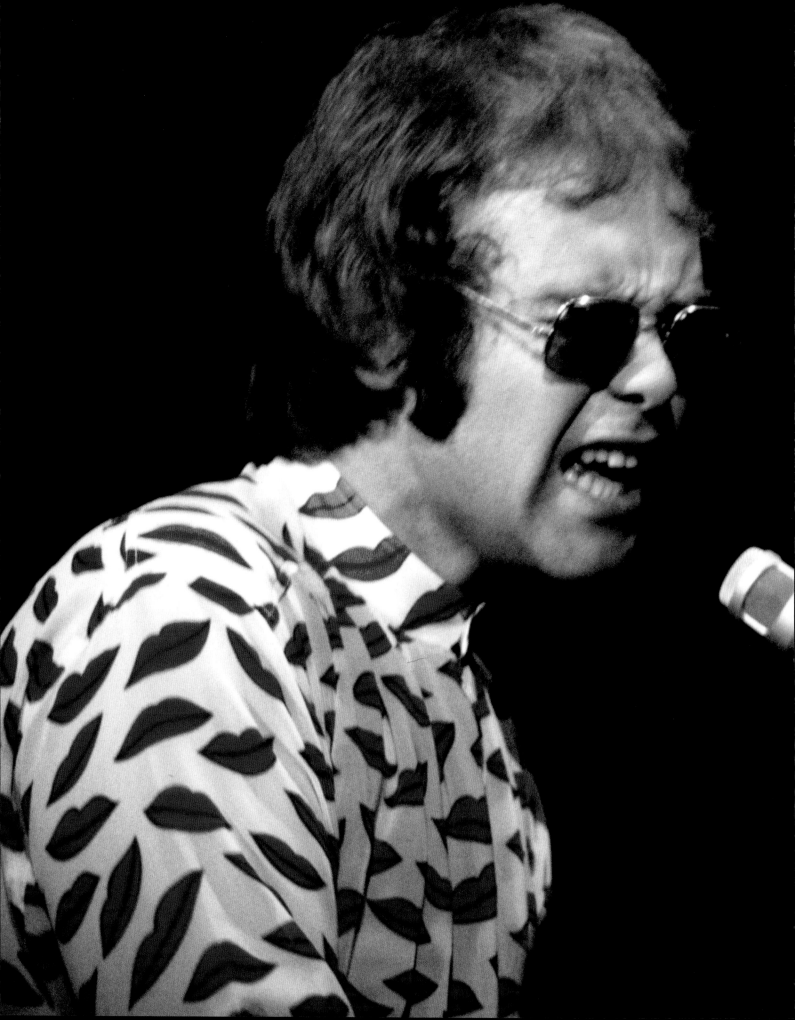

"AN UNIMAGINABLY ECCENTRIC LIVE PERFORMANCE . . ."

★ ★ ★ ★ ★ ★ ★ ★ ★ ★ ★ ★ ★ ★ ★ ★ ★ ★ ★ ★

—HEIBON PUNCH, 1971

Elton performs his first-ever
concert in Tokyo in 1971.
The show took place at the
Shibuya Kōkaidō.

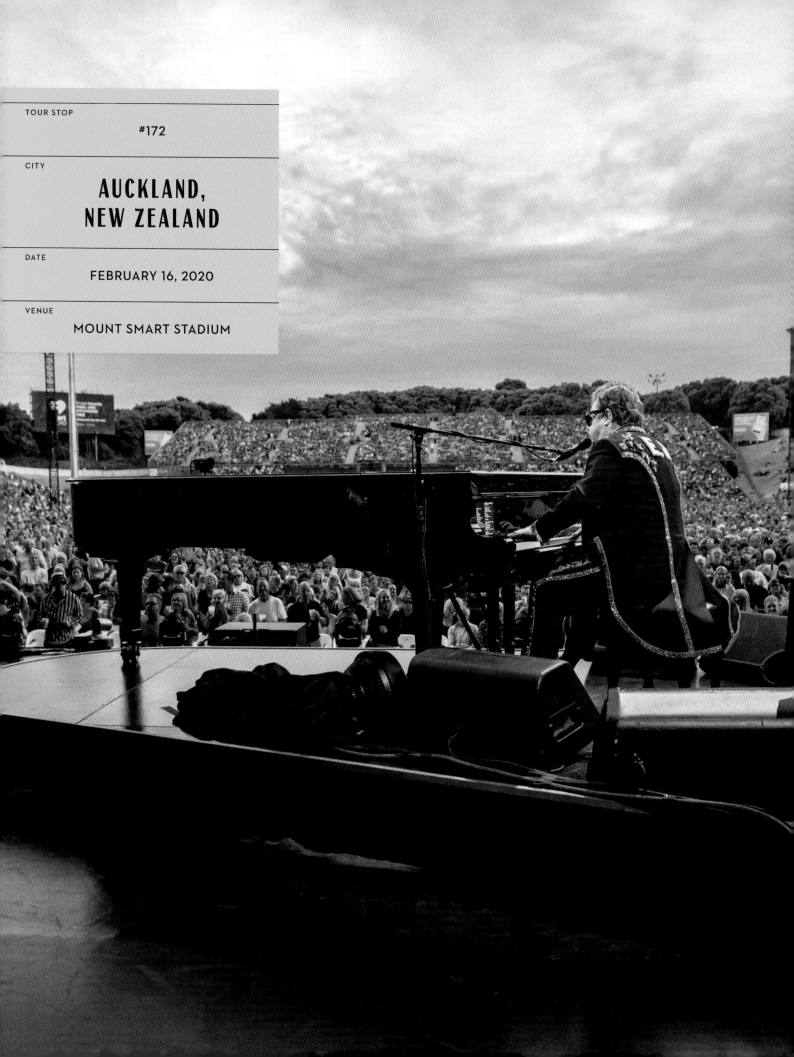

TOUR STOP
#172

CITY
**AUCKLAND,
NEW ZEALAND**

DATE
FEBRUARY 16, 2020

VENUE
MOUNT SMART STADIUM

"ELTON JOHN'S SHOW AT WESTERN SPRINGS LAST NIGHT WAS THE BEST I'VE BEEN TO. IT WAS GREAT, NON-STOP ENTERTAINMENT ALL THE WAY, FROM THE TIME ELTON TOOK THE STAGE. . . . 'THE INCREDIBLE ELTON JOHN' CERTAINLY LIVED UP TO HIS HYPE."

★ ★

—*THE AUCKLAND STAR*, 1971

Although I've performed thousands of concerts, I've rarely canceled one. I'm dedicated to my fans, and I know how much money and time they devote to coming to see me play. But the reality is that sometimes things go wrong. And you can't always control it when they do. There have been a few concerts I just couldn't finish, for one reason or another. I remember performing at the Convention Hall in Asbury Park in 1971 when a massive storm blew in. Rain was pouring all over the stage. The band and I were soaking wet. The show had to be cut short because everyone was worried we'd be electrocuted. I wanted to keep playing, but we were sent back to our hotel, which by then had no power. More recently, in the summer of 2012, a performance in Blackpool, England, had to end early because of high winds. Again, I wanted to keep playing despite it being impossible.

During the farewell tour in January 2020, while we were in Australia, another storm blocked my path. We had played a string of dates at wineries in Australia and were in the Yarra Valley in Victoria. It was beautiful weather. The sun was beating down on what seemed like a hot summer day. But out of nowhere a flash storm blew in. It was so bad that the rain actually poured sideways. It dumped directly onto me and my piano as I was playing "Funeral for a Friend." The band and I carried on, although we got absolutely soaked. Some of the crew appeared onstage with tarps and attempted to cover me, to no avail. My piano began to fill with water. I kept going. Suddenly, the piano gave up. The water had short-circuited it. I couldn't keep playing even if I wanted to. The concert was shut down after only ninety-five minutes of a two hour set. I was devastated. But I've learned through my recovery that you have to let go of those things you simply can't control.

Looking back, it's hard to be angry about uncontrollable moments of bad weather. The safety of the band and the fans comes first. I'm not as forgiving when I'm the reason a concert can't go on. But there are moments where your body can't keep up with your tour schedule and it simply quits. Often I've managed to push through with sheer force of will, like when I collapsed onstage at the Universal Amphitheatre in Los Angeles during a performance in 1979. I was dragged off, but I bolstered myself up and finished the show. Another time, in South Africa, I played a concert while I had food poisoning. I was sick the entire night before and in the car on the way there. Afterward, I told David, "I have no idea how I made it through that."

Elton performs onstage in Auckland in 2020. The singer was scheduled to play three shows, but lost his voice during the first evening's concert.

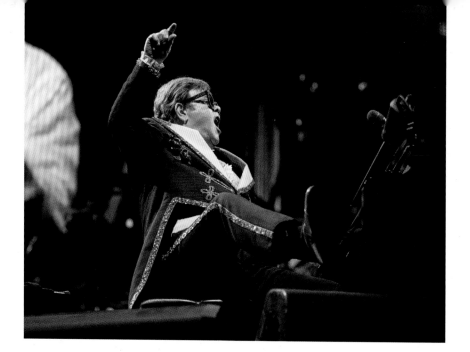

The truth is, I've played a lot of concerts I shouldn't have. I've gone on against doctor's orders and I've nearly fainted onstage. I will do everything in my power to finish a show. When I can't—and that's rare—I'm racked with guilt and remorse. But like I said, sometimes things go wrong and there's nothing you can do about it. In February, we flew back to Los Angeles for the Oscars, where Bernie and I won Best Original Song for "(I'm Gonna) Love Me Again." It was a huge moment in my career. I was overwhelmed and emotional. But I was also not feeling well. I pushed myself through the awards ceremony and the parties, but when I went onstage to perform at the Oscars, I was anxious, feverish, and sweating. Flying from Los Angeles to Auckland a few days later, something was seriously off. I was run-down and light-headed. I coughed for the entire flight. No one suspected it was Covid at the time, but I'm now convinced it was.

Despite my illness, I was thrilled to be back in New Zealand. I first performed in Auckland at the Western Springs Stadium on October 29, 1971, which I remember fondly. On the farewell tour, we had played one show in Napier at the Mission Estate Winery before the Oscars, and we were now back for one more just over a week later. Performing was a struggle. I felt sick in a way I'd never experienced before. It makes sense now to know I probably had Covid, but at the time, it felt like some kind of weird contagion that had me coughing and exhausted.

The local doctor diagnosed me with walking pneumonia. "You should rest," he said. We had one final New Zealand performance scheduled for Mount Smart Stadium in Auckland. David urged me to cancel the performance. No way. I had a sold-out crowd waiting for me. I wanted to give them the best show humanly possible. And Jacinda Ardern, the country's prime minister, who I deeply admired, was coming to see me perform. I couldn't bring myself to cancel the show, because I didn't want to let anyone down. I mustered what little energy I had left and told David I was going to go out there and give the best performance I could. I wasn't backing down.

Once I took the stage, I knew it was going to be a challenge. I made it through some of the show with a paramedic on standby. But midway through the set, it became clear I couldn't continue. My head spun. I stood up from the piano to take a bow at the end of "Someone Saved My Life Tonight" and saw spots. I nearly tumbled off the stage. The band paused the show as the paramedic checked my oxygen. David begged me again to stop. "Take a few songs out, at least," he said. "You've just had a paramedic onstage. You were dizzy. You lost your breath. Come on."

Elton gives a lively performance in Auckland before having to end the show early due to illness. Although he looks full of energy in the photo, the musician was struggling to keep the show going.

"EVER THE CONSUMMATE SHOWMAN, HE WAS DETERMINED THAT NOT ONLY MUST THE SHOW GO ON BUT THAT HE'D HAVE A DAMN GOOD TIME TO BOOT."

★ ★ ★ ★ ★ ★ ★ ★ ★ ★ ★ ★ ★ ★ ★

—NEW ZEALAND HERALD, 2020

"No," I insisted. "I will not cut anything." David knew how I felt about prematurely ending a concert. "This is your health," David argued. "Your fans will understand."

By now we were screaming at each other. My voice creaked. "Cue the music," I insisted as David yelled, "Turn it off!" It was a stand-off. Finally, I conceded that I would take some songs off the setlist. "Just a few," I sighed. I huffed back onto the stage. I could do this. I'd proven in the past that I could perform through anything. And unlike bad weather, I *could* control it. I soldiered on through half a dozen more songs, but as soon as I started singing "Daniel," nothing came out of my mouth. I'd played and sung my heart out until I just couldn't sing anymore. I realized with resignation: The show could not go on.

Special Reserve Seats

On Stage Live

ELTON JOHN

and BERNIE TAUPIN

Western Springs

Friday Oct. 29th 8.30p.m.

No 3165 $3.50

Elton appeared at Western Springs Stadium in New Zealand in 1971.

"I've just completely lost my voice," I told the audience. I could feel myself getting choked up. "I can't sing," I said. "I've got to go. I'm sorry." I put my head in my hand and leaned on the piano, tears falling from my eyes. I wanted to finish the performance so badly. The crowd was cheering and shouting, "We love you!" Eventually, I allowed my team to help me off the stage. I could hear the cries of "Elton! Elton!" behind me. Their support made me even more emotional. When I got backstage, I collapsed. David, to his credit, didn't say "I told you so." The next day, our doctor flew down to New Zealand to check on me and help get my voice back.

It was a humbling reminder that certain moments in our lives are out of our hands. No matter the good intention, you can't control everything. My relationship with my fans is one of the most important in my life, and that night on the stage in Auckland, I was so grateful for their support. The Kiwis are an understanding lot, and they gave me a standing ovation even though I couldn't finish my set. After Auckland, I was able to take a few days to rest. We weren't scheduled for another concert until February 22, in Melbourne, and by then I would be back on my feet.

When I think about Auckland, I have so many positive memories. I felt so guilty about not finishing my farewell concert, but I knew I had given so much to the fans in the city. I could still go out with a bang. Since 1971, I've played in Auckland thirteen times. I returned to Western Springs Stadium in 1974 during my Australian tour, and performed there in 1980 during my World Tour. I've also toured throughout New Zealand, to cities like Christchurch, Wellington, New Plymouth, and Dunedin. It's a beautiful country. It feels very far away from home, especially for someone who grew up in Pinner, and I marvel at how many times I've been able to perform somewhere like that. I never could have imagined I'd become a regular fixture on the tour circuit in New Zealand, and I'll miss the fans there dearly.

Due to the pandemic and the tour dates being postponed several times, I didn't get my chance at a do-over in Auckland until early 2023. I was scheduled to perform two more nights at the Mount Smart Stadium in January, but again, fate intervened. We arrived in Auckland to massive floods. The weather reports were conflicted, but water was surging through the city. The fans could barely get to the stadium. Only moments before the first concert was scheduled to begin, the police arrived and shut us down. It wasn't safe to continue. Auckland had been put into a state of emergency. We had to cancel yet again.

It was absolutely devastating. I still regret that I wasn't able to give my New Zealand fans those promised final shows. It always saddens me to cancel, but even more so on a farewell tour—I hate that more than anything. Afterward, when we got back to LA, I sank into a depression for a few days. I felt so responsible, although it was out of my reach. I know the fans understood, just as they understood when I couldn't finish the first concert. You can't control the weather, and you certainly can't control Covid. Still, that doesn't make it any easier. I always play, rain or shine, but this time the police said, "You're done. Shut it down." And we had to.

Now, with a clearer head, I'm able to look back on moments like the ones in Auckland as hurdles I managed to surmount. Covid was responsible for a lot of disruption, and it certainly derailed that first concert in 2020, despite my best intentions. I did everything I could to make up for it in 2023. I never want to disappoint anyone, including myself. But every good story has its highs and its lows. My story certainly does. It would be a fucking boring story if it didn't. And we were about to find out just how not-boring it was going to be.

Elton and his team had so much fun working with different artists on the custom lithographs for different locations on the farewell tour. This one, by Tom Whalen, celebrates Elton's knighthood.

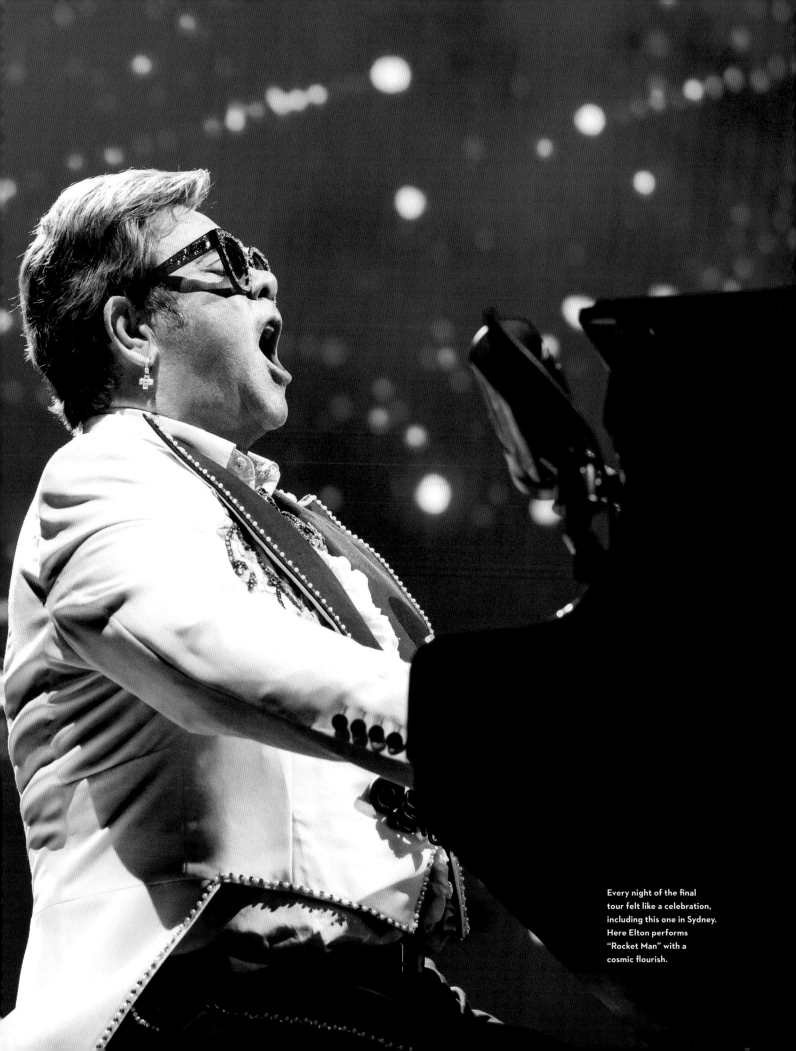

Every night of the final
tour felt like a celebration,
including this one in Sydney.
Here Elton performs
"Rocket Man" with a
cosmic flourish.

"ELTON JOHN AND FOO FIGHTERS ARE AMONG THE LATEST SUPERSTAR ACTS TO POSTPONE TOUR DATES AS THE WORLD STRUGGLES TO CONTAIN THE CORONAVIRUS."

★ ★

—*DEADLINE*, 2020

By early March 2020, Covid had infiltrated the news. Everyone was nervous. There was talk of social distancing and mask wearing. We were still in Australia, and there was a lot of uncertainty in the air, especially with the proximity to Asia, where the initial outbreaks occurred. David was particularly concerned about me. We didn't know I'd likely already had Covid, and he wanted to ensure I was protected. "You're the definition of high risk," he said. There were discussions about putting a bubble around the tour. David and the team had conversations about sterilizing the equipment and about isolating different factions of the band and tour crew. David searched Sydney for face masks. We were plagued by misinformation and a lack of understanding about the virus. What were we supposed to be doing to protect ourselves and to protect the fans?

I was scheduled to perform in Sydney on the final night of the Australia and New Zealand tour leg. It had been a great run of shows, despite my illness in Auckland, and I was keen to keep up the momentum. But it was becoming clearer that Covid was very serious. I played my usual set at the Bankwest Stadium to a cheering, upbeat crowd. It was great fun, but there was a palpable sense of unease. In the early days of the pandemic, it seemed like something that was happening far away. By March, however, there was no escaping reality. After the concert, we packed up and flew back to Los Angeles. The farewell tour was meant to continue onward in Indianapolis on March 26. But how could we carry on? The world was shutting down. Other artists' tours were being canceled left and right. We decided that it wasn't right to continue. On March 16, we released a statement notifying fans of the tour postponement through May. At that point, we didn't imagine Covid would last very long. No one did. "Oh, this will be over in a few weeks," we all said. I assumed I'd be back on the road as planned at the end of that month.

No one could have anticipated that our concert in Sydney would be the last one for nearly two years. As Covid became more widespread and health services around the world became overwhelmed, it became impossible to resume playing. Live

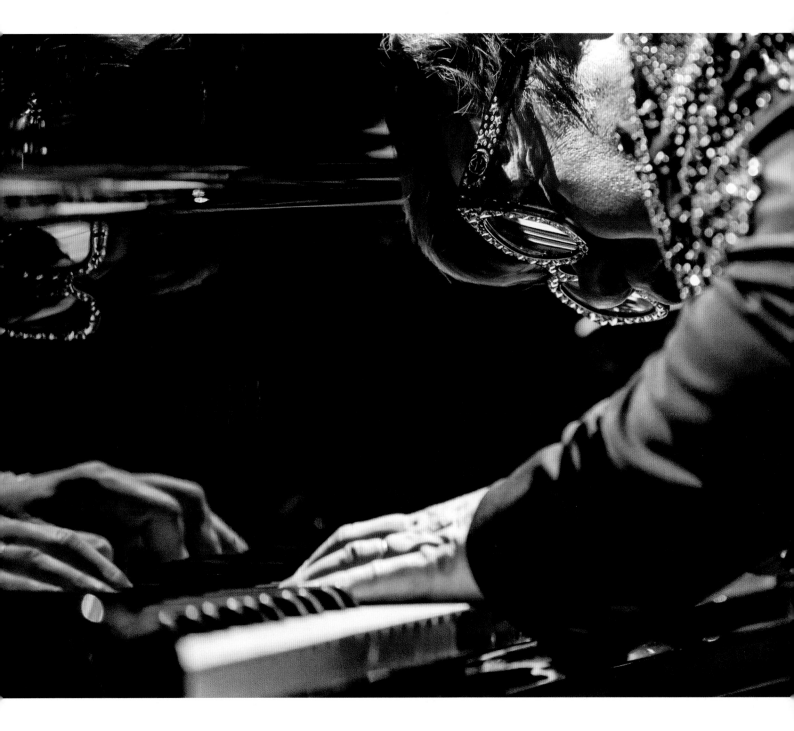

The magical moments of the farewell tour were forced to stop when the pandemic hit, pulling Elton and his band off the road in the spring of 2020.

performances were a perfect storm of infection. There was no insurance against Covid, which was killing people en masse. It was so serious it stopped our business completely. The safety of everyone was paramount. We needed more information before we could really do anything. Privately, David and I wondered if I'd ever tour again.

I never take rescheduling or canceling shows lightly. But this was a safety decision. I had to ensure that my band and my team and the fans were protected from a potentially deadly virus. But of course it was disappointing. We had been going strong for over a year, and suddenly everything had come to a thudding halt. Not only could I no longer tour, but like everyone else, I was suddenly stuck in lockdown. We had to batten down the hatches and wait.

n one moment, we were flying through my farewell tour, and in the next moment, everything was unsettlingly still. I'd never experienced anything similar. Like everyone else, I went through a roller coaster of emotions. But mostly it was weird—there was no other way to explain it. And it was scary. Really scary. But despite the tour being sidetracked, I wasn't angry. There was nothing I could do to change the circumstances. In Alcoholics Anonymous, you learn to hand things over to a greater power, whatever that means to you. I was perplexed by how to proceed, of course, but my family and I were safe. For many, the pandemic, especially in the early days, was an absolute nightmare. It was a challenging time, but I had to accept that it was out of my control.

What could I, as one man, do? I couldn't heal the world. I couldn't come up with a vaccine. I had to wait it out. However, I am not one to sit still. David has compared me to a shark, always moving and searching for something to do. Once it became apparent that the Farewell Yellow Brick Road Tour was on an indefinite hiatus, I tried to settle into the new normal. David, the kids, and I were living in our house in Beverly Hills. I watched *The Handmaid's Tale* and *Chernobyl*. I found myself obsessed with *Tiger King*. I listened to a lot of music. I played with Zachary and Elijah—we had a daily family Snakes and Ladders tournament, which my kids invariably won every time. David showed me how to use FaceTime and Zoom.

I had moments of anxiety and fear, but I also enjoyed being with my family. I enjoyed being in a space of less obligation. In the spring of 2020, I saw the daffodils in our yard bloom for the first time ever. Every year before, I'd been on tour. It was miraculous, and it hinted at what I had to look forward to after I retired from the road. Throughout it all, I was aware that I was one of the fortunate ones.

Creatively, though, I grew restless. My touring life had been unexpectedly upended by the bloody pandemic, but I was still an artist and a musician. "I need something to do," I complained, more than once. But what was that when I couldn't tour? A lesson, perhaps, in what my life was going to look like soon enough. Thankfully, a distraction presented itself in the form of new music. David and I met Charlie Puth, a singer who I very much admire, at a restaurant in Los Angeles shortly before lockdown. Charlie lived four doors down from us in Beverly Hills, and we became friends during lockdown. He had a studio in his house, and one day he invited me over to write a song. It was complicated because of the pandemic, and we had to take safety measures. Finally, something to do!

Charlie and I wrote and recorded several tracks, including our single "After All." It felt like a great relief to be making music. It released some of the stagnancy I was feeling. Immediately, I wanted to do it again. I ended up writing and recording "Learn to Fly" with Texas duo Surfaces, whose music I had played on my Apple Music radio show *Rocket Hour*, over Zoom. Usually, I don't have time for these sorts of collaborations. But now I had all the time in the world.

By the time we returned to England, I had immersed myself fully in a series of collaborative remote recording sessions. I recorded "Nothing Else Matters" with

THE BIG TOUR PAUSE

CITIES

LOS ANGELES
AND LONDON

DATES

MARCH 2020–
JANUARY 2022

RIGHT:
Elton and David brought the singer's career virtual during the lockdown in 2020. After some time on pause, Elton eventually began writing and recording a new album.

BELOW:
Elton and David announce their virtual Oscar party on social media with the help of a cardboard Dua Lipa.

Miley Cyrus and producer Andrew Watt virtually, and teamed up with Damon Albarn and Gorillaz on "The Pink Phantom." Rina Sawayama came to the Rocket office after quarantining for two weeks so we could record "Chosen Family" together. It was amazing. Here I was in my seventies becoming a session musician again. And there were no restrictions. It was different sorts of music. It was also interesting to play on other artists' records, rather than something that was my own. I had to go in with no ego and give them exactly what they wanted. It was really enjoyable. After a while, David said, "You know, you've almost got half an album's worth of songs. Let's finish it."

In the spring of 2021, Olly Alexander and I performed a cover of Pet Shop Boys' "It's a Sin" at the Brit Awards. It was so much fun. Around that same time, I recorded "One of Me" with Lil Nas X at Abbey Road Studios in London. Travel was slowly coming back after a long enforced lockdown in England, and I returned to Los Angeles to do more songs with Andrew Watt. I recorded with Stevie Nicks, Eddie Vedder, Nicki Minaj, and Young Thug. Earlier in the year, David and I had connected with Dua Lipa

when she was part of our virtual Oscar party. I was immediately enchanted by her. We met her for dinner while we were in Los Angeles and asked if she would sing vocals on "Cold Heart," a song I'd created with Australian dance group Pnau.

It all unfolded very organically, and soon enough we had a full album's worth of songs. David suggested calling it *The Lockdown Sessions*. It was a strange, uncertain time, and I'm grateful I could still make music. I never planned to make or release an album—it just happened. Opportunities presented themselves and I said yes. My radio show *Rocket Hour* is very much about spotlighting young artists. I want to boost the next generation of musicians in every way I can. These songs were a step further in championing these performers' music and their voices.

After a series of cancellations in 2020, we intended to resume the farewell tour in 2021. But, yet again, life had other plans. Over the summer, I slipped and fell, landing awkwardly on a hard surface. It bloody hurt. Pain shot through my hip, and try as I might, I couldn't get myself back on track. I saw specialists and went to multiple sessions with a physiotherapist, but nothing worked. I was in pain all the time. It was immensely uncomfortable. Nothing like falling to make you really feel your age. "I'm an old man," I sighed to David, dramatically. I was half joking, but it became clear I needed surgery. It was frustrating. I was desperate to get back out on the road and finish these shows for all my fans. They'd been so patient. But this was an injury I couldn't just push through or try to ignore. I had to put my health first. Yet another thing I couldn't control.

That September, we announced we would be postponing the tour yet again. I was devastated. The doctors agreed that I could perform as part of the Global Citizen concert on September 25, 2021, but after that, I had to go in for surgery and focus on my recovery. It broke my heart to disappoint the fans. I promised them

Elton and Dua Lipa perform together during the Elton John AIDS Foundation 2021 Academy Awards viewing party in London. Elton joined Dua Lipa for two songs, "Bennie and the Jets" and "Love Again."

"SOMEWHAT MIRACULOUSLY, COVID MADE HIM FEEL YOUNG AGAIN. THAT KIND OF MAGICAL THINKING IS PURE ELTON. AND HIS RESILIENCE AND OPTIMISM SHOULD BE A LESSON TO US ALL."

★ ★ ★ ★ ★ ★ ★ ★ ★ ★ ★ ★ ★ ★ ★ ★

—ROLLING STONE, 2021

those shows would happen in 2022. And I meant it—I was going to do everything in my power to get myself back on tour. I was determined that the show would go on. The fans, as usual, were so gracious. They wished me the best, which I appreciated very much. I knew they were disappointed that the tour dates kept getting pushed back, but they made me feel like they understood.

I returned to the stage in Paris for Global Citizen Live shortly before my surgery, performing for an actual crowd again. It was amazing. I focused on the hits: "Rocket Man," "Tiny Dancer," and "Your Song." Charlie Puth joined me for a rendition of "After All." The event was broadcast live and held across six continents. Several other artists performed in Paris, as well, including Doja Cat, Ed Sheeran, and Christine and the Queens. Ed and I had been secretly collaborating on a holiday single, "Merry Christmas," and it was great fun hanging out backstage with all of these young artists. That sort of collaboration was at the heart of *The Lockdown Sessions*.

After Paris, I went in for my surgery, which was a success, and then released *The Lockdown Sessions* on October 22, 2021. A week later, the LP went to No. 1 on the UK charts. I was elated and so proud of what we'd done. For me, the album represented the idea of bringing people together. It was about forming new friendships and connections, even in a time of isolation. It proved that we were all together in this, no matter what might keep us apart, and I was so gratified that the fans appreciated what I was offering. I never imagined that a few pandemic collaborations would result in a No. 1 album. It did nearly as well in America, and the reviews were glowing. *NME* wrote, "All in all, *The Lockdown Sessions*' all-bets-off

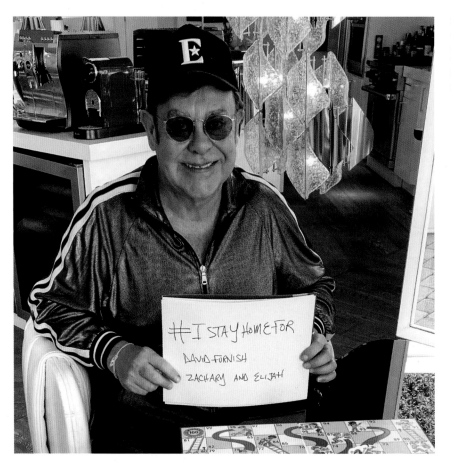

Elton offers his support during the coronavirus pandemic in 2020. The singer found solace in David and their sons Zachary and Elijah.

Elton wears a one-of-a-kind mask by Gucci on the cover of his album *The Lockdown Sessions*, which was photographed by his friend Greg Gorman.

THE LOCKDOWN SESSIONS

stylistic game of spin-the-bottle feels attuned to 2021's post-genre Spotify world, as Elton continues to further his musical universe." It proved what I ultimately believed—that, musically, I wanted to focus on the future.

In some ways, the pandemic offered me a glimpse of *my* future. I'd hoped to spend more time with my family, and I got that opportunity—although it wasn't quite in the way I expected. I listened to far more new music than I'm typically able to while on tour. And I made more music, too. It's funny how life sometimes gives you exactly what you need. I was lucky to be safe and healthy during such a terrifying time. So many others weren't. It gave me a chance to really reflect on this big decision I'd made to stop touring. I never second-guessed the choice—I was resolutely ready to retire from the road—but now I really knew what it would feel like to have more time at home.

We planned to resume the Farewell Yellow Brick Road Tour in January 2022, assuming my hip was fully healed. By Christmas, when I released "Merry Christmas" with Ed, I was feeling much better. I was no longer in pain. I know I'm not as spry as I once was, but I like to think I still have some energy left. It took some time to remobilize the tour. We had to pull sets and costumes out of storage. There were still months of the tour to go because we'd postponed so many dates, all the way into the summer of 2023, and I wanted these shows to be just as good—if not better—than the ones prior. Once the new year came around, we were ready. We headed to New Orleans, a city I've always adored, and shook the cobwebs off once more. It was time for round two.

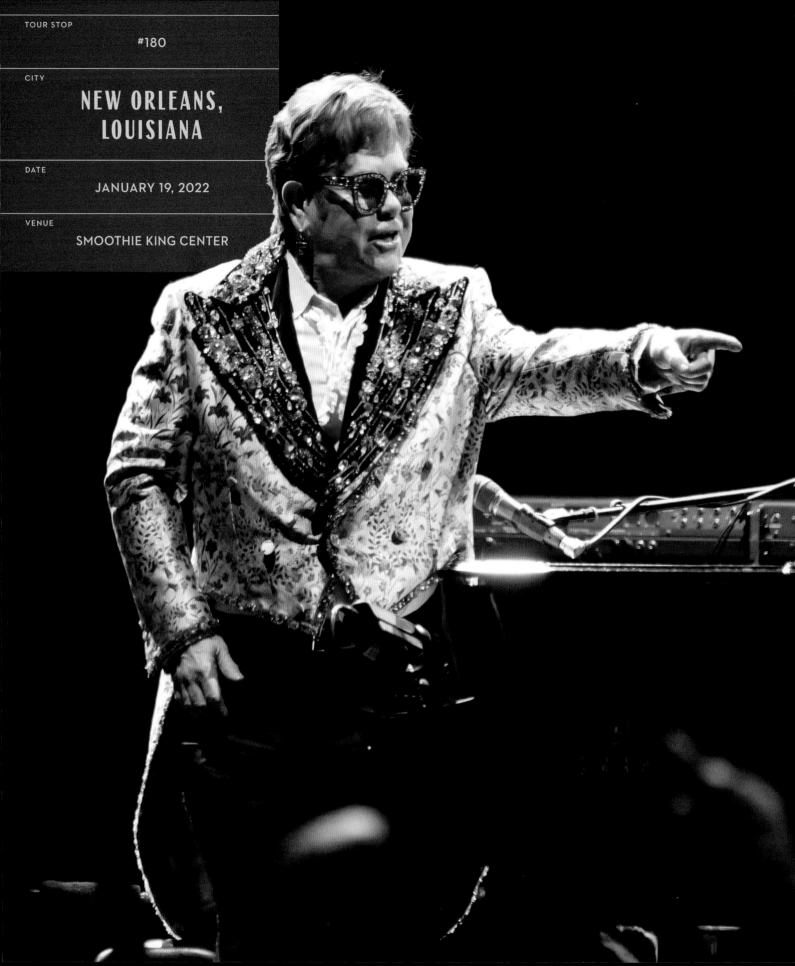

TOUR STOP

#180

CITY

NEW ORLEANS, LOUISIANA

DATE

JANUARY 19, 2022

VENUE

SMOOTHIE KING CENTER

t was a giddy rush to walk out onto the stage in New Orleans in January of 2022. The adrenaline was pumping. The crowd shouted and cheered. The speakers hummed with anticipation. The buildup of months and months of delay was finally released. What a tremendous feeling. As I played the first notes of "Bennie and the Jets" on the piano and they rang through the arena, I immediately recalled what I love so much about performing live. Being back in a room with my fans gave me an undeniable surge of energy. I wanted to bask in the moment. I took a few peeks at the shrieking audience before I put my mouth to the microphone and began to sing once more.

The show was similar, although not identical, to the concerts I'd performed prior to the pandemic. Returning to tour after nearly two years meant that I wanted to make some changes to the setlist. I dropped "All the Girls Love Alice," "Daniel," "Sorry Seems to Be the Hardest Word," and "Indian Sunset" in favor of "Have Mercy on the Criminal" and "Cold Heart." David suggested adding "Cold Heart" to the set because it had become a massive hit. But it broke the mold of the tour. It wasn't like the other songs, which I'd created with Bernie and the band. But it was something a bit more up-to date and reflected the sort of music I want to be making now, so in theory I liked the idea of placing it side by side with some of my classic tunes.

We had arrived early in New Orleans for a few days of rehearsal and to get the tour back up again. There were some things that made me uncharacteristically nervous. First, we didn't have a keyboard player. Kim Bullard tested positive for Covid just before the tour was set to resume and would have to miss the first few nights. We were going to play without him, which would impact the sound. Second, adding "Cold Heart" into the set was a challenge because it required Dua Lipa's vocals and the instrumentals on a backing track.

As I've said, my band and I don't play to tracks. We've always embraced the spontaneity of live performance. But Dua was on her own tour, so I had to try something new. Initially, it was suggested that I should stand to perform the vocals. It didn't work. I stomped off the stage during rehearsal and proclaimed I wasn't going to sing it. "But it's such a hit!" David argued. We tried it again, this time with me at the piano, and it felt much better. It turned out to be really fun, and the crowd knew all the words.

Once we got into the groove of the show in New Orleans, I couldn't help but marvel at how it felt to be back after such a long pause. "Wow, we haven't played a show since the seventh of March 2020," I told the crowd. "This is a new experience for us—I've never had this amount of time off in my life. I've been playing music, well, at least since I was seventeen years of age. I have a fact for you, you have been holding on to these tickets for 745 days. And I can't thank you enough for being so patient. We live in funny times, but we're gonna have a great time."

When you've been touring as long as I have, you notice that audiences are especially happy to have music when times are troubled or strange. Music is a means of escape from tumultuous politics or social strife or a plummeting economy, as well as a great uniter. People need music during peace and during war. If you're going to be a musical artist, you can't expect to only perform when everything

After twenty-two months on pause, Elton returned to the road. Here, he performs in New Orleans in 2022.

is carefree. Sometimes, it's even more cathartic to perform for a crowd when they're going through something challenging and when they need the music more than ever. Listening to music kept me going through the early months of the pandemic, and I think it did the same for a lot of other people. I've heard fans say that it was my music that got them through. How incredible it is that songs can free us from the arduous moments of life. New Orleans was an especially significant city to return to after years of a deadly virus disrupting our reality. It's a place that has been through so much, but the people there have never lost their optimistic spirit.

"I've been coming to New Orleans since 1971, and I've always loved coming to this city," I recalled during the concert, remembering my first show there at the Warehouse. "I fell in love with the music of this city in 1957 when I first heard Fats Domino," I continued. "The music that has come out of this city is so typical of New Orleans. It's a funk that no other city has. It's not Memphis. It's not Detroit. It's New Orleans. The music is amazing and stands the test of time. And this city had horrible things happen here."

I paused, letting the memory sink in. What better place than New Orleans to reflect on the incredible human capacity for resilience. "You've always picked yourself up from the ground, and you've come through it," I said. "You know why? Because you have character. This city has character. It has soul. Not a lot of cities can do that. You've done it time after time after time. You should be so proud of yourself. It's electric, this city. You're electric people. I'm very humbled to be here tonight."

As I danced around the stage, jumping up and down from my piano stool, I was glad I'd taken the time off to sort out my hip. I felt really good. I could move around the stage without pain, and I still had the stamina for a two-hour-plus set. As we came to the end of the show, I could feel the momentum building again. The air pulsed with a renewed energy. "Let's get this thing started so we can finish it," I told everyone. "Let's finish it in style." I knew there were more than one hundred concerts left to play. The tour was scheduled for most of 2022, and then we had more tour dates in 2023 that had been pushed back when I had my surgery. The world was slowly reawakening, and we were ready to reawaken with it.

In order to get back on the road in the midst of a global pandemic, however, the band, the crew, and I had to enter carefully controlled Covid bubbles. I remained in my bubble, of only a few people, until we completed all the 2022 tour dates, concluding in Los Angeles ten months later. It was very odd. I couldn't go out. I couldn't have people over. I couldn't spend time with my band. I saw maybe four or five people regularly. It got very lonely at times. In order to complete the Farewell Yellow Brick Road Tour, I essentially had to enter a monastic life. It took a lot of discipline, but I did it because I was determined to complete the tour and perform for every fan who had a ticket.

Throughout my lifetime, I've seen a lot of change in the world. I was born at the end of World War II, a pivotal turning point in history, and I lived through the Cold War and the fall of the Berlin Wall. The British prime ministers and governments have flipped from one to the next, from Conservative to Labour and back again. A similar series of political shifts has taken place in America. I've visited countries under communism. I've seen people become more open-minded about the LGBTQ+ community, but I've also experienced laws and ideologies that aim to make things worse for those who are gay. But during all of it, I'd never seen anything like the pandemic. It fundamentally altered our existence.

"HAD JOHN CONTINUED TO PLAY, MY GUESS IS THAT MOST OF THE WELL-HEELED CROWD WOULD'VE STAYED UNTIL THE SUN CAME UP ON THEM."

★ ★ ★ ★ ★ ★ ★ ★ ★ ★ ★ ★ ★ ★ ★ ★ ★

—OFFBEAT MAGAZINE, 1997

Like Brexit, Covid made it immeasurably more difficult for bands and artists to tour. As we trekked along in 2022, we saw dozens of musicians forced to cancel shows and tours due to positive cases and the rising cost of living. Many countries kept their borders closed, including to performers. Other countries, like England, tossed out all Covid safety measures, putting the vulnerable at risk. I think it's important to acknowledge hardship and to speak out when it impacts people. The pandemic upended everything, scattering our lives into piles of messy rubble. But like with everything in life, we had a choice: We could mourn what was past, or we could pick up the pieces and look forward.

I was immensely grateful we would be able to finish the Farewell Yellow Brick Road Tour. There was never any doubt that we would complete it, but it was uncertain when and how that would be possible. We had lots of logistical discussions, although we never had a conversation about potentially canceling any of the remaining tour dates. David and I agreed that my goodbye tour would be the celebration it was always intended to be. I had set out to give my fans the best possible swan song I could, and that was what I was going to do.

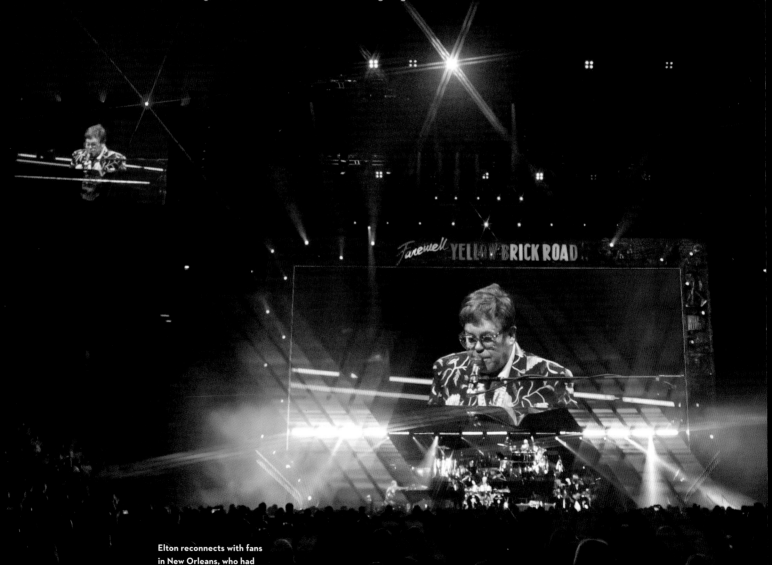

Elton reconnects with fans in New Orleans, who had been patiently awaiting his farewell tour for months.

"JOHN SET THE TONE. HIS ONSTAGE HIGH-KICKS AND HEADSTANDS LONG AGO RECEDED IN THE REARVIEW MIRROR. BUT HIS ENTHUSIASM IS STILL HIGH."

★ ★ ★ ★ ★ ★ ★ ★ ★ ★ ★ ★ ★ ★ ★ ★ ★ ★ ★

—NOLA.COM, 2022

FAREWELL YELLOW BRICK ROAD TOUR SETLIST

NEW ORLEANS, LOUISIANA
SMOOTHIE KING CENTER
JANUARY 19, 2022

1 . Bennie and the Jets
2 . Philadelphia Freedom
3 I Guess That's Why They Call It the Blues
4 .Border Song
5 . Tiny Dancer
6 .Have Mercy on the Criminal
7 Rocket Man (I Think It's Going to Be
a Long, Long Time)
8 . Take Me to the Pilot
9 Someone Saved My Life Tonight
10 .Levon
11 . Candle in the Wind
12 Funeral for a Friend / Love Lies Bleeding
13 . Burn Down the Mission
14 . Sad Songs (Say So Much)
15 Don't Let the Sun Go Down on Me
16 . The Bitch Is Back
17 .I'm Still Standing
18 . Crocodile Rock
19 Saturday Night's Alright (For Fighting)

ENCORE:

20. Cold Heart (PNAU Remix)
21 .Your Song
22 . Goodbye Yellow Brick Road

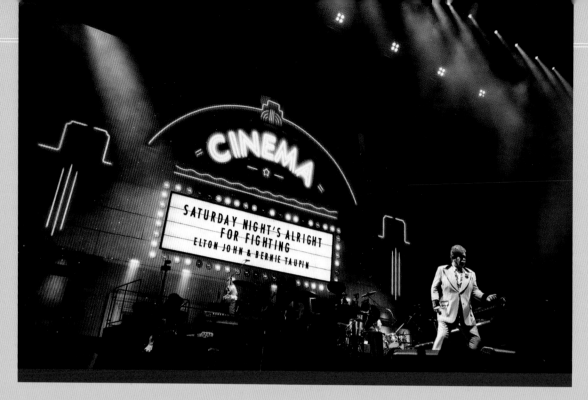

Elton launches into "Saturday Night's Alright (For Fighting)" on the farewell tour.

THE FAREWELL TOUR SONG VISUALS

Within the impressive stage on the Farewell Yellow Brick Road Tour was an essential element: a sixty-six-foot panoramic video screen with four million pixels. Throughout the performance, the screen acted as a portal, taking the audience on a trip through time with carefully curated and newly created visuals served up as a kaleidoscopic backdrop to Elton John's performance. David Furnish, Tony King, and Sam Pattinson, who runs Treatment Studios, conceptualized and brought to life vibrant, dynamic videos for the tour.

"I've been with Elton for many years now," Furnish explains. "I've been sitting in the audience and hearing him perform these songs for so many years. And I've been making movies in my head for many years, knowing what Elton's passions are in life and knowing his values as an artist and as a humanitarian. The idea was: How can we use the songs that he's chosen to celebrate all of that? That drove the content of what's in the films and what's on the screen. Every film had a story to tell and a reason for being there."

While all the videos were compelling, here are some of the highlights, including the final farewell moment that saw Elton walk off into the sunset.

"BORDER SONG"

Onstage each night during the Farewell Yellow Brick Road Tour, Elton John paid tribute to Aretha Franklin, who once covered his 1970 tune "Border Song." During the performance, however, Elton wanted to reflect on a more expansive collection of people who had broken down barriers in his lifetime. Joseph Guay created an emotional video projecting the faces of Aretha Franklin, Nelson Mandela, Stephen Hawking, Martin Luther King Jr., Muhammad Ali, Nina Simone, Elizabeth Taylor, Princess Diana, Little Richard, Jerry Lee Lewis, Elvis Presley, Pussy Riot, Lech Wałęsa, John Lennon, Yoko Ono, and many other people and notable events onto the screen. It was a fitting way to honor so many significant figures whose lives and work have inspired and impacted Elton over the years.

"SOMEONE SAVED MY LIFE TONIGHT"

In 1975, Elton John released his ninth studio LP, *Captain Fantastic and the Brown Dirt Cowboy*. The concept album, recorded with producer Gus Dudgeon at Colorado's Caribou Ranch, told the story of Captain Fantastic, aka Elton John, and the

Brown Dirt Cowboy, aka Bernie Taupin, as they struggled through the early years of their musical careers. "Someone Saved My Life Tonight" was the first and only single to emerge from the release, depicting Elton's 1968 suicide attempt and a notable piece of advice given to him by Long John Baldry. The album cover was designed by British artist Alan Aldridge, who drew inspiration from Hieronymus Bosch's painting *The Garden of Earthly Delights*. There were plans for Aldridge to create an entire animated film based off the songs, but the movie never materialized.

For the Farewell Yellow Brick Road Tour, Elton and his team opened the vaults to reveal animation cels and illustrations from the potential movie, which director Lisa Wrake transformed into a short film. The colorful video, which plays as a backdrop to the song, follows the Captain as he strolls down a darkened street, spins wildly through a pinball machine, and leads a fantastical procession of creatures. In the end, he and the Brown Dirt Cowboy stand amid the revelry as pink flower petals swirl in the wind. It's a striking glimpse of the animated film that might have been.

"PHILADELPHIA FREEDOM"

In the past, set designs for Elton John's 1975 track "Philadelphia Freedom" have centered on classic stars-and-stripes motifs. This time the team wanted something that felt fresh. They tapped

A still from the "Philadelphia Freedom" onstage backing visuals

Toronto filmmaker Sammy Rawal to film a contemporary dance piece to act as the visual backdrop to the song. Using bright colors and upbeat free-form moves, the dancers augmented the hit song's liberating vibe. The idea was to throw a party where everyone was invited—the original spirit of America. It's that vision of the USA that Elton finds so inspiring. The video emphasizes patriotism as something inclusive rather than divisive, and affirms the positive aspects of being an American.

"CANDLE IN THE WIND"

Elton John and photographer David LaChapelle have had a long and fruitful artistic partnership. For Elton's first Las Vegas residency, The Red Piano, LaChapelle created two stage visuals, for "Candle in the Wind" and "Daniel," and the team decided to reuse them during the farewell tour. "Candle in the Wind," released first as part of Elton's 1973 LP *Goodbye Yellow Brick Road* and as a UK single the following year, was written by Elton and Bernie Taupin in honor of Marilyn Monroe, who had died over a decade prior, as well as other Hollywood figures whose lives were cut too short due to the pressures of stardom and media scrutiny. Although the song has since become associated with Princess Diana—Elton performed an emotional, rewritten rendition at her funeral in 1997—for the farewell tour the team felt it was appropriate to harken back to the song's original inspiration.

The video, created by LaChapelle, features video and still imagery of actress Susan Griffiths dressed as Monroe. The pair re-created a photo shoot Monroe did with Bert Stern over three days in June of 1962 in the Hotel Bel-Air in Los Angeles. It acted as an apt reflection on the perils of fame and addiction, making it the perfect backdrop for one of Elton's most poignant songs. It also reflects Elton's love of collecting photography. The video for "Daniel," meanwhile, reveals the true meaning of the 1973 song as it grapples with the horror of war.

"THE BITCH IS BACK"

Elton John and RuPaul have been friends since 1993, when the pair recorded a new version of Elton's song "Don't Go Breaking My Heart" for his *Duets* LP. The duo unveiled a campy music video for the track the following year and paired up to cohost the Brit Awards in 1994. Elton has given RuPaul great support over the years and has a history with the drag scene. The musician has wonderful memories of his friendships with RuPaul and Divine, so it was only natural that Elton bring drag to life in the stage visual for his 1974 hit "The Bitch Is Back," made in collaboration with RuPaul's team. Set in a Hollywood mansion, the video, created by World of Wonder's Steve Corfe, sees a group of drag queens in a knock-out fight that spills over into the swimming pool. The video

embraced everything that is Elton: vibrant color, flamboyance, and a sense of fun.

"I'M STILL STANDING"

Throughout his career, Elton John has been part of many iconic pop culture moments. To celebrate that cultural ubiquity, the team compiled a video montage for "I'm Still Standing," the upbeat single off the singer's 1983 LP, *Too Low for Zero*. The life-affirming video clip flashes through key experiences in Elton's career, including appearing on *Soul Train* in 1975, being knighted by Queen Elizabeth II in 1998, performing on *The Muppet Show* in 1978, being part of the soundtrack to Disney's *The Lion King*, and having animated cameos on *The Simpsons* and *South Park*. Elton's many cinematic appearances are highlighted, with Elton playing himself in films like *The Country Bears*, *Spice World*, and *Kingsman: The Golden Circle*. It's almost overwhelming to see just how expansive the musician's reach has been, and it solidifies the fact that Elton himself is pop.

Elsewhere in the montage are glimpses of Elton's personal life, from the birth of his sons to ribbon-cutting events with the Elton John AIDS Foundation. It's a poignant remembrance for the singer's fans, but Elton's sense of humor is also on view. In 2014, he famously tumbled out of his chair during a tennis

TOP:
A video still from
"The Bitch Is Back"

BOTTOM:
Elton performs
with the Muppets
in the onstage
backing visuals for
"I'm Still Standing."

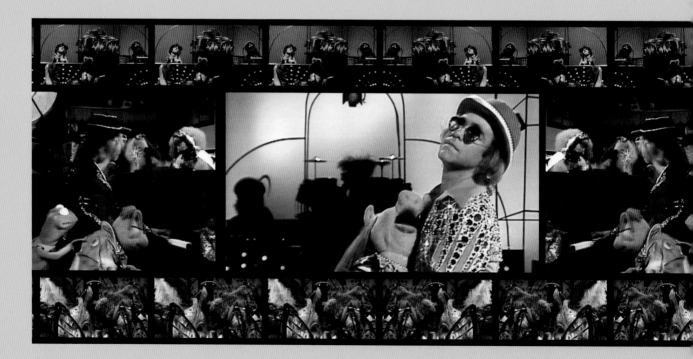

event at London's Royal Albert Hall. Not only does the footage play during "I'm Still Standing," but it hilariously repeats. The montage underscored the title of the song: After so much, Elton is still standing.

"CROCODILE ROCK"

While all the songs performed on the Farewell Yellow Brick Road Tour are intended as a gift for the fans from Elton John, "Crocodile Rock" was an extra-special moment. The single, released in 1972 and famously performed on *The Muppet Show* with the help of a few hungry crocodiles, was dedicated to the fans during the finale tour. The vibrant clip showcases some of the singer's actual fans showing off their memorabilia, from bobbleheads to signed photos to themed apparel. The team brought in rails of stage costumes from Elton's archive, including capes and jackets, for the fans to wear alongside their own items. The video, which opens with the title card "This song is dedicated to all my fans," was a fitting tribute to Elton's style as it's been embraced by his fans young and old.

"SATURDAY NIGHT'S ALRIGHT (FOR FIGHTING)"

To celebrate Elton John's rousing 1973 song "Saturday Night's Alright (For Fighting)," the creative team wanted to keep it simple. During the final chorus, they compiled famous movie fight scenes from all genres of film. Eagle-eyed fans could spot everything from *Kung-Fu Panda* to *Gladiator* to *Hercules* to *Popeye*. There is one cinematic fight scene, however, that stands out amongst the rest. In 2017, Elton played a version of himself in director Matthew Vaughn's spy epic *Kingsman: The Golden Circle* alongside Taron Egerton and Colin Firth. After Elton is kidnapped by Julianne Moore's villainous Poppy Adams, he fights off a squad of her goons while wearing a colorful feather suit. As it turns out, Elton is quite the fighter, smashing one inside his grand piano and kicking down two more with his platform boots.

"GOODBYE YELLOW BRICK ROAD"

Each evening, in a flood of emotion and memory, the Farewell Yellow Brick Road Tour came to a fitting close with "Goodbye Yellow Brick Road." The 1973 song, which references L. Frank Baum's *The Wizard of Oz*, needed an appropriate visual to conclude the performance. The team created a video that compiled scenes from Elton's touring career, recalling so many experiences from on the stage: the night at Madison Square Garden with John Lennon, the Central Park performance in 1980 in the Donald Duck suit, the Red Piano residency and tour. It's all there, reminding fans of how much Elton has given to his concerts over the years.

At the end of the song, Elton rose from the piano and stepped onto a platform, which brought him upward to a shimmering door. Without looking back, the singer stepped into the stage's video screen backdrop and slowly walked away down the yellow brick road. The video of Elton strolling off into the future isn't animation. It's real footage of the musician that the team filmed at his house over several hours to create that one last magical moment of goodbye—a lasting image that will linger with fans for years to come.

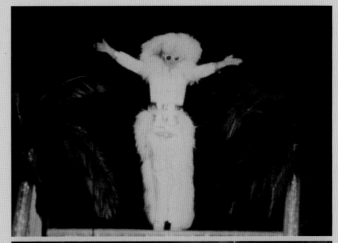

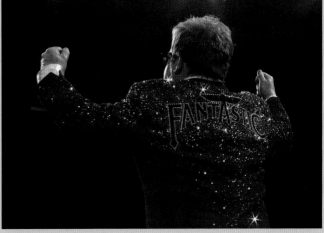

TOP AND BOTTOM: Shots from Elton's career appear in the "Goodbye Yellow Brick Road" onstage backing visuals.

Elton feels the love
from fans as he returns
to Greensboro on the
farewell tour.

TOUR STOP

#214

CITY

GREENSBORO, NORTH CAROLINA

DATE

APRIL 19, 2022

VENUE

GREENSBORO
COLISEUM COMPLEX

"HIS GOODBYE TO THE GREENSBORO AUDIENCE, IN COMBINATION WITH THE FINAL SONGS ('COLD HEART,' 'YOUR SONG,' AND 'GOODBYE YELLOW BRICK ROAD'), LEFT MANY IN TEARS. THOSE WHO WERE THERE WILL REMEMBER THE CONCERT FOR A VERY LONG TIME."

★ ★ ★ ★ ★ ★ ★ ★ ★ ★ ★ ★ ★ ★ ★ ★ ★ ★

—*GREENSBORO DAILY PHOTO, 2022*

When you've taken the stage as many times as I have, there are bound to be some mishaps. Not every show is going to be perfect, and not every audience is going to accept you. And that's okay. I learned early on to not beat myself up about mistakes or accidents. Sometimes things just happen. You have to take it in stride and look for the humor in it. I've already told you about the time in the early '70s when the band and I were pelted with fruit by an audience in Paris. Another time I was on holiday in Maui in the early '80s and played two impromptu gigs at a bar there. On one of the nights, I stood up to accept the crowd's applause and I got hit by the ceiling fan. It was actually quite funny. If the sound is bad during a concert, I get pissed off because that's someone's job and it should be good. But getting your head smacked by a ceiling fan? Hilarious.

Of course, sometimes a concert calamity is only funny in retrospect. One of the most memorable ones took place on November 8, 1974, when the band and I took the stage at the Greensboro Coliseum Complex. It was my third American tour, and we'd gone from playing clubs to selling out arenas. We'd previously trekked around the country on a rented Greyhound bus, but by this time we had the *Starship One*, a private Boeing jet that made being on the road feel a lot more glamorous. We were playing forty-five concerts in thirty-one cities. I was the biggest I'd ever been. My most recent LP, *Caribou*, had arrived that June, becoming my third straight No. 1 album on the *Billboard* charts. My record label, MCA, had just dropped a collection of my greatest hits. Imagine having greatest hits after only four years of being a solo artist! And before the tour, the band and I had

been in the studio with Bernie to write and record *Captain Fantastic and the Brown Dirt Cowboy*, which would come out the following year. It was a real whirlwind.

During the 1974 North American tour—my eighth tour in four years—I was going big and bold with my stage costumes. Some of the wardrobe pieces were almost indescribable. There was a black wet suit covered in colorful balls. A silver spaceman suit with a long cape. And, of course, the multicolored feather suit, which I famously wore on *The Muppet Show*. It was enormous and so much fun to wear, even though I always got feathers in my mouth when I sang. A photographer named Sam Emerson was following me on the tour to document what happened onstage as well as off,

Part of a tour costume created for Elton by Bill Whitten. Elton wore the feathered ensemble during a photo shoot with Terry O'Neill in July 1974, as well as onstage during various concerts in 1973 and 1974. The jacket was paired with white trousers that featured a vertical satin stripe.

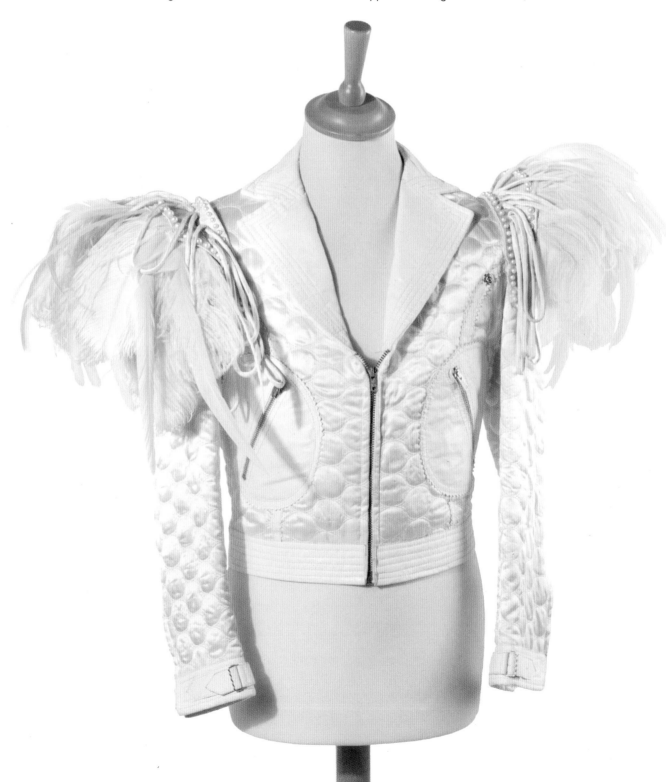

and he captured some of my best stage ensembles. Everything I wore added to my performance. I felt like my costumes gave the shows an extra allure. The fans weren't just seeing me; they were seeing the superstar Elton John.

By the time we arrived in Greensboro, we'd already hit eighteen cities across North America, including three shows in Hawaii. Kiki Dee was the opening act, and we were all in top form. There was a lot of momentum. Everyone wanted to give the best performances they could each night, no matter where we were. I felt a real duty to the fans—something I still feel—because they spent their hard-earned money to buy tickets. They had such admirable dedication. That night in Greensboro the energy in the crowd was high. The Coliseum is a huge venue, holding more than twenty thousand people, and it was completely sold out. Fans have often thrown things onstage when I'm playing, but usually it's been something reasonably soft. Not in Greensboro.

As we plowed through a rendition of "Burn Down the Mission," someone hurled a metal hash pipe toward the stage from the crowd. I didn't see it coming. The silver pipe smashed against my temple, drawing blood, and I completely blacked out. The band kept playing because it took them a second to realize what had happened. They told me later they thought I'd been shot because they saw blood pouring down my face. At the time, my bodyguard, Jim Morris, was a former Mr. Universe who was part of the show. He would appear shirtless in swim trunks during concerts. After I was knocked out, Jim dragged me—in my full feather suit— across the stage to the side. When I came to, I was lying on the floor backstage. There were feathers everywhere. A paramedic was bandaging my head. "I've got to get back out there," I insisted. "We've got to finish the show." The truth is I was probably in shock. But what was a little head wound when there were thousands of fans waiting for me to return?

After about ten minutes, I strolled back out, a small bandage on my head. The crowd cheered. I didn't feel like I needed to say anything about what had happened. We played six more songs, including my upcoming single, a cover of "Lucy in the Sky with Diamonds," and then brought the evening to a rowdy close with a two-song encore. Ending the show with "The Bitch Is Back" took on a whole new meaning. Looking back, it's a great story. I don't remember all of it, but it makes for a good anecdote every time a reporter asks me for my favorite tour memories. *Sounds* mistakenly reported the incident as if it happened in Atlanta, where we played two days later. The Greensboro gig in the fall of 1974 wasn't one of my most famous concerts, but fans who were in the audience will certainly remember that night.

It was funny to come back to the Greensboro Coliseum Complex so many decades later. How unbelievable it was to realize that I'd been performing in the same venue in Greensboro since 1974. Prior to the hash-pipe episode, I had played the arena once before in 1973. I returned in 1976 on the Louder Than Concorde tour, but didn't appear in the venue again until 2001 on the Face to Face tour, which I co-headlined with Billy Joel. For the farewell tour, we were originally scheduled to perform in Greensboro in May of 2020—a segment of the tour that was rescheduled due to the pandemic. By the time we reached North Carolina nearly two years later, it was a relief to finally be taking the stage. Some of the fans had bought their tickets back in 2019, so this was a real moment of delayed gratification.

As we played our final show in Greensboro, I smiled to myself when I recalled being knocked out with a hash pipe. It was like a rite of passage. This time, thankfully, no one threw anything on the stage. Everyone sang along and danced. Maybe

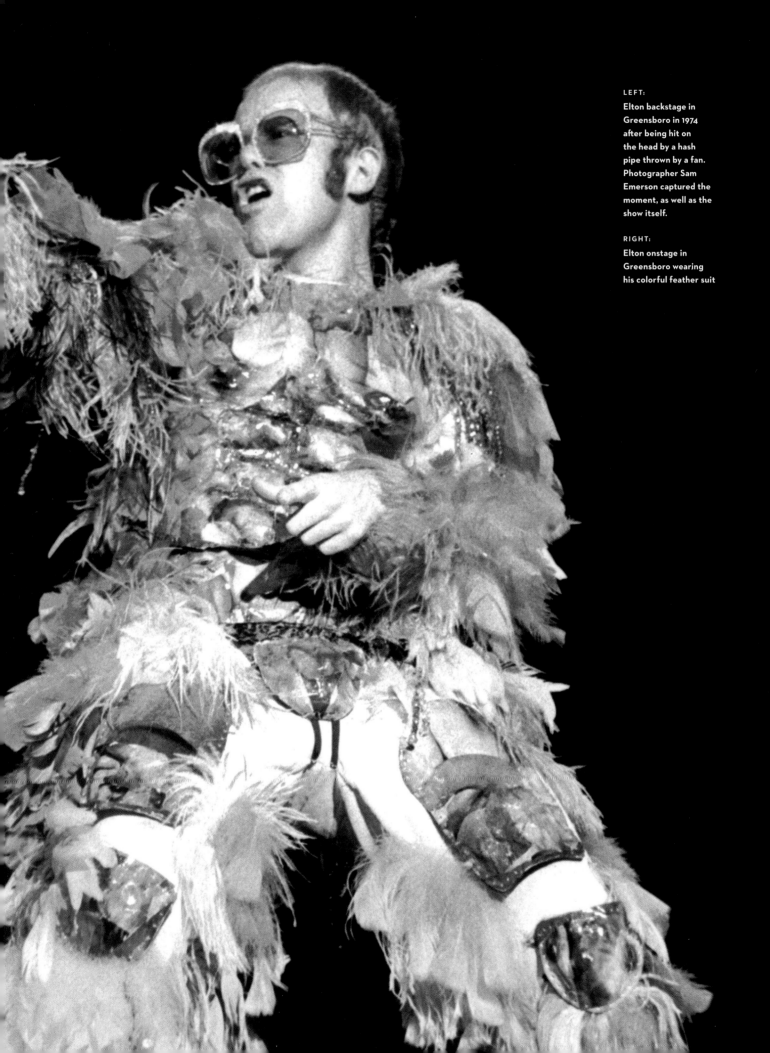

LEFT:
Elton backstage in
Greensboro in 1974
after being hit on
the head by a hash
pipe thrown by a fan.
Photographer Sam
Emerson captured the
moment, as well as the
show itself.

RIGHT:
Elton onstage in
Greensboro wearing
his colorful feather suit

"ELTON JOHN IS A BONA-FIDE ROCK STAR. . . . HOWEVER TRANSITORY OR FLEETING IS HIS ROCK STAR EXISTENCE, NO ONE WAS HAPPIER OR ENJOYED THE NIGHT ANY MORE THAN ELTON JOHN."

★ ★ ★ ★ ★ ★ ★ ★ ★ ★ ★ ★ ★ ★ ★ ★ ★ ★ ★ ★

—*THE DAILY TAR HEEL*, 1973

Elton's feather suit has made numerous onstage appearances over the years. Here he wears it during his 1974 US tour.

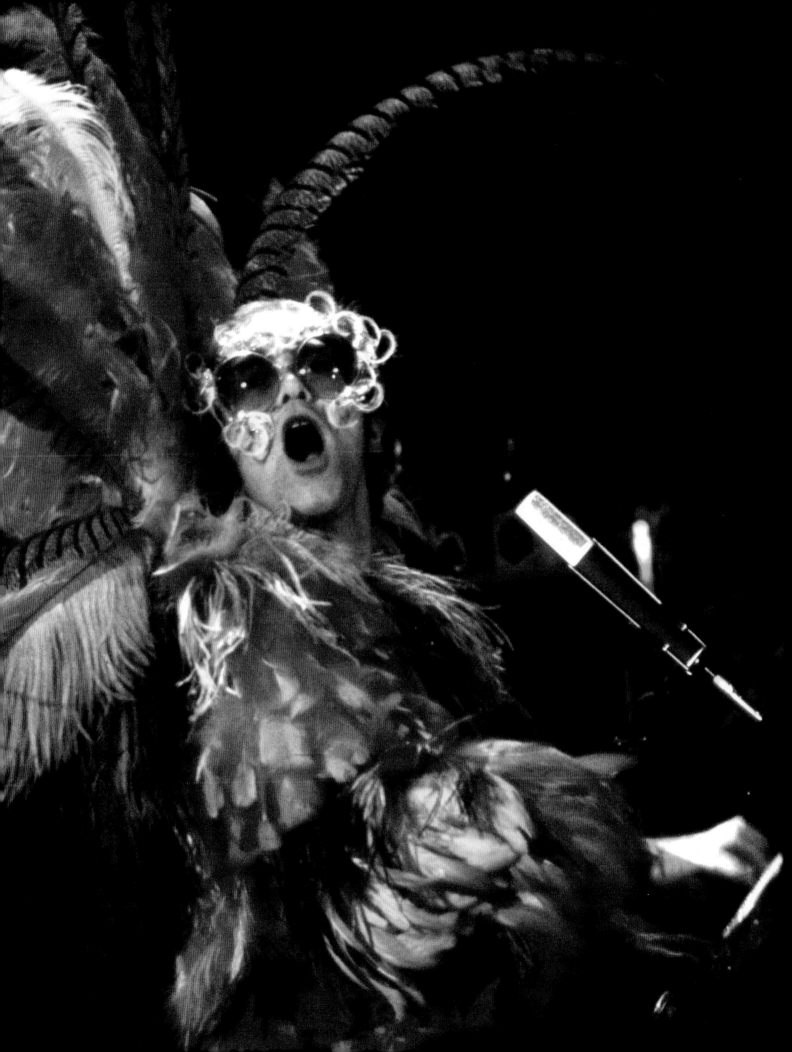

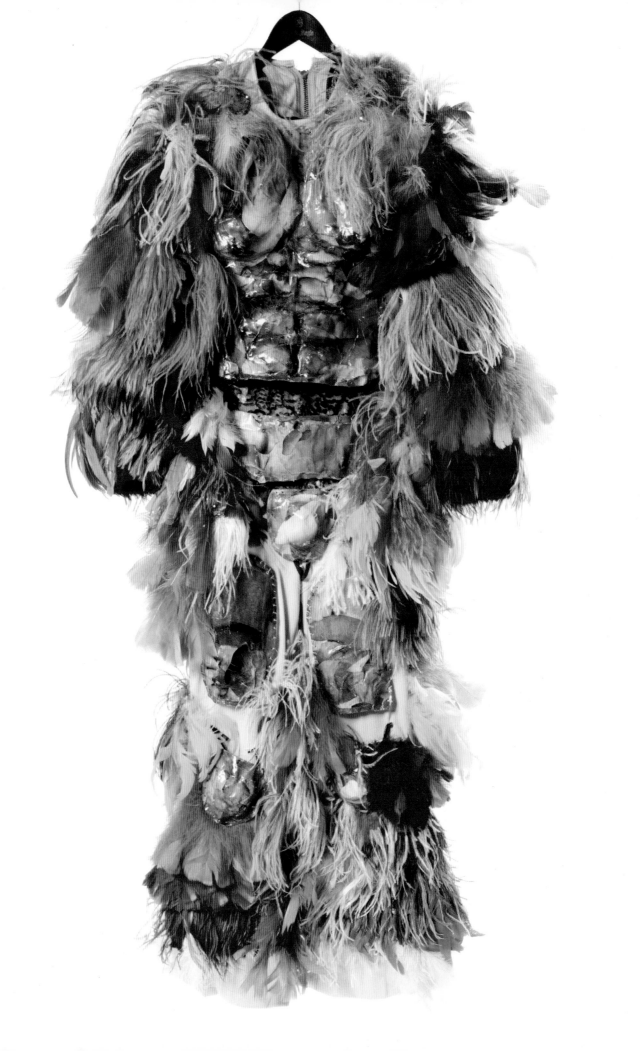

LEFT:
The feather suit has been lovingly preserved in Elton's archive.

ABOVE:
Elton performing on his 1974 US tour, which was well documented by photographer Sam Emerson. The vibrant colors of the costume against his red piano showcase glam rock at its finest.

some of the fans had even been there in 1974, returning to see me play almost forty years down the road. I'm so grateful to all my new fans and to people who have only just discovered me in recent years. But it's amazing to think about how long some of my fans have stuck by my side. They've been with me through it all.

In 1974, I was famous and living a glamorous rock star life, but I wasn't always happy. My life went by in a blur some of the time. I was always on the move, heading to another venue in another city, and there was no rest for the weary. Today, I'm much happier. I'm settled and content. I've relaxed into myself. I imagine that's true for a lot of my fans, as well. As I've grown and changed, so have they, and we've done it together. I certainly don't recommend being smacked in the head with a hash pipe, but it's a good lesson in getting back up when you're knocked down. It's also a reminder not to take everything in life so seriously. There's joy in the ridiculous moments, if you can find it. Take it from the guy in the feather suit: You can.

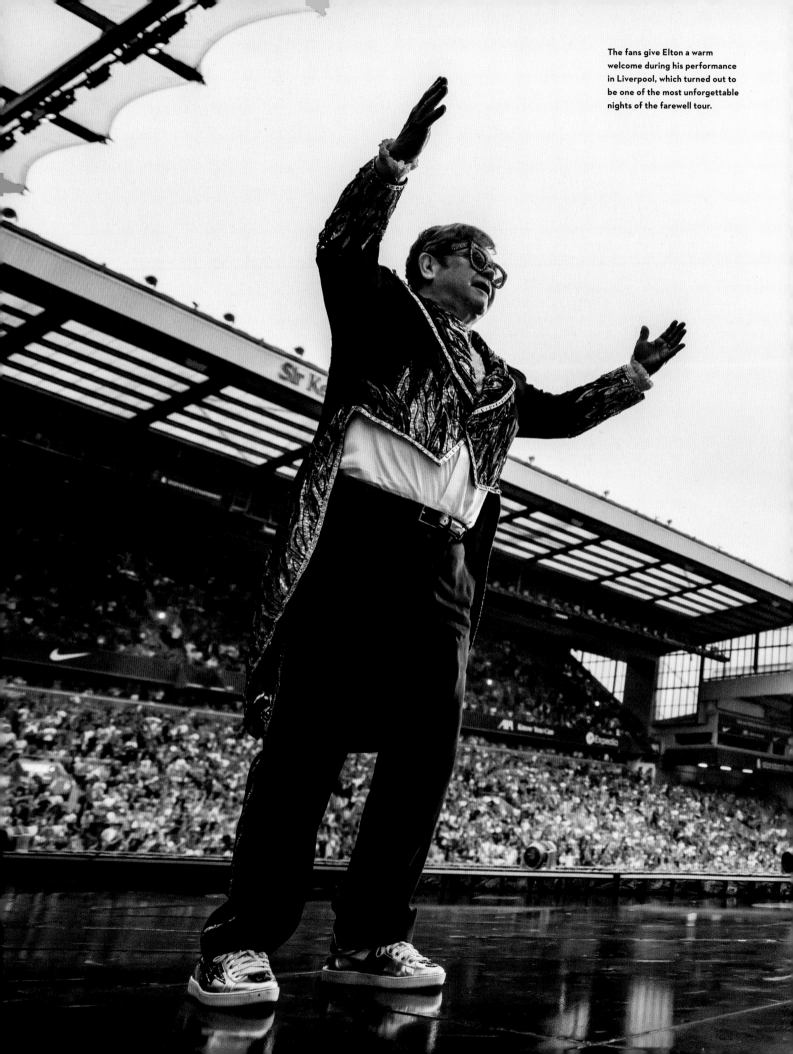

The fans give Elton a warm welcome during his performance in Liverpool, which turned out to be one of the most unforgettable nights of the farewell tour.

TOUR STOP	#231
CITY	**LIVERPOOL, ENGLAND**
DATE	JUNE 17, 2022
VENUE	ANFIELD STADIUM

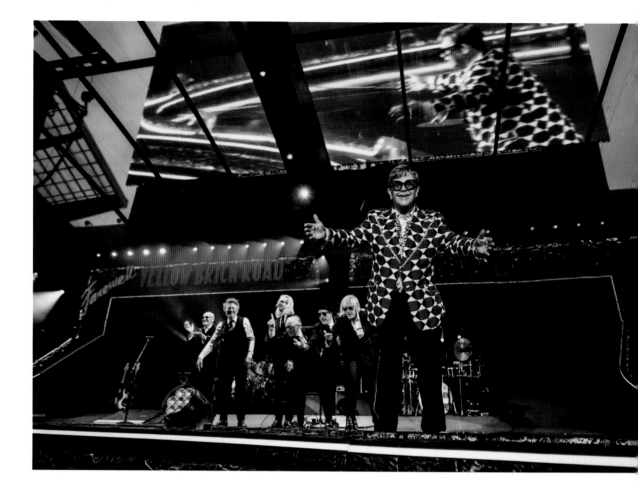

There are certain shows that stand out above all the rest. It's difficult to pinpoint exactly why it happens, but some evenings, standing on a stage in front of an audience, there's a magical reaction. It's happenstance, like my first night at the Troubadour. It's not something you can manufacture or replicate; it just emerges unexpectedly. That's what transpired in Liverpool at Anfield Stadium on June 17, 2022. It was one of the most incredible concerts I've ever played. It's in the top five of my career in terms of the reaction from the audience. It was the most beautiful, heartfelt moment between a performer and his fans.

We finished our North American spring leg in Miami in late April, and the band and I took a few weeks off. We reconvened in Oslo for another two months of shows in Europe and the UK. I was really looking forward to being back onstage in England after the pandemic and my hip surgery. We had gigs booked in a lot of places I really enjoy playing, including Paris, Liverpool, London, and Watford. I hadn't been to Liverpool since 2016, on my summer European tour, but it's a city that feels connected not only to the Beatles and my friend John Lennon, but to my history with Watford FC. As we took the stage on the farewell tour, I was reminded of my previous visit to Anfield, which is home to Liverpool FC. "I've been looking forward to playing this stadium," I told the crowd. "It's like a piece of history for us.

ABOVE:
Elton and his band are overwhelmed with joy as the Liverpool crowd sings "You'll Never Walk Alone."

RIGHT, TOP:
A tour itinerary from 1976, which includes two concerts in Liverpool

RIGHT, BELOW:
Ticket stub from the Empire Theatre in Liverpool

"THE AURA CREATED BY THE GREATEST POP SHOWMAN LIFTED EVERYONE ABOVE THE COUNTRY'S CRISES AND BOOSTED THEM INTO A STATE OF EUPHORIA UNEQUALED AT ANY LIVERPOOL POP CONCERT IN EIGHTEEN MONTHS."

★ ★

—*LIVERPOOL DAILY POST, 1973*

I last came here with my dad when I was chair of Watford and I haven't been back since, so I was determined to put on a good show for you tonight."

I've been performing in Liverpool for my entire career, as far back as when I was in Bluesology. In 1966, we played the Cavern Club as the backing band for Doris Troy, and we returned in 1968 to the Victoria Club once we'd joined up with Long John Baldry. As Elton John, I booked a gig at the Liverpool Philharmonic Hall in early 1971 and I've kept the city on my touring itinerary ever since. In the '70s and '80s, I frequented the Empire Theatre, a beautiful venue in the heart of the city. Later, I moved up to the Echo Arena. But I'd always wanted to take the stage at Anfield Stadium. Although I hadn't performed there before, it almost felt like home.

As I stood in front of the cheering crowd, I could see Kenny Dalglish's stand in the stadium. He's one of the greatest football players of all time. He was in the audience, and I wanted to shine a spotlight on him, if only for a moment. "Kenny, I love you dearly," I told him as the fans roared with enthusiasm. "Thank you for being an inspiration." I dedicated "Don't Let the Sun Go Down on Me" to Sir Kenny. The crowd sang along as the band and I launched into the song. I could feel their appreciation. It's hard to explain, but there was

```
ELTON JOHN U.K. TOUR 1976 - DATE LIST

29th April            Leeds Grand
30th April            Leeds Grand

1st May               Manchester Belle Vue
2nd May               Preston Guildhall
3rd May               Liverpool Empire
4th May               Liverpool Empire
5th May               Leicester De Montfort Hall
6th May               Hanley Victoria Hall
7th May               Wolverhampton Civic Hall
9th May               Croydon Fairfield Hall
11th May              Earls Court, London
12th May              Earls Court, London
13th May              Earls Court, London
16th May              Birmingham Odeon
17th May              Birmingham Odeon
18th May              Sheffield City Hall
20th May              Newcastle City Hall
21st May              Edinburgh Usher Hall
22nd May              Dundee Caird Hall
24th May              Glasgow Apollo
25th May              Glasgow Apollo  (Also Extra Midnight Show)
27th May              Coventry New Theatre
28th May              Coventry New Theatre
29th May              Southampton Gaumont
30th May              Taunton Odeon
31st May              Bristol Hippodrome

1st June              Bristol Hippodrome
3rd June              Cardiff Capitol
4th June              Cardiff Capitol
```

Plus one show at Bailey's nightcluf Watford which is an independent Promotion on May 14th, 1976.

"PEOPLE WERE
SINGING INTO
DRINK BOTTLE
MICROPHONES,
DANCING
AROUND ON
THE PITCH, AND
IT FELT LIKE THE
WHOLE STADIUM
WANTED THE
NIGHT TO GO
ON FOREVER."

★ ★ ★ ★ ★ ★ ★ ★ ★ ★ ★ ★ ★ ★ ★ ★

—LIVERPOOL ECHO, 2022

something palpable in the air. Everyone really wanted to be in that stadium together. There was a great sense of love between the audience, the band, and myself.

Liverpool's football fans are a passionate group. Since the 1960s, they've sung Gerry and the Pacemakers' version of the Broadway musical number "You'll Never Walk Alone," and Liverpool FC later adopted the title as their motto. The song is in their blood. Usually, the fans belt it out during football matches, both in Anfield and at away games. But they've also been known to bring it out during concerts. It's a true honor for a Liverpool crowd to sing "You'll Never Walk Alone" in unison, so I was shocked when the entire stadium joined their voices together after I left the stage. I couldn't believe it. It was so touching, so unexpected. A real out-of-body experience. My shows always get great responses, but that surge of love coming from the audience in Liverpool was unbelievable. There was so much passion. Their human spirit was so strong, and I was really moved by it.

I was so moved, in fact, I was almost speechless. That doesn't happen often. I remember having a similar feeling at the Troubadour and during my performance with John Lennon at Madison Square Garden. It also happened in Adelaide, Australia, when I was playing with an orchestra in the '80s. And it happened once in Paris—that night was extraordinary. Those moments onstage are joyful, celebratory, and almost hedonistic in nature. But it doesn't occur at every show. It comes once a year, or once every five years, or even once in a lifetime. You can't predict when the right crowd will come together in exactly the right way. It's something you chase throughout your career as a performing artist. It can feel similar to being an addict: You just want more and more and more.

People have asked if I'm sad to leave the possibility of that feeling behind. But the truth is, I've had enough. I can't get any more applause than I've had. Those special moments stay with you because they're very, very special. But I've had my fill. I'm so grateful for a career that has given me the opportunity to experience that sort of reaction from an audience more than once over the years. It's inexplicable

Elton graciously welcomes the audience to an epic show in Liverpool.

and almost holy. That night in Liverpool, as the fans' voices filled the stadium with "You'll Never Walk Alone," an incredible tingling came over my body. I was at one with the crowd, and they were at one with me. It was momentous. I returned to the stage. After a moment sitting at my piano, I gathered myself back together.

"This has been one of the greatest shows and greatest venues I've played in my career," I marveled. There was an uproar of cheers from the audience. I could hear shouts of love and encouragement. I understood how much they would miss me. And I knew I would miss them, as well. "I've played a lot of shows," I said, my voice choked with emotion. "When I was younger I even played at the Cavern. What a beautiful city, what a beautiful stadium, what a beautiful heart you have."

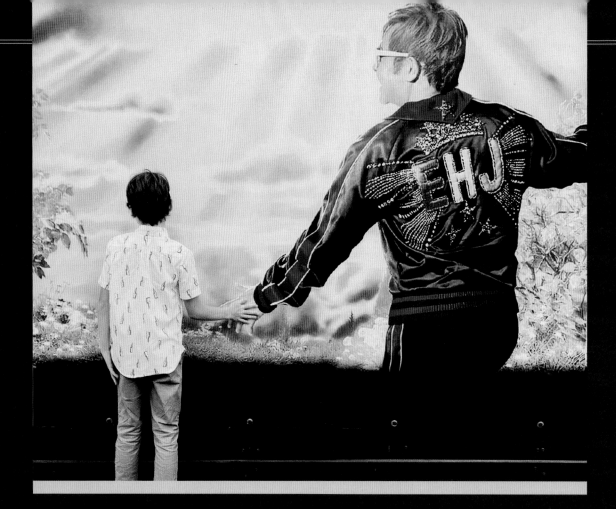

FAN REMEMBRANCES

For decades, Elton John's fans have stood by his side. They've turned up to gigs all over the world, and sent his records and albums up the charts. Their support has meant the world to the performer, who wanted to dedicate his final tour to fans new and old, who've been there singing along. Many fans have seen Elton perform numerous times throughout the years, while others saw him play for the first time on the Farewell Yellow Brick Road Tour. Their experiences and emotions may differ, but they have a collective love for Elton and his music. While it would be impossible to spotlight everyone's favorite memory of the farewell tour, this glimpse reveals a deep, undying devotion to the singer that will continue to resonate long after he leaves the stage.

"It was such a special moment to take my entire family along to the performance in Melbourne, Australia. The very first concert I ever went to was Elton with the Melbourne Symphony Orchestra in my hometown of Sydney in December 1986. This performance brought the experience full circle for me. My sons still refer to this as their favorite concert ever, and they have been to more than a few! Thanks, Elton, and much love."

KEN GILLESPIE
BOX HILL, AUSTRALIA

"My dad had me listening to Elton John from the moment I could walk. It was always my dream to bring my dad to see Elton John to thank him for making me the musician I am and the person I am. When I moved to Vancouver in 2020 and then Covid hit, I didn't think that dream would be possible anymore, but in October 2022 my dad made the long trip from Dublin to Vancouver so that I could take him to the farewell tour on Elton's last night in Vancouver. That night meant the absolute world to both me and my dad, and we made memories that we will cherish forever. My dad hasn't taken off his Elton John tour T-shirt since he got home."

EMMA QUINN
VANCOUVER, BRITISH COLUMBIA

"Seeing Elton John perform was one of the best things I have ever experienced. Hearing his music live and being in the front row felt like a dream. His music has made me an amazing person and has changed my life."

DANA SALEH
MILL CREEK, WASHINGTON

"**M**y family and I flew from Mexico City to San Antonio to see Elton one last time. That night, Saturday, October 29, became the best night of my life. I'm twenty-six years old, and Elton changed my life. Since I was a kid, I listened to Bernie and Elton's music for confidence and comfort. I used to get bullied at school, and whenever I hear their music it feels like home, like a safe place where I can be myself. I even learned to play the piano because of Elton. It was an emotional, surreal experience. And like I said before: the greatest night of my life."

FÉLIX W. RAMÍREZ
MEXICO CITY, MEXICO

"**I**t was overwhelming joy to see Elton again in concert—I'm now at seventy concerts since 1976. I got to attend my sixty-eighth Elton concert in Cleveland, Ohio, with my thirty-seven-year-old son. The last time my son went with me to see Elton in concert he was twelve! My circle of life."

NANCY BOSS
KETTERING, OHIO

"**E**lton's final show in North America at Dodger Stadium was my one hundred and fourteenth concert since first seeing him in Boston in 1974. As with every concert of his—but even more so because of the circumstances—it left me both invigorated and exhausted; full of joy and emotionally drained; amazed at his stamina and in need of a long nap myself. But, most of all, it felt like home. And for the past forty-eight years there has been no place like it. Thank you, Elton, from my fourteen-year-old and current self."

JOHN F. HIGGINS
CAMBRIDGE, MASSACHUSETTS

"**W**e flew from Peru to attend two magical concerts in New York and New Jersey in 2022. It was such an amazing experience to be surrounded by other fans, singing our favorite songs and enjoying every second. Elton's outfits, the story of overcoming challenges, and his music and lyrics all play a big role in our lives."

JUVENAL LUNA ORTEGA
& SHEYLA ESPARZA TREBEJO
LIMA, PERU

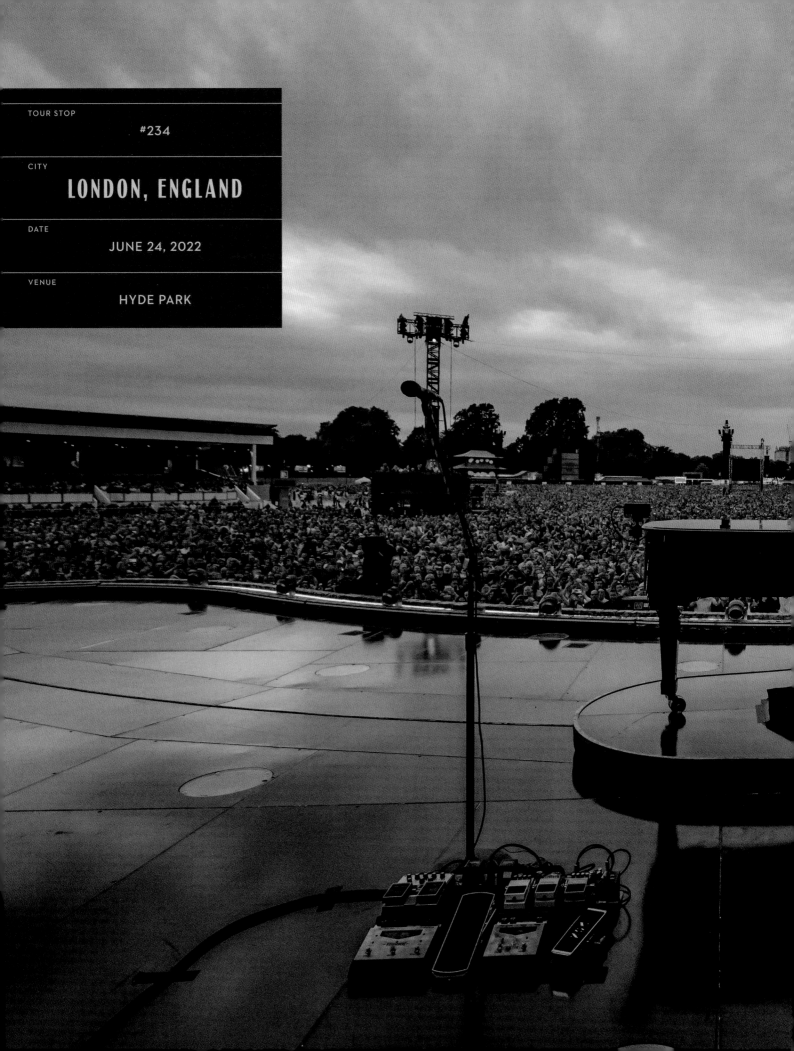

TOUR STOP

#234

CITY

LONDON, ENGLAND

DATE

JUNE 24, 2022

VENUE

HYDE PARK

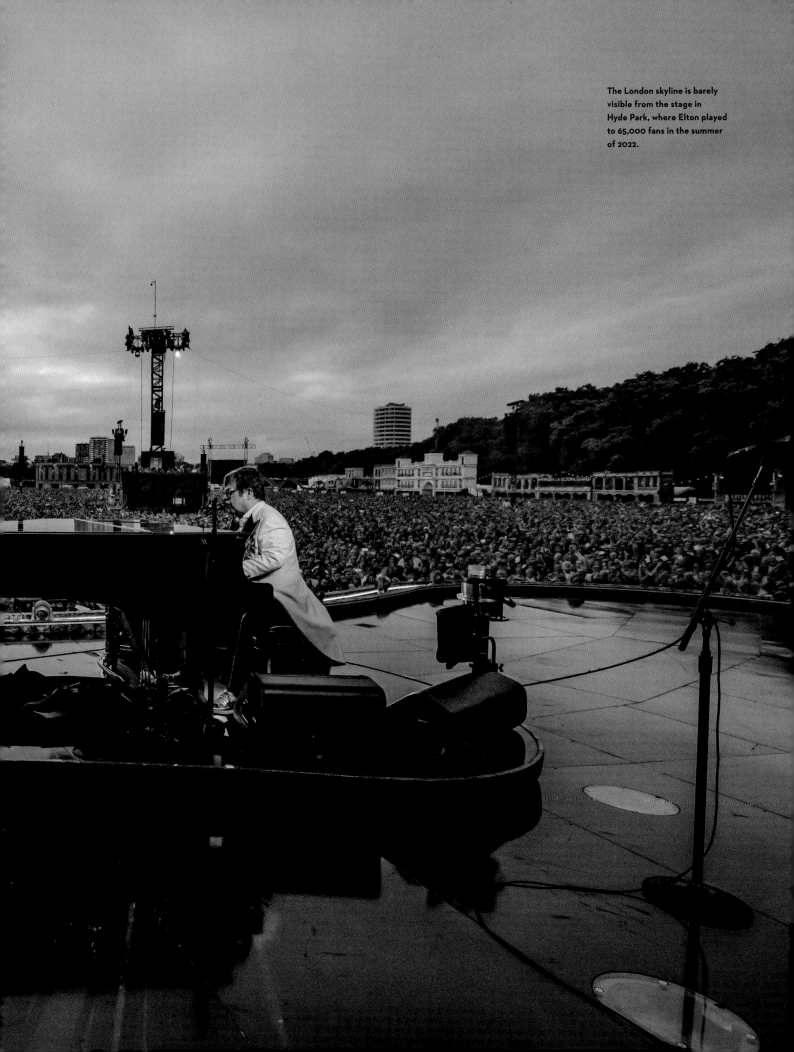

The London skyline is barely visible from the stage in Hyde Park, where Elton played to 65,000 fans in the summer of 2022.

Although I'm now a global artist, London will always be my hometown. It's where I grew up, where I got my start, and where I've performed so many times throughout my career. It hasn't always been the easiest city, but it's the one closest to my heart. Without London, I wouldn't be the British pop star I am today. I've had a lot of big moments in London, from taking the stage at Wembley during Live Aid in 1985 to performing during Queen Elizabeth II's Platinum Jubilee in 2022. But perhaps one of the biggest was bringing the Farewell Yellow Brick Road Tour to Hyde Park for the British Summer Time concert series.

As we were booking the concert in Hyde Park, the promoter asked if I wanted to select the acts who would open the show. "Anyone?" I asked. I had a lot of ideas. "Yes, anyone," they agreed. I wanted to offer a showcase to up-and-coming artists whose music I liked. Instead of focusing on the most established musicians or bands, I wanted my opening acts to reflect what I believed to be the future of music. I selected Juanita Euka, Tom A. Smith, Thomas Headon, Berwyn, Let's Eat Grandma, Gabriels, and Rina Sawayama. The entire lineup was handpicked by me, which felt very special. It was also set to be the biggest show on the farewell tour, with sixty-five thousand tickets being sold.

The show came in the midst of the same European and UK tour leg as Liverpool, so emotion and excitement were high. I had played Hyde Park before, but this really felt like my show. I met all the other artists before my set and had pictures taken with them backstage. Despite the positive vibe, there were a few hurdles. Performing in a giant outdoor park is challenging, to say the least. We took the stage as the sun was setting, and it was freezing. A park can be an especially awkward venue because the sound and

the applause go straight up into the air. They almost vanish because there is nothing for them to bounce off of. I found it difficult to start. It took me a few songs to get the hang of the sound. Everyone in the crowd was standing, and I could see this massive sea of people against the London skyline, but I couldn't hear them.

It's hard to pull off shows like that. I've encountered similar challenges at big music festivals. You have to really rely on your experience to know that the crowd is having a good time even if you can't hear it or feel it. But I quickly got used to it—you can get used to playing almost anywhere after a while—and the crowd was fantastic. By the end of the night, it felt phenomenal. It was magic to play my music to that many people in the center of Hyde Park.

I felt somewhat nostalgic before and after the concert. It was emotional because our sons were in the audience. David couldn't be there because he was working on another Elton John project, but it was so meaningful to have my children be part of a night like that. It was hard to fathom how much had changed for me in London over the past five decades. As a young performer, I found British

Elton and Rina Sawayama pose backstage at the Hyde Park concert. The pair became friends after Elton sang on one of her singles and she appeared on his *Rocket Hour* show. Her costume references his vibrant onstage looks.

In 1970, Elton performed as part of Pop Proms at the Roundhouse in London. This advertisement appeared in *New Musical Express* ahead of the week of shows.

audiences difficult. I used to dread doing tours in England because the crowds were quiet and stoic. I could never properly gauge the reaction. So much about a concert is that connection between the audience and the musician. American fans were much livelier and noisier. You knew where you stood with them. But over the years, the Brits have opened up. The crowds here have gotten so much better. Hyde Park was living proof of that.

During the 1960s, I played all over London with Bluesology. The Flamingo Club, the Marquee Club, Klooks Kleek, and the Cue Club were our most frequent venues, but we also performed at Birdland, Whisky-A-Go-Go, Cromwellian, New All Star Club, and many more. After I became Elton John, I continued touring England, with an emphasis on London. My first official solo gig was on April 30, 1968, at London's Marquee Club, a venue I knew very well, having performed there more than twenty times prior with Bluesology and Long John Baldry. I did another show there later that year, and then hit the Revolution Club in Mayfair on my twenty-third birthday, March 25, 1970. At the time, I was promoting my self-titled LP. It was great fun.

By April, I'd booked the Roundhouse as part of the second night of the BBC's Pop Proms alongside Tyrannosaurus Rex (later known as T. Rex), Pretty Things, and Heavy Jelly. John Peel was the host. My set lasted for about an hour, and the

"THE SIZE OF THE CROWD WAS A TRIBUTE TO HIS RECENT SUCCESS IN AMERICA, BUT THEY WERE ENRAPTURED BY ACHIEVEMENT RATHER THAN MERE REPUTATION. . . . ALREADY, HE'S A GIANT."

★ ★ ★ ★ ★ ★ ★ ★ ★ ★ ★ ★ ★ ★ ★ ★ ★

—MELODY MAKER, 1970

Elton onstage at Royal Festival Hall, a venue he played several times in the early 1970s. David Larkham took this photograph during the afternoon rehearsal.

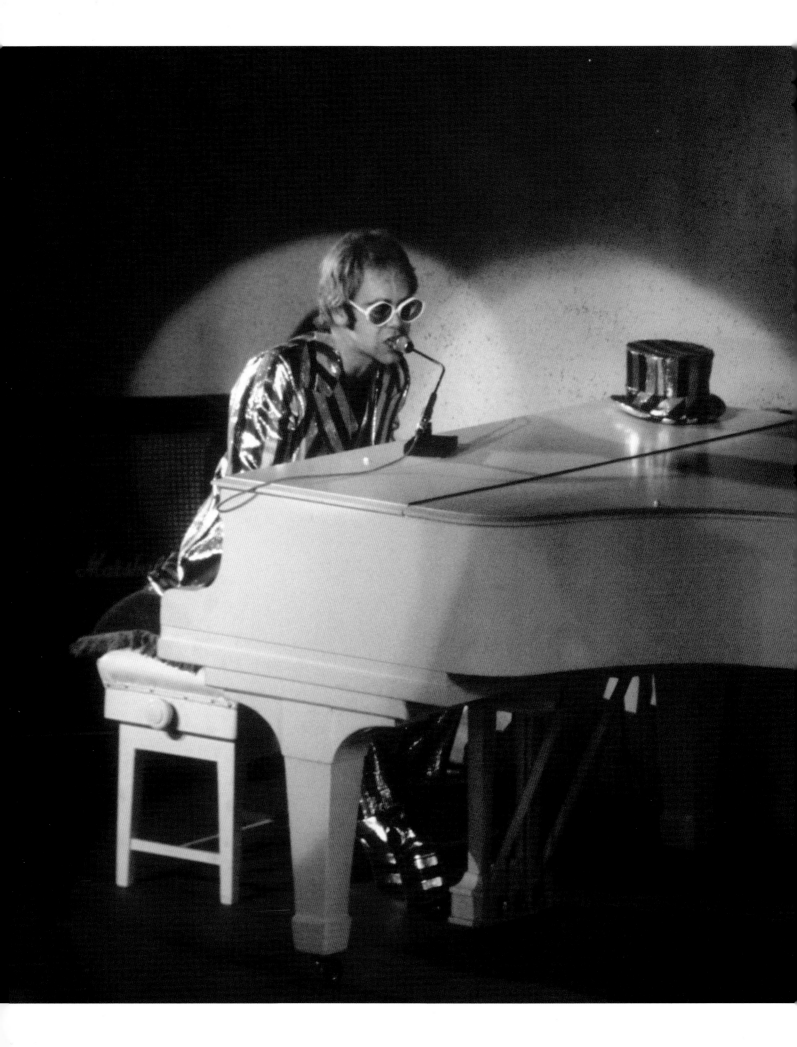

LEFT:
Elton performing as
part of the Royal Variety
Performance at the London
Palladium in 1972

RIGHT:
The cover of the Royal
Variety Performance's
official program, which
Elton has kept in his archive

*Royal
Performance
in the presence of
Her Majesty
The Queen Mother
on the Evening of
Monday October 30ᵗʰ 1972
at
The Palladium
London*

reviews were solid. In the *Record Mirror*, Robert Partridge called me "Britain's first real answer to Neil Young and Van Morrison"—an accolade I quite enjoyed. I was over the moon to be compared to Neil Young. I returned to the Roundhouse several more times that year. It began to feel like a good home base for me and the band in London.

Before we left on our flagship American tour, I performed at the Hampstead Country Club, the Revolution Club, and several other venues around town. But it was after we returned from America that things began to really get wild. Expectations were high, to say the least. The reviews from America had picked up steam, and people were anxious to see what all the hype was about. On October 2, 1970, I was invited to open for Fotheringay, a British folk-rock group led by singer Sandy Denny, at Royal Albert Hall. Even though the historic venue was much bigger than I was accustomed to, I had the audience up on their feet during my double-whammy finale of "Burn Down the Mission" and Elvis Presley's "My Baby Left Me."

It felt like a triumphant return to my home country, even if I wasn't the headliner. In a review in *Sounds*, Penny Valentine mused, "Putting Elton John second billing to Fotheringay at the Royal Albert Hall on Friday night was a taste of mistaken booking if there ever was one." She added, "John has reached the status now where it is improper to see him anywhere but topping the bill—and certainly Fotheringay . . . found it impossible to follow him." It was validating to see someone acknowledge my performances in America weren't a blip. I could bring these high-energy shows anywhere in the world, to venues big and small, even with tricky British crowds.

It's difficult to top the prestige of Royal Albert Hall as a performer. But I managed it in 1971 when I headlined Royal Festival Hall in March with a full orchestra. It was billed as "the first major London concert appearance of Elton John," which wasn't entirely true, but it aptly captured the significance of the moment. It was a milestone in my touring career, certainly, and it felt like the first time I was able to bring my full spectacle to the stage in London. It seemed like everyone turned up for the show. Marc Bolan, Long John Baldry, Leon Russell, my close friend Muff

"IT IS A RARE KIND OF SHOWMAN THAT MANAGES TO TRANSFIX A 65,000-STRONG CROWD WHILE STAYING FIRMLY SEATED ON HIS PIANO STOOL."

★ ★

—EVENING STANDARD, 2022

Winwood, and Bernie were all in the sold-out audience. Performing with an orchestra was incredible. The sheer scope of the songs with strings, harps, and brass revealed a lot of possibilities for the future.

The shows in London were plentiful, even as I began touring around the world. In the summer of 1971, we played at the Crystal Palace Bowl for an event dubbed Garden Party II. It deluged rain outside, but inside the crowd was lively. We performed at Royal Festival Hall again in 1972, and returned to Crystal Palace for Garden Party III to sit in with the Beach Boys the same year. On October 30, 1972, I was invited to be part of the lineup at the Royal Variety Command Performance at the London Palladium. The Jackson Five, Liberace, and Jack Jones were also on the bill, and the Queen herself sat in the audience, presiding over the evening.

The day before, the venue received a telephone call with a bomb threat, and security guards showed up during rehearsals to search our instrument cases. It was an enjoyable bit of drama, but the show itself wasn't very lively, although not for lack of trying. I played "I Think I'm Going to Kill Myself" with tap dancer "Legs" Larry Smith against the concert organizer's objections and enlisted my sound tech, Clive Franks, to dress up in a crocodile costume and play organ during "Crocodile Rock."

One of my most fond memories of playing in London was the Elton John Christmas Party concerts I held at the Hammersmith Odeon in the winter of 1973. The band and I did five shows in four nights, which involved as much theatricality as I could cram onto a stage. The performances were so much fun that we did them again in 1974 over five more nights. Both years, I donned flamboyant outfits and set out to give everyone a great time. One of the 1973 shows was recorded for broadcast, and there's still a bootleg of it floating around, complete with me performing "Rudolph the Red-Nosed Reindeer."

My biggest show up to that time occurred in 1975, when I joined the bill for the Midsummer Music festival at Wembley Stadium. The crowd was absolutely massive. More than seventy-two thousand people crammed into the stadium to see me play alongside the Beach Boys, Eagles, Rufus featuring Chaka Khan, and Joe Walsh. Reportedly, it was the largest concert England had seen in years. I was nervous, which was unlike me. I had a new band—I'd fired Nigel and Dee, an act I later regretted—and although we'd rehearsed for several weeks in Amsterdam, it was a lot of pressure.

I decided to play my new album, *Captain Fantastic and the Brown Dirt Cowboy*, in sequence, which I knew might be a mistake. There was some trepidation from

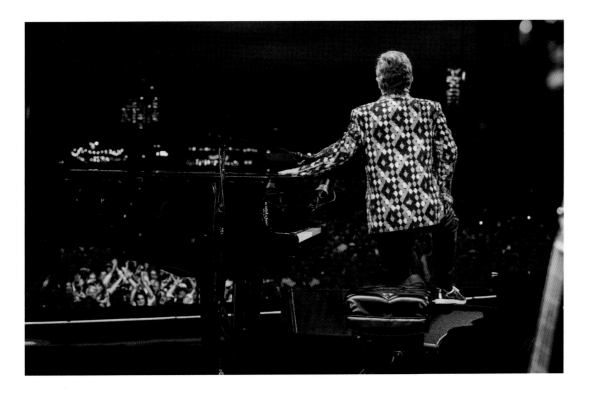

Elton takes a triumphant bow onstage in Hyde Park on his farewell tour, looking out over the crowd and the London skyline at night.

the crowd, especially during the songs they didn't know, and in fact some seemed to meander away while I played. But I've always felt it's important to take risks. It's not always a home run, but it's worth the chance it could be. On this occasion, however, I can admit it completely backfired. The show was an absolutely horrible experience. I learned an important lesson that day: You have to play the hits.

London was included on every tour itinerary I had going forward. Earls Court Arena in 1976 on the Louder Than Concorde tour, the Rainbow Theatre in 1977 on my first series of two-man shows with Ray Cooper, and the Theatre Royal Drury Lane in 1979 on the A Single Man tour. In 1982, I decided to spotlight my home country and embarked on the On Tour in the U.K. tour. During that run, I performed for sixteen straight nights at the Hammersmith Odeon. Every show sold out. I made guest appearances during other artists' concerts, including walk-on performances with Boy George and Tina Turner, both at Wembley Arena in the 1980s. I popped onstage during Wham!'s final concert in 1986, and played numerous benefit shows for the Prince's Trust. My annual world tours brought me back time and time again to Wembley Arena and Wembley Stadium. Ray and I did a lengthy stint at Royal Albert Hall in 1994, which was great fun.

By the time my farewell tour came to an end in 2023, I had performed one hundred and seventy-eight public concerts in London during the course of my career. That doesn't even count the private shows and the TV and radio performances—and there have been many of those as well. London has had a substantial impact on me as a performer. The crowds have loosened up over the years, and I've grown to really love a hometown gig. Although my future remains uncertain, I imagine there are more shows to be played in London. Maybe a short residency at a smaller venue where I can unearth some of my lesser-played songs. Something more intimate and connected. They say you can never go home again, and sometimes that's true, but London feels like part of my past and part of my future simultaneously. I have a lot of memories here, but I still have many more to make.

REMEMBERING LIVE AID

"MICK JAGGER SHRED THREE SHIRTS, TORE BITS OF LEATHER OFF TINA TURNER AND, STILL GASPING IT WAS ONLY ROCK AND ROLL, MOLTED HIS TROUSERS [TO] SHOW PSYCHEDELIC GREEN LONG JOHNS. ONLY ELTON JOHN CAN BE MENTIONED IN THE SAME BREATH. IN PURPLE, GOLD, DIAMOND EARRINGS, AND A TOQUE HE LOOKED LIKE QUEEN MARY GONE MAGNIFICENTLY OFF HER HEAD, THOUGH HE KEPT INSISTING HE WAS A ROCKET MAN."

★ ★

—*THE GUARDIAN*, 1985

There are some shows you love for the performance itself, and there are some you remember for what happened off the stage. Live Aid is the latter. In 1985, Bob Geldof and Midge Ure organized a concert to raise funds for famine relief in Ethiopia. They'd previously released the single "Do They Know It's Christmas?" in December, although I wasn't on that record. Live Aid was planned as two simultaneous concerts, one at Wembley Stadium in London and one at John F. Kennedy Stadium in Philadelphia. Thousands of people would attend, and millions more would watch on their televisions worldwide. I was invited by Bob, who called and told me that Queen and David Bowie had already agreed to perform. He told them the same thing about me.

I was part of the bill at Wembley along with Queen, Elvis Costello, U2, David Bowie, and the Who. I performed the day's longest set, which included a duet of my song "Don't Let the Sun Go Down on Me" with George Michael. I hated the entire show, except for Queen. It was a brilliant event, but I'm not keen on those sorts of things. It wasn't my type of gig. At the end, all the performers came back out on the stage to sing "Do They Know It's Christmas?" Everyone was jostling to get the microphone, but I just left. Mick Jagger did the same thing at the American concert. It might be surprising for fans to hear, but I didn't like performing at Live Aid despite the scope of the event.

Backstage, however, I had a ball. I decorated my own little area and set up a barbecue. I made sure there were seats for everyone so that the other people who were playing could come sit down and chat. Lots of the performers stopped by to have a drink, and I was entertaining everybody. Princess Diana was there, and someone photographed her with George Michael and me. I enjoyed the social part of Live Aid. It was really lovely. The actual playing? Not so much. Memorably, after

Queen's performance, Freddie Mercury came over and announced to me that his band had stolen the show. And the truth was, they absolutely had.

"Freddie, nobody should go on after you," I confirmed. "You were magnificent." He was buzzing with excitement. "You're absolutely right, darling, we were," Freddie told me. "We killed them. You, on the other hand, dear, you looked like the fucking Queen Mother when you were onstage. Where did you get that absolutely awful hat?" But I wasn't offended. It was a very Freddie comment to make. He always said something that would make me laugh, even later when he was dying. I had the best time with him.

When I look back, that memory of him backstage at Live Aid is one of my absolute favorites. Although the concert itself wasn't particularly special to me, I reflect fondly on those moments behind the scenes, especially with Freddie. And the truth is, not every show can be your favorite. I've performed thousands of times, and so many of them have been incredible. But I'm a solo artist for a reason. I have my band, who are integral to my concerts, but I prefer the nights where I connect with an audience that has come to see me.

In the years since Live Aid, I've played a few other charity shows, and I'm glad to have done them because the causes were important. In 2005, I performed as part of Live 8 in Hyde Park, where I sang a duet with Pete Doherty, who was stoned out of his mind. The thought behind the show, to raise awareness and money for global poverty, was fantastic. But Hyde Park felt like a charisma-free zone that day. Musically, it wasn't a highlight for me.

Still, I believe in using my platform to help raise money and awareness, which was what Live Aid was all about. But I don't look back wistfully on that day at Wembley Stadium. My touring career has been tremendous. I'm proud to have been part of something as historic as Live Aid, even if I didn't particularly enjoy the performance. And Freddie was right about the hat.

Elton performing as part of the star-studded finale of Live Aid at Wembley Stadium. Other performers included David Bowie, George Michael, Sting, Roger Daltrey, Paul Weller, Freddie Mercury, Adam Ant, and Bono.

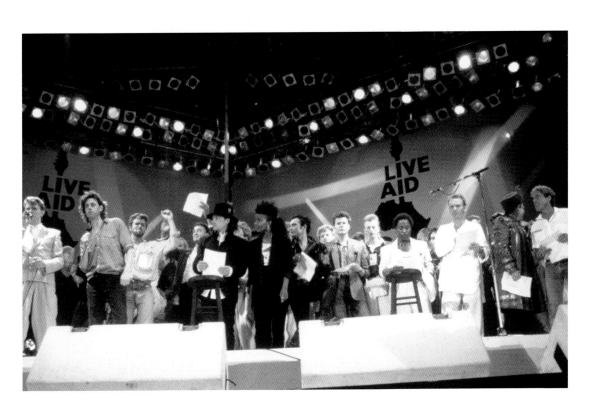

181 ★

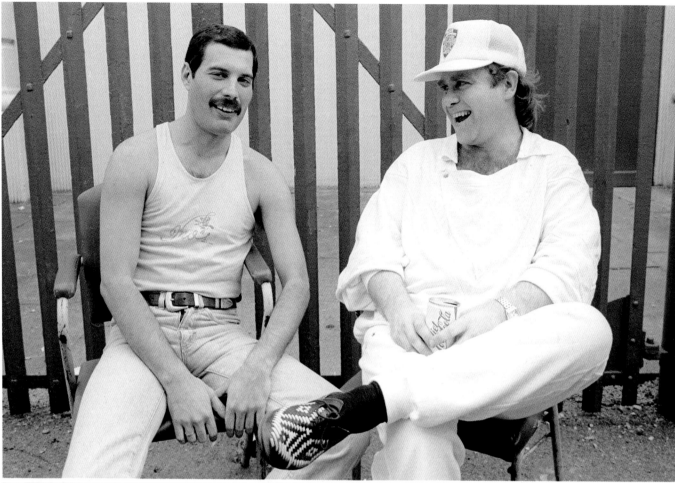

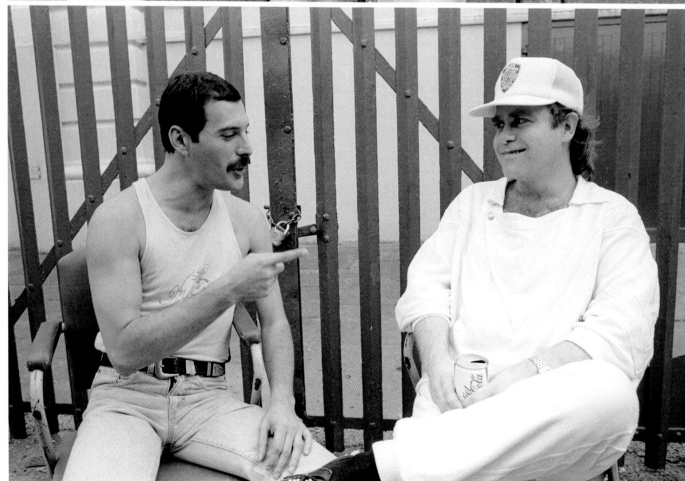

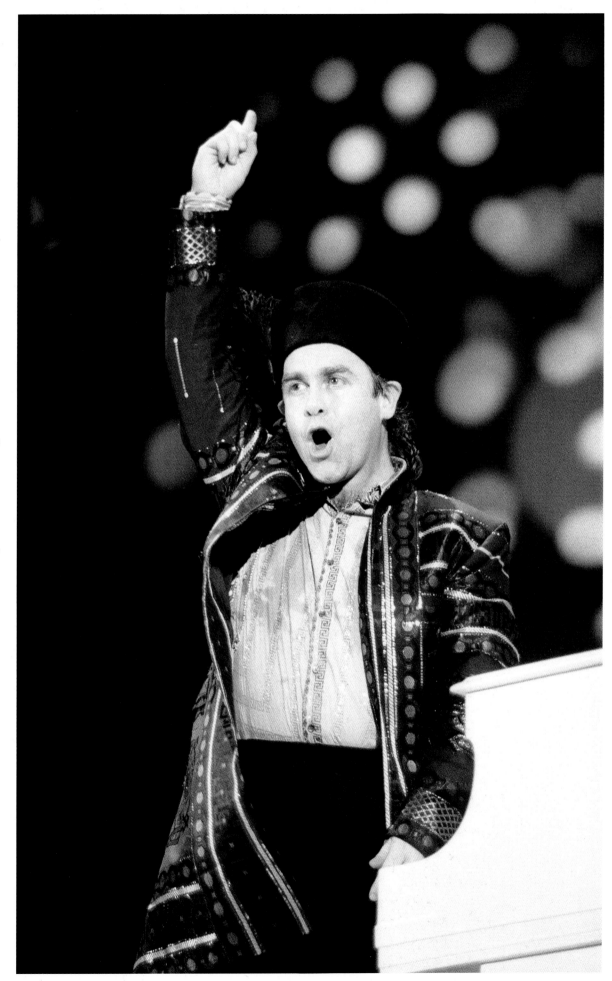

LEFT:
Photographer Richard
Young shot Elton
backstage at Live Aid
with Freddie Mercury
next to Elton's mobile
home dressing room
and barbecue grill. The
singer cooked burgers
for all his visitors.

RIGHT:
Elton performed six
songs during Live Aid
and welcomed three
special guests onstage,
including Kiki Dee,
Andrew Ridgeley,
and George Michael.
Elton poses onstage
at Live Aid wearing his
infamous hat, made by
Kenneth D. King.

THE FAREWELL TOUR MERCHANDISE

To celebrate Elton John's final tour, the musician's team wanted to give fans lots of options for memorable tour merchandise. Many of the apparel items paid homage to Elton's storied career, including a baseball jersey and a "Bennie and the Jets" T-shirt. Fans could also buy hats, tote bags, key rings, mugs, and commemorative laminates. The most popular merch? Red-and-blue flashing LED glasses, the perfect accessory for the Farewell Yellow Brick Road Tour. For those feeling a bit emotional, there was a pack of branded tissues to wipe away any tears. But don't be too sad—all the merchandise will remind fans of their fond memories from Elton's last global adventure for years to come.

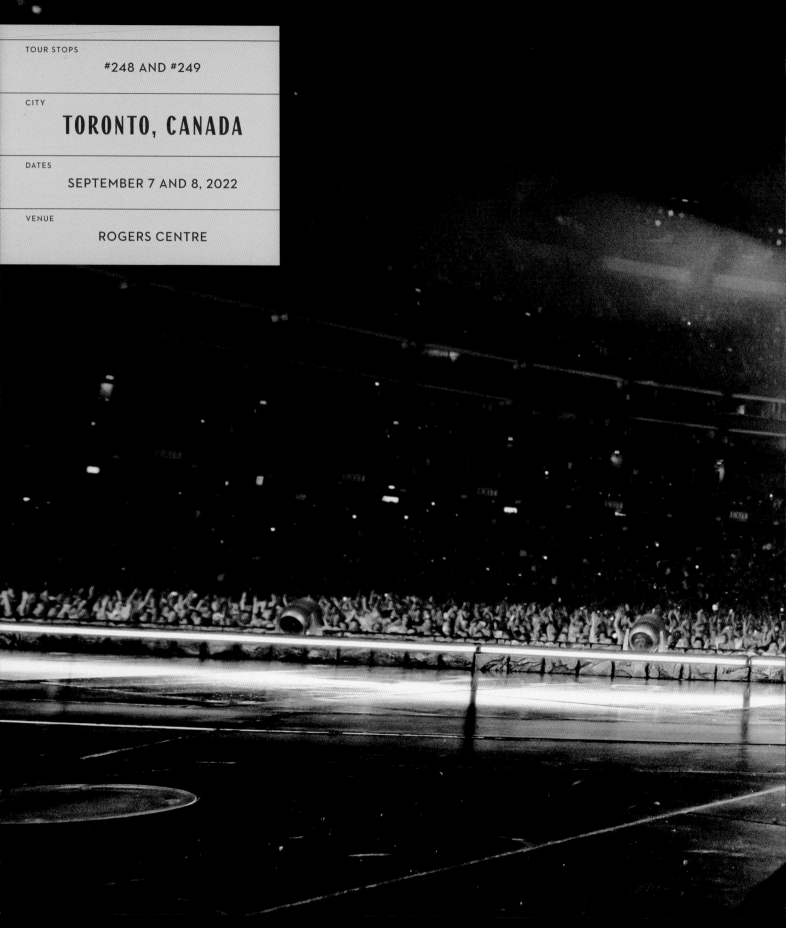

TOUR STOPS
#248 AND #249

CITY
TORONTO, CANADA

DATES
SEPTEMBER 7 AND 8, 2022

VENUE
ROGERS CENTRE

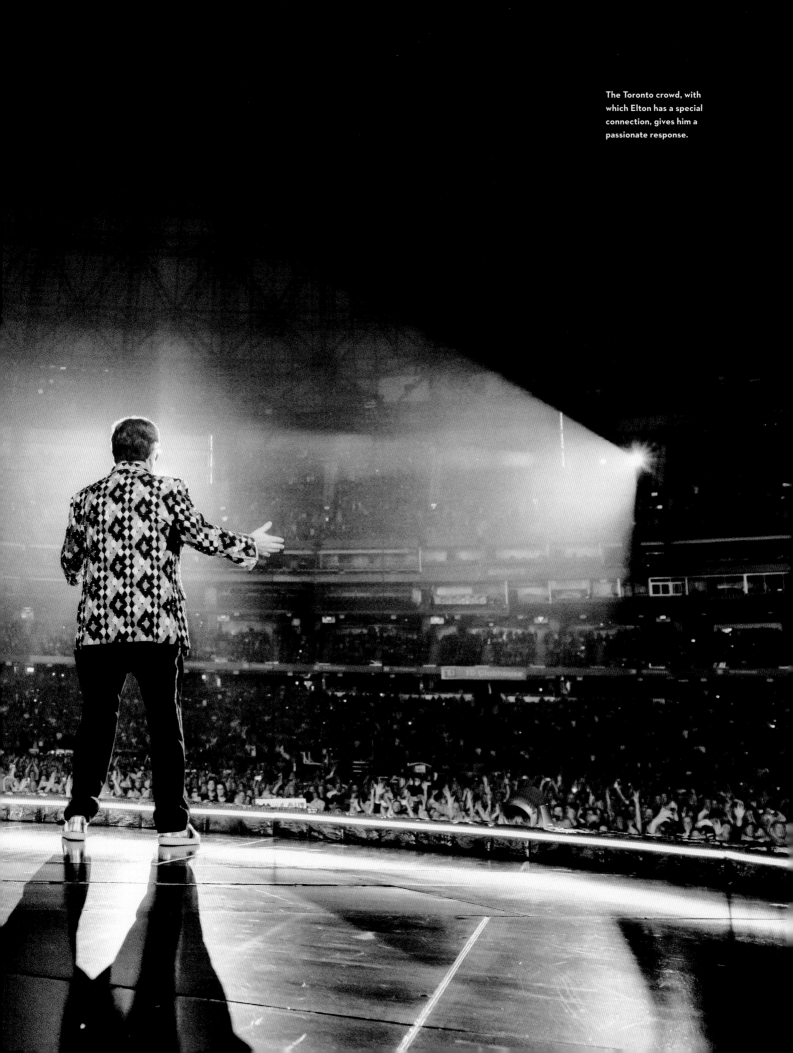

The Toronto crowd, with which Elton has a special connection, gives him a passionate response.

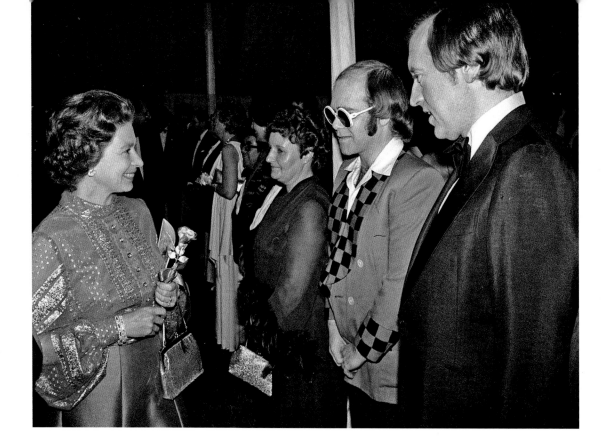

n 1998, I was knighted by Queen Elizabeth II at Buckingham Palace. I'd known the British royal family for many years. Princess Margaret came to a few of my concerts, and Princess Anne and the Queen Mother both professed their love of my music. I met Princess Diana in 1981, and we immediately clicked and became great friends. She attended Live Aid in 1985, and I performed for her at a Prince's Trust concert in 1997.

Queen Elizabeth was an icon to me, but she was also someone I knew personally and who I'd celebrated onstage many times. In 2012, it was a great honor to perform at the Queen's Diamond Jubilee Concert outside Buckingham Palace alongside Paul McCartney and Robbie Williams. The event commemorated her sixtieth year on the throne. The crowds stretched all the way down Pall Mall. I could hear them screaming as I came onstage in my glittering pink jacket and we kicked off the show with "I'm Still Standing." I had the opportunity to address Her Majesty from the stage, congratulating her on such an incredible achievement. Later, we shook hands backstage.

As a figurehead, the Queen meant a lot to me, as well. She was a part of my life from my childhood, as she was in the lives of so many in England and around the world. I was born in 1947, after the end of the war. I remember her coronation. I was fascinated by everything royal, although I didn't know everything she had to go through. She was a constant in my life. She was there, and she was someone you could trust. Her Christmas broadcasts on the BBC each year were always a source of such levity. Politicians always lost their credibility. Businessmen lost their credibility. You couldn't trust the banks. But she was stable. She offered a sense of continuity that felt very comforting to people. Although she had a stiff upper lip, you could feel her humanity coming through. She had a genuine, caring warmth.

"IT WAS, AS ROCK GOES, WONDERFULLY LOW-KEY AND CONTROLLED. OH, IT ROCKED—BUT SO EASILY, WITHOUT FORCE OR STRAIN. JOHN HAS TWO IMPORTANT THINGS GOING FOR HIM— A GENEROSITY IN PERFORMING, NOT ALL THAT COMMON A QUALITY IN ROCK, AND SOME SONGS WITH SATISFYINGLY LITERATE LYRICS, ANOTHER RARE ROCK COMMODITY."

★ ★ ★ ★ ★ ★ ★ ★ ★ ★ ★ ★ ★ ★ ★ ★ ★ ★ ★ ★

—*THE GLOBE AND MAIL*, 1972

LEFT:
Elton meets Queen Elizabeth II in Windsor in May 1977 with Sir David Frost looking on.

BELOW:
Elton onstage in Toronto as the band pays tribute to the late Queen of England

During the pandemic, Queen Elizabeth helped us feel less alone in a time of great isolation. You have to remember that she gave up a lot of her life in service to the country. She did a wonderful job as the Queen, but it took priority over everything. Not many people make that kind of sacrifice. In some ways, she was like a sacrificial lamb, and she did something amazing with that position. I knew she was growing older—her health was constantly discussed on the British news—though I always pictured her being there, that constant presence. I've lost a lot of people in my life, and the surge of grief is surprising every time. It always hits in a slightly different way. On September 8, 2022, the morning of my second concert in Toronto, Britain's beloved monarch died at her home in Balmoral at ninety-six years old.

I can't recall how David and I learned of her passing. Maybe from a friend, maybe the news. But it was genuinely emotional. It marked a turning of the tide in Britain. With Prince Philip's passing and then her passing, something changed. She was the last great leader. And I don't mean that as any slight on King Charles. The

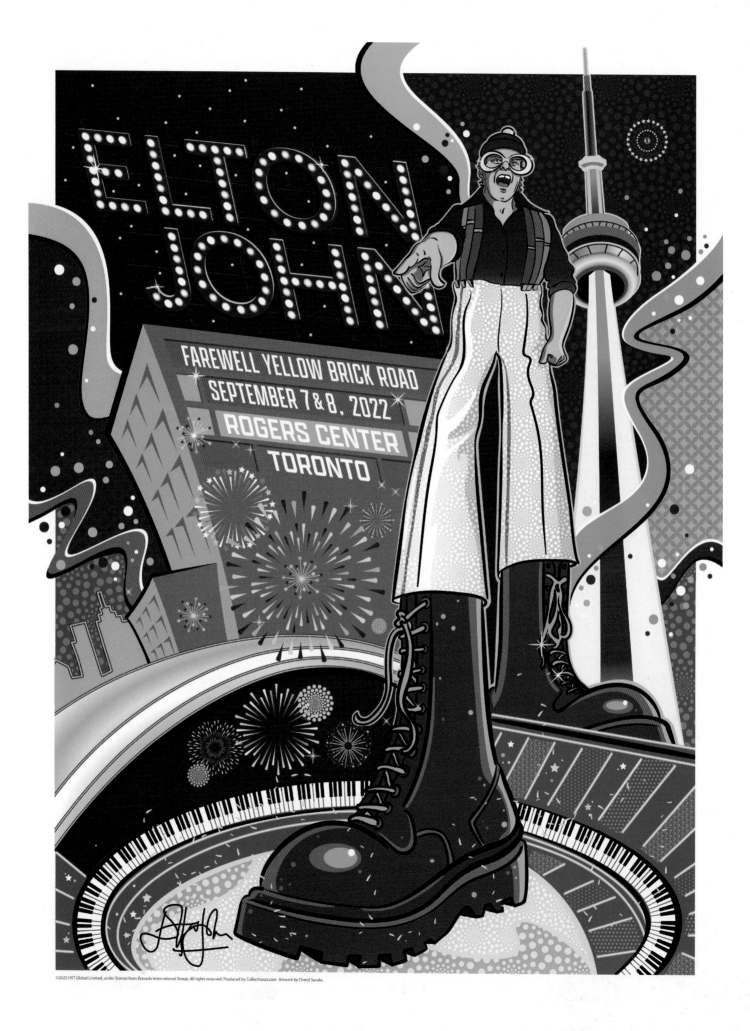



"IF THIS WAS SIR ELTON JOHN'S TORONTO SWAN SONG IN TERMS OF CONCERT APPEARANCES, THEN IT WAS A DOOZY."

★ ★

—TORONTO STAR, 2022

LEFT:
One of the special lithographs created for the farewell tour by Cheryl Savala, featuring Toronto's iconic CN Tower

monarchy won't ever be the same without her. No one is going to have the same effect as the Queen. I felt her loss as both someone I had met throughout my lifetime and as someone who meant a great deal to the country.

It was fitting to take a moment onstage in Toronto to pay tribute to Her Majesty, who had reigned over my country for seventy years. "She was an inspiring presence to be around," I remembered. "I've been around her, and she was fantastic. She led the country through some of our greatest and darkest moments with great decency and a genuine caring warmth. I'm seventy-five, and she's been with me all my life, and I feel very sad that she won't be with me anymore. But I'm glad she's at peace, and I'm glad she's at rest, and she deserves it—she's worked bloody hard. I send my love to her family and her loved ones. She will be missed, but her spirit lives on, and we celebrate her life tonight with music." To honor her, the band and I performed "Don't Let the Sun Go Down on Me," which felt right for the mournful occasion.

If I couldn't be in England to grieve the Queen, Canada was a good second choice. The country, which is part of the British Commonwealth, has always held a special place in my heart. I've been touring there since 1971, when I performed at Vancouver's Agrodome Theatre, and I've often returned over the years. The first time I took the stage in Toronto itself was on October 5, 1972, at the Maple Leaf Gardens for a crowd of fifteen thousand fans. The concert was sold out, and it went over swimmingly. A review in the *Toronto Star* called the gig the "greatest rock 'n' roll show the city had ever seen."

I returned to the Maple Leaf Gardens several times: in 1974 with Kiki Dee, for two nights in 1980 on my world tour, and again in 1982 and 1984. It was a home away from home for me in Canada—I recorded my 1976 LP *Blue Moves* there—and I appreciated the fans who turned up to the shows time and time again. To date, I've performed in every Canadian province. During the farewell tour, besides Toronto, we played in Vancouver, Edmonton, Saskatoon, and Winnipeg. Canada is an amazing country, and I have great memories from my concerts there.

Canada is also special to me because it's where David is from. He grew up in Toronto, so we have a personal connection to the city. We love bringing the boys there during the summers, and in 2022, we bought our own home in Toronto. I look forward to discovering more of the city outside of my concerts, as I've done in Atlanta and Los Angeles. Being a touring artist has dramatically broadened my perspective of the world. I'm a British national, but I now base myself in many countries, including Canada. It's amazing how far you can travel and still feel at home.

THE FAREWELL TOUR CREW

A large-scale production like the Farewell Yellow Brick Road Tour would be impossible without its intrepid crew. It took more than one hundred people to keep the tour running in top form around the globe. From the lighting to the wardrobe to the videos to the sound, everyone involved worked tirelessly to give Elton's fans the best possible shows during his final trek. There were challenges along the way, including a global pandemic, but ultimately the tour's crew was the best in the business. Here a few of the team members share their favorite memories from the road.

LUKE LLOYD DAVIES,
CHIEF OPERATING OFFICER

"I think the final three nights at Dodger Stadium have to be up there as one of the favorite memories. The atmosphere was unbelievable, and there was such a buzz in Los Angeles in the week leading up to it. Those nights and the show at Hove back in 2019 when I took my boys to see Elton for the first time have to be up there as the best memories of the tour. They watched on while he played 'Don't Let the Sun Go Down on Me' as there was the most beautiful sunset happening at the same time. It's one of my favorite songs and one of my lasting memories of this great tour. Most of all I'll miss seeing the fans' faces in the crowds and how lost in the moment they got, as well as working with our incredible team and all our tour partners on the road and at Rocket. They really are the best on the planet at what they do. Music really does bring the world together, and there is no one better at doing that than Elton John."

KEITH BRADLEY,
TOUR DIRECTOR

"Having been part of the Farewell Yellow Brick Road Tour fills me with enormous pride. It was an incredible journey with a superb road crew, the best live band, world-class promoters, great venues, amazing fans, and Elton—I'm sure this tour will remain a highlight in the lives of all who were involved. What will I miss most about being on tour with this brilliant man? Everything and everyone. Stellar job, guys, and thank you for the memories."

ALAN RICHARDSON,
MONITOR ENGINEER

"The thing I am most proud of with the Farewell Yellow Brick Road Tour is the fact that people of all ages and demographics came to see Elton and to bid him farewell. They realized the man is a legend, and they were there to enjoy his music and show their appreciation for fifty-plus years of unbelievable music. The thing I will miss most about this tour is the relationships that have been built up over the years. I've been Elton's monitor engineer for twenty-seven years, and so many people have become so much more than just friends. We have truly become extended family for each other. With Elton, the band and crew, and everyone at Rocket, I couldn't have asked for a nicer group of people to spend such a huge part of my life with."

DALE STICHA,
PIANO TECH

"I'm proud of the way the entire crew worked together and through the many challenges, including, but not necessarily limited to, time away from home, logistics and travel, climate and weather . . . but especially during the unknown and unforeseen portion of the FYBR Tour with all of the Covid pandemic–related circumstances that Team Elton faced. We continually worked through all of these challenges together to ensure the overall success of the FYBR Tour. Most of all, I will miss being around Team Elton on a regular basis, as it's been such a part of my life since I joined in 1992!"

MATT HERR,
FRONT-OF-HOUSE SOUND ENGINEER

"I've been very fortunate to have been touring with Elton for the past twenty years. This is the biggest production we've taken on the road. To be able to make Elton and the band sound great, every night, with this massive production has been something truly special. Being that I've been involved with Elton and the band as long as I have, I'd say it's the relationships with them and the crew that I'll miss the most. We've become a family, and that's something very special and unique."

MICHAEL GOMEZ,
CHIEF RIGGER AND CO–STAGE MANAGER

"I am most proud of our crew and how we always came together to make this very tough stadium production tour friendly, and to hear from many reputable stage unions how Elton John's crew was the best. Most of all, I am proud to be sharing these moments with my son Hunter, who has been working out on the road with me. I will miss the most unbelievable crew out there, the amazing band members, and the artist that gives his all for every performance!"

JOHN STEER,
TOUR VIDEO DIRECTOR

"The memory from the tour that stands out from the rest is very personal to me. I was diagnosed with prostate cancer in 2018 and unfortunately had to leave the tour to have treatment. Elton came and spoke to me and gave some words of comfort and told me not to worry and even gave me a mention during the show, where he mentioned the crew being like a family and for me to get better and come back soon. I will undoubtedly miss my brilliant team—and that's across all departments—who, along with the band, have become more like family and uniquely a big part of my life. I know it's going to be incredibly hard not seeing them each day and singing out, 'Hey baby, how you doing?' when this tour is over."

KEVIN "STICK" BYE,
TOUR LIGHTING DIRECTOR

"In our industry, they say you're only as good as your last show. On November 20, 2022, at Dodger Stadium I felt that production was the culmination of the previous year's of hard work by the entire touring team, the design team, and ultimately the television team. Everyone at the top of their game, extremely professional, and a joy to work with. What an epic end to our North American run. I will miss the band, the crew, and all the friends and colleagues I've worked and traveled with for the last twenty-three years. I've spent more time with them than my actual family."

TOUR STOP

#254

CITY

ATLANTA, GEORGIA

DATE

SEPTEMBER 22, 2022

VENUE

MERCEDES-BENZ STADIUM

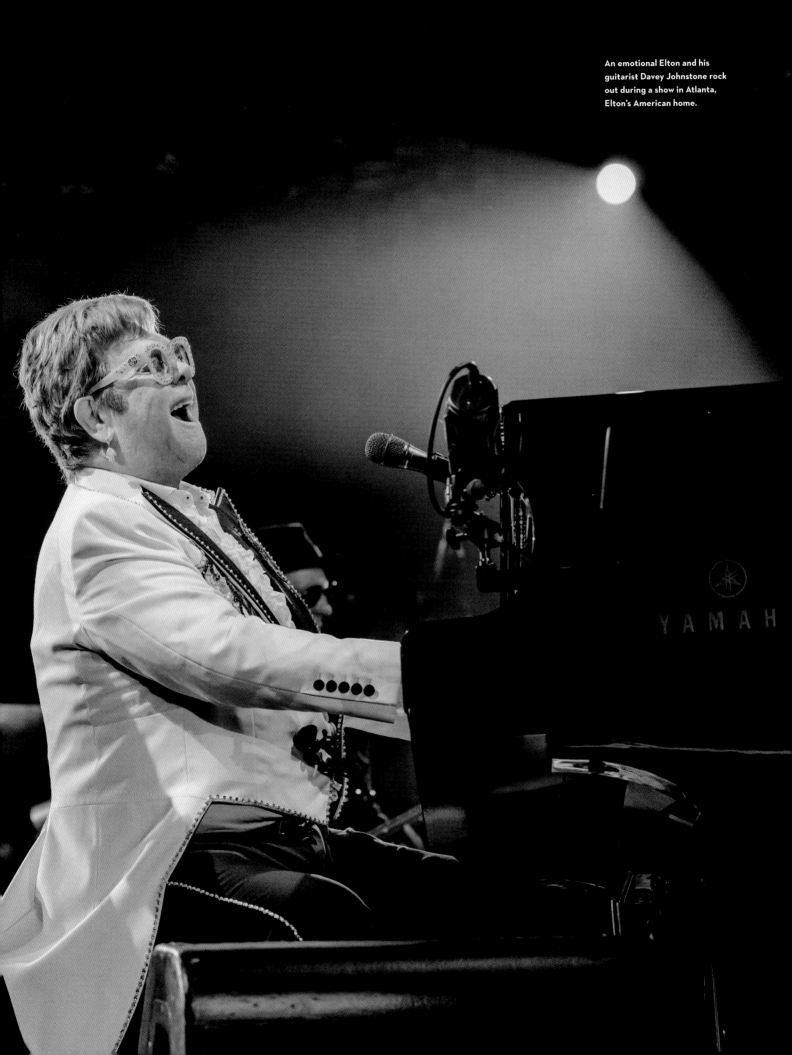

An emotional Elton and his guitarist Davey Johnstone rock out during a show in Atlanta, Elton's American home.

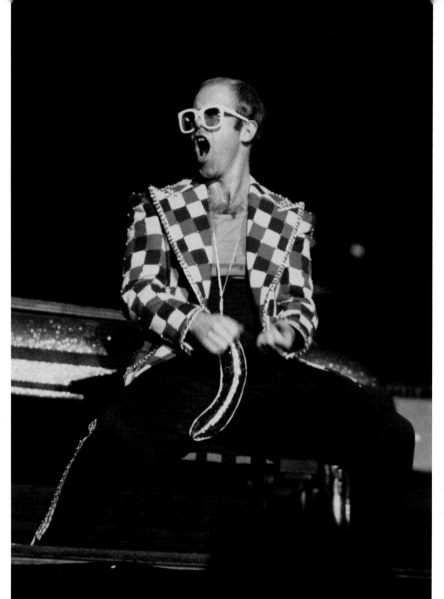

LEFT:
Elton performing in Atlanta in 1976 on his US tour

RIGHT:
The jacket Elton wore onstage in Atlanta, now preserved in his archive. Gucci re-created a version of the jacket for their Spring–Summer 2018 ready-to-wear collection.

n another life, I would be from the American South. I admire the music scene there so much, and my own music has been inspired by soul and gospel and blues. It was only natural that I would eventually call the South my home. I'd been performing in Atlanta since the early '70s, but I hadn't spent much time there outside of my tours. But in the late '80s, I went to visit some friends in Atlanta and really liked it. I had just turned forty, which coincided with me getting sober. It felt like the time to make big changes.

I suddenly decided to empty out my home in Windsor, where I'd been living since 1976. I hired Sotheby's to auction everything off and set about to redesign the entire estate, which meant months of construction. With nowhere to live, I decided to look for somewhere new in America. At the time, Los Angeles and New York City felt too overwhelming. But Atlanta was just right for me. I liked the Southern hospitality. Everyone was incredibly courteous and friendly, and I didn't feel socially obliged to go out, which appealed to me.

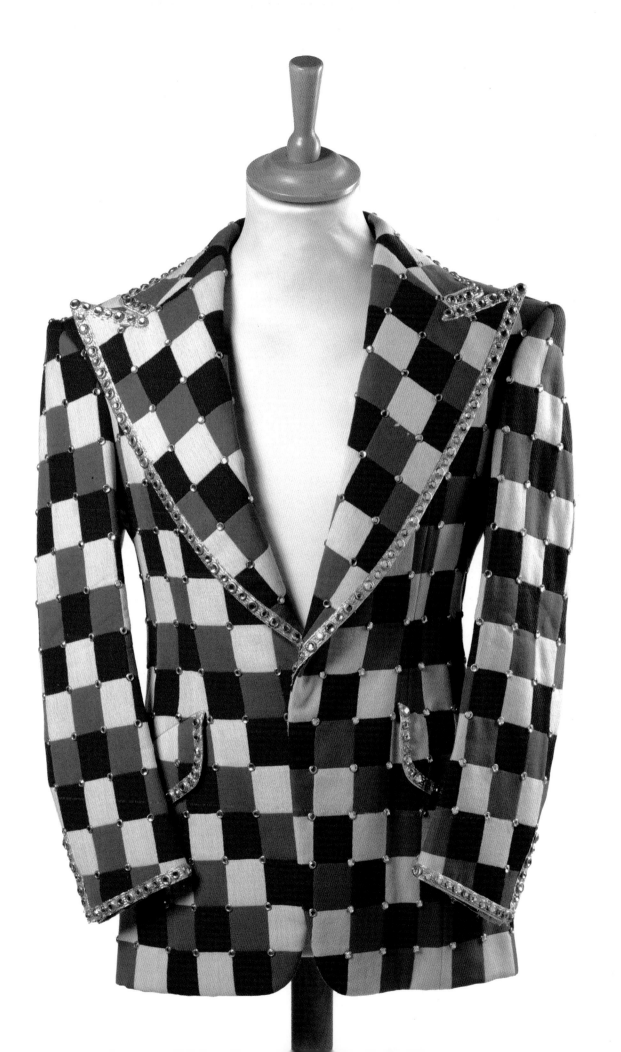

Postcard 1 (Jamaica)

Dear Helen, Chris.

Hullo there - good evening - goodbye. Weather is good - 85° and the natives are friendly. Food is great. Start recording today (2nd) and am really excited by the songs. Hope you are all well

Love Elt xxx

AUTHENTIC JAMAICA SCENE

Post Card

MISS HELEN WALTERS
DJM RECORDS
71-75 NEW OXFORD ST
LONDON WC1
ENGLAND

Pub. by The Novelty Trading Co., Ltd., Kingston, Jamaica

A
JAMAICA
Land of sun kissed beaches and beautiful sunsets.
DT-98890-B © 1972 D.C.C. Ltd.

MADE BY DEXTER COLOR CANADA CORNWALL, ONT., CANADA

Postcard 2 (Hawaii)

Warm waters, abundance of sunshine, and cooling trade winds makes Hawaii ideal for surfing enthusiasts.

HAWAII COLOR CARD

Dear Helen, Chris and anybody.

Wow Hawaii is incredible Am getting turned already - in one day!! John and I have a cottage on the beach - by the pool and the temperature is a sickening 85° or more. Everything is fantastic gigwise. I'm a superstar! Nudge Nudge Wink Wink Sayno more.

Se Elton John xxx

Mike Roberts Color Productions, Berkeley, Calif. 94710

Distributed by Movie Supply of Hawaii, Honolulu

J3326

HONOLULU AUG 27 PM 1971

WASHINGTON 5 UNITED STATES

Miss Helen Walters.
D.J.M Records,
71-75 New Oxford Street,
London WC1
ENGLAND

Postcard 3 (St. Louis)

GATEWAY ARCH & ST. LOUIS WATERFRONT
View from East St. Louis, Ill.

Jefferson National Expansion Memorial on St. Louis waterfront, memorializes this historic area as the "Gateway to the West". The inspiring 630 ft. stainless steel GATEWAY ARCH, focal point of St. Louis' skyline, embraces within its environs, the Old Courthouse, the Old Cathedral, new buildings to complement its graceful curve, and the ever-active Mississippi waterfront.

A1225 photo by Union Electric Co. Photographer

St. Louis Color Postcard Co., 1123 Washington, St. Louis 63101

Dear Helen and Chris,

Having a great tour. Not doing any interviews here (TEE HEE). 'Rocket Man' doing well here (thank God) Davey is really having a ball so far, it's all new to him. See you on the 23rd. love EH - John xxx

ST. LOUIS MO 11 MAY 1972

EISENHOWER USA EISENHOWER USA

Post Card

MRS. HELEN WALTERS
DJM RECORDS
71-75 NEW OXFORD ST
LONDON WC1
ENGLAND

LEFT:
Elton sent a series of postcards to the office of Dick James Music while touring. These are from Jamaica, Honolulu, and St. Louis.

RIGHT:
Ticket stubs from Elton's Atlanta concerts in the early 1970s

"IT WAS FOURTEEN YEARS AGO THAT 'ROCKET MAN' PUT HIM INTO SUPERSTAR ORBIT AND JOHN'S STILL FLYING HIGH WITH AN ELABORATE, HOT-TICKET TOUR."

★ ★

—ATLANTA JOURNAL-CONSTITUTION, 1986

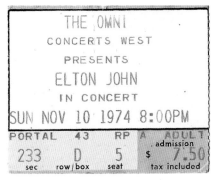

At first, I stayed in a hotel, then I rented an apartment, and eventually I bought one of my own. I moved into a high-rise condo in the Buckhead neighborhood, combining two apartments into one. People have often asked me, "Why do you have a place in Atlanta?" It's simple: I've always been welcomed. But moving to Atlanta also coincided with my sobriety. I went to a lot of meetings at the Triangle Club, which was a fundamental part of me getting sober and instrumental in my rehabilitation. I knew a lot of other sober people in the city, which helped. Spending time in Atlanta allowed me to become mentally and emotionally calmer.

A fundamental truth of growing older is that you want to spend as many nights in your own bed as possible. It was loads of fun crashing in shitty hotel rooms across America when I was twenty-three, but it's far less fun in your forties. Even going back to high-end hotel rooms after a concert gets tedious after a while. You just want to sleep in your own bed. In the '90s, we began booking my tours so that I could return home between shows. If I was playing on the West Coast, I could fly back to Los Angeles. If I was performing in Paris, I was only a short flight from Windsor. Atlanta was a great hub for me because it's so central. I could do Boston, Texas, Toronto, Miami—wherever—and then hop on my plane to come home to Atlanta. Not only was I sober, I was more settled. The city was like a salvation for me.

After I moved to Atlanta in the '90s, the music scene there absolutely exploded. It was incredible. Atlanta has always been a great place for music, anyway— I remember the Atlanta Rhythm Section and bands like that. But it really exploded, especially in the hip-hop and rap scene. All sorts of music was happening in Atlanta, and, in fact, Mariah Carey was based there for a long time. It's now emerged as the center of hip-hop in America. I love being in a place where there's music every- where. I met a lot of great Atlanta artists, and in 2021, I collaborated with Young Thug. It was amazing to be involved in that scene. You can feel the energy. Some-

times, you can even smell the energy. All of the great music came from the South, including the blues, and then it spread across America. I made a few records there, and I wrote several musicals in Atlanta, including *Billy Elliot*, *Lestat*, and *Aida*, and the inspiration has never dissipated.

Atlanta was hugely significant to me for both personal and professional reasons. I fell in love with the city's amazing baseball team, the Atlanta Braves. I wasn't just dipping in and out between shows. I became a resident of Atlanta. I was a fixture on the scene, in a way. The city is where I began collecting photography. I kept buying different apartments so I could put up more and more photographs. When I met David, he didn't quite understand my connection with Atlanta. It's not his favorite place in the world. But over the years, he's grown to appreciate what the city has given me. It allowed me to tour more extensively with less stress. It helped me become—and stay— sober. It's a joyful place to be. Which, of course, means my concerts there are particularly special.

I first played a gig in Atlanta in the summer of 1971 at the Municipal Auditorium on my American tour. I began to return annually, performing in the Atlanta Coliseum, Atlanta-Fulton County Stadium, and the Omni. Ray and I took the stage at the Civic Center in 1979 on our Back in the U.S.S.A. tour, and I played lots of shows in the '80s and '90s at the Lakewood Amphitheatre. There's a real sense of music history in the city, which you can feel when you per- form. In the '70s, I was thrilled to be playing in the home of the blues—it was the same when we went through somewhere like Memphis or Nashville. As a British performer, there's something almost mythic about sharing your music with a crowd in the American South. For the Farewell Yellow Brick Road Tour, we plotted several stops in Atlanta throughout the various tour legs. I wanted to maximize my time with all the fans who have been part of my journey in the Georgia city.

I performed at Philips Arena, now the State Farm Arena, twice in 2018 and twice in 2019. My big finale in Atlanta came nearly three years later, in September of 2022. I was emotional about the show, but in some ways, it didn't feel like I was saying goodbye. In many cities, especially around America, my final concert was like a punctuation mark ending a very long paragraph of time. My last night in Portland or Denver or Durham had the sense of being finite. But it wasn't quite the same in Atlanta because I still lived there sometimes. I was still a part of the city.

ABOVE:
A special lithograph by Robert Bruno, designed for Elton's final Atlanta concert, re-creates the skyline view from Elton's apartment in the Georgia city.

RIGHT:
Elton wears a Gucci-designed jacket that evokes one he wore in 1976. His wardrobe was designed to reflect his mood and spirit, and enabled him to express himself night after night.

"ELTON JOHN PULLED OUT ALL THE STOPS FOR HIS
LAST ATLANTA SHOW—THE COLORFUL COSTUMES,
THE POWERFUL PIANO, THE RICH VOCALS—
FOR A PERFORMANCE THAT PAID TRIBUTE TO HIS
ENDURING LEGACY AND ADORING FANS."

★ ★

—*THE ATLANTA JOURNAL-CONSTITUTION, 2022*

Standing in front of the crowd at the Mercedes-Benz Stadium, I marveled at how I'd created this other life for myself outside of England. Home can be more than one place. Home is where you're from, but it's also where you create pockets of life for yourself. I have several houses around the world, but home is something bigger. Atlanta became my home because it helped me to find myself in my sobriety. It's where I discovered my love for collecting photography. It embodies a history of music, of which I humbly consider myself to be a tiny part. Home is a place that embraces you and builds you up when you need it most. Home is where you can lay your head after a long night on the stage.

Many of my fans in Atlanta know I've been a local. They've spotted me out and about, and asked for photos and autographs. But as the concert neared its end, I wanted to assure the audience that just because I was retiring from touring didn't mean Atlanta would leave my heart. "I will take you with me in my heart, in my soul," I confirmed. "I'll never forget you."

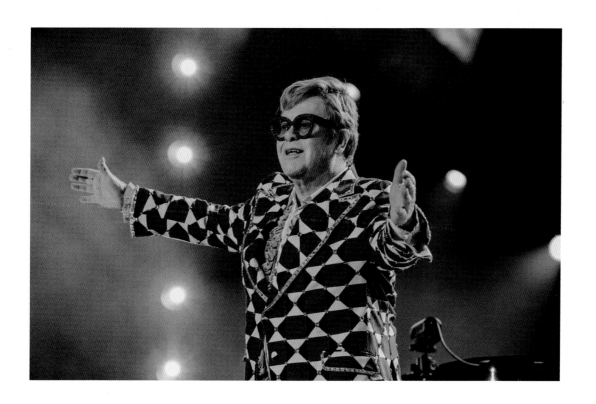

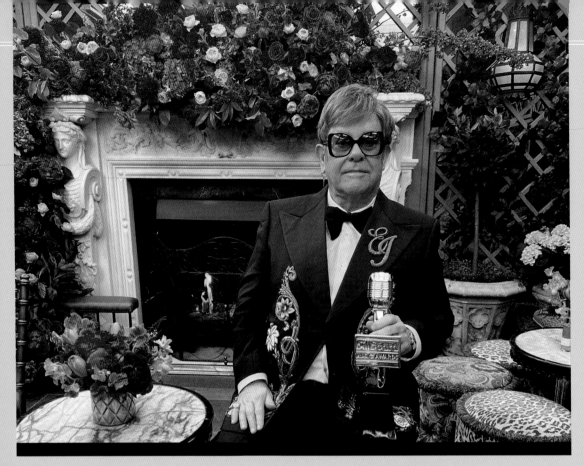

MAKING TOURING HISTORY

The original objective of the Farewell Yellow Brick Road Tour was to give fans a memorable goodbye experience that aptly celebrated Elton John's storied career. The creative team, led by David Furnish, imagined a live spectacular that put Elton's music and songwriting on display in an unparalleled manner—which is ultimately what they were able to achieve. Along the way, any accolades or records broken were icing on an already-fabulous cake.

By the end of its five-year run, the Farewell Yellow Brick Road Tour officially became the highest-grossing tour of all time. It grossed more than $939.1 million and sold six million tickets in total. Across his touring career, Elton has grossed $1.98 billion and sold 20.6 million tickets, making him the highest-grossing and best-selling solo artist in *Billboard* Boxscore history, since it began recording statistics in 1986. In 2019, the Farewell Yellow Brick Road Tour won Best Rock Tour at the Billboard Music Awards, and in 2023, Elton and his band were honored with Billboard touring awards for making history on the road. Truly a way to go out on top.

"I am overwhelmed and overjoyed that the tour broke records and earned awards," Furnish reflects. "We played to full houses every night. It's great to sell out and great to break the box-office records, but at the end of the day, the most important thing for us is that audiences came away feeling that they got a wonderful show, a wonderful experience, and a wonderful final touring memory."

While the Farewell Yellow Brick Road Tour sent Elton out with a bang, his touring history is equally impressive. The musician has set a remarkably high standard for other performers, ultimately proving his belief that having a good time together is what makes life worth living. Here are some of the significant ways Elton John has made history on the road.

- Within thirteen months of his first US show on August 25, 1970, at the Troubadour in Los Angeles, Elton had toured North America four times.
- In order to play for Queen Elizabeth II at the Royal Variety Performance in London on October 30, 1972, Elton jetted from San Diego,

California, on October 27 to London and back to Stillwater, Oklahoma, on November 1.

- Elton's largest crowd was in Central Park in New York City on September 13, 1980, estimated to be around 400,000 people.
- Elton's most-played venue is the Colosseum at Caesars Palace in Las Vegas, Nevada, where he held two multiple-year residencies. He performed there 448 times.
- Elton has played every state in the US. The most-played is Nevada with 475 shows, followed by California with 205, New York with 156, Pennsylvania with 90, and Texas with 81. His least-played are Delaware and Vermont at once each. He also performed once in Puerto Rico in 2007.
- Some of Elton's most-played US cities include: Las Vegas with 469 concerts, New York City with 108, Los Angeles with 102, Philadelphia with 52, and Atlanta with 39.
- Throughout his career, Elton has performed in Europe 1,332 times. He has toured in more than ninety countries, from Andorra to Yugoslavia. These famously included the Soviet Union and other communist countries before the fall of the Iron Curtain in 1991.
- Elton's second residency in Las Vegas, The Million Dollar Piano, became the fifth-highest-grossing Las Vegas residency of all time (as of 2022). It earned $131 million from 2011 to 2018.
- Elton has been joined onstage by more than five hundred fellow artists throughout his career, from Leon Russell, Kiki Dee, and John Lennon in the 1970s to Lady Gaga and Ed Sheeran in the 2020s.
- Elton has performed as part of many historical events. Some of the most memorable include Live Aid in 1985, the Concert for New York City in 2001, the Concert for Diana in 2007, and the Queen's Platinum Jubilee Concert in 2022.
- With a total of 19,080 days between his first and last shows in the US, Elton averaged one US show every nine and a half days.
- In total, Elton performed 3,933 public concerts in his touring career as a solo artist. Of those, 2,001 have been in the US, 561 in the UK, 237 in Australia, 139 in Canada, 41 in Japan, 36 in South America, and 24 in New Zealand.
- In addition to his public concerts, Elton has tallied more than seven hundred private, television, radio, and guest performances. Including his 241 concerts with Bluesology between 1965 and 1968, Elton has played piano or sung in front of an audience more than 4,900 times since 1965.

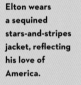

Elton wears a sequined stars-and-stripes jacket, reflecting his love of America.

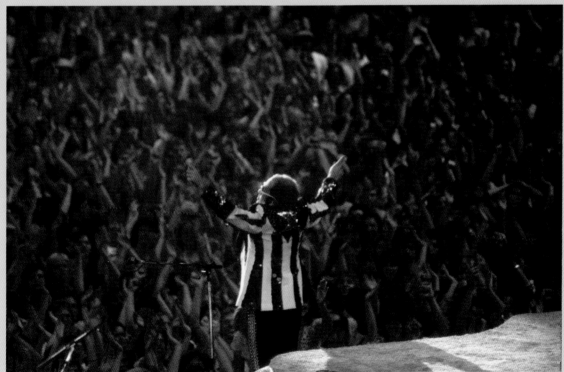

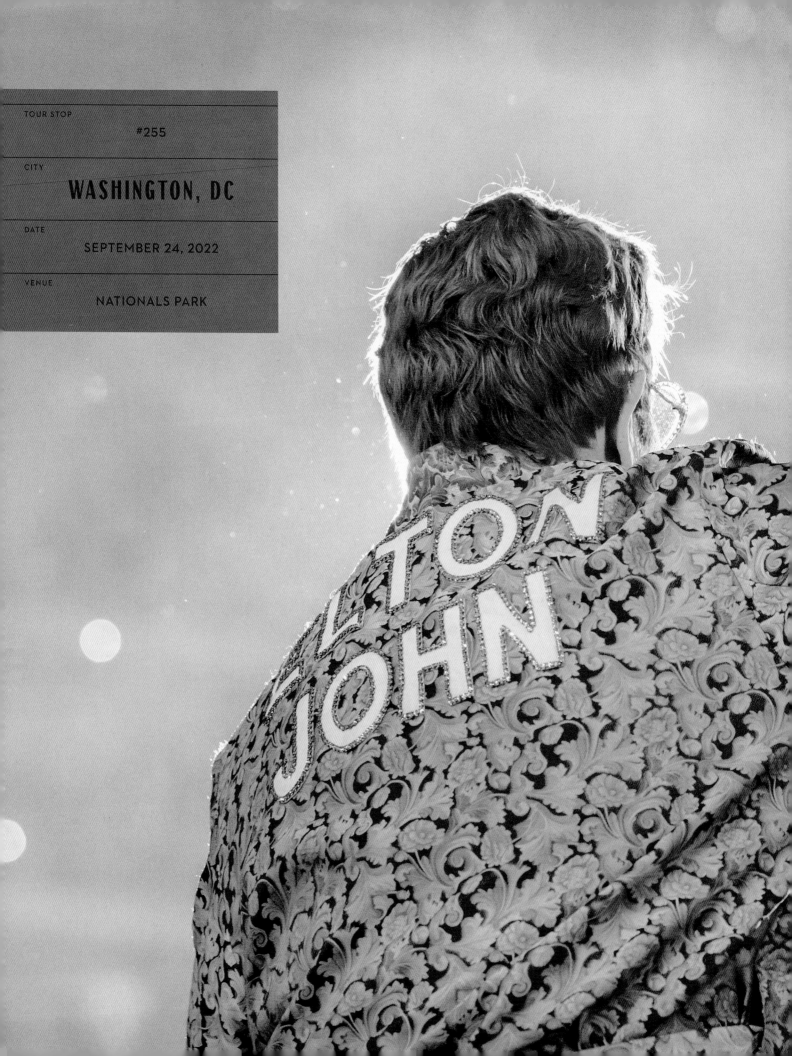

Elton bids the fans farewell
after a performance at
Nationals Park wearing a
custom Gucci dressing gown
with his name emblazoned in
crystals across the back.

Elton and David pose with President Joe Biden and First Lady Dr. Jill Biden at the White House in 2022.

As we began to reach the end of the final North American leg of the Farewell Yellow Brick Road Tour, I was in awe of the response from the fans. The outpouring of love for me on the tour was truly humbling. I couldn't believe how kind and welcoming the audience had been in each city. We had less than two months left to go before we would arrive back in Los Angeles at Dodger Stadium and the tour would wrap for the year. By the time we arrived in Washington, DC, I was elated from the reaction. It was our second time around in the American capital, this time at Nationals Park, the city's baseball stadium.

Washington, DC, is a fun place for a British performer. You feel part of history, in a way. The national monuments and the White House seem like something out of a movie. Despite its prestige, I missed out on DC proper during my first few American tours. In 1970 and 1971, I performed in nearby Baltimore at the Painters Mill Music Fair, and in 1972 and 1973 moved up to the Baltimore Civic Center. By 1974, I made it to DC's suburb of Landover, Maryland. That November, the band and I performed two nights at the Capital Centre, an indoor arena that had opened the year prior. It held more than eighteen thousand people, so it was a big venue for my first gig in the area. I returned there a lot over the next few decades, including during my Louder Than Concorde tour in 1976 and the Breaking Hearts tour in 1984.

The fans in DC and the surrounding states are amazing, with a great energy at every show. But for me, my most significant memories in the American capital involve a more private venue: the White House. In 1982, I was invited there to meet Ronald Reagan in the Oval Office. For many reasons, I didn't agree with Reagan's policies, but it was a real thrill to visit the White House. You never imagine you'll go somewhere like that in your lifetime, let alone multiple times throughout your career.

"ELTON'S PERFORMANCE OF THE MATERIAL IS SO FULL OF LIFE THAT IT REALLY LEAVES LITTLE TO BE DESIRED. MANY OF THE SONGS, FOR EXAMPLE 'THE KING MUST DIE,' HAVE THE ROUNDED SENSE OF COMPLETENESS OF A GOOD SHORT STORY."

★ ★

—*THE BALTIMORE SUN*, 1971

Thanks to the Elton John AIDS Foundation, I've had a long relationship with Washington, DC, and the American government. My work has been truly nonpartisan, which is important because it's helped to open channels of discussion between politicians who are usually on opposing sides of the aisle. I've appeared in front of Congress to discuss the impact of AIDS and HIV on the world, and urged US leaders to support funding to help ease the impact of the disease. In 2003, President George W. Bush launched the US President's Emergency Plan for AIDS Relief, also known as PEPFAR, which was an important moment for us. I give the former president a lot of credit for his work in the space.

The following year, I was celebrated at the Kennedy Center Honors alongside Warren Beatty, Ossie Davis and Ruby Dee, Joan Sutherland, and John Williams. It was a really meaningful moment for me in my career as an artist, but even more so as an activist. The early '00s were a particularly divisive time in politics, both in America and globally. The ceremony was held over two nights, the first at the White House, where Colin Powell presented me with the commendation. Aretha Franklin was there, much to my delight, and she said, "They should have given this to you years ago." On the second night, at the Kennedy Center, David and I sat adjacent to the president's box. We spoke to President Bush about AIDS and HIV and our work with my foundation, and we found him to be very receptive and warm. He was very well-informed on the issue, which caught us by surprise. I haven't always agreed with the former president, but we have to respect people's differences. I encouraged the American government to step up with PEPFAR and, thanks to President Bush, it did.

I continue to work in Washington, DC, and David and I have relationships with politicians of all viewpoints. To me, it's important to sit down with people from different political backgrounds and listen, as well as speak. If we can't have conversations with those who disagree with us, the world will never be able to come together. Real change happens when there is dialogue and understanding. The truth is, we're not as far apart as we think we are. I've visited

Ticket stubs from Elton's early concerts in Washington, DC

the White House while it was held by both Republicans and Democrats. But the first few times I went to Washington, DC, I never imagined I would get to actually perform for the president of the United States.

It's always meaningful to play at the White House. In 1998, I took the stage there during a state dinner held by President Bill Clinton in honor of British prime minister Tony Blair. There was a special relationship between the Clintons and the Blairs. The event was intended to shine a light on the great connection between America and Britain. They wanted a British musician to play alongside an American one, so I performed with Stevie Wonder, a musician I really admire. I had an out-of-body moment as it dawned on me what was happening. I'd played for the British royal family before that, but for some reason this felt even more unbelievable. The White House is such a piece of history. It's a very impressive place, and to be asked to go there, no matter who is the president, is a real honor. America is the most powerful country in the world, which you can feel when you step inside the building's walls. It's overwhelming to sing and play piano in a place like that.

Over the years, I've been offered other opportunities to play for American presidents. In 2017, an invitation came to perform as part of President Donald Trump's

Elton and Stevie Wonder perform on dual pianos at the White House in 1998. The pair represented British and American music at a dinner to celebrate UK prime minister Tony Blair.

inauguration. Although it was an honor to be asked, and I was aware that he was a fan of my music, I politely declined. I've been asked to sing the American national anthem many times, but as a British national, I always decline. "Thank you so much for the extremely kind invitation to play at your inauguration," I responded in a letter. "I have given it a lot of thought, and as a British national I don't feel that it's appropriate for me to play at the inauguration of an American president. Please accept my apologies."

Five years later, I accepted a different sort of summons to the White House. I was invited by A+E's History Channel to perform a six-song set for two thousand people on the South Lawn for an event called "A Night When Hope and History Rhyme," hosted by President Joe Biden and First Lady Dr. Jill Biden. It was held the night before my show at Nationals Park, and I was in complete awe of the setting. I'd never performed on the South Lawn before, and it was such a beautiful night, with the White House lit up beautifully in the background. If you'd told me as a young boy I'd be doing something like this, I would have said, "Are you mad?" I've played concerts all over the world for some very important people, but moments like this still give me a thrill. Anything like that is still a thrill. I've kept that side of me that comes from Pinner that thinks, "Oh my God, this is incredible. Here I am."

It took me a moment to get over my awe of the surroundings. I decided to make light of it. "I don't know what to say," I told the audience before joking, "What a dump! I've played in some places before that have been beautiful, but this is probably the icing on the cake." I performed a selection of favorites—"Your Song," "Tiny Dancer," "Rocket Man," "Don't Let the Sun Go Down on Me," "Crocodile Rock," and "I'm Still Standing"—and it went over swimmingly.

I included "Crocodile Rock" on the setlist because I knew President Biden was a fan of the song. I'd first met him during a taping of the late-night show *Jimmy Kimmel Live!* back when he was the country's vice president. He told me how he used to sing "Crocodile Rock" with his two sons in the car. Later, David and I went to visit President Barack Obama at the White House, and we discovered that Biden's son Beau was terminally ill with brain cancer. He was unconscious in the hospital and unable to respond. After our visit, Biden went to see Beau and told him I'd been at the White House. Then he sang "Crocodile Rock" to Beau one last time. That song has meant a lot to a lot of people, but that story really moved me. It was important to me to include it for my performance on the South Lawn.

Along with the Bidens, what a crowd. Nancy Pelosi was there, as were Pete Buttigieg and his husband, Chasten, and my old friend Billie Jean King. Laura and Jenna Bush, along with the Bushes' grandchildren, attended, and I took the opportunity to again praise President Bush's work with PEPFAR from the stage. It's incredible what we can achieve when we pull together in a nonpartisan way. I've always been welcomed by all political parties in Washington. Beyond the famous faces were the even more important guests: first responders, teachers, and activists. They were the real heroes to me. David and I had said yes to the event because it was a chance to talk about common humanity, healing through unity, and philanthropy. It was a nonpartisan event, although President Biden is a Democratic leader. It felt important to me because I always look for opportunities to shine the spotlight on my AIDS activism.

Before playing "Don't Let the Sun Go Down on Me," I spoke about Jeanne White-Ginder—the mother of Ryan White, who died of AIDS in the 1990s—who was in the audience. I met them when Ryan was dying and credit the family for my early interest in the cause. "I got to love them and look at them and they faced such terrible hostility," I recalled onstage. "And yet when Ryan was dying in the hospital in Indianapolis, the last week of his life where I went and tried to help Jeanne do menial things, there was no hatred. There was no hatred. There was just forgiveness." Not long after Ryan died, I checked into rehab and got sober. That night in DC, I wanted the crowd to know how he and his family had saved my life.

After my performance, there was a big surprise, unknown even to David, who always knows what's going on. I was about to leave the stage when President Biden came out and presented me with the National Humanities Medal for my work with the Elton John AIDS Foundation. I was flabbergasted. I could feel my jaw actually drop. As they read the citation aloud, I began to cry, removing my glasses to wipe away the tears. I tried to hold it together and reached for the First Lady's hand. She gave me a squeeze. The crowd cheered as Joe placed the medal around my neck. I hugged Jill in a daze. It's rare that I don't know what to say, but I was truly speechless. "I think we surprised him," President Biden quipped.

The president handed me the microphone, and I grappled for words. "I just said to the First Lady, 'I'm never flabbergasted, but I'm flabbergasted,'" I told the audience. "And humbled and honored by this incredible award from the United

An original lithograph created for the farewell tour by Sam Gilbey

States of America." I held the medal in my hand, still in disbelief. I could sense David standing onstage with me, and I was glad the president had included my husband in this moment. It's always powerful to give a same-sex marriage such visibility. "I will treasure this so much, and it will make me double my efforts to make sure this disease goes away," I continued, hoping I could properly convey my gratitude. "Your kindness, America's kindness to me as a musician, is second to none. But in the war against AIDS and HIV it's even bigger, and I cannot thank you enough. I'm really emotional about this."

When something like this happens that is so unexpected, it makes it even more special. It was especially meaningful to receive the award before a crowd of front-line workers—the people who really do the work. I felt very emotional that I was being given this honor in front of the people who are in the trenches every day. I'd started the Elton John AIDS Foundation thirty years prior at my kitchen table in Atlanta, and now here I was, being honored by the president of the United States. It affirmed everything I'd worked for, and it encouraged me to keep going. I've always said that we're striving for a future where people of all races, ethnicities, nationalities, sexual orientations, and gender identities have the opportunity to live free from AIDS, stigma, injustice, and maltreatment. This kind of recognition on a global scale really does bring us a step closer to achieving those goals. Every city I tour through has a special place in my heart, but I'll always treasure this memory of performing in Washington, DC. It meant the world to me.

My touring career has involved both public and private concerts. I've performed at numerous benefit and charity events, at parties, at corporate gatherings, and as a guest at other artists' shows. When I look back over my career as a performer, sometimes these all blend together. A concert is a concert, and I always try my best. It's an honor to be asked to play somewhere like the White House. But it's equally fulfilling for me to perform in an arena for my fans. Throughout the tour, I wasn't always able to properly express my sentiments about a particular city or venue. Saying goodbye to DC was a bittersweet moment. Onstage at Nationals Park, all I could think to tell the audience was "This is my last-ever appearance in Washington, DC, so let's make it a good one!" It certainly was.

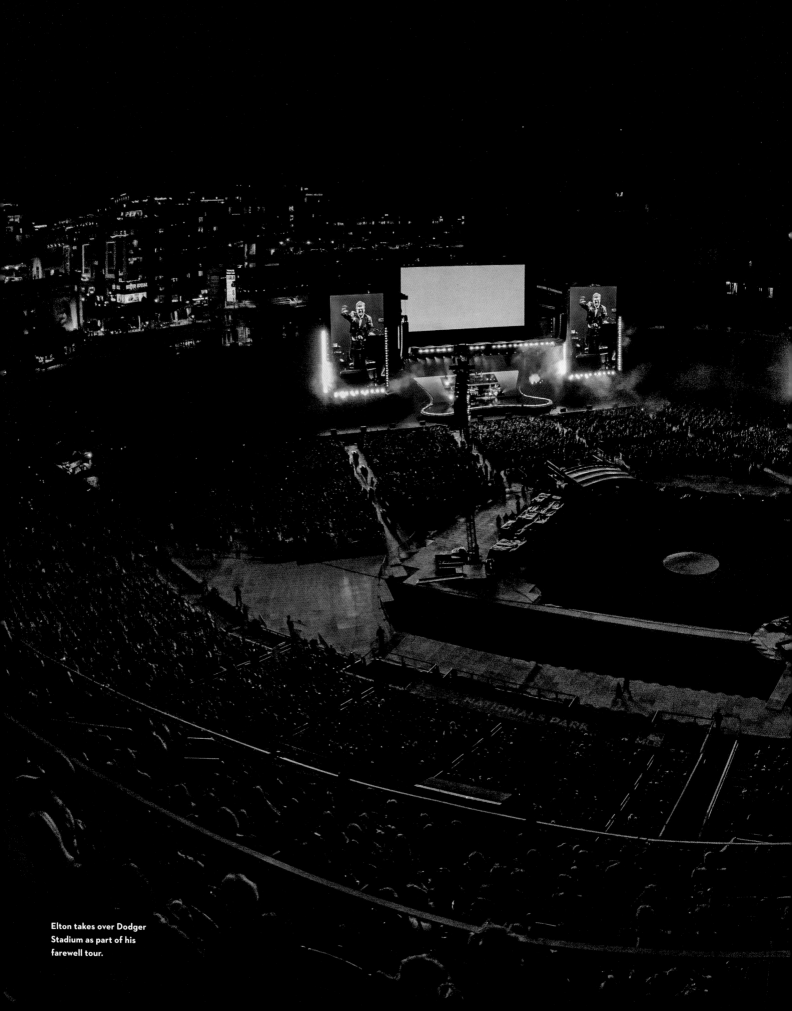

Elton takes over Dodger
Stadium as part of his
farewell tour.

"HE AND HIS BAND HAD DELIVERED ... THAT MAGIC IN A BOTTLE THAT IS, BEYOND A DOUBT, ELTON JOHN."

★ ★ ★ ★ ★ ★ ★ ★ ★ ★ ★ ★ ★ ★ ★ ★ ★

—DC MUSIC REVIEW, 2022

CELEBRITY TRIBUTES

NEIL PATRICK HARRIS

"Attending an Elton concert is watching a comic-book hero use their superpowers—witnessing the genius in his ivory lair, as he owns the piano keys and belts out lengthy versions of massive hit after massive hit. The sheer breadth of his unflagging talent is undeniable, and his passion and lust for music is intoxicating, infectious. Whether large venue (Dodger Stadium!) or small (our wedding!), we've experienced his songs enter souls and leave everyone forever changed. Elton John is Eternal Joy."

KATE BECKINSALE

"From being a little child watching *Top of the Pops* and admiring the force of nature in the sparkly glasses, to taking my mum who had been very ill to his farewell concert in Los Angeles, and watching her joyfully sing along to 'I'm Still Standing,' meaning every word, both of us holding hands with tears streaming down our faces, Elton has provided a unique and emotional backdrop to so many significant moments in my life. He's unique—a survivor, an inspiration, an irreverent, naughty, brilliant laugh, and always entirely himself. His shows are so generous, huge, and fresh and full of energy and heart. There's no one like him."

JULIA ROBERTS

"Elton John is simply a one of a kind. His decades of records and performances have spanned my entire life. When I moved to NYC in 1985, I was so out of place and homesick. If it had not been for the near-constant playing of *Tumbleweed Connection*, I do not think I would have found myself. When I was lucky enough to see him on his farewell tour in Italy it was one of the most moving experiences of my life, and I will never forget it."

BILLIE JEAN KING

"I remember the first time I heard 'Your Song' on the radio very clearly. It was the fall of 1970, and I was driving on Van Ness Avenue in San Francisco when I had to pull over to the side of the road and fully listen to this amazing song. I loved his piano playing and his rich voice. That was the moment I knew Elton John was my favorite musical artist. Now, more than fifty years later, I am blessed to be his friend. Elton and his music have been relevant in our world for more than six decades, but because he used his platform to help others, it is his generosity that makes him the man he is. Real champions, especially champions in life, are resilient, and Elton takes it one step further—he is a role model for all people. He really is a genius, and our world is better with him in it."

JOJO SIWA

"Elton has changed the world and the music industry forever. He is a legend. Thank you, Elton, for sharing your gift with everyone."

KACEY MUSGRAVES

"*Elton.* It'd be impossible to fit more sparkle, more pop culture, and more personality into just five little letters. It's as wonderful seeing him radiate his greatness onstage as it is in his living room. Shoes off, sipping coffee, and talking about music. (Above all else, Elton is a TRUE fan of every kind of music, and it's inspiring.) My times with him I will never forget. Whoever said *don't meet your heroes* was wrong."

KATE MOSS

"Elton is a genius, and an inspiration. I loved the show and was transported to musical heaven."

BOY GEORGE

"When I was a kid I played 'Daniel' over and over. It was my first gay song. I was mesmerized by Elton's beautiful voice. He has managed to remain present in every decade. The epitome of a legend. Radio on, Elton John."

STING

"I've known Elton for many, many decades, and the first time we met was in Los Angeles at the Forum and he was wearing a Minnie Mouse dress. And he looked gorgeous, as he still does."

LENNY KRAVITZ

"Thank you to Elton for being on this earth and blessing us with your gifts as a musician and as a human being."

PRINCE HARRY

"Thank you, Elton, for entertaining everybody for so many decades. Thank you for being the friend that you were for my mum."

MEGHAN, DUCHESS OF SUSSEX

"We're so grateful we were able to see him on his farewell tour."

TARON EGERTON

"Thank you to Elton for an amazing night."

MARK RONSON

"Elton and the band were so fucking heavy. I really wasn't expecting the raw power of 'Funeral for a Friend'; I left my body during that one."

EDDIE VEDDER

"God, Elton worked hard tonight."

RINA SAWAYAMA

"When you watch an Elton John show you are witnessing the pinnacle of musicianship and performance. As someone whose show includes heaps of choreo, running around stage, changing sets, interludes, and costume changes (oh, the hectic stage life of a pop star!) I'm blown away by the power that Elton holds while he holds position still behind the piano, during the majority of his three-hour show. He commands the stage with his powerful voice, incredible musical skill honed over decades, his playful mastery of the piano, and the band—the band! The chemistry between Elton and his band would inspire any budding musician in the audience; it certainly does every time I see him play. I'm proud to know him on- and offstage."

BEN STILLER

"I found the show to be extraordinary and very emotional. I don't think I can overstate how important Elton's music is in my life. Every individual person, I think, felt it, this personal connection, because he was so genuine, he had such gratitude to the audience and their love for him. The whole thing was just amazing, but then on this other emotional level you just realize how important music is in people's lives and how much he's given us all."

BRANDI CARLILE

"Elton John means everything to me. He's my greatest hero of all time, since I was eleven years old. He was my gateway drug to rock 'n' roll. My gateway to making music and writing songs. He's everything to me. He's my favorite of all time."

TIM RICE

"Working with Elton is a rare privilege. His extraordinary musical gifts and his generosity of spirit inspire lyricists and all who work with him, just as they have inspired and enthralled millions of admirers around the world for over half a century."

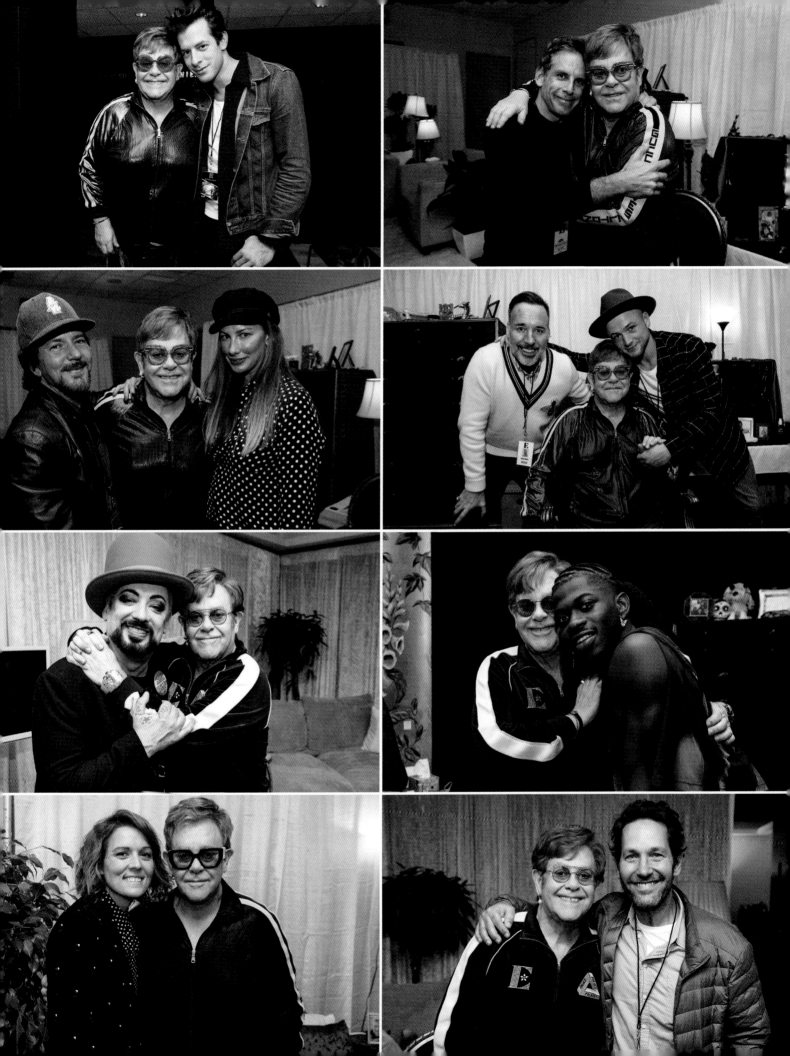

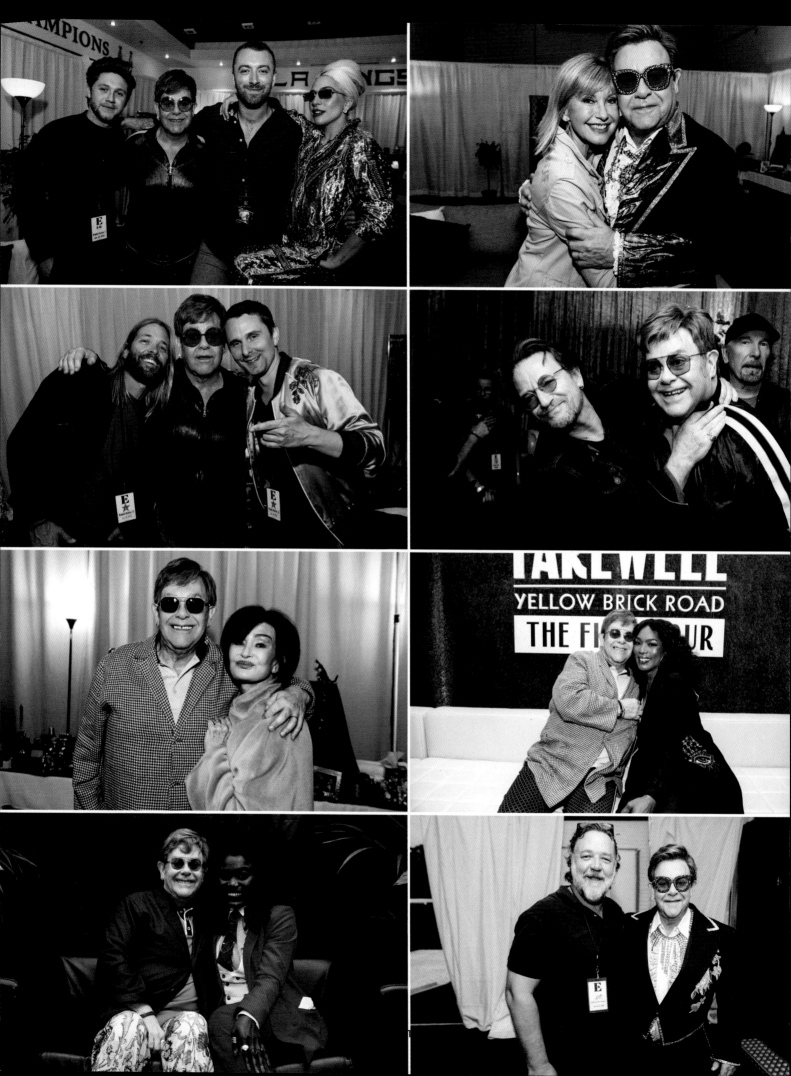

DUA LIPA

"Elton John is my musical hero, and when I got up onstage and I got to sing the song that we did together it really was a massive pinch-me moment for me."

TONI COLLETTE

"I feel high as a kite and quite moved. Elton's just all heart. He wears it on his sleeve, and he gives so much. I can't believe he's out there just pumping it out like this, and I can't believe the tour is this long! He's so generous, so talented. He's an absolute legend."

ED SHEERAN

"Elton has been there at almost every stage of my career, and for all the ups and downs of my personal life as well, and I'm so happy to know him as a person. He's a mentor, a friend, and also my musical hero. I'm very, very proud to be his friend."

BETTE MIDLER

"Oh my goodness, what a career you've had, Elton. Full of laughter, full of fun, full of music, full of great costumes, and full of generosity! You are the bomb, baby."

DAVID BECKHAM

"To have performed at the highest level like Elton has for so long and still have the passion that he does is really incredible."

JOHN LEGEND

"Thank you to Elton John for being the soundtrack to our lives. Thank you to him for all the work he's done to fight AIDS and to make so many lives better. We appreciate him."

CHRIS MARTIN

"It's amazing what Elton John has given to the world and given to us."

JUANITA EUKA

"I have been listening to Elton John since I was a little girl in Buenos Aires, Argentina. One of the first vinyl records my parents had at home was of Elton John's music. I couldn't imagine my life without his music. I have always had a deep admiration for his love for music and his dedication to his art and his humanity. I absolutely love you, Elton John."

BONO

"Is this a hugging or a mugging? Edge is definitely unsure. . . . In fact, on seeing this image, Edge reminded me that he is happy to be in the background of Elton John, but not me. . . . It's not the glam rags or regalia, it's not the vivid staging, or even the luminous personality behind the spectacular spectacles. What makes Elton the showman's showman is the generosity of his songs . . . and his person. If he loves you. And he loves us fans so much that he's been trying to not say goodbye to the Yellow Brick Road for quite some time. This is the long goodbye of lovers. Mischievous and measured. Fantastical and finely tuned. When the music takes him, he takes us with him to that other place where singer and audience merge, and I always think it's better there."

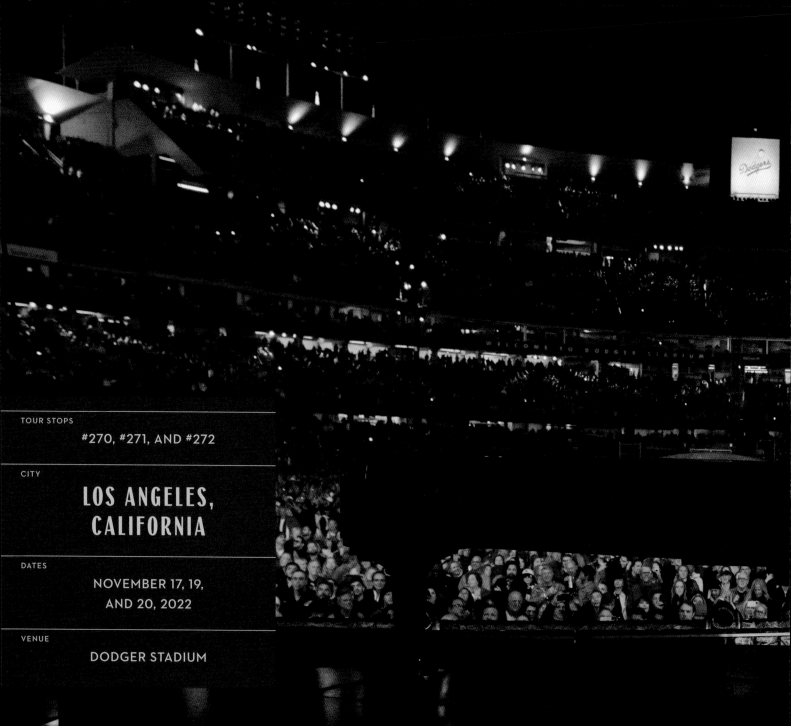

TOUR STOPS

#270, #271, AND #272

CITY

LOS ANGELES, CALIFORNIA

DATES

NOVEMBER 17, 19, AND 20, 2022

VENUE

DODGER STADIUM

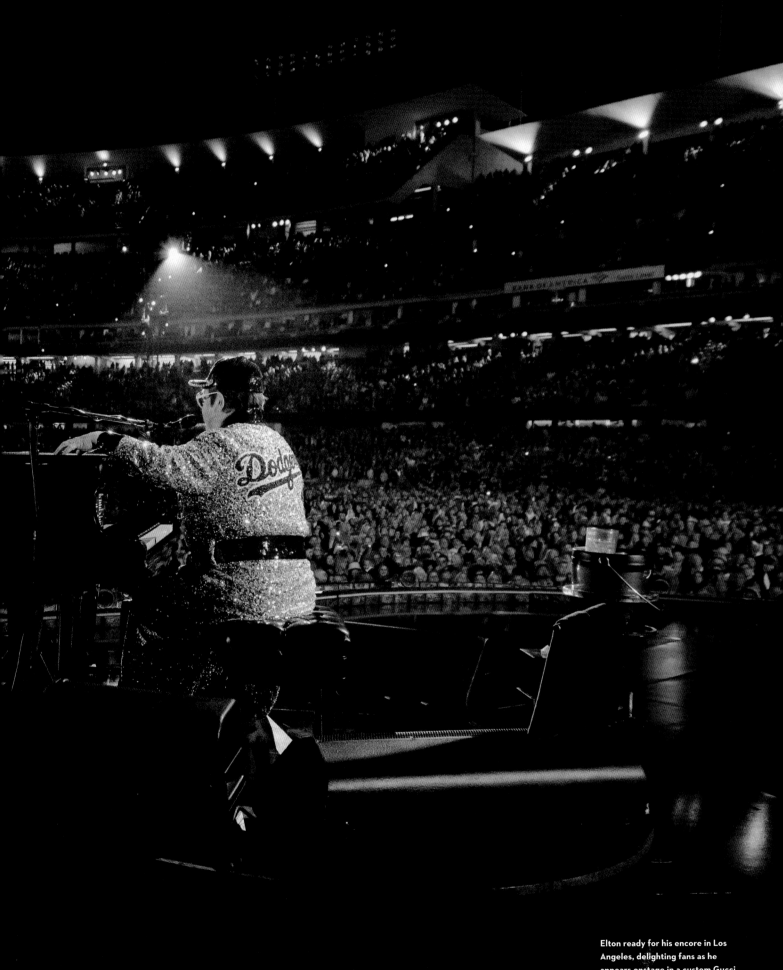

Elton ready for his encore in Los Angeles, delighting fans as he appears onstage in a custom Gucci robe made especially for the performances at Dodger Stadium

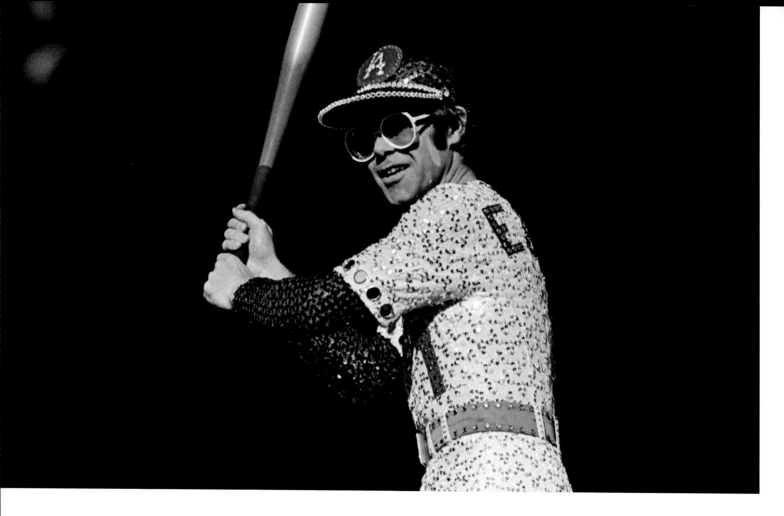

When we planned the Farewell Yellow Brick Road Tour, the pandemic was nowhere in sight and I didn't need hip surgery. Originally, we routed the global tour to end with three nights at Dodger Stadium in Los Angeles to purposefully bring my touring career full circle. Even the best-laid plans often go awry. Because of postponements, the farewell tour would now end in Europe in 2023, not at Dodger Stadium as we'd hoped. But that feeling of everything coming back again was palpable as the tour arrived in Los Angeles in November of 2022 for three final North American shows.

In 1975, I was at the peak of my fame in my career to date. My ninth studio LP, *Captain Fantastic and the Brown Dirt Cowboy*, was released in May and hit No. 1 on the *Billboard* Top 200 in its first week, something no artist had done before. It stayed at No. 1 for its first seven weeks on the Top 200, and within the first four days of its release, the album sold 1.4 million copies. Its follow-up, *Rock of the Westies*, came out in October and went straight to No. 1. It's safe to say that by that fall, I was the biggest pop star in the world. Personally, I was in a dark place. I was extremely rich and famous, and I was extremely unhappy. I was descending into addiction. The only time I really felt in control of myself was when I was performing live.

To promote my new album, I embarked on the West of the Rockies Tour. The tour was scheduled for fifteen concerts in America and Canada, starting in San Diego on September 29, 1975. All of the shows were, as the title suggests, west of the Rocky Mountains. It would culminate with two concerts at Dodger Stadium in

Los Angeles on October 25 and 26. At the time, I was playing with a slightly different band that included three backing vocalists. To prepare, we booked five warm-up gigs over three nights at the Troubadour on the fifth anniversary of my career-launching shows there, and Kiki Dee joined us onstage. Dodger Stadium was a big deal. The Beatles had previously played there in 1966, but no rock or pop act had performed in the stadium since. It took months of negotiations to plan it properly.

To celebrate the occasion, Tom Bradley, the mayor of Los Angeles, declared it Elton John Week. I got a star on the Hollywood Walk of Fame in front of Grauman's Chinese Theatre—a surreal moment if there ever was one—and I brought my family, friends, the Rocket team, and even a documentary crew over from England on a chartered Boeing 707. They were delighted. Everyone went to Universal Studios Hollywood and Disneyland and generally had a very outrageous time. I was in a weird space mentally. How could you not be when the mayor names an entire week after you and you're preparing to perform in front of 110,000 people over two nights? That's an immense amount of pressure. The spotlight will get to anyone. As those who read my memoir know, shortly before the first show at Dodger Stadium I took a bunch of pills and jumped into a swimming pool in front of all my friends and family in an act of desperation. I wanted a different sort of attention than I was getting, but I was too proud to admit that I wasn't living the perfect, glamorous life I seemed to have. "Okay," I said to myself after I was given something to make me throw up the pills, "I have to get it together and play these shows."

The concerts were an absolute spectacle. Cary Grant was there, much to the delight of my mum. Cal Worthington, California's most famous used-car dealer, had brought a lion, which was backstage. Photographer Terry O'Neill was seemingly everywhere, taking hundreds of photographs. My security guards were dressed up in ridiculous purple jumpsuits covered in pink feathers. Billie Jean King performed "Philadelphia Freedom," the song I had written for her and her World TeamTennis team, with me. For part of the show, I wore a sequined Dodgers uniform created by Bob Mackie and swung a baseball bat atop the piano. Even Bernie, who is usually so shy, came onstage. We played for more than three hours. The setlist was made up of thirty songs, one of the longest I've ever done. I gave it my absolute all. By the end of the show, my fingers were red from playing the piano keys so hard. I was exhausted and elated at the same time. It was a complete and absolute triumph.

As I've mentioned, there are rare live performances where everything comes together like magic. It all just works, and the audience can feel it, too. As a performer, I live for moments like that. After the second night, which went even better than the first, I assumed this was the pinnacle of my career. It couldn't get any better or bigger than this. There I was, twenty-eight years old, at the top of the

LEFT:
Elton onstage at Dodger Stadium for his legendary concerts in 1975, a short but historic and iconic run. His sequined costume was designed by Bob Mackie.

RIGHT:
A ticket stub from one of the Dodger Stadium concerts

mountain with nowhere left to climb. I could never have imagined that there was so much farther for me to ascend. Somehow I'm bigger now than I was in 1975, which is extraordinary. But what's more extraordinary is how much happier I am.

The Dodger Stadium concerts in 1975 were a once-in-a-lifetime moment. I could never replicate them if I tried. In 1992, I performed at the baseball stadium again, this time with Eric Clapton. At the time, we were promoting our duet single, "Runaway Train," off my LP *The One*. It was great fun to return, and George Michael even came onstage to sing "Don't Let the Sun Go Down on Me." There was a lot of nostalgia for the '70s as I recalled those legendary concerts. But it wasn't the same. The circumstances were different, I was different, and it's fruitless to try to recapture old magic. You have to create new magic. That was the philosophy going into the three-night stand at Dodger Stadium in November of 2022. The shows would conclude the final North American leg of the Farewell Yellow Brick Road Tour, so we wanted to go out with a real bang. David and the Rocket team partnered with Disney+ to globally live-stream broadcast the third night worldwide, which was really exciting. I loved the idea of sharing my farewell tour with all of the fans who couldn't make the shows or hadn't been able to get tickets. And it felt like a good way to say a proper goodbye to Los Angeles and America.

An enormous amount of planning and work went into preparing the concert for broadcast, which was titled *Elton John Live: Farewell from Dodger Stadium*. I also had a documentary crew, led by filmmaker R.J. Cutler, following me around, just as I had in 1975 with Russell Harty and Mike Mansfield. To film the concert itself, the teams had forty-six different cameras along with three drones and a helicopter camera to capture every angle of our performance. I wasn't nervous about the live broadcast—this is what I do—but there were a lot of moving parts. Although it wasn't officially Elton John Week, there were several pop-ups and events held around Los Angeles the week of the shows. We opened Elton John Eyewear at the Grove, a mall in the center of town, and we held a fashion pop-up at the Webster with limited-edition designs, which I visited (much to the delight of the other shoppers). We also invited fans to take part in a scavenger hunt, dubbed #EltonLATakeover, throughout the city. It felt very celebratory, although I didn't have time to feel overly nostalgic or emotional before the shows.

The first show was on November 17, a Thursday evening. David and I had been in Los Angeles for a few weeks, with me occasionally flying off to the remaining North America shows in Las Vegas, Denver, San Diego, and Phoenix. Our sons had stayed behind in London, but we brought them out to California right before the concerts at Dodger Stadium. It was important to me that they were there. The documentary crew,

LEFT:
A lithograph created for one of the Dodger Stadium shows by artist Cheryl Savala

RIGHT:
Fireworks illuminate the stage during Elton's performance of "Saturday Night's Alright (For Fighting)" at one of the Dodger Stadium shows from the farewell tour.

★ 224

"LEADING A ROCK-SOLID SIX-PIECE BAND FILLED
WITH GUYS HE'S BEEN PLAYING WITH FOR
DECADES (INCLUDING DRUMMER NIGEL OLSSON,
PERCUSSIONIST RAY COOPER, AND GUITARIST
DAVEY JOHNSTONE), JOHN PERFORMED NEARLY
TWO DOZEN OF HIS BEST-KNOWN TUNES LIKE A
MAN WHO STILL GETS A KICK OUT OF PLOPPING
DOWN BEHIND A PIANO AND LETTING IT RIP."

★ ★

—*THE LOS ANGELES TIMES*, 2022

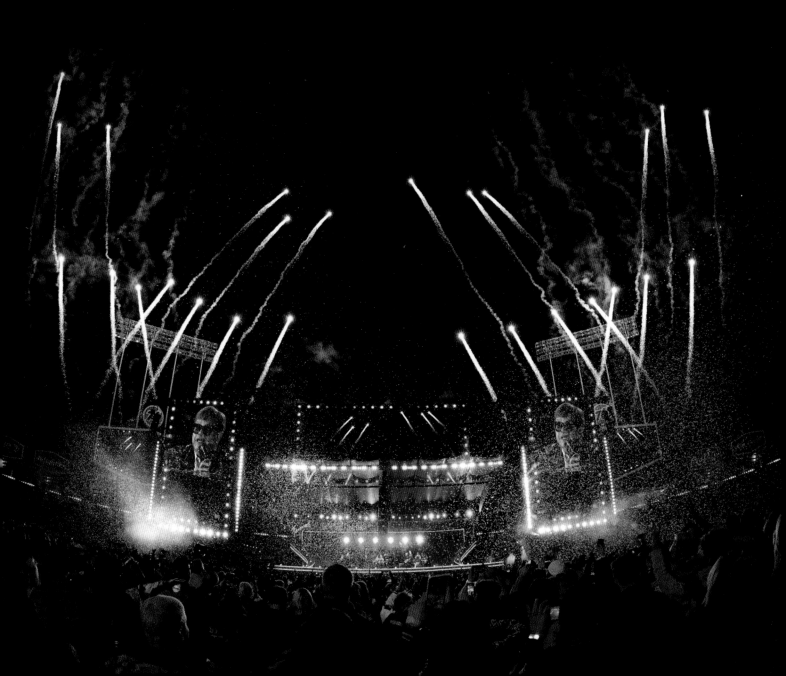

"ELTON JOHN TRIUMPHED AT DODGER STADIUM HERE OCT. 25. NO POSSIBLE ARGUMENT OR GRIPE ABOUT THAT FACT. IT WAS A STANDING OVATION. ONE HUNDRED PERCENT EMOTIONAL AND DRAMATIC TRIUMPH."

★ ★ ★ ★ ★ ★ ★ ★ ★ ★ ★ ★ ★ ★ ★ ★ ★ ★

—BILLBOARD, 1975

Elton was famously photographed by Terry O'Neill during his 1975 Dodger Stadium show.

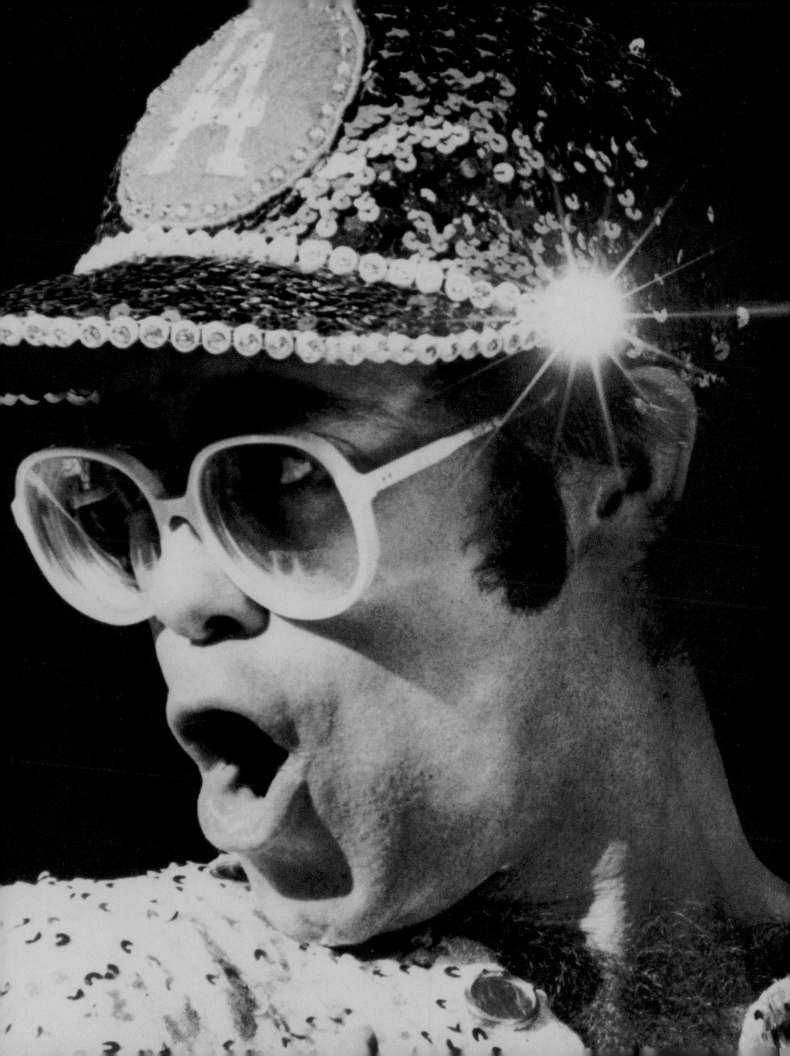

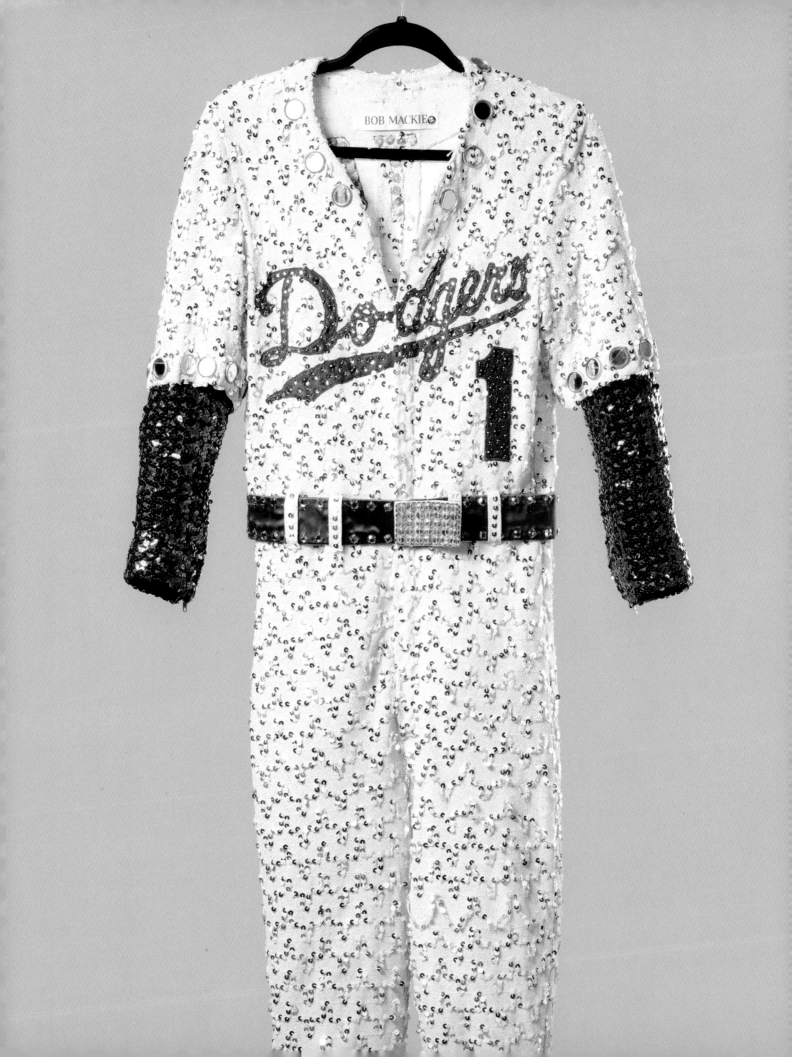

Although Elton didn't wear it for the entire performance, his sequined Dodgers costume has become one of his most iconic stage ensembles. The one-piece suit, designed by Bob Mackie, features a rhinestone belt, mirrored detail, and the number 1. The suit was returned to Elton's archive in recent years and was displayed during his farewell shows at Dodger Stadium.

including David, who was carrying around a camera, kept asking me how I was feeling about the final shows, but I wasn't ready to think about it. I didn't want to waste my energy allowing nerves or emotion to take over offstage. I wanted to save every iota of energy for the concerts. I wanted to stay in the zone until we'd completed all three nights so I could give all that emotion to the fans. For me, it's an almost meditative focus. I had a job to do, and I took that responsibility very seriously. I wanted to deliver the best possible shows to my fans. Any emotional reflection could wait.

Thursday night's show went off without a hitch. I loved being back on the Dodger Stadium stage. I could feel the energy from the fans, who welcomed me so graciously. To commemorate the occasion, Gucci designed a sequined robe that referenced my old Dodgers uniform—which was on display in the stadium—and Bob Mackie re-created the original blue sequined baseball cap to top it off. It was a nice throwback, but still felt modern. The initial reviews were unbelievable. It felt similar to the raves I got after my opening night at the Troubadour in 1970.

"There was nothing about the almost two-and-a-half-hour performance that suggested a fellow about to actually retire, apart from the 'Farewell Yellow Brick Road' lettering atop the massive proscenium," *Variety* wrote. "As much as he's taken his sweet time in leaving the road, though, Thursday's show made it feel like he's actually sprinting to the finish. This was John in top vigorous form, sounding and feeling like he's ready for the next 50-some years—leaving the touring scene still at the top of his performing game, exiting because he wants to, not because he has to."

I was delighted by the response. Amazingly, it felt as though my voice had only gotten better as the tour went on. David's theory is that I felt loved fully for the first time in my life and it allowed me to open up. "It's made your voice more open too," he said. Whatever was happening, I was in a really positive place. The day after the first show, I attended an event in honor of Bernie, where he received his CBE (Commander of the Most Excellent Order of the British Empire). I made a short speech, saying, "He honestly is one of the greatest lyric writers of all time. Every time I sing his songs, the better they get to me. His lyrics never fade and our friendship never fades." It was also the first time I was able to speak to my band close-up for months because we'd been kept in separate Covid bubbles. That night, Elijah and Zachary went to a Lakers basketball game and got to sit courtside. By the time they got home I was already in bed, resting up for the final shows. "We got to shoot hoops!" they told me excitedly. "We thought we'd be sitting in the stands, but we were next to the court!" All of the day's moments—the positive reviews, Bernie's ceremony, the boys' excitement—converged, and I felt true joy. I looked over at David and said, "I've never felt so happy in my life."

The second night at Dodger Stadium went just as well as the first. Onstage, Dodgers chairman and principal owner Mark Walter and Billie Jean King, who is a Dodgers co-owner, surprised me with a check for a $1 million donation for the Elton John AIDS Foundation. I was floored by the generosity. As the final concert approached, I was ready. Throughout the Farewell Yellow Brick Road Tour, I'd played a similar set nearly every night. But for the last North American show, we had a few special things planned. I'd selected three of my favorite female vocalists to join me onstage: Kiki Dee for "Don't Go Breaking My Heart," Brandi Carlile for "Don't Let the Sun Go Down on Me," and Dua Lipa for "Cold Heart." All of them represent something important to me. Kiki is part of my history. Brandi has been my spiritual child for nearly twenty years. And Dua embodies the next generation of music. Although I don't love rehearsal, the band and I did run through the songs a

Elton sits backstage before one of his Dodger Stadium shows with Brandi Carlile, Kiki Dee, Dua Lipa, and Joni Mitchell—a magical moment with four extraordinary women.

few times the afternoon before with each singer. The rehearsals were over in about twenty minutes because they are so professional and talented. It was especially fun because although Dua and I had performed live for the Oscars, it had been virtual and we'd never played "Cold Heart" live before.

Before the show, as everyone was making final preparations for the broadcast, I sat in the hospitality suite backstage with Kiki, Brandi, Dua, and Joni Mitchell. It was poignant to be surrounded by four such significant female figures on this important night. I had a complicated relationship with my mother, who was not particularly affectionate with me. I chased her approval for a long time. But now, decades later, here I was in the midst of these extraordinary women who loved me for who I was. David later said there was something symbolic about that moment. And maybe there was. But it just felt nice to be supported. I'm so glad the shows at Dodger Stadium could include these women, who have been a big part of my life. They all pulled it off brilliantly. And it was a joy to have Joni there. She's a formidable woman, and that's what you'd expect because she's one of the greatest artists in the world.

An endless stream of friends, acquaintances, and celebrities came to see all three shows, although the final night was the most star-studded. Everyone was there: Paul McCartney, Mick Jagger, Taron Egerton, Jude Law, Billie Jean King, the Edge, H.E.R., Rina Sawayama, Neil Patrick Harris and David Burtka, Tom Hanks and Rita Wilson, Angela Bassett, Pnau, and Donatella Versace. It meant a lot to me that so many people wanted to be part of these concerts. During the show, there were a lot of memorable moments, some planned and some spontaneous. I dedicated "Don't Let the Sun Go Down on Me" to the four members of my band who have died over the years. "During my life onstage, I've lost four great musicians," I shared, after introducing my farewell tour band. I recalled Dee Murray, Roger Pope, Guy Babylon, and Bob Birch. "They were such great members onstage and on record. I would like to dedicate this song to the memory of those great guys."

Later in the show, after I had donned my new Dodgers costume, I brought Bernie onstage to share in the applause. "If it wasn't for him, I wouldn't be sitting here right now," I admitted to the audience. He gamely came out and took a bow as everyone cheered wildly. After we hugged, I got momentarily emotional. I could feel myself stumble over my words as I said, "We still love each other more than we've ever done before. He's an amazing guy." I kissed him on the cheek, adding, "I love you." I pushed past the choked-up feeling. I had a show to finish. But first, I wanted

to share my family with the fans. I felt it was important that my husband and sons join me on the stage at Dodger Stadium as I said my last goodbye to Los Angeles.

"I want to spend time with my family because I'll be seventy-six next year," I told the crowd. "I want to bring them out and show you why I'm retiring." David and the boys walked onstage. Elijah and Zachary wore matching Dodgers jackets with ELTON on the back for the occasion. They smiled and waved to the cheering audience. How amazing to share my family with my fans. I could see the pride in David's eyes as he looked over the crowd. He had brought this tour to life and helped to keep it going through numerous challenges. This night was a culmination of so much creative effort for him, as well as for me. I was grateful for the opportunity to acknowledge him publicly as my husband, but it was equally meaningful to see him standing up there in tribute to his incredible vision.

As they walked off the stage, I sat back down at the piano. I thanked the fans one last time. "I wish you health and love and prosperity," I said. "Be kind to each other, okay? And, farewell." I put my hands to the piano keys and began to play "Goodbye Yellow Brick Road," the final song of the final show at Dodger Stadium. The band joined in. In the end, as I stood on my platform in my Gucci tracksuit and began to rise up over the audience, I urged more cheers from the fans. They grew louder and louder. And then, as suddenly as I had appeared, I vanished from view.

Of course, I didn't really vanish. I went backstage and said hello to all the friends who had come to see me perform. I took off my stage costumes, which would go into storage until we resumed the farewell tour the following year, and I went home to bed. I had done what I came to do. The shows couldn't have gone any better, which David and I kept telling each other for days after. I was thrilled by the response and by the fact that fans around the world got to see the concert from their living rooms. It was an incredible moment. In the weeks that followed, we returned to England, with a stop in New York City to switch on the Christmas lights at Saks Fifth Avenue, which generously donated $1 million to the Elton John

Elton in his Gucci-designed robe at Dodger Stadium

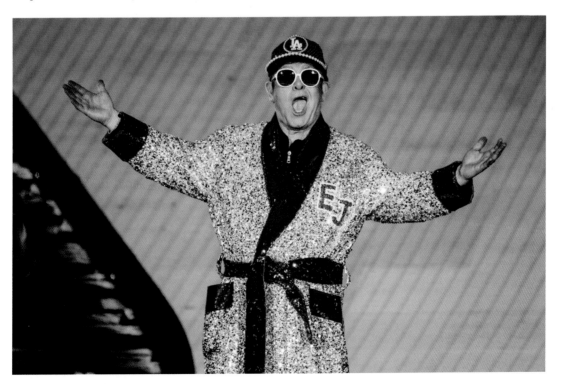

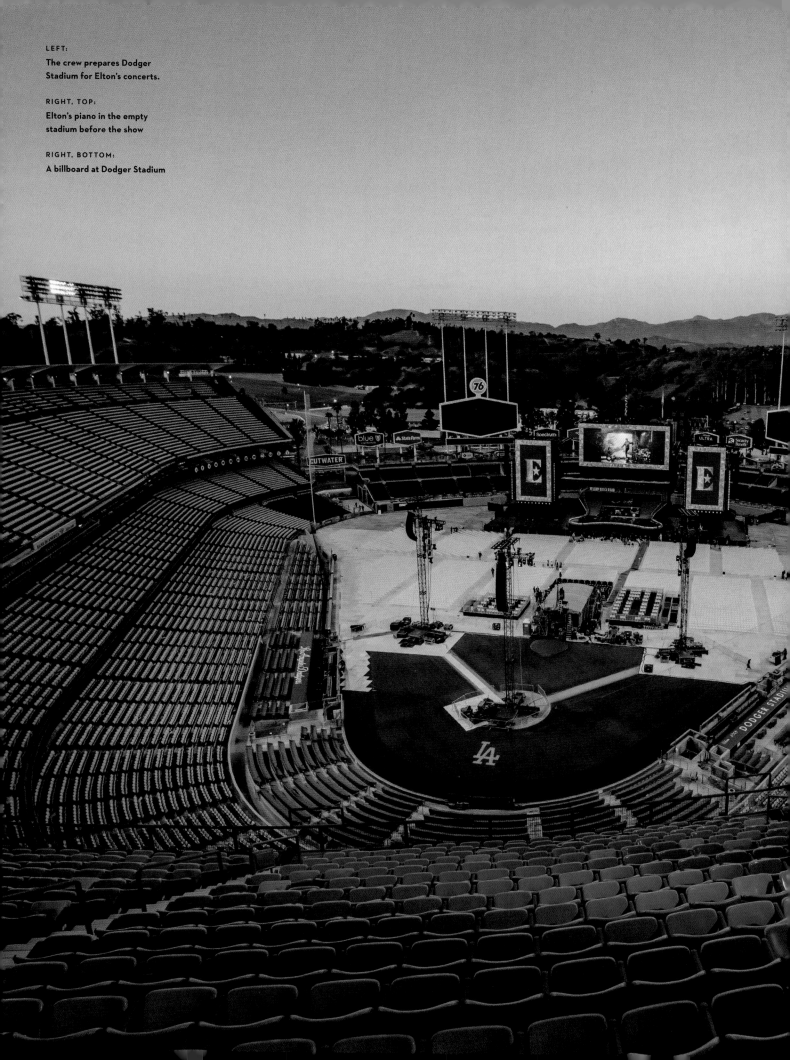

LEFT:
The crew prepares Dodger
Stadium for Elton's concerts.

RIGHT, TOP:
Elton's piano in the empty
stadium before the show

RIGHT, BOTTOM:
A billboard at Dodger Stadium

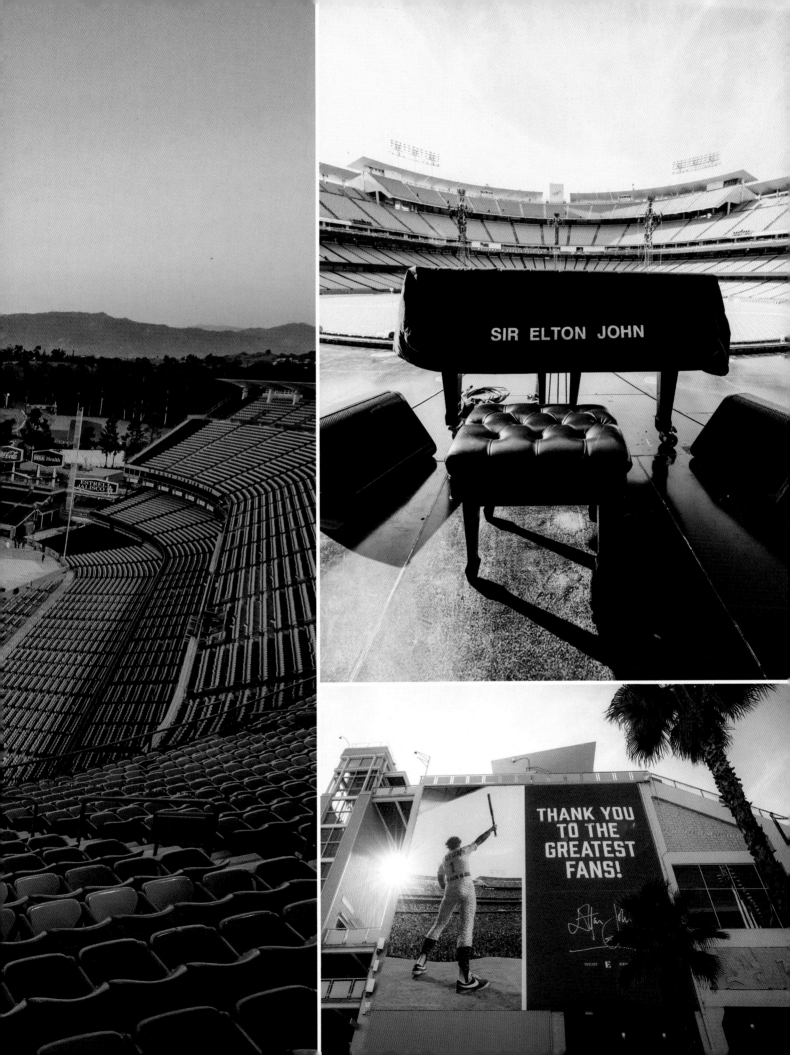

AIDS Foundation as part of their holiday campaign. We then flew to Australia for the holidays.

I could feel myself decompressing. I had glimmers of nostalgia and bittersweet emotion, as you might expect, but mostly I was content. And as we picked the tour back up in 2023 and continued onward, sometimes with more hurdles along the way, I could feel the next chapter beginning to open up. In June, I played a final show at Glastonbury with many of my friends and family by my side. After I left the stage behind, I felt I'd delivered what I had set out to deliver. I wanted my farewell tour to feel like a celebration for me and for my fans, and it did. Together, we sang and danced and felt united by the power of song. Together, we left the worries of the world behind and there was only music.

People often ask me what I've learned as an artist. I've been doing this for so long that I must have acquired some kind of wisdom. And certainly I have learned things and I've become a better performer. But the Farewell Yellow Brick Road Tour gave me a true appreciation of my audience. After four years of shows, I really understood how kind and loyal my fans are. I saw a lot of faces I recognized in the crowds, especially in Europe and America, and it offered me a sense of calm. I was never nervous, really, about the tour because I wanted it to be a celebration from the word *go*. Throughout, it was a festival of love, fun, kindness, and tribute. It got better and better and better. I have always appreciated my audiences, but this time, at the age I am, with these as the last shows, I really soaked it in. The truth is, I can't take a compliment. Ask David. But I took the audience in this time and it was so touching.

As we wound around the globe, I was astonished by the sheer diversity of my crowds. There were people who were eighty, people who were fifty, people who were thirty, and people who were eight. There were kids in the front row with their parents, dressed in light-up glasses, and they knew every single word. Do you know how great that makes me feel? It's challenging for me to speculate why I appeal to so many people, but I imagine it's because I'm fun. I'm fond of dressing up and spectacle. I always aim to offer fans a safe space to be themselves completely, to indulge in joyful self-expression. If I can celebrate myself, so can they.

Playing more than three hundred shows over the course of four years also revealed how my songs have stood the test of time. And, in fact, the songs have gotten better, which is a real testament to the lyrics. The melodies seemed to get catchier each time I played them on the farewell tour. Just look at "Crocodile Rock." That song is a bit of a folly, but the fans love it. And there's nothing wrong with making people feel good. Nobody starts writing songs imagining they'll endure for this long. You stay in the moment and look to the next record and the next concert. If you had told me in 1973 that fifty years later we'd be celebrating like this, I would have said, "Are you kidding me?" But it's a wonderful feeling to be here now and to get to experience the next great thing, whatever it may be.

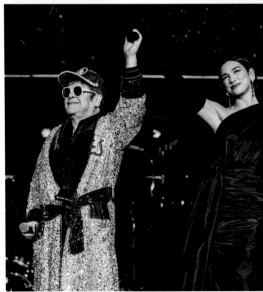

TOP:
Elton singing "Don't Go Breaking My Heart" onstage with Kiki Dee

MIDDLE:
Elton with Brandi Carlile after a duet of "Don't Let the Sun Go Down on Me"

BOTTOM:
Elton and Dua Lipa take a bow after performing their global smash hit "Cold Heart (PNAU Remix)."

As the Farewell Yellow Brick Road Tour came to an end in the summer of 2023, in Stockholm, I continued to get questions about what was next for me. "Are you really done touring?" people asked. The critics seemed skeptical that this was it. But it is. As a touring performer, I am retired. It seems fitting at age seventy-seven. I gave much of my life to the road, and now I want to see what else there is. I want to be with my family. I want to see the daffodils outside our house bloom each year in the spring. I want to make more music and more art. I want to keep collaborating. I want to champion younger artists. I want to write more musicals and curate exhibitions and create special releases for my fans. I want to be a father and a husband. I want to do more hands-on work with the Elton John AIDS Foundation and better understand what's happening on the ground. I want to take each moment as it comes. A lot has changed for me since I became Elton John, but my appreciation of the extraordinary life I've been given has never wavered. What a joy to look back and remember what I've achieved. But it's a greater joy, and a privilege, to look forward.

FAREWELL YELLOW BRICK ROAD TOUR SETLIST

LOS ANGELES, CALIFORNIA

DODGER STADIUM

NOVEMBER 20, 2022

1. Bennie and the Jets
2. Philadelphia Freedom
3. I Guess That's Why They Call It the Blues
4. Border Song
5. Tiny Dancer
6. Have Mercy on the Criminal
7. Rocket Man (I Think It's Going to Be a Long, Long Time)
8. Take Me to the Pilot
9. Someone Saved My Life Tonight
10. Levon
11. Candle in the Wind
12. Funeral for a Friend / Love Lies Bleeding
13. Burn Down the Mission
14. Sad Songs (Say So Much)
15. Sorry Seems to Be the Hardest Word
16. Don't Let the Sun Go Down on Me with Brandi Carlile
17. The Bitch Is Back
18. I'm Still Standing
19. Don't Go Breaking My Heart with Kiki Dee
20. Crocodile Rock
21. Saturday Night's Alright (For Fighting)

ENCORE:

22. Cold Heart (PNAU Remix) with Dua Lipa
23. Your Song
24. Goodbye Yellow Brick Road

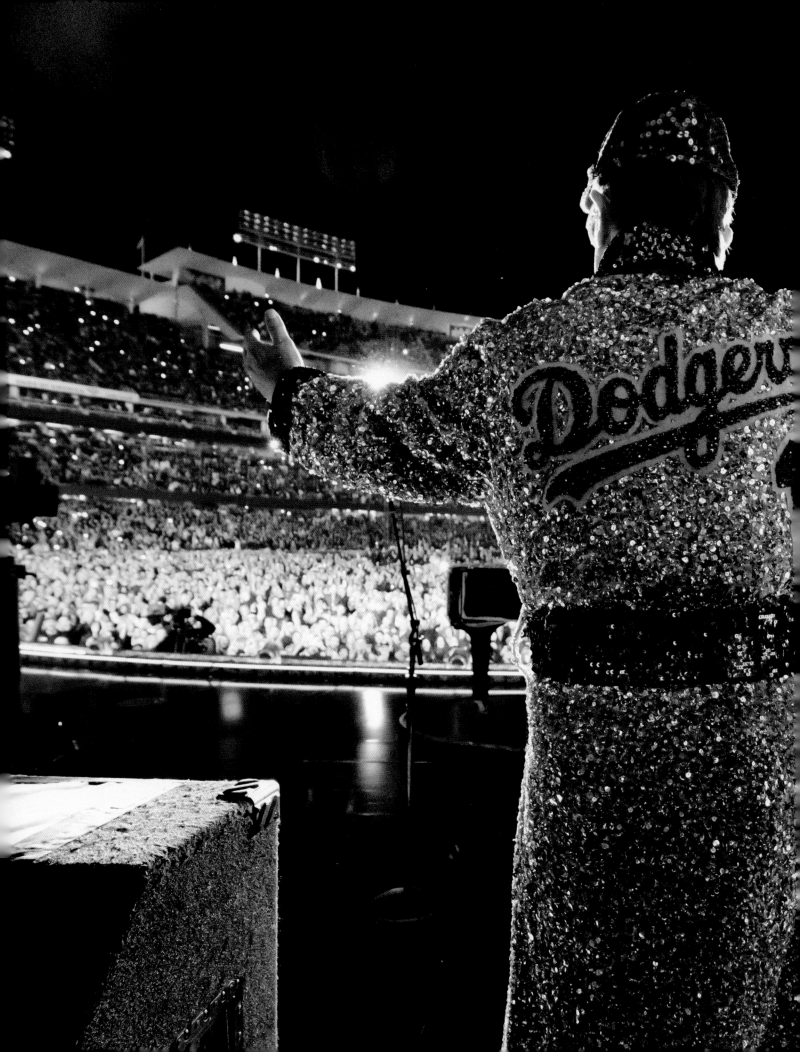

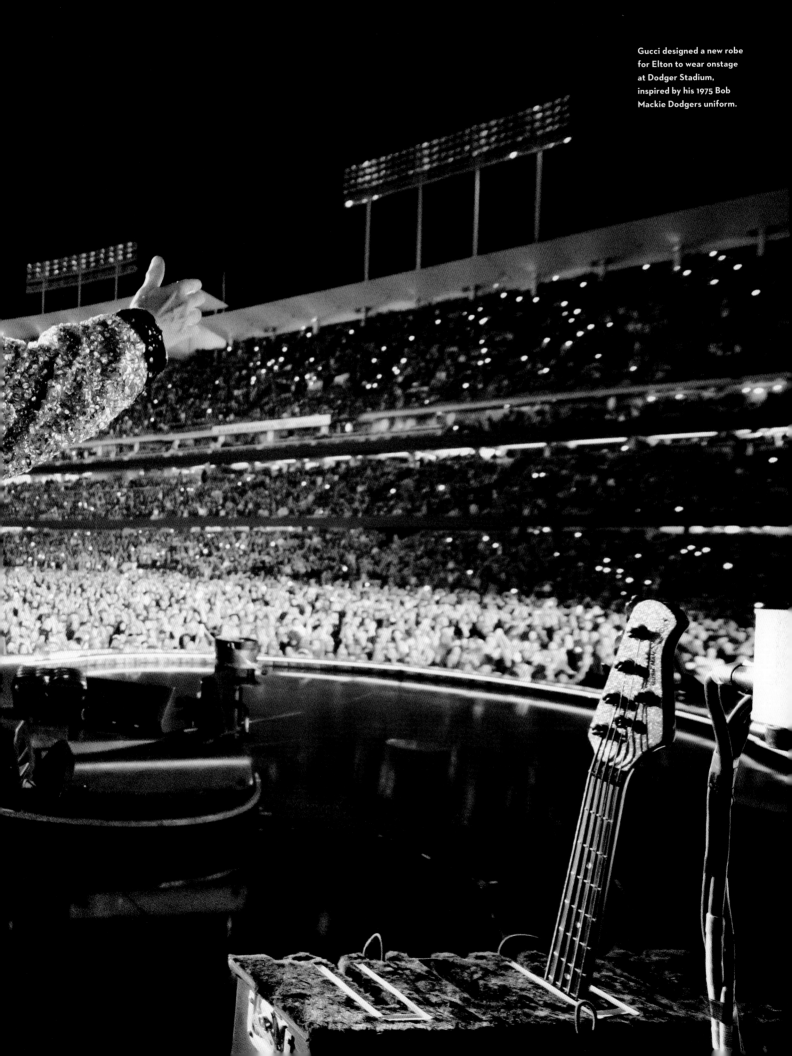

Gucci designed a new robe for Elton to wear onstage at Dodger Stadium, inspired by his 1975 Bob Mackie Dodgers uniform.

THE FINAL HURRAH AT GLASTONBURY

CITY

WORTHY FARM
SOMERSET, ENGLAND

DATE

JUNE 25, 2023

"IT'S ROCK HISTORY IN THE MAKING, BUT IT ALSO DOESN'T FEEL LIKE THE END: STRADDLING ERAS AND WITH POP STANDARDS TO BEAR, ELTON JOHN FEELS ETERNAL."

★ ★

—*THE GUARDIAN*, 2023

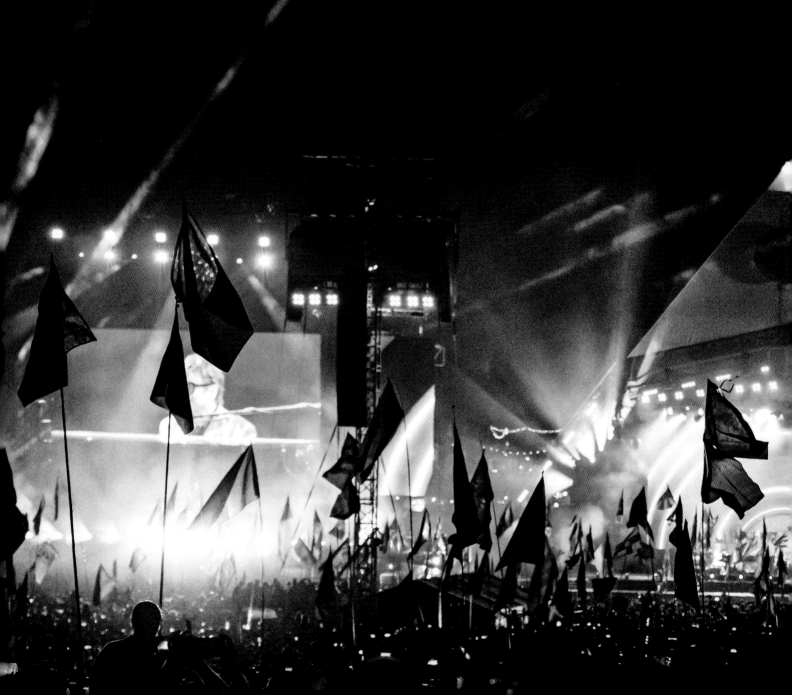

I always said I'd go out with a bang, and Glastonbury proved to be just the place to wrap up my UK touring career. I never thought I'd play the outdoor festival, but there I was, standing on the Pyramid Stage with fireworks exploding over my head. It felt like a proper way to bring my touring career to a close and to say farewell to my home country of England.

Although it wasn't technically part of the Farewell Yellow Brick Road Tour, the band and I brought a similar setlist and vibe to the performance, and I strutted onstage in a new Gucci-designed gold lamé suit. "It's a very special and emotional night for me, as it may be my last-ever show in England," I told the audience. "I better play well and entertain you as you've been standing there so long."

Because the show felt extra special, I brought out some guests, just like I had at Dodger Stadium. My pal Brandon Flowers joined me on "Tiny Dancer," and Rina Sawayama sang on "Don't Go Breaking My Heart." I also wanted to support a few lesser-known artists. I invited out Jacob Lusk, from the band Gabriels, for "Are You Ready for Love" and ceded a spot on my own setlist for Stephen Sanchez to perform his hit "Until I Found You." Although the night was a celebration of my songs, it seemed right to spotlight the future of music, too.

As the sun set over Worthy Farm, I felt nostalgic and hopeful at the same time. We closed the show with "Rocket Man," and the crowd's voices joined in with mine. I stood up from my piano, arms outstretched, and smiled. It felt like a moment I'd remember for a long, long time. "I'm so happy to be here," I said. "I'm never going to forget this."

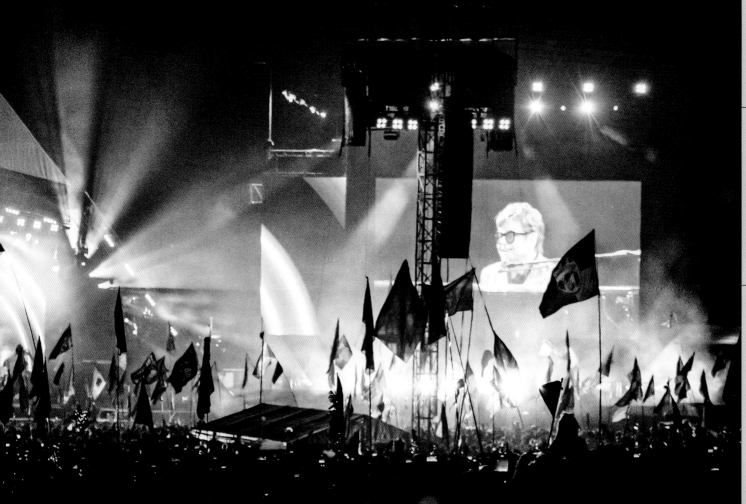

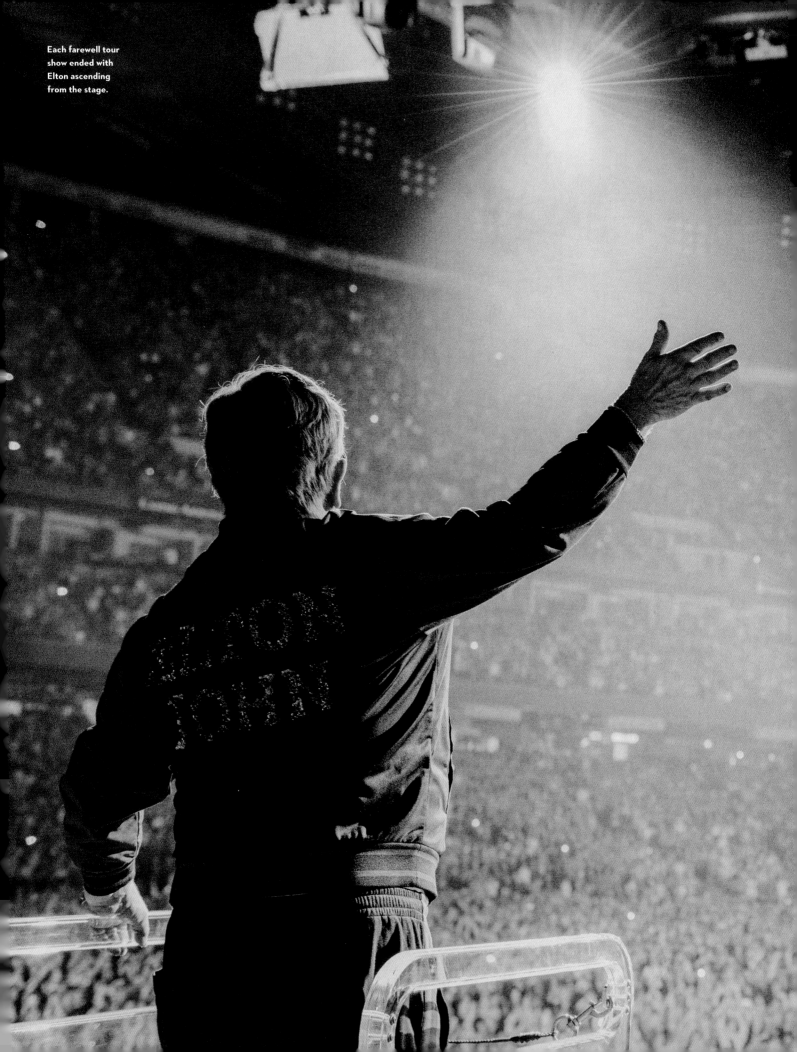

Each farewell tour show ended with Elton ascending from the stage.

AFTERWORD

I never set out to be a touring artist. I wanted to write songs and make records. Of course I wanted to perform them live, but when I was younger, I didn't imagine myself as someone who would spend their life on the road. Like so many things in my life and career, becoming an international performer has been happenstance. Maybe even fate. It's where the path has led me, and I've followed it with curiosity and delight. But now I've arrived at the end of that path. It's been long and winding and unexpected, but it's led me here, to a new, undiscovered one. I have yet to explore the route that's opened up in front of me, which is part of the fun.

For more than five decades, I've created a family of fans around the world. From the very beginning, it was the fans who drove me to continue performing and touring and making music. You have supported me through every step I've taken. Just because I stop touring doesn't mean that family will cease to exist. Our relationship may evolve, but my love for the fans will never diminish. An ending is bittersweet. It is the conclusion of something, but it is also a beginning. I am certain that we are just getting started.

Looking back throughout the Farewell Yellow Brick Road Tour was strange at times. I recalled a lot of moments that were truly amazing, but also some that I'd prefer to leave in the past. I've learned from each one, and I'm grateful to have had so many opportunities to grow. As the farewell tour came to a close in the summer of 2023, I felt a tinge of sad-

ness, but mostly I felt hopeful. I am the happiest I've ever been. I have a wonderful husband and two wonderful sons. I have an extended family I'm looking forward to knowing better. I'm part of a community of artists and musicians who are creating incredible things. I'm not done creating music, and I still plan to play select live shows. I'm excited about the possibility of new ventures, too. Every door is open to me. I could not ask for anything better at seventy-seven.

Music is one of the greatest forces on earth. It connects us in momentous, meaningful ways. It breaks barriers. It brings people together despite stark differences. I've been embraced by audiences all over the world. I've gained so much from visiting every single place I've ever toured. It's made me who I am today, and I'm humbled by the outpouring of support I continue to get from the fans. To those who attended my final shows, and to those who couldn't make it, I owe you everything. This isn't goodbye. As you watch me stroll off into the sunset, down the yellow brick road, it takes only a change of perspective to realize that I am actually walking toward you.

Love,
Elton

FAREWELL YELLOW BRICK ROAD TOUR DATES

Date	City, State / Territory	Country
LEG 1		
9/8/2018	Allentown, PA	USA
9/11/2018	Philadelphia, PA	USA
9/12/2018	Philadelphia, PA	USA
9/15/2018	Buffalo, NY	USA
9/16/2018	University Park, PA	USA
9/19/2018	Hartford, CT	USA
9/21/2018	Washington, DC	USA
9/22/2018	Washington, DC	USA
9/25/2018	Toronto, ON	Canada
9/26/2018	Toronto, ON	Canada
9/28/2018	Ottawa, ON	Canada
9/29/2018	Quebec City, QC	Canada
10/4/2018	Montréal, QC	Canada
10/6/2018	Boston, MA	USA
10/9/2018	Uniondale, NY	USA
10/10/2018	Pittsburgh, PA	USA
10/12/2018	Detroit, MI	USA
10/13/2018	Detroit, MI	USA
10/15/2018	Grand Rapids, MI	USA
10/18/2018	New York, NY	USA
10/19/2018	New York, NY	USA
10/23/2018	Louisville, KY	USA
10/24/2018	Nashville, TN	USA
10/26/2018	Chicago, IL	USA
10/27/2018	Chicago, IL	USA
10/30/2018	St. Louis, MO	USA
11/2/2018	Columbus, OH	USA
11/3/2018	Cleveland, OH	USA
11/6/2018	Boston, MA	USA
11/8/2018	New York, NY	USA
11/9/2018	New York, NY	USA
11/23/2018	Sunrise (Fort Lauderdale), FL	USA
11/24/2018	Miami, FL	USA
11/30/2018	Atlanta, GA	USA
12/1/2018	Atlanta, GA	USA
12/4/2018	Birmingham, AL	USA
12/6/2018	New Orleans, LA	USA
12/8/2018	Houston, TX	USA
12/9/2018	Houston, TX	USA
12/12/2018	San Antonio, TX	USA
12/14/2018	Dallas, TX	USA
12/15/2018	Dallas, TX	USA
LEG 2		
1/11/2019	Boise, ID	USA
1/12/2019	Portland, OR	USA
1/15/2019	Fresno, CA	USA
1/16/2019	Sacramento, CA	USA
1/18/2019	Oakland, CA	USA
1/19/2019	San Jose, CA	USA
1/22/2019	Los Angeles, CA	USA
1/23/2019	Los Angeles, CA	USA
1/25/2019	Los Angeles, CA	USA
1/26/2019	Glendale (Phoenix), AZ	USA
1/29/2019	San Diego, CA	USA
1/30/2019	Los Angeles, CA	USA
2/1/2019	Inglewood (Los Angeles), CA	USA

Date	City, State / Territory	Country
2/2/2019	Inglewood (Los Angeles), CA	USA
2/6/2019	Denver, CO	USA
2/7/2019	Denver, CO	USA
2/9/2019	Tulsa, OK	USA
2/12/2019	Omaha, NE	USA
2/13, 2019	Kansas City, MO	USA
2/15/2019	Rosemont (Chicago), IL	USA
2/16/2019	Rosemont (Chicago), IL	USA
2/21/2019	Minneapolis, MN	USA
2/22/2019	Minneapolis, MN	USA
2/27/2019	Cincinnati, OH	USA
3/1/2019	Albany, NY	USA
3/2/2019	Newark, NJ	USA
3/5/2019	New York, NY	USA
3/6/2019	New York, NY	USA
3/8/2019	Brooklyn (New York), NY	USA
3/9/2019	Brooklyn (New York), NY	USA
3/12/2019	Raleigh, NC	USA
3/13/2019	Columbia, SC	USA
3/15/2019	Jacksonville, FL	USA
3/16/2019	Sunrise (Fort Lauderdale), FL	USA
3/18/2019	Orlando, FL	USA
LEG 3		
5/1/2019	Vienna	Austria
5/2/2019	Vienna	Austria
5/4/2019	Kraków	Poland
5/7/2019	Prague	Czech Republic
5/9/2019	Bremen	Germany
5/11/2019	Stuttgart	Germany
5/12/2019	Oberhausen	Germany
5/18/2019	Copenhagen	Denmark
5/19/2019	Gothenburg	Sweden
5/22/2019	Hanover	Germany
5/23/2019	Antwerp	Belgium
5/26/2019	Munich	Germany
5/29/2019	Verona	Italy
6/1/2019	Wiesbaden	Germany
6/4/2019	Bergen	Norway
6/6/2019	Copenhagen	Denmark
6/8/2019	Amsterdam	Netherlands
6/9/2019	Hove	UK/England
6/12/2019	Dublin	Ireland
6/13/2019	Dublin	Ireland
6/15/2019	Cardiff	UK/Wales
6/17/2019	Amsterdam	Netherlands
6/18/2019	Lille	France
6/20/2019	Paris	France
6/22/2019	Bordeaux	France
6/23/2019	Nîmes	France
6/26/2019	Madrid	Spain
6/29/2019	Montreux	Switzerland
7/3/2019	Graz	Austria
7/5/2019	Munich	Germany
7/7/2019	Lucca	Italy
LEG 4		
9/4/2019	Salt Lake City, UT	USA
9/6/2019	Las Vegas, NV	USA

Date	City, State / Territory	Country
9/7/2019	Las Vegas, NV	USA
9/10/2019	Anaheim, CA	USA
9/11/2019	Anaheim, CA	USA
9/13/2019	San Francisco, CA	USA
9/15/2019	San Francisco, CA	USA
9/17/2019	Tacoma (Seattle), WA	USA
9/18/2019	Tacoma (Seattle), WA	USA
9/21/2019	Vancouver, BC	Canada
9/22/2019	Vancouver, BC	Canada
9/24/2019	Vancouver, BC	Canada
9/27/2019	Edmonton, AB	Canada
9/28/2019	Edmonton, AB	Canada
10/1/2019	Saskatoon, SK	Canada
10/2/2019	Saskatoon, SK	Canada
10/4/2019	Winnipeg, MB	Canada
10/5/2019	Winnipeg, MB	Canada
10/19/2019	Milwaukee, WI	USA
10/23/2019	Toronto, ON	Canada
10/24/2019	Toronto, ON	Canada
10/28/2019	Nashville, TN	USA
10/30/2019	Memphis, TN	USA
11/1/2019	Atlanta, GA	USA
11/2/2019	Atlanta, GA	USA
11/4/2019	Tampa, FL	USA
11/6/2019	Charlotte, NC	USA
11/8/2019	Philadelphia, PA	USA
11/9/2019	Philadelphia, PA	USA
11/11/2019	Cleveland, OH	USA
11/13/2019	Pittsburgh, PA	USA
11/15/2019	Boston, MA	USA
11/16/2019	Uniondale, NY	USA
LEG 5		
11/30/2019	Perth, WA	Australia
12/1/2019	Perth, WA	Australia
12/4/2019	Adelaide, SA	Australia
12/5/2019	Adelaide, SA	Australia
12/7/2019	Geelong, VIC	Australia
12/10/2019	Melbourne, VIC	Australia
12/11/2019	Melbourne, VIC	Australia
12/14/2019	Melbourne, VIC	Australia
12/15/2019	Melbourne, VIC	Australia
12/18/2019	Brisbane, QLD	Australia
12/19/2019	Brisbane, QLD	Australia
12/21/2019	Darling Harbour (Sydney), NSW	Australia
12/23/2019	Darling Harbour (Sydney), NSW	Australia
1/7/2020	Sydney, NSW	Australia
1/9/2020	Sydney, NSW	Australia
1/11/2020	Hunter Valley, NSW	Australia
1/12/2020	Hunter Valley, NSW	Australia
1/14/2020	Sydney, NSW	Australia
1/16/2020	Brisbane, QLD	Australia
1/18/2020	Mount Cotton, QLD	Australia
1/19/2020	Mount Cotton, QLD	Australia
1/22/2020	Bathurst, NSW	Australia
1/25/2020	Macedon Ranges, VIC	Australia
1/26/2020	Macedon Ranges, VIC	Australia
1/29/2020	Rutherglen, VIC	Australia

Date	City, State / Territory	Country
1/31/2020	Coldstream, VIC	Australia
2/1/2020	Coldstream, VIC	Australia
2/5/2020	Dunedin, Otago	New Zealand
2/6/2020	Napier (Hawke's Bay)	New Zealand
2/15/2020	Napier (Hawke's Bay)	New Zealand
2/16/2020	Auckland	New Zealand
2/22/2020	Melbourne, VIC	Australia
2/25/2020	Coffs Harbour, NSW	Australia
2/26/2020	Coffs Harbour, NSW	Australia
2/29/2020	South Townsville, QLD	Australia
3/3/2020	Sunshine Coast, QLD	Australia
3/4/2020	Sunshine Coast, QLD	Australia
3/7/2020	Parramatta (Sydney), NSW	Australia
LEG 6…AFTER COVID BREAK		
1/19/2022	New Orleans, LA	USA
1/21/2022	Houston, TX	USA
1/22/2022	Houston, TX	USA
1/29/2022	Little Rock, AR	USA
1/30/2022	Oklahoma City, OK	USA
2/1/2022	Kansas City, MO	USA
2/4/2022	Chicago, IL	USA
2/5/2022	Chicago, IL	USA
2/8/2022	Detroit, MI	USA
2/9/2022	Detroit, MI	USA
2/22/2022	New York, NY	USA
2/23/2022	New York, NY	USA
2/25/2022	Newark, NJ	USA
2/27/2022	Hollywood (Miami), FL	USA
3/1/2022	Brooklyn (New York), NY	USA
3/2/2022	Brooklyn (New York), NY	USA
3/5/2022	Uniondale, NY	USA
3/6/2022	Uniondale, NY	USA
3/10/2022	Dallas, TX	USA
3/11/2022	Dallas, TX	USA
3/19/2022	Fargo, ND	USA
3/22/2022	St. Paul, MN	USA
3/23/2022	St. Paul, MN	USA
3/26/2022	Des Moines, IA	USA
3/27/2022	Lincoln, NE	USA
3/30/2022	St. Louis, MO	USA
4/1/2022	Indianapolis, IN	USA
4/2/2022	Milwaukee, WI	USA
4/5/2022	Grand Rapids, MI	USA
4/8/2022	Knoxville, TN	USA
4/9/2022	Lexington, KY	USA
4/12/2022	Columbus, OH	USA
4/13/2022	Hershey, PA	USA
4/16/2022	Louisville, KY	USA
4/19/2022	Greensboro, NC	USA
4/20/2022	Columbia, SC	USA
4/23/2022	Jacksonville, FL	USA
4/24/2022	Tampa, FL	USA
4/27/2022	Orlando, FL	USA
4/28/2022	Miami, FL	USA
LEG 7		
5/21/2022	Fornebu, Bærum (Oslo)	Norway
5/22/2022	Fornebu, Bærum (Oslo)	Norway

Date	City, State / Territory	Country
5/27/2022	Frankfurt	Germany
5/29/2022	Leipzig	Germany
6/1/2022	Bern	Switzerland
6/4/2022	Milan	Italy
6/7/2022	Horsens	Denmark
6/9/2022	Arnhem	Netherlands
6/11/2022	Nanterre (Paris)	France
6/12/2022	Nanterre (Paris)	France
6/15/2022	Norwich	UK/England
6/17/2022	Liverpool	UK/England
6/19/2022	Sunderland	UK/England
6/22/2022	Bristol	UK/England
6/24/2022	London	UK/England
6/26/2022	Bristol	UK/England
6/29/2022	Swansea	UK/Wales
7/1/2022	Cork	Ireland
7/3/2022	Watford, Herts	UK/England
7/4/2022	Watford, Herts	UK/England
LEG 8		
7/15/2022	Philadelphia, PA	USA
7/18/2022	Detroit, MI	USA
7/23/2022	East Rutherford, NJ	USA
7/24/2022	East Rutherford, NJ	USA
7/27/2022	Foxborough, MA	USA
7/28/2022	Foxborough, MA	USA
7/30/2022	Cleveland, OH	USA
8/5/2022	Chicago, IL	USA
LEG 9		
9/7/2022	Toronto, ON	Canada
9/8/2022	Toronto, ON	Canada
9/10/2022	Syracuse, NY	USA
9/13/2022	Charleston, SC	USA
9/16/2022	Pittsburgh, PA	USA
9/18/2022	Charlotte, NC	USA
9/22/2022	Atlanta, GA	USA
9/24/2022	Washington, DC	USA
9/30/2022	Arlington (Dallas), TX	USA
10/2/2022	Nashville, TN	USA
10/8/2022	Santa Clara (San Francisco), CA	USA
10/9/2022	Santa Clara (San Francisco), CA	USA
10/16/2022	Tacoma (Seattle), WA	USA
10/17/2022	Tacoma (Seattle), WA	USA
10/21/2022	Vancouver, BC	Canada
10/22/2022	Vancouver, BC	Canada
10/29/2022	San Antonio, TX	USA
11/1/2022	Paradise (Las Vegas), NV	USA
11/4/2022	Denver, CO	USA
11/9/2022	San Diego, CA	USA
11/11/2022	Phoenix, AZ	USA
11/12/2022	Phoenix, AZ	USA
11/17/2022	Los Angeles, CA	USA
11/19/2022	Los Angeles, CA	USA
11/20/2022	Los Angeles, CA	USA
LEG 10		
1/8/2023	New Lambton (Newcastle), NSW	Australia
1/10/2023	New Lambton (Newcastle), NSW	Australia
1/13/2023	Melbourne, VIC	Australia

Date	City, State / Territory	Country
1/14/2023	Melbourne, VIC	Australia
1/17/2023	Sydney, NSW	Australia
1/18/2023	Sydney, NSW	Australia
1/21/2023	Brisbane, QLD	Australia
1/24/2023	Christchurch	New Zealand
LEG 11		
3/23/2023	Liverpool	UK/England
3/24/2023	Liverpool	UK/England
3/26/2023	Birmingham	UK/England
3/28/2023	Dublin	Ireland
3/29/2023	Dublin	Ireland
3/31/2023	Belfast	UK/Northern Ireland
4/2/2023	London	UK/England
4/4/2023	London	UK/England
4/5/2023	London	UK/England
4/8/2023	London	UK/England
4/9/2023	London	UK/England
4/12/2023	London	UK/England
4/13/2023	London	UK/England
4/16/2023	London	UK/England
4/17/2023	London	UK/England
4/27/2023	Munich	Germany
5/2/2023	Hamburg	Germany
5/4/2023	Hamburg	Germany
5/5/2023	Hamburg	Germany
5/8/2023	Hamburg	Germany
5/10/2023	Berlin	Germany
5/11/2023	Berlin	Germany
5/16/2023	Cologne	Germany
5/18/2023	Cologne	Germany
5/19/2023	Cologne	Germany
5/22/2023	Barcelona	Spain
5/23/2023	Barcelona	Spain
5/27/2023	Antwerp	Belgium
5/28/2023	Antwerp	Belgium
5/30/2023	London	UK/England
5/31/2023	Manchester	UK/England
6/2/2023	Manchester	UK/England
6/3/2023	Manchester	UK/England
6/6/2023	Leeds	UK/England
6/8/2023	Birmingham	UK/England
6/10/2023	Birmingham	UK/England
6/11/2023	Birmingham	UK/England
6/13/2023	Aberdeen	UK/Scotland
6/15/2023	Aberdeen	UK/Scotland
6/17/2023	Glasgow	UK/Scotland
6/18/2023	Glasgow	UK/Scotland
6/21/2023	Paris	France
6/25/2023	Glastonbury	England
6/27/2023	Paris	France
6/28/2023	Paris	France
7/1/2023	Zürich	Switzerland
7/2/2023	Zürich	Switzerland
7/5/2023	Copenhagen	Denmark
7/7/2023	Stockholm	Sweden
7/8/2023	Stockholm	Sweden

ABOUT THE AUTHOR

Elton John is the most successful male solo artist in the *Billboard* Hot 100 singles chart's history, having logged seventy-one entries, including nine No. 1s and twenty-nine Top 10s. In the UK and US charts alone, he has two diamond, forty-three platinum or multi-platinum, and twenty-six gold albums as well as over eight-five Top 40 hits. He has sold more than three hundred million records worldwide.

In America, Elton holds the record for the longest span between *Billboard* Top 40 hits, with his most recent chart success coming fifty-two years after his chart debut. He also holds the *Billboard* Adult Contemporary chart record with eighteen No. 1s and seventy-six total songs.

Elton's Farewell Yellow Brick Road Tour kicked off on September 8, 2018, in North America and subsequently saw Elton play 330 shows to over 6.25 million fans across the UK, Europe, North America, and Australasia. The shows marked his retirement from touring after more than fifty years on the road. Elton has delivered over 4,600 performances in more than eighty countries since launching his first tour in 1970.

Among the many awards and honors bestowed upon him are six Grammys (including a Grammy Legend award), a Tony, two Oscars, a Best British Male Artist BRIT Award, induction into the Rock and Roll Hall of Fame and the Songwriters Hall of Fame, the Kennedy Center Honor, the Legend of Live Award, thirteen Ivor Novello Awards, and a knighthood from Queen Elizabeth II for "services to music and charitable services." In January 2024, Elton joined Hollywood's elite group of EGOT winners after securing his first-ever Emmy Award for his historic live Disney+ concert special *Elton John Live: Farewell from Dodger Stadium*.

In 1992, Elton established the Elton John AIDS Foundation, which today is a leader in the global fight against HIV/AIDS. So far, the foundation has raised more than $565 million for HIV/AIDS grants, funding more than three thousand projects in over ninety countries. In June 2019, President Emmanuel Macron presented Elton the Légion d'honneur, France's highest award, for his lifetime contribution to the arts and to the fight against HIV/AIDS. Elton was awarded the Companion of Honour in the 2021 New Year Honours list in the UK. September 2022 saw President Biden awarding him the National Humanities Medal in recognition of Elton's storied career and advocacy work to end HIV/AIDS.

Always a tireless champion of new artists, Elton has been a leading industry voice in lobbying the government for young artists' visa-free touring rights in Europe post-Brexit.

Elton is married to David Furnish, and they have two sons.

ART & PHOTOGRAPHY CREDITS